U0063282

圣洁的
西藏
TIBET
THE HOLY LAND

邓予立
Tang Yu Lap

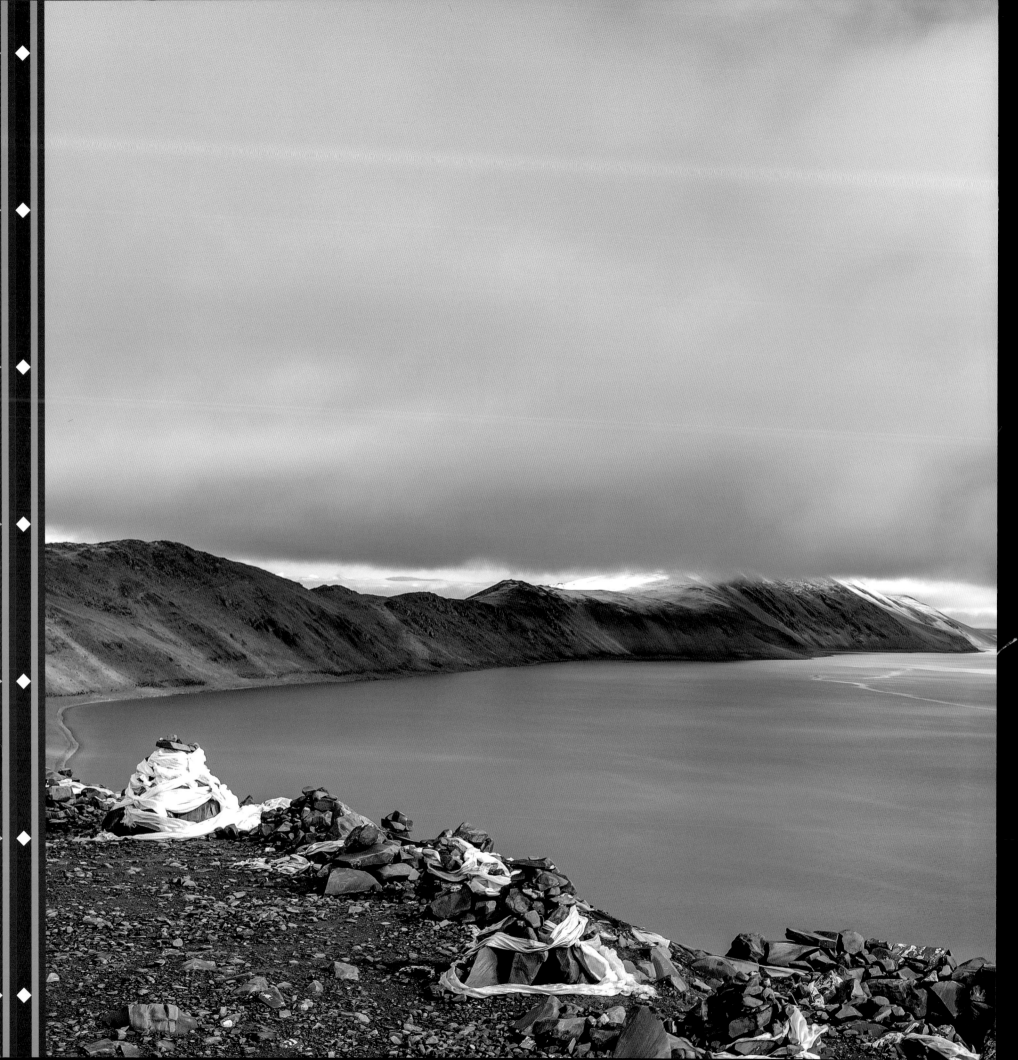

ན་ཡེ་ངྀ་ཤ་ཀ་ནེ་ན་མཧད་པ་ཏི་ཧེཾ༔ ཧྲུ་ཨུ་ཙཀྲ་རསྨ༔

བ་ཛ་ར་ཁུ་ཨེ་ག་ལེ་ཀ་སུཾ༔ ཙེཾ་མ་ཤ་ར་ཐྱེ་ག་ས་བུ་

ཤེ་ན་པ་ཏེ་ཙུ་ལཿ༔ ར་ན་ཙེ་ན་ཀྲུ་ན་ཀ་སུ་ཙོཾ་ག་ཤ་

བ་སུ་མ་སུ༔ བ་དུ་དུ་ད་སྨེ་ན་པ་ཏེ་ཤ་ག་ཚོ་ན་མཛེ་

ས་ེ༔ མེ་ས་པ་ཏེ་ཐུ་ལ་སུ་ར་སྨེ་ན་མ་ཛ་ངྀ༔

序

人间圣地 天上西藏
—— "人间圣地" 胜似天堂，"天上西藏" 人人神往

"人一生中必定要走一趟西藏，才不会有遗憾！" 许多朋友都这么告诉我。

2021 年，随着新冠疫情在国内普遍受到控制，我决定来一次青藏高原之旅。若问我的目的是什么？"自由和神圣" 便是我此行追求的目标！

西藏到底是高海拔的高原地区，一方面令人却步，另一方面却又让人产生一股冲动，因此我想探索、挑战自己。出于安全考量，我并未单独行动，而是与来自北京、重庆和长春三个城市的四位青年友好一齐前往。我们从四川成都出发，全程 20 天整，沿着有 "中国最美景观大道" 之誉的 318 国道，游遍了西藏的东、南、西、北。旅途中，不仅跨过千山之巅、万水之源，还见到危耸的皑皑雪峰、辽阔的高原牧地，以及承载着传统文化信仰的古老寺庙，处处都充满神秘、充满诱惑。西藏同时是藏羚羊的摇篮和牦牛的乐园，即使是渺无人烟的野地，依旧显得生气蓬勃。

这一路上，行程十分紧凑，早出晚归，且路途的海拔高度一次比一次高，非常具有挑战性，所幸一切安然无事，甚至连海拔 5,600 多米的高度都被我征服了。最后，我要用路途中学到的藏族祝福语 "扎西德勒"，来感谢沿途照顾我的四位年轻人！

我把这一路的感动与惊叹变成影像，但愿我的作品能让你一窥这片土地的美妙。

西藏！我会再来！

Preface

I was often told that 'one should go to Tibet at least once, or else a lifetime regret'.

In 2021 as the COVID pandemic situation was under reasonable control, I decided to make a trip to Tibet. If one asks the purpose of my trip, I would respond that 'freedom and holiness' was what I would look for.

Truly, Tibet's high elevation has caused much hesitations for one to visit. Yet on the other hand, it arouses one's strong impulse to explore and to meet the challenges. Considering the safety factors, I chose not to travel alone but to go with my 4 friends from 3 cities viz. Beijing, Chongqing and Changchun. We started out journey from Chengdu, Sichuan, and took on the National Highway 318, which earns it fame as the most beautiful scenic highway in China. We spent a full 20 days visiting various spots in different regions in Tibet. During the trip, we crossed numerous mountain peaks and witnessed the origins of our running waters. We were amazed by the magnificent snowy mountains, the vast-stretching pastures, as well as the monasteries and temples, symbols of Tibet's culture and custom. These places were full of mysteries and attractions. As the motherland of Tibetan antelopes and the paradise of domestic yaks, the places exhibited its vibrancy though appeared to be uninhabited.

We ran a tight schedule with most of the time on the road, and the progressively higher elevations brought immense challenges. We were gratified of our ability to withstand an elevation of 5,600m, and finished the trip safe and sound. To conclude, I would like to say 'tashi delek', a Tibetan greeting which I have learnt, to the 4 young men who had so kindly taken care of me during the trip.

Tibet, I'll be back......

Tang Yu Lap

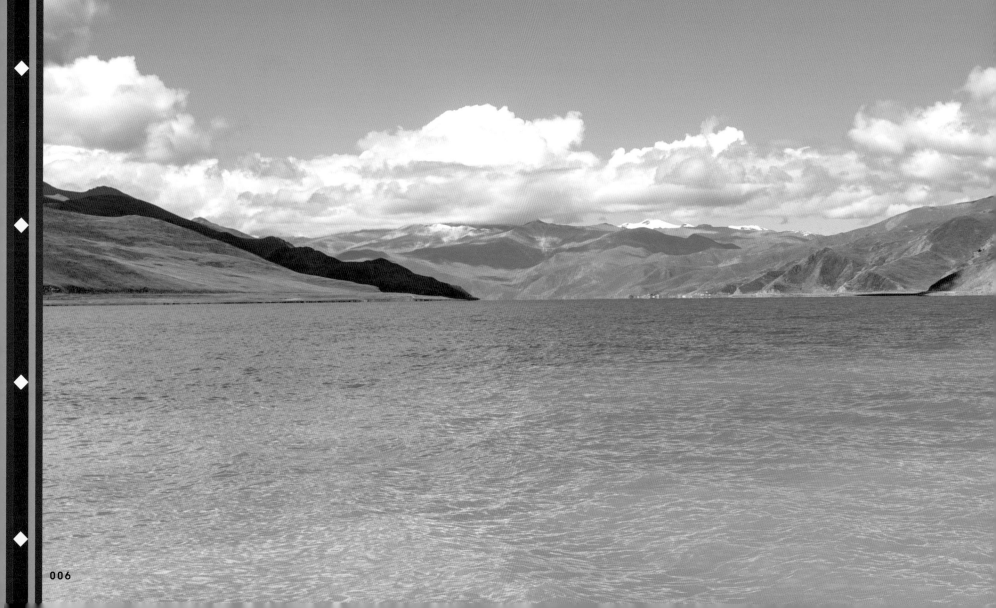

邓予立先生是一位企业家、金融家、收藏家及旅游家。

他在金融业累积超过 50 年经验，曾于数家本地及国际银行担任高级行政人员。于 1990 年在香港创办亨达集团，带领亨达成为香港交易所首家以单一外汇业务上市的香港企业，亦曾于 97 年亚洲金融风暴时配合香港政府击退海外的量子基金，素有"外汇教父"之称。

邓先生热心公共事务，曾出任多项公职，包括中国人民政治协商会议北京市委员会港澳台侨工作顾问、亚太台商联合总会永远荣誉会长及瑞士华商会会长等等。另外，他对慈善事业亦不遗余力，曾在内地兴建多家亨达希望小学及捐赠图书馆、捐助华东水灾及台湾地区台风风灾等。

邓先生的成就不限于金融业，他对文化创意同样有很高追求，多次以收藏家及文化人的身份接受媒体访问，展出稀有的收藏品。同时，邓先生亦是著名的旅游家及作家，目前已到访接近 150 个国家及出版了 14 本书刊。

亨达集团继承了邓先生的理念，用以人为本的精神，培养众多金融人才；用以诚待客的精神，打造一家有诚信、有社会责任的公司；用开拓创新的精神，成功在全球十多个国家建立了据点；用文化创意的精神，创办了一家金融与文化兼备的综合企业。

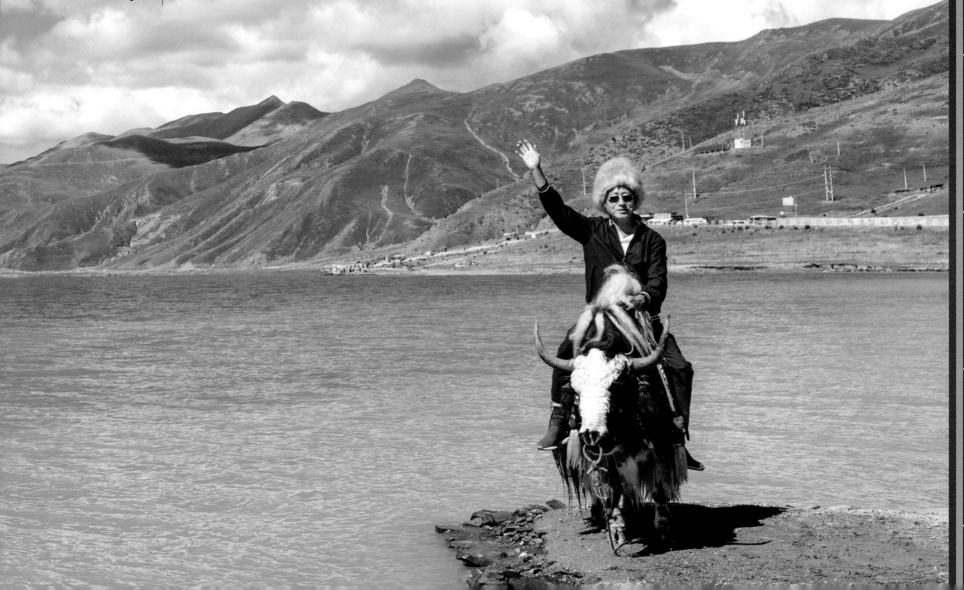

About Mr. Yu Lap Tang

Mr. Tang is an entrepreneur, a financier, a collector and a traveller.

He enjoys over 50 years of rich experience in the financial industry and has worked as a senior executive in several local and international banks. In 1990, he founded the Hantec Group in Hong Kong and led Hantec to become the first public Hong Kong company with a pure foreign exchange business. He also worked with the Hong Kong government to repel overseas quantum funds during the Asian financial crisis in 1997 and is known as the 'Godfather of Foreign Exchange'.

Mr. Tang is a keen public servant, holding a number of public offices, including Advisor to the Beijing Municipal Committee of the Chinese People's Political Consultative Conference on Hong Kong, Macau, Taiwan and Overseas Chinese, the honorary chairman of Asia Pacific Taiwan Federation of Industry & Commerce and the chairman of Association Suisse des Commercants d'Orignine Chinoise. He has also spared no effort in charity work, constructing a number of Hantec Hope Primary Schools, donating libraries in the Mainland, and offering financial assistance to the disaster victims from the floods in East China and the typhoon damage in Taiwan.

Mr. Tang's achievements are not only in the financial industry, but also in his pursuit of cultural creativity, and he has been interviewed publicly on many occasions as a collector and cultural figure, exhibiting rare collectibles. He is also a renowned traveller and author, having visited nearly 150 countries and published 14 books.

Hantec Group has inherited his philosophy, nurturing a large number of financial talents; forging a company of complete integrity and social responsibility by treating customers with sincerity; establishing branches in more than 10 countries around the world in a pioneering and innovative attitude; and founding a comprehensive enterprise combining financial and cultural qualities by virtue of cultural creativity.

目录 Contents

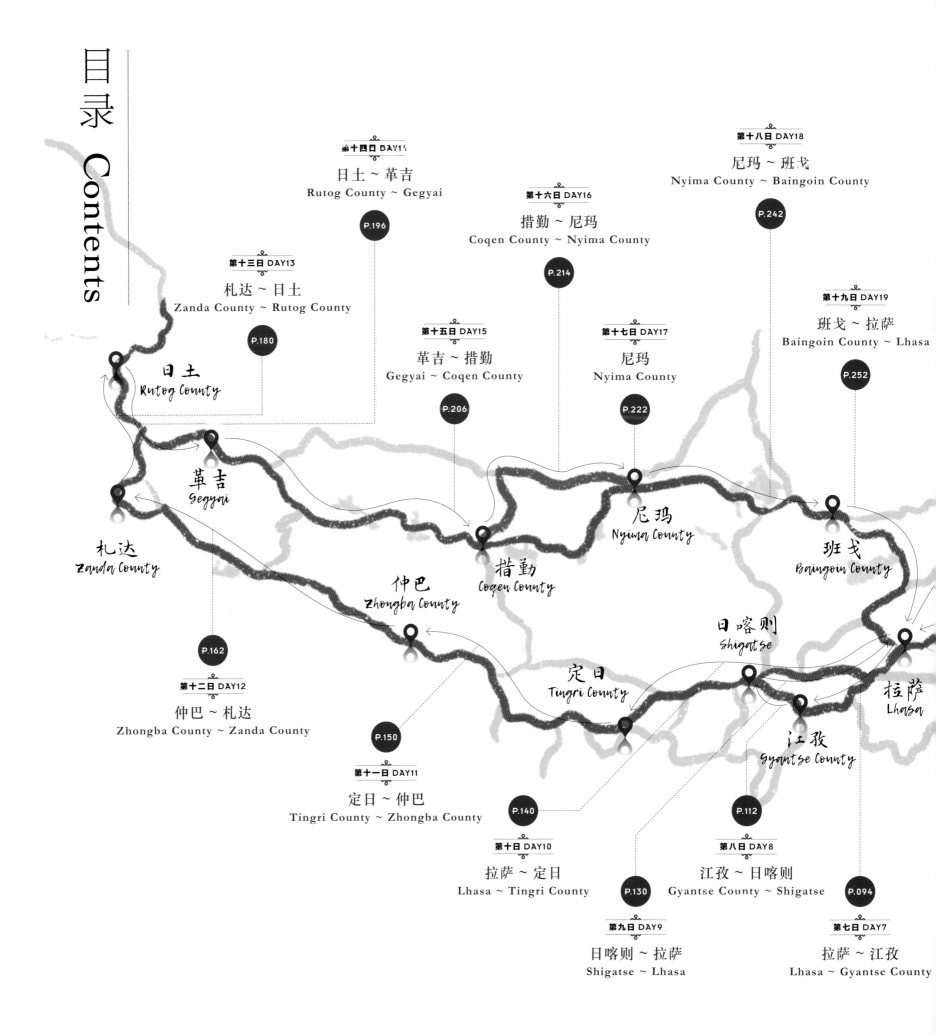

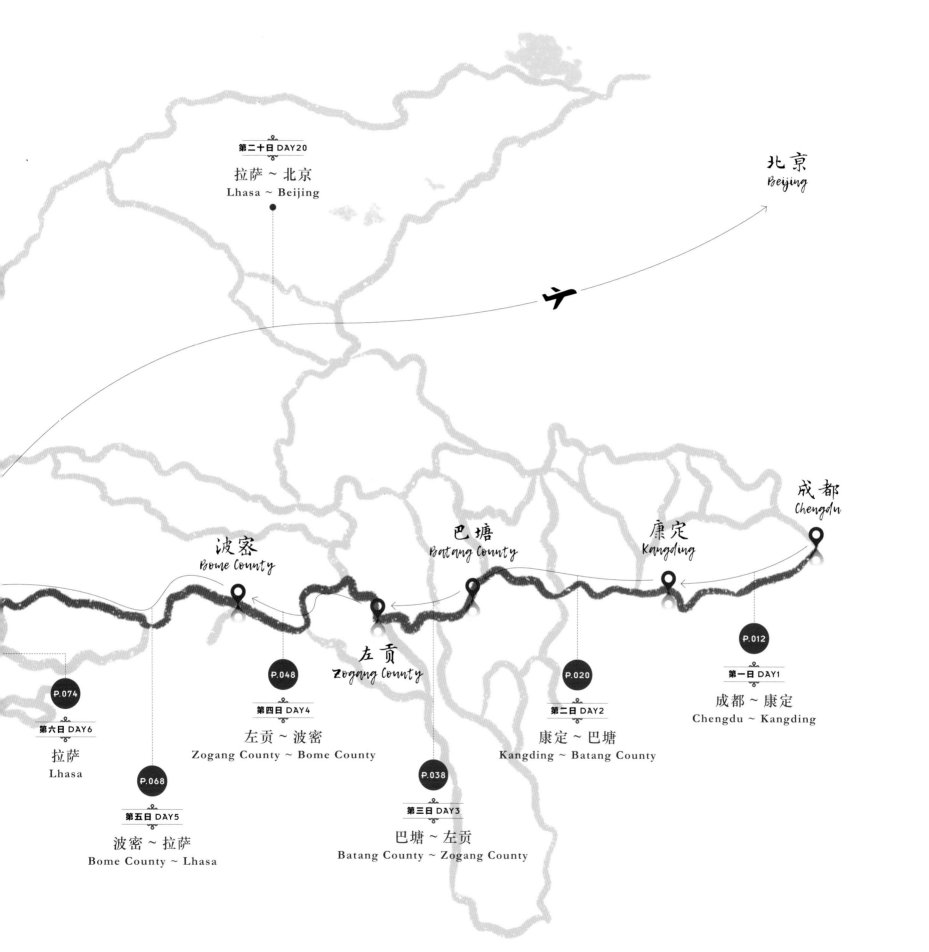

第二十日 DAY20
拉萨 ～ 北京
Lhasa ~ Beijing

北京
Beijing

成都
Chengdu

巴塘
Batang County

康定
Kangding

波密
Bome County

左贡
Zogang County

P.012
第一日 DAY1
成都 ～ 康定
Chengdu ~ Kangding

P.020
第二日 DAY2
康定 ～ 巴塘
Kangding ~ Batang County

P.038
第三日 DAY3
巴塘 ～ 左贡
Batang County ~ Zogang County

P.048
第四日 DAY4
左贡 ～ 波密
Zogang County ~ Bome County

P.068
第五日 DAY5
波密 ～ 拉萨
Bome County ~ Lhasa

P.074
第六日 DAY6
拉萨
Lhasa

བཀྲ་ཤིས་བདེ་ལེགས།

扎 西 德 勒

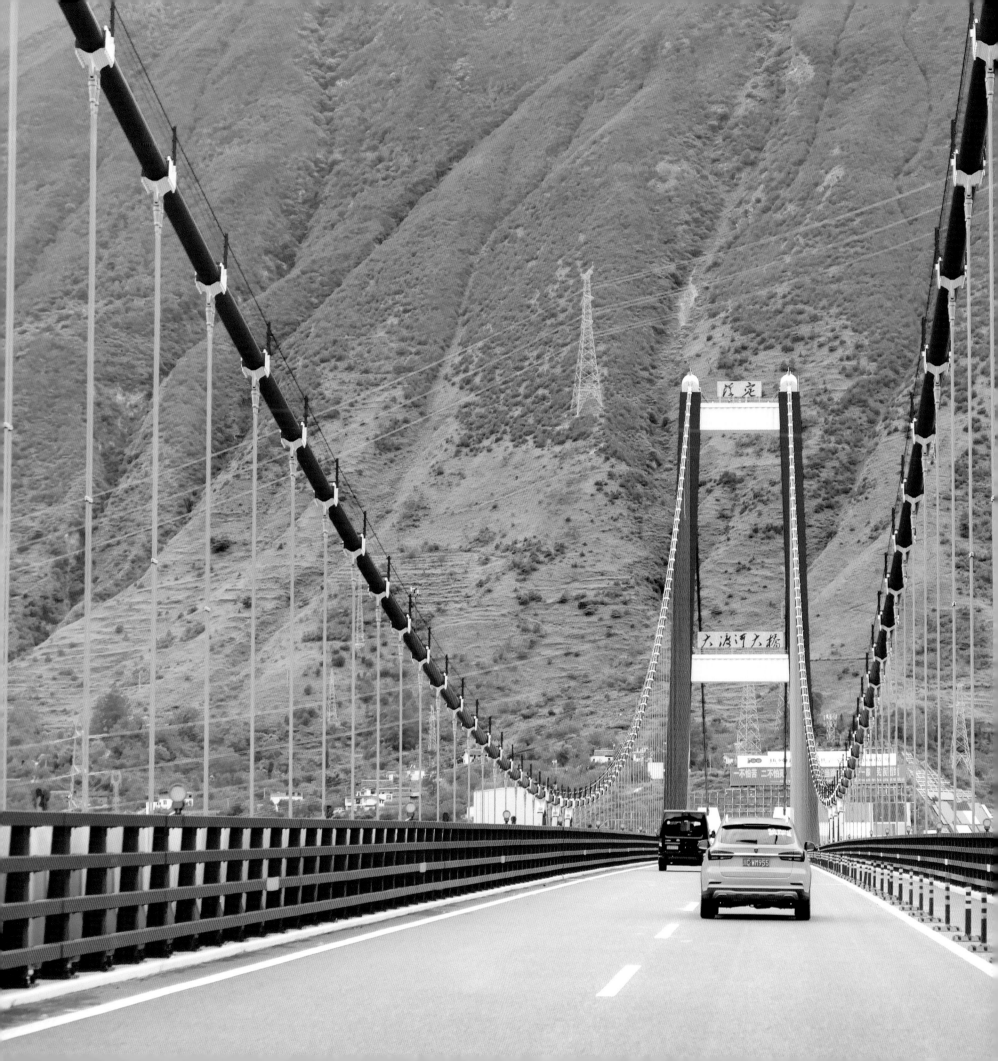

成都～康定

　　这趟旅程以成都为起点，路况大致上都相当好，尤其多亏了从雅安到康定的雅康高速，大幅度缩减交通时间，否则在道路开通之前，成都到康定需要一整天的车程才能抵达。"蜀道之难，难于上青天"，这段进藏之路修筑在山岭云雾间，建造过程困难重重，算得上是半步人间、半步鬼门。五年建设换来 15 分钟的车程，二郎山隧道的贯通，终征服了"川藏第一险"。另外，还有一条泸定大渡河大桥，又名兴康特大桥，横跨 1,400 米的大渡河，作为一座建立在高地震烈度带、高海拔的钢桁梁悬索桥，是中国桥梁史上的一颗璀璨明珠，它的雄伟和壮观堪称人类奇迹，不愧为"川藏第一桥"。

　　早年一首《康定情歌》遍地传唱，歌词中溜溜的山、溜溜的云、溜溜的人……几乎让大江南北的人们都记住了康定这座"溜溜城"。作为四川省甘孜藏族自治州的首府，康定是中国西部地区重要的历史名城，是川藏咽喉和茶马古道重镇，也是藏汉交汇中心。老城康定安静却富有韵味，城南奔腾的折多河跟城北湍流的雅拉河在郭达山脚下汇合，再相拥流向泸定及大渡河，直至汇入长江。两条河流翻涌着、咆哮着，以湍急之势一路向前，不曾停歇。

Day 1

Chengdu ~ Kangding

The trip started in Chengdu, and most of the traffic on the way flew smoothly, especially the Yakang Highway from Ya'an to Kangding that significantly reduced the traffic time, otherwise it would have taken a whole day's drive to reach Kangding before the road opened. 'The road to Shu (today's Sichuan Province) is harder than to climb to the sky' (*Hard is the Road to Shu* by Li Bai, the greatest romantic poet of the Tang Dynasty and of China of all times). The path to Tibet winds along the mist-coiled mountains, the construction of which was once fraught with enormous difficulties, as if walking on a tightrope between miracle and calamity. The five-year determined efforts to build the Erlangshan (Mount Erlang) Tunnel, the conquest of 'the Greatest Danger of Sichuan-Tibet' as well, have won a mere 15-minute drive to cross the journey. Spanning 1,400 meters across the Dadu River, Luding Chain Bridge, also known as Xingkang Bridge (or Xingkangte Bridge), is a steel-trussed suspension bridge positioned in a seismic zone at high altitudes. As the most brilliant achievement in the history of Chinese bridges, it is a marvel of mankind, with its majesty and grandeur worthy of its reputation, the First Bridge of Sichuan-Tibet.

In the early years, a folk song named *Kang Ding Love Song* has enjoyed a proverbial currency all over the country, and the elegant mountains, puffy clouds as well as lovely folks extolled in the song imprint the endearing city of Kangding in the mind of many people. As the capital of Ganzi Tibetan Autonomous Prefecture in Sichuan Province, Kangding is an important historical city in western China, the strategic passage of Sichuan-Tibet, the key position on the ancient Tea Horse Road and the interchange point between Tibetan and Han (the dominant ethnic group in China) ethnic groups. The old district of Kangding is serene with a regional flavor. The rushing torrents of Zheduo River in the south and the Yala River in the north of the city converge at the foot of Mount Guoda, then flow into the Dadu River before finally joining the Yangtze River. Roaring waves upon waves, the two rivers surge ahead ceaselessly.

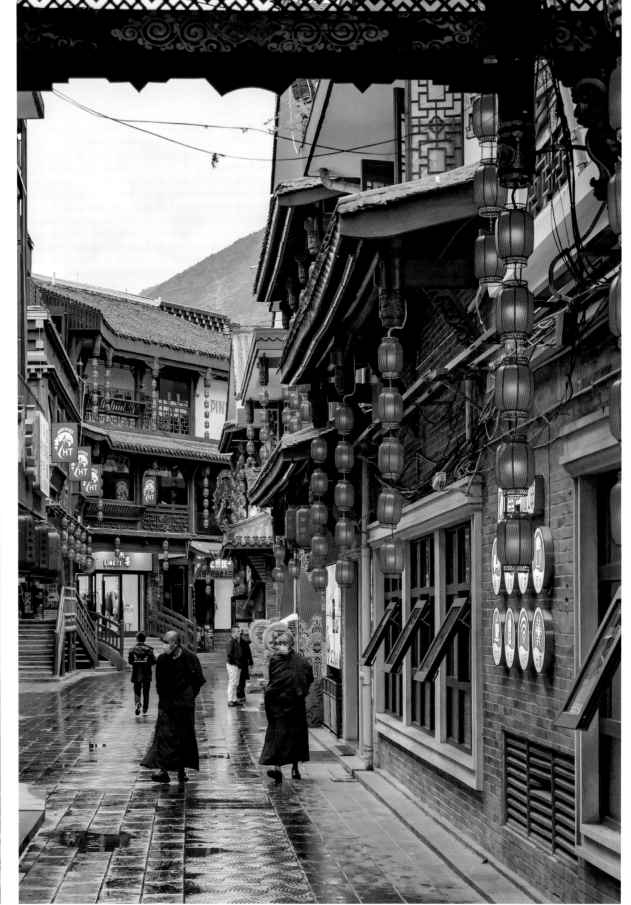

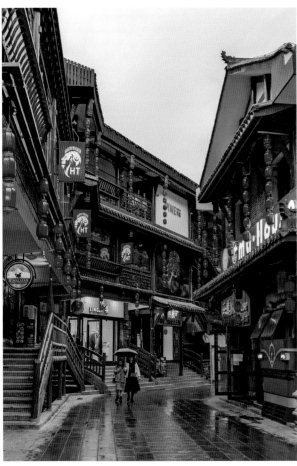

成都～康定　　Chengdu ～ Kangding

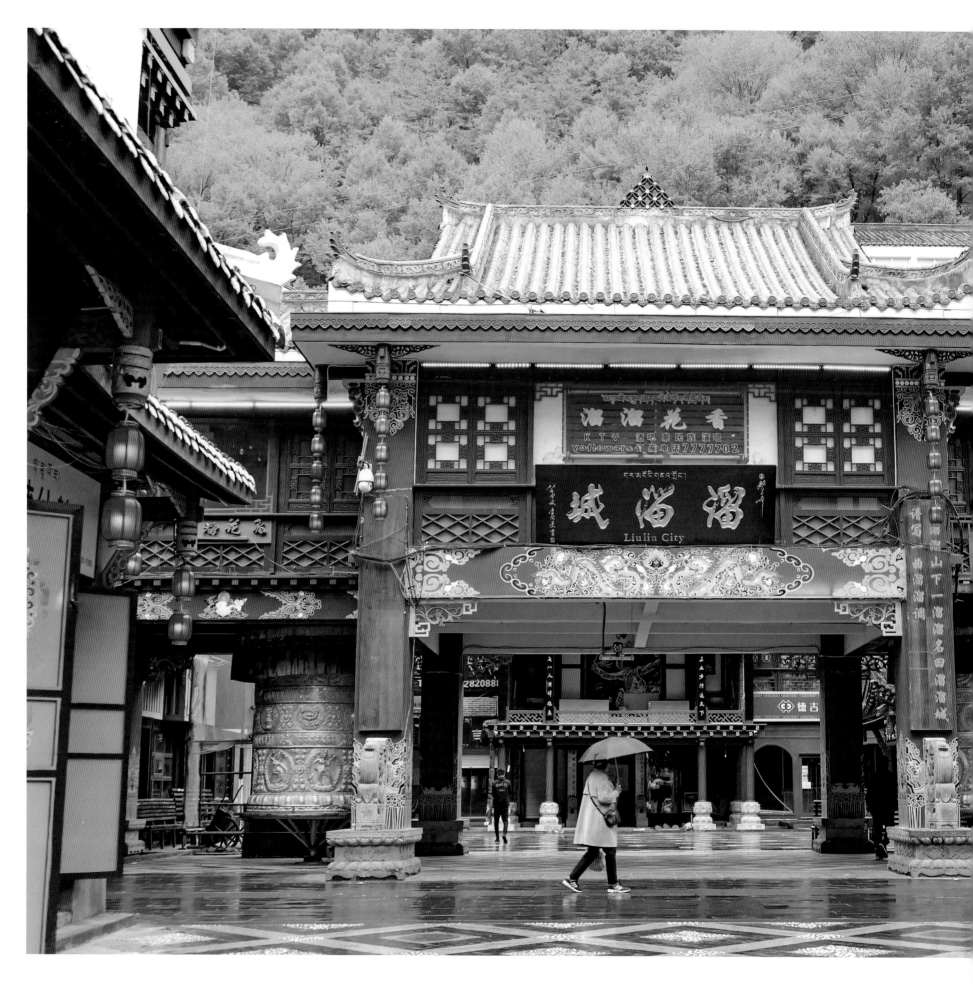

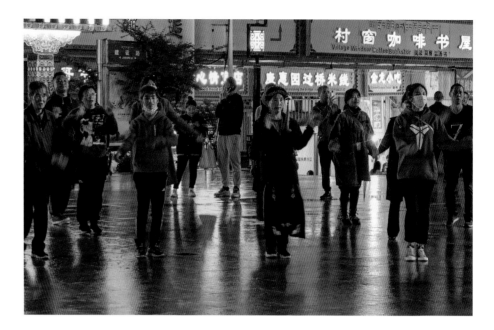

康定城广场上载歌载舞的市民，纷纷跳起藏族舞，
热情又随意，洋溢着发自内心的快乐。
Singing and dancing in the city square of Kangding,
people were brimful of energy and enthusiasm, their faces alight with genuine joy.

康定是中国西部地区重要的历史名城，它作为四川省甘孜藏族自治州的首府，
是川藏咽喉、茶马古道重镇、藏汉交汇中心，因此有"藏卫通衢"和"川藏要冲"的称号。
As the capital of Ganzi Tibetan Autonomous Prefecture in Sichuan Province,
Kangding is an important historic city in western China, the strategic passage of Sichuan-Tibet,
the key position on the ancient Tea Horse Road and the interchange point
between Tibetan and Han (the dominant ethnic group in China) ethnic groups,
hence named the 'thoroughfare to Tibet' and the 'hub of Sichuan-Tibet'.

一条由城南湍急奔来的玉绿色的折多河，
声响巨大，咆哮着穿城而过，汇入大渡河，直至流进长江。
The raging torrents of jade-green Zheduo River roar through the city from the south,
then flow into the Dadu River before finally joining the Yangtze River.

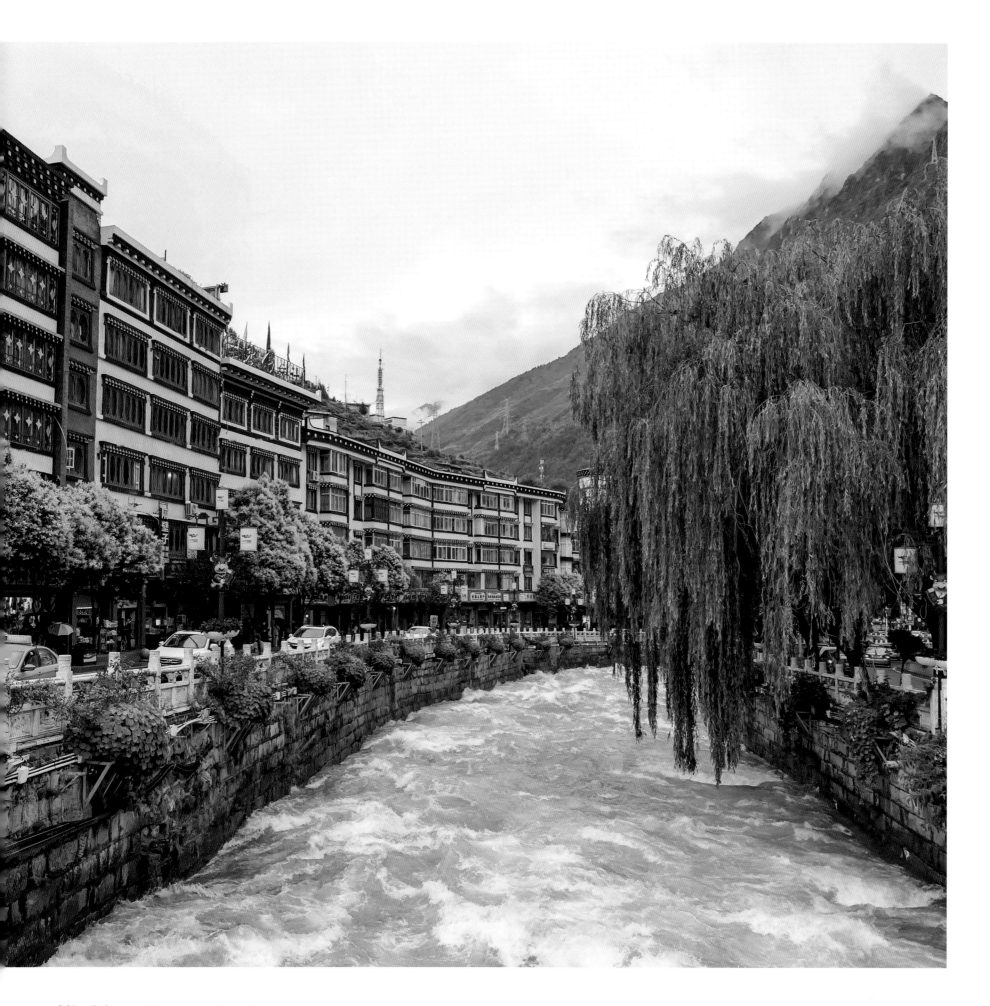

318 国道的起点在上海黄浦区人民广场，终点为西藏中尼友谊桥，全长 5,476 千米，几乎和北纬 30 度线重合。自从《中国国家地理》杂志把 318 国道列为"中国人的景观大道"，这条国道几乎成为所有旅行者的终极梦想。而今，我也要踏上这条无数旅人的朝圣之路。

折多山被称为进藏第一关，是 318 国道进藏方向第一座超过海拔 4,000 米的高山。早上从康定出发时天气尚好，到了折多山已是雨雪纷飞，气温骤降，不愧是"隔山不同天，一天有四季"。继 2019 年以来，这是我第二度登上折多山，而翻过折多山，才算进入真正意义上的青藏高原。云雾迷蒙，为眼前矗立的白色佛塔更添一份圣洁。

从山上下来，顺路行经被称作"摄影家的天堂"的新都桥，转入有着"中国松茸之乡"之称的雅江，之后便又再次翻山越岭。

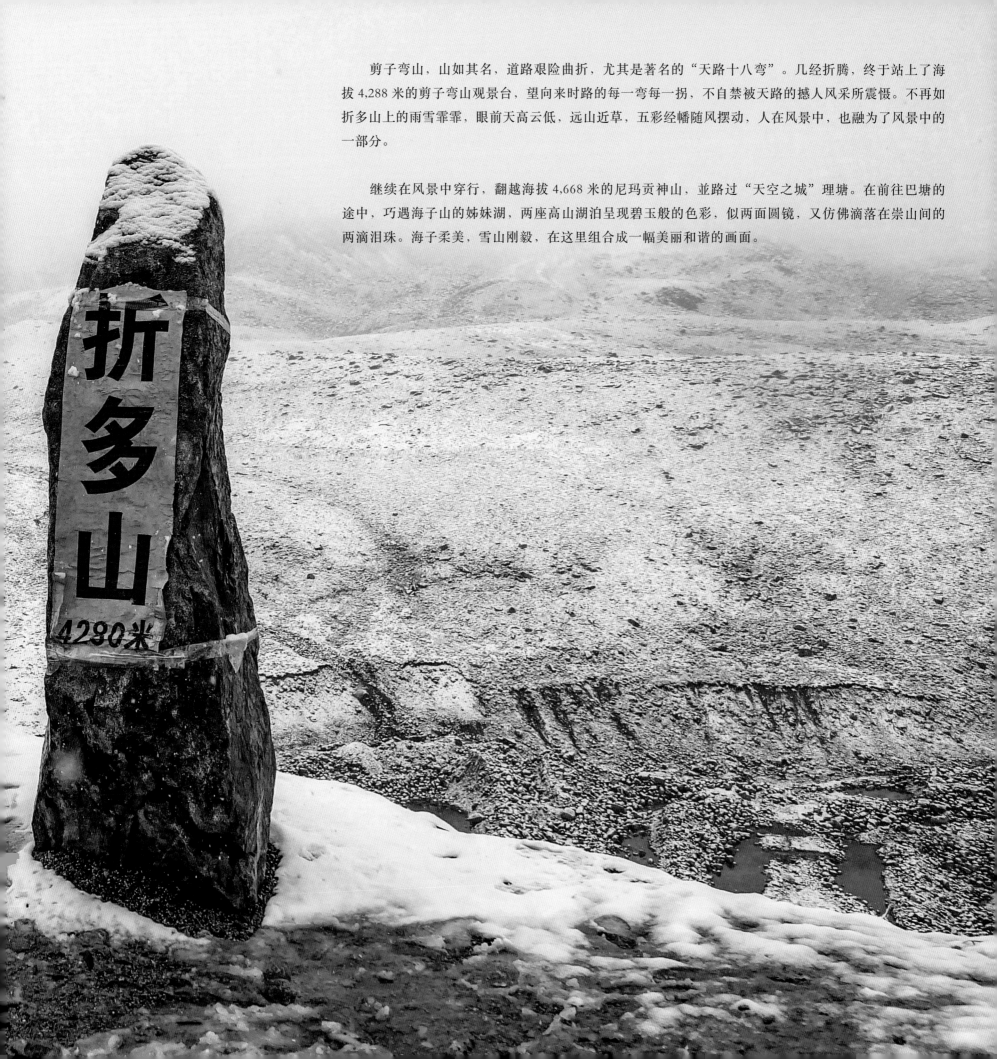

剪子弯山，山如其名，道路艰险曲折，尤其是著名的"天路十八弯"。几经折腾，终于站上了海拔 4,288 米的剪子弯山观景台，望向来时路的每一弯每一拐，不自禁被天路的撼人风采所震慑。不再如折多山上的雨雪霏霏，眼前天高云低，远山近草，五彩经幡随风摆动，人在风景中，也融为了风景中的一部分。

继续在风景中穿行，翻越海拔 4,668 米的尼玛贡神山，並路过"天空之城"理塘。在前往巴塘的途中，巧遇海子山的姊妹湖，两座高山湖泊呈现碧玉般的色彩，似两面圆镜，又仿佛滴落在崇山间的两滴泪珠。海子柔美，雪山刚毅，在这里组合成一幅美丽和谐的画面。

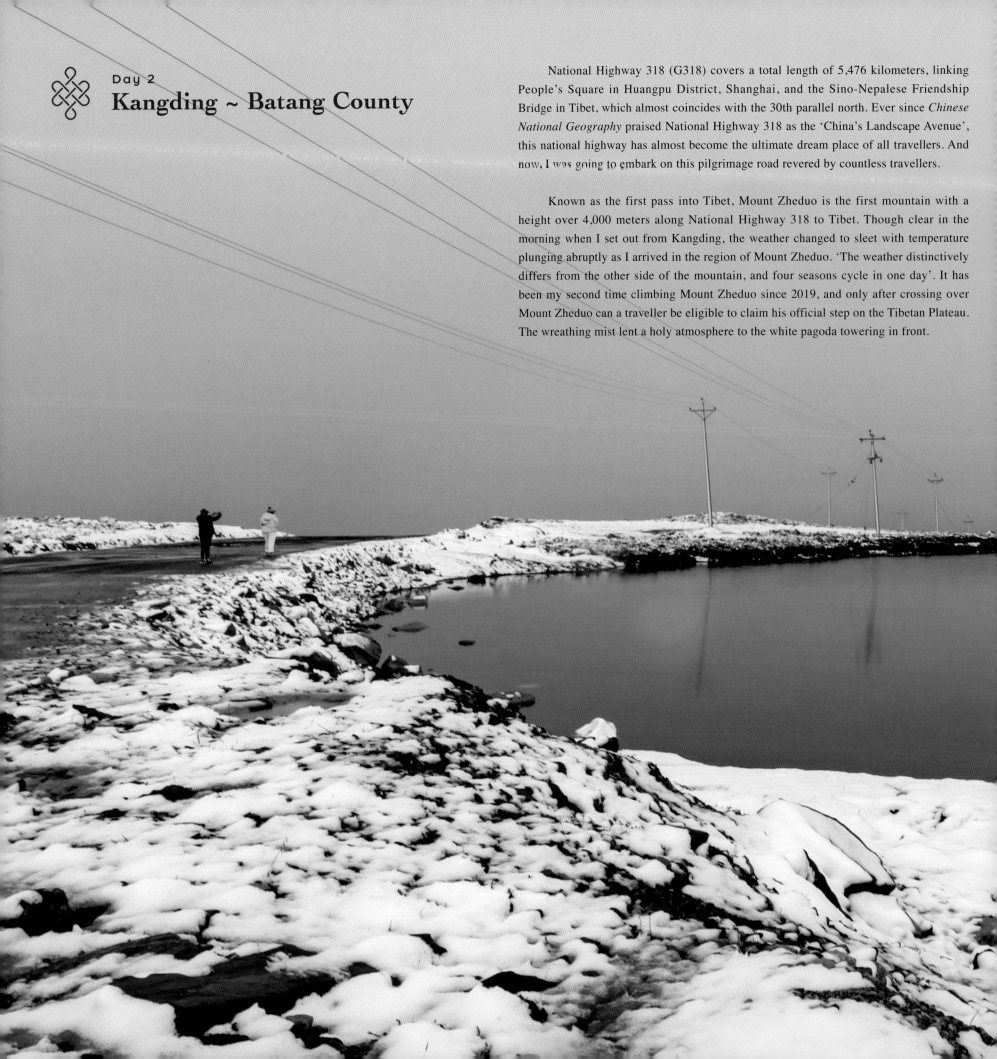

Kangding ~ Batang County

National Highway 318 (G318) covers a total length of 5,476 kilometers, linking People's Square in Huangpu District, Shanghai, and the Sino-Nepalese Friendship Bridge in Tibet, which almost coincides with the 30th parallel north. Ever since *Chinese National Geography* praised National Highway 318 as the 'China's Landscape Avenue', this national highway has almost become the ultimate dream place of all travellers. And now, I was going to embark on this pilgrimage road revered by countless travellers.

Known as the first pass into Tibet, Mount Zheduo is the first mountain with a height over 4,000 meters along National Highway 318 to Tibet. Though clear in the morning when I set out from Kangding, the weather changed to sleet with temperature plunging abruptly as I arrived in the region of Mount Zheduo. 'The weather distinctively differs from the other side of the mountain, and four seasons cycle in one day'. It has been my second time climbing Mount Zheduo since 2019, and only after crossing over Mount Zheduo can a traveller be eligible to claim his official step on the Tibetan Plateau. The wreathing mist lent a holy atmosphere to the white pagoda towering in front.

Down the mountain, my route of travel included the Xindu Bridge hailed as 'photographers' paradise' on the way, followed by Yajiang County, which is home to matsutakes in China, and then another mountain climbing.

Mount Jianziwan, just as its name suggests, boasts difficult and winding paths, not to mention its terrifying 'Eighteen Sharp Bends' known to all. My unremitting effort finally sent me to the 4,288-meter-high viewing platform of Mount Jianziwan, and when looking back at the twists and turns on the way, I couldn't help but be astounded by the magnificent spectacle of great nature. Unlike the confused falling of rain and snow on Mount Zheduo, the clouds here floated gently against the high sky and a green expanse stretched away from near to the mountains in the distance, Tibetan prayer flags riotous in colors flying back in the wind. The landscape admirers have unknowingly become a part of the scenic beauty.

My journey continued by crossing over the 4,668-meter-high Nyima Sacred Mountain and then passing Litang County, which is praised as 'the Castle in the Sky', and on my way to Batang County, I had an unexpected encounter with twin lakes on Haizi Mountain. The two plateau lakes bore jasper-like colors, like two round mirrors or two crystal teardrops cherished by the mountains. Glorified by tender lake waters and magnificent snow-capped mountains, a wonderful picture was harmoniously composed right here.

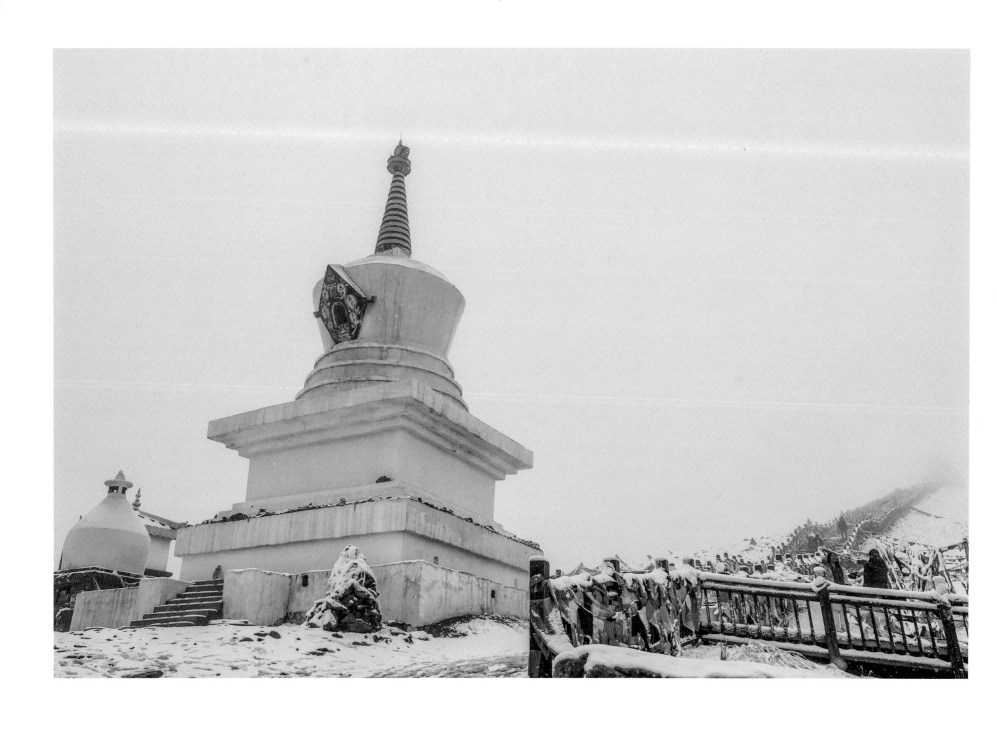

此次是我继 2019 年后再度攀上折多山，我四下观望，雪雨纷纷，浓雾中的白塔多添一份圣洁。

It has been my second time climbing Mount Zheduo since 2019. In my sight,
the heavy mist lent a holy atmosphere to the white pagoda in the confused falling of rain and snow.

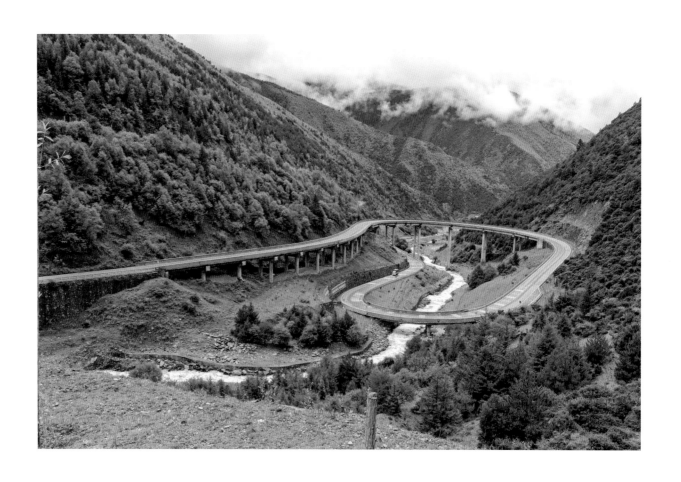

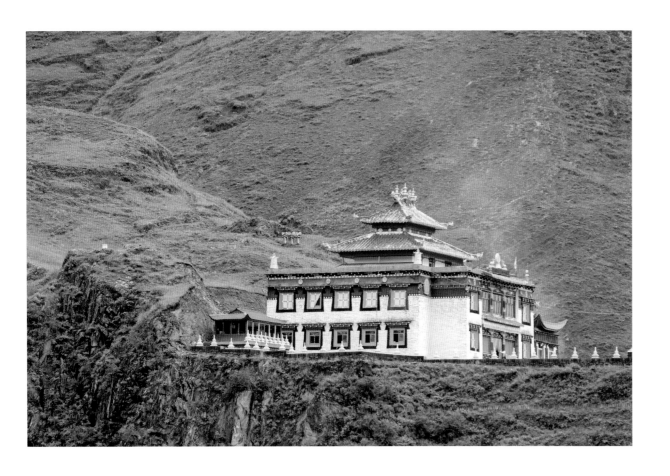

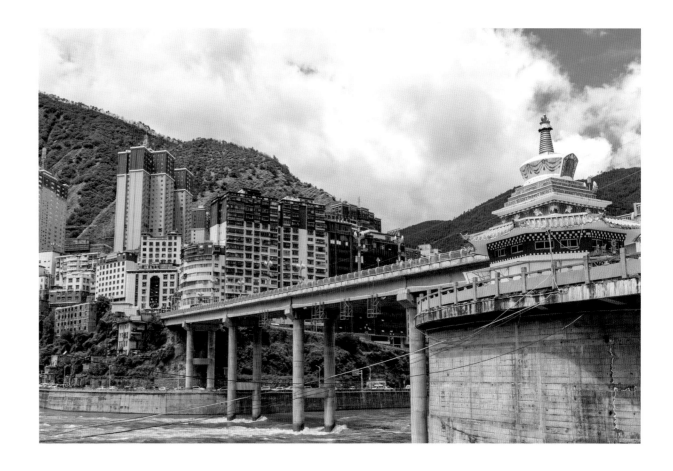

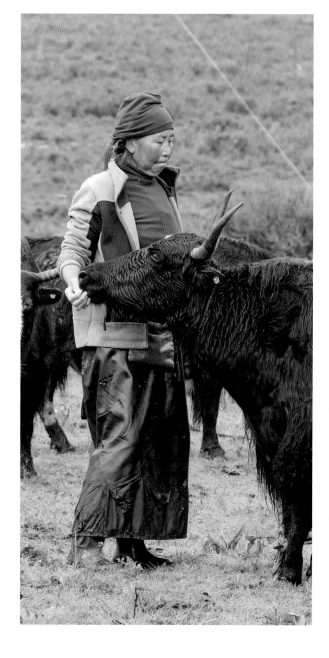

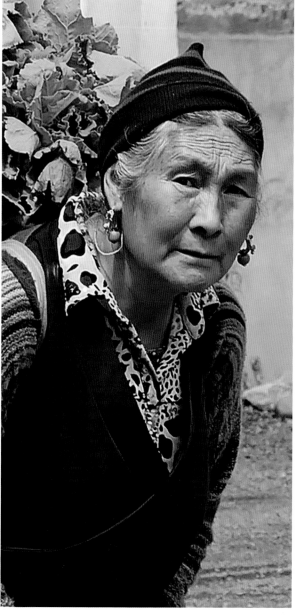

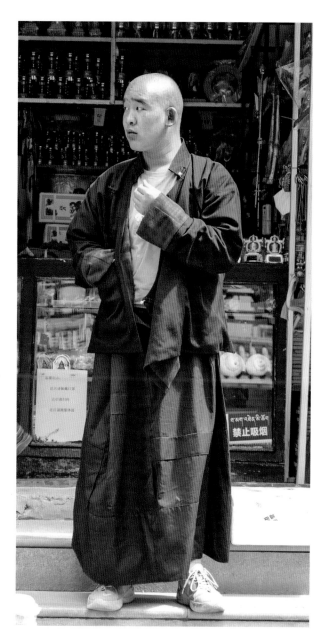

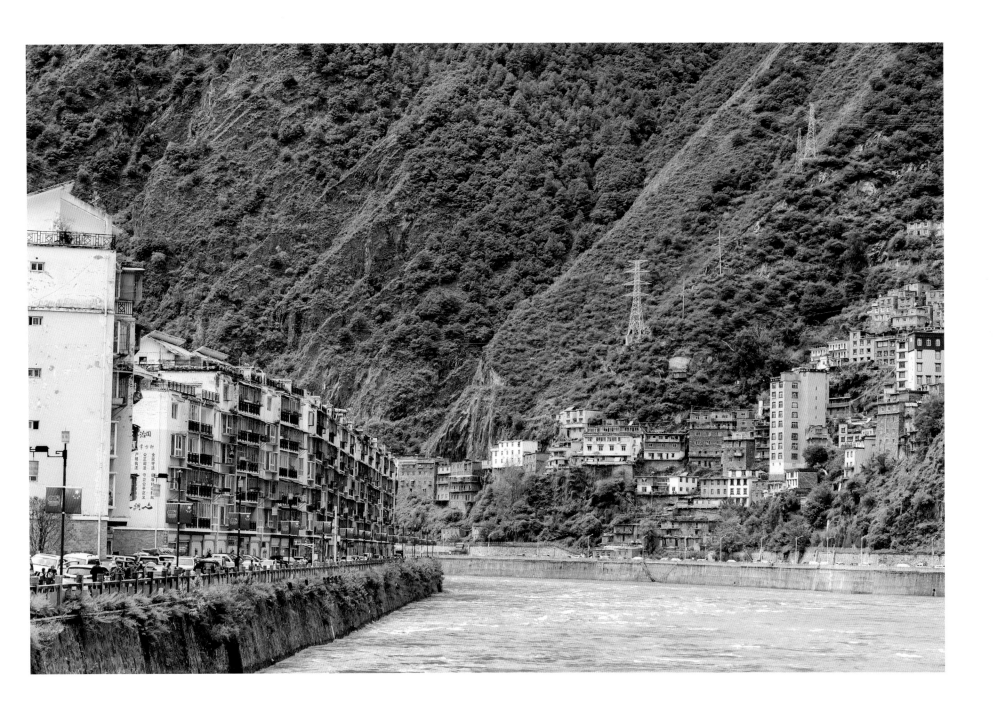

康定～巴塘　　Kangding ~ Batang County

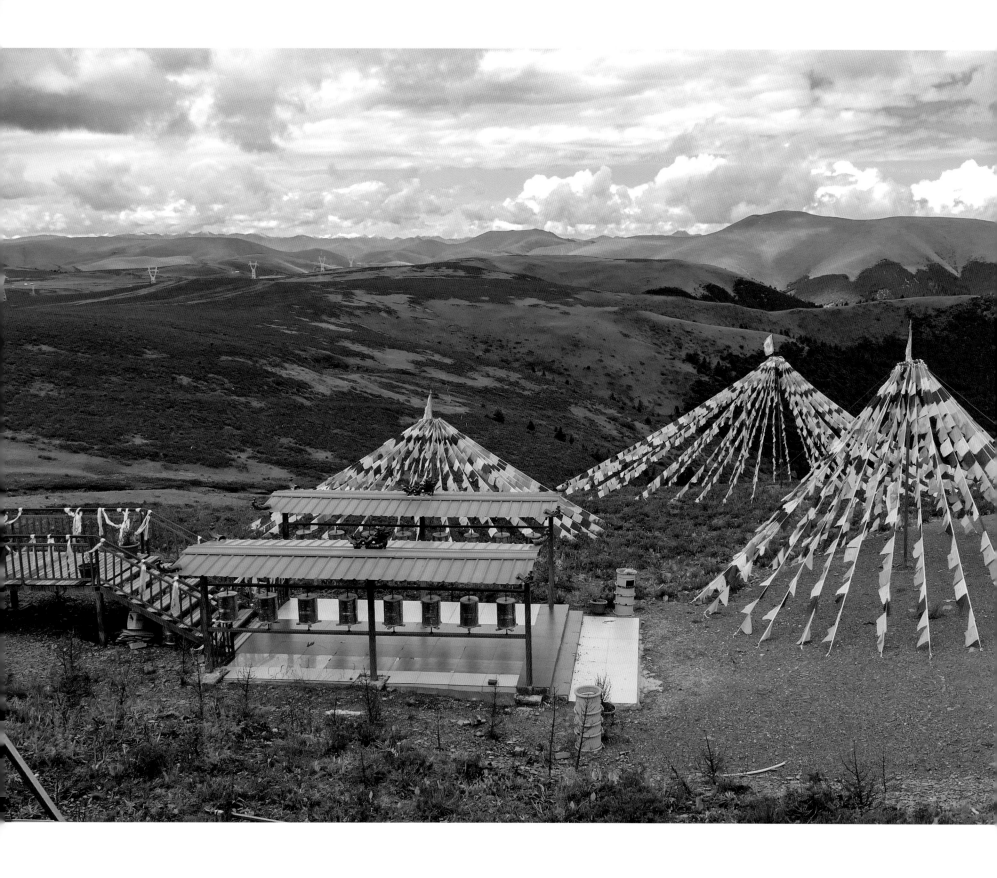

登上海拔 4,288 米的剪子弯山观景台，天空像个大滤镜，云朵洁净仿佛触手可及。
云很近天很远，多条由信徒挂起的五彩经幡（又叫风马旗）随风摆动，秀丽的景色令人流连忘返。
On the viewing platform of Mount Jianziwan at 4,288 meters above sea level,
the sky seemed to me like a huge photo filter and the clouds were well within reach. High above was the firmament,
near were the clouds, strings of colored Tibetan prayer flags flying back in the wind. Such an enchanting view is unforgettable.

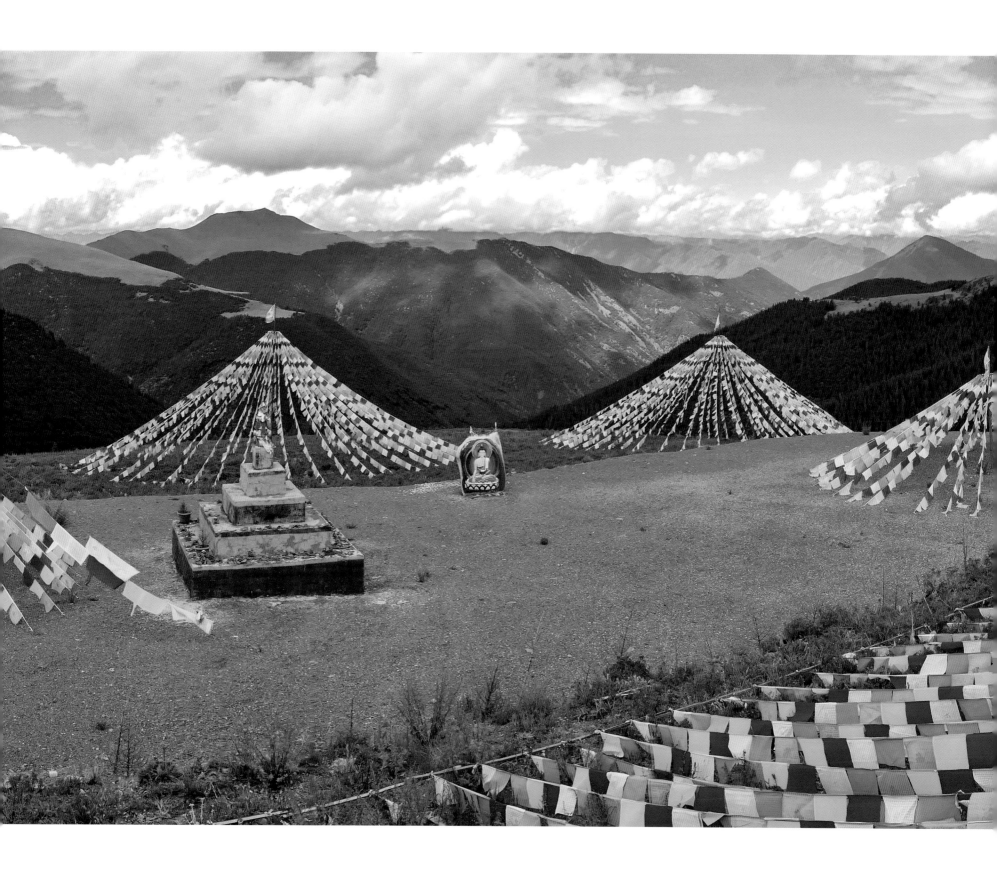

继续在风景中穿行，
翻越海拔 4,668 米的尼玛贡神山。
My journey continued by crossing over
the 4,668-meter-high Nyima Sacred Mountain.

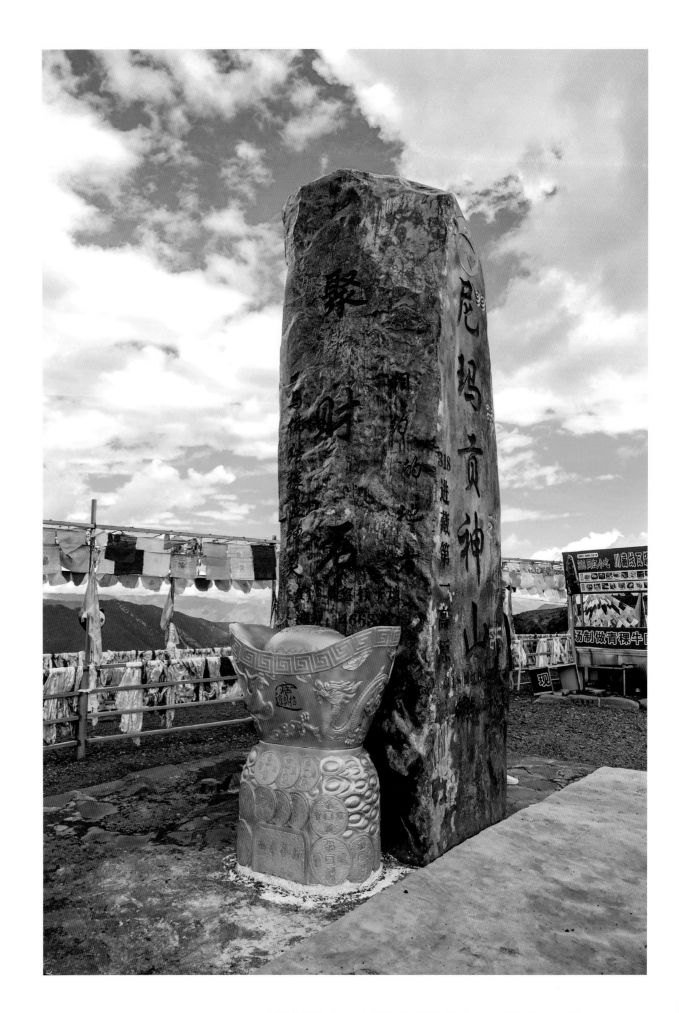

康定～巴塘　　Kangding ～ Batang County

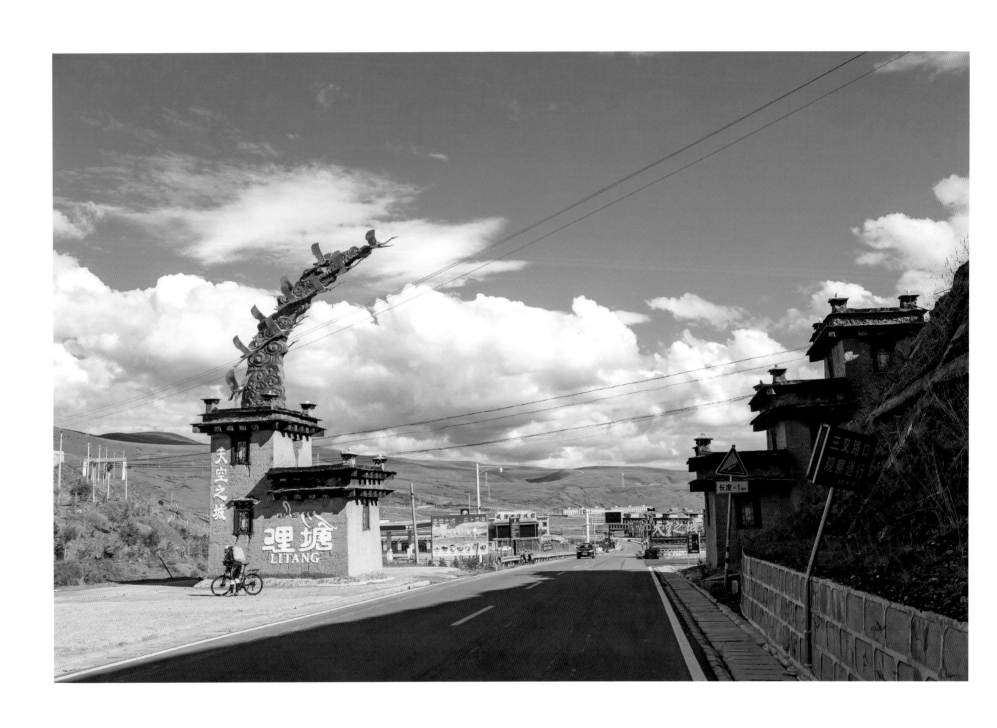

理塘历史悠久，是汉藏交汇处，文化底蕴深厚，是了解藏传佛教、藏区文化的重要之地。

Blending the cultures of Han and Tibetan ethnic groups,

Litang County enjoys a long history and a rich cultural heritage.

The place is significant to learn about Tibetan Buddhism and the culture of the Tibetan region.

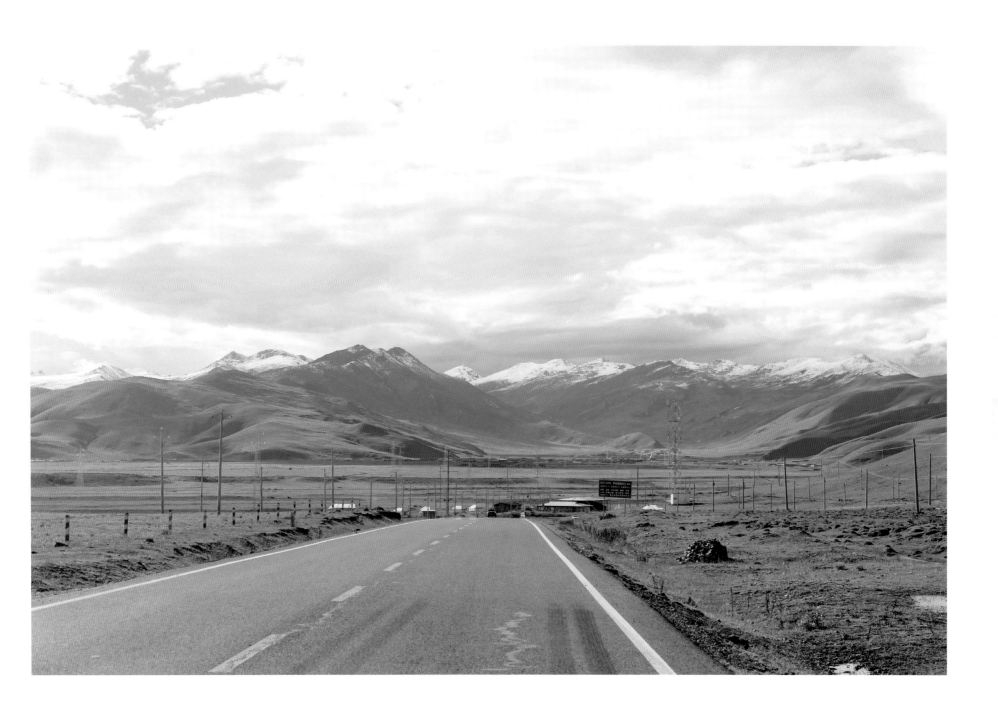

康定～巴塘　　Kangding ~ Batang County

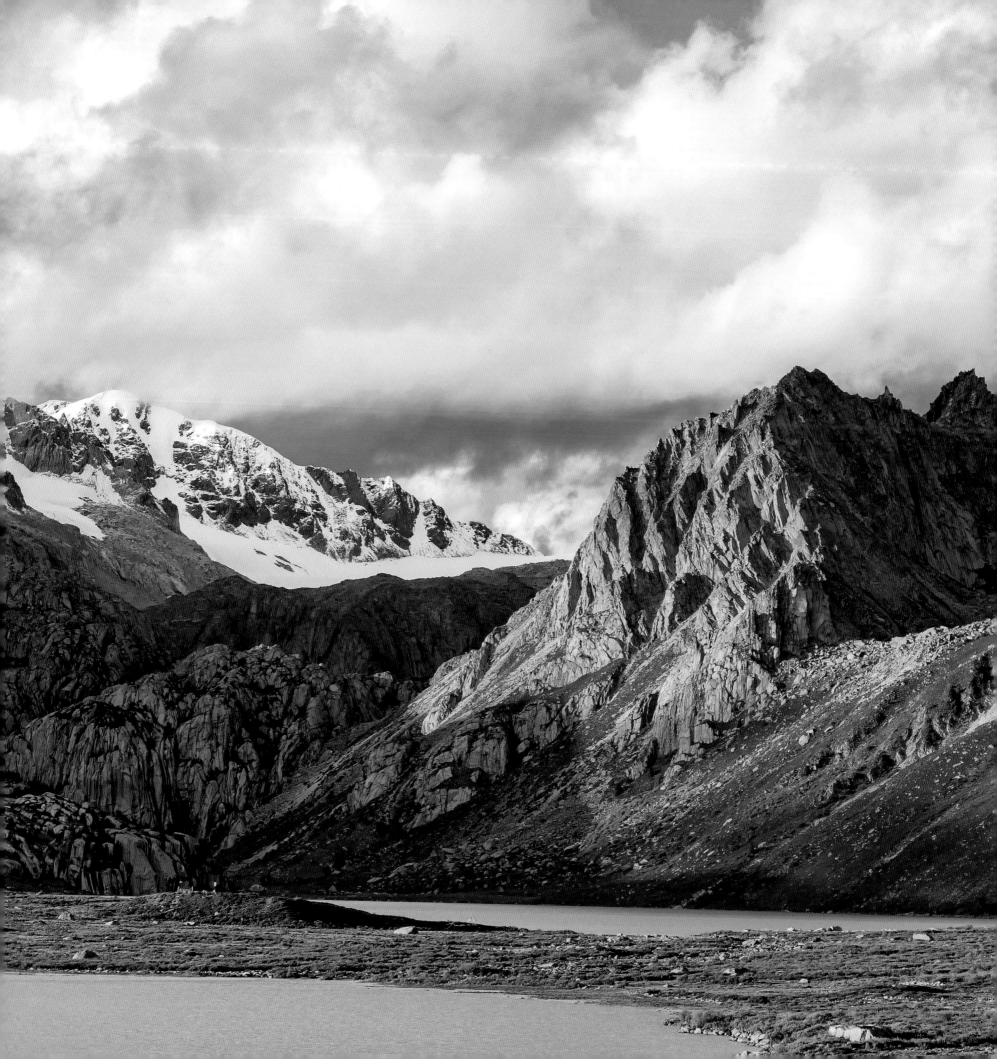

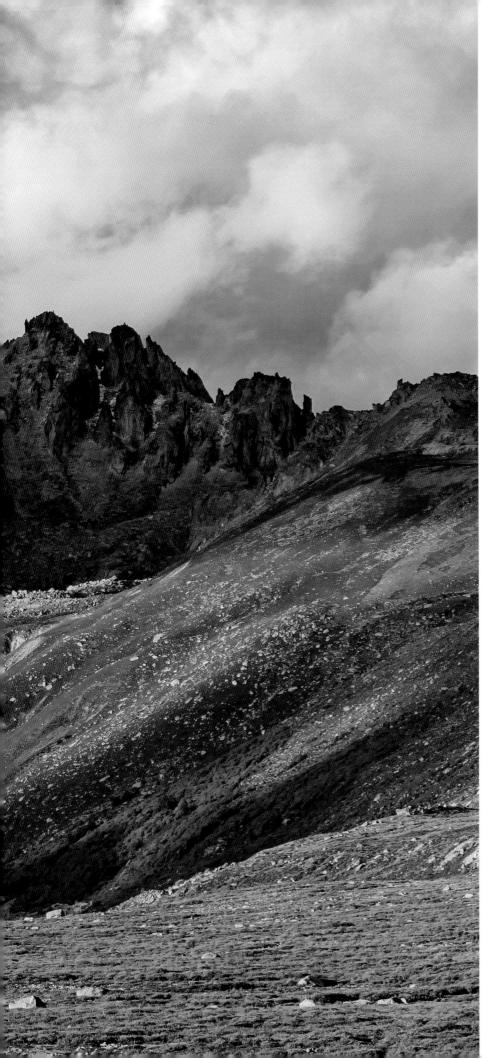

姉妹湖如天上坠落人间的两面镜子，在夕阳下呈现出碧玉般的色彩。

The twin lakes appear like two mirrors that descend from heaven to the world, glistening in jasper-like colors at sunset.

巴塘～左贡

伴随着奔流不息的金沙江与淅淅沥沥的雨丝，我们一路行进在318国道上。说到金沙江，最熟悉的是当年毛主席吟出的"金沙水拍云崖暖"，尽管这是我首度与金沙江碰面，却有股深深的亲切感。翻滚的金沙江水如野马般弃腾向前，衬着远处青山环抱，真是一幅壮丽山水图！

金沙江大桥横跨两地，一边是四川巴塘，一边就是西藏地界。318国道进藏的第一个检查站设在芒康，这里自古就是西藏的东南大门，疫情期间检查尤其严格，我们一行人出示绿码，填报行程，顺利通行。

接下来是一连串的盘山道，不仅路幅狭窄，蜿蜒而险峻，还得防备山上落石、坑洼、塌方等一系列状况，算是考验司机师傅的一段险路。道路虽崎岖，景色却绮丽无比，可谓是对这一段颠簸之路的最佳补偿。

芒康县海拔4,376米的拉乌山植被丰茂，阴雨天中云雾缭绕，有种寂静的美。离开拉乌山顶，足有将近30公里的下坡路，迂回曲折、峰回路转，伴随疾行车辆的，却是在山坡上悠闲觅食的牦牛和山羊。

海拔5,130米的东达山是川藏线上最高的垭口，可比肩珠峰大本营，据称是生命禁区，氧气浓度仅有平原的30%左右。我头一次闯进海拔如此高的山峰，雪势又大又急，远处山上已铺了一层素白，在云雾中若隐若现。银装素裹的世界，犹如一幅黑白抽象画。

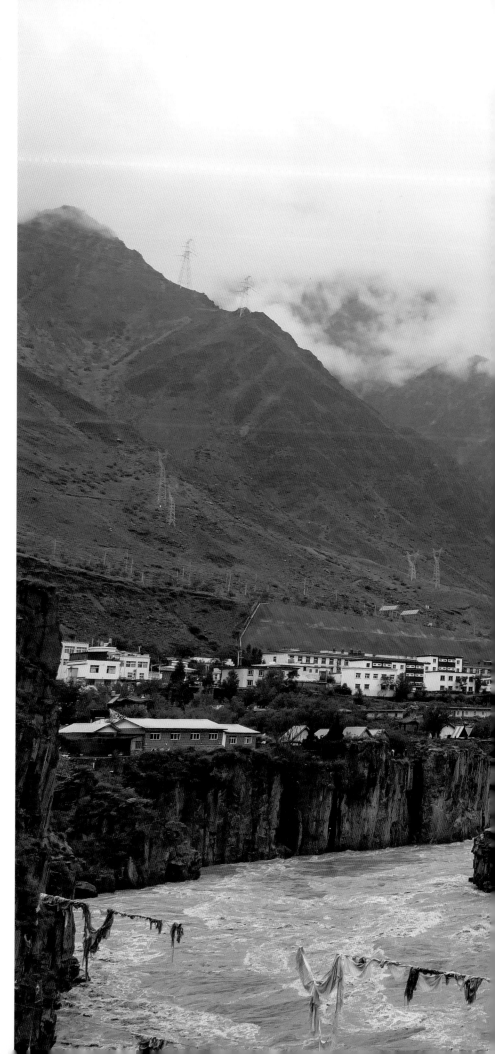

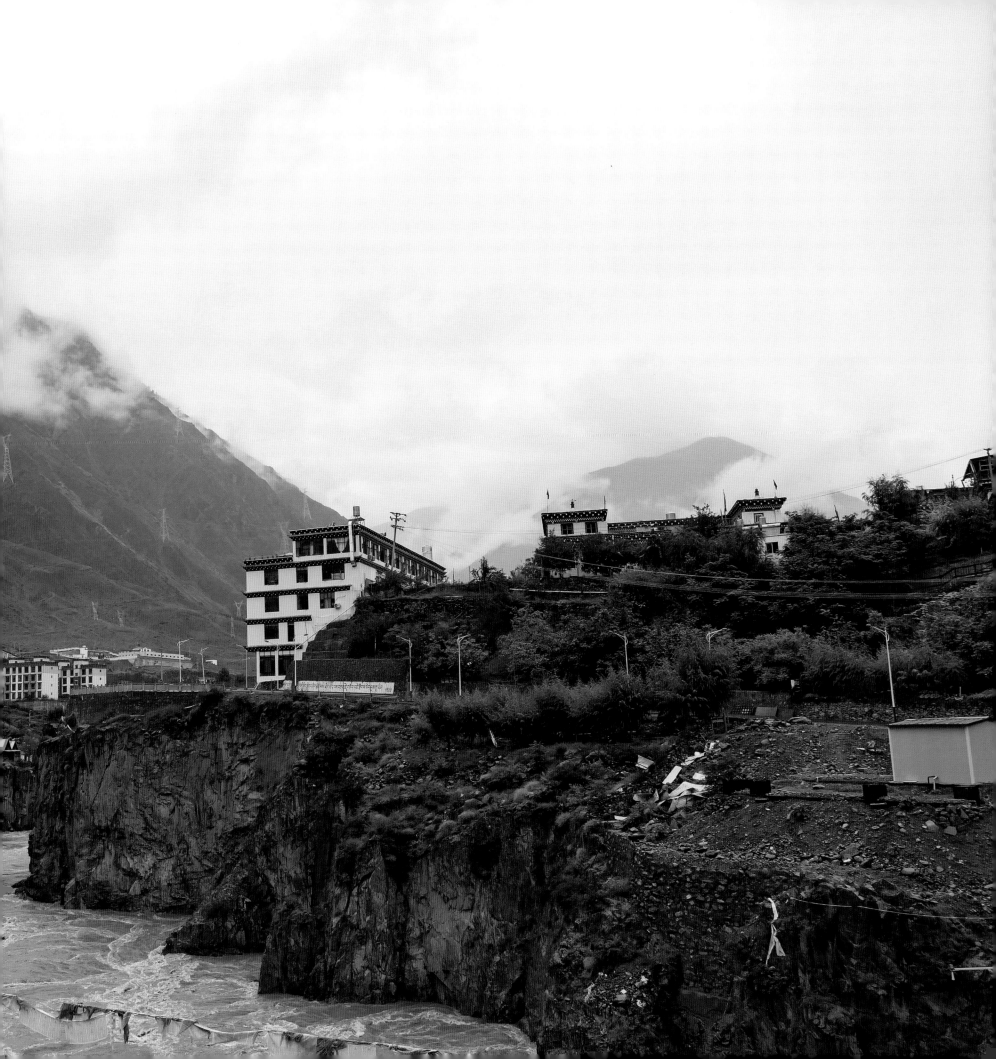

Day 3
Batang County ~ Zogang County

In the continuous patter of raindrops, we proceeded along National Highway 318 next to the raging torrent of the Jinsha River. Speaking of Jinsha River, I couldn't be more familiar with the remarkable poem, *the Long March* (1935), by our Chairman Mao Zedong who eulogized that 'waves of the Jinsha River crash against the sheer cliffs' in those days. Although it was my first encounter with the river, a warm feeling flooded me in waves. With the mighty river surging onward like horses galloping, a grand landscape painting spread out against the mountainous background, exuding a long-lost beauty of hard work and simplicity.

The Jinsha River Bridge straddles two regions, Batang of Sichuan Province on one side and Tibet on the other. The first checkpoint on National Highway 318 to Tibet is positioned in Mangkang County, which has been the entrance from the southeast of Tibet since ancient times. Because the inspection has become especially strict during the epidemic, we were required to show the green health QR code, declared the recent travel history and then were allowed to have free passage.

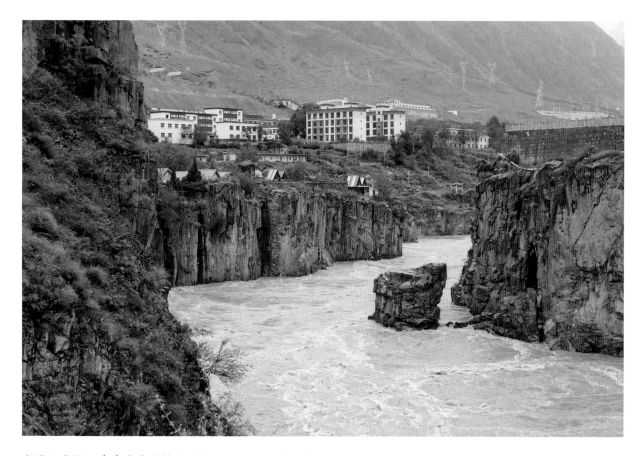

金沙江发源于青海省唐古拉山主峰，流经川、藏、滇，
属于长江流域一部分，因江水含大量沙土呈黄色而得名。
Rising in the main peak of Tanggula Mountains, Qinghai Province, the Jinsha River flows through Sichuan,
Tibet and Yunnan, which is part of the Yangtze River Basin.
The river contains a large amount of yellowish-brown sand,
hence the name, 'Jinsha' (meaning 'gold sand' in Chinese).

What expected us next was a chain of winding mountain roads, narrow and precipitous, and coupled with possible contingencies, such as falling rocks from mountains, bumps and hollows in the drive, landslides and others, all could be regarded as a test for our driver. The rugged path, however, led to a stunning spectacle of the mountain, which was more than compensates for the bumpy journey.

Faintly obscured in the mist, the 4,376-meter-high Mount Lawu in lush vegetation revealed a placid beauty in the rain. Descending from the top of Mount Lawu, we bumped along nearly 30 kilometers of downhill road, winding and twisting, and contrary to the fast-moving traffic, the passing scenery on the road was yaks and goats foraging on the hillside at a relaxed pace.

Mount Dongda of 5,130 meters, comparable with the Everest Base Camp, is the highest pass along the Sichuan-Tibet belt and is known as a forbidden zone for life with rarefied air containing oxygen 30% of that in the plains. It was my first time conquering such a high peak, and the distant mountains against the driving snow had already dressed up in white, the clouds and mist blurring their profiles. The world was bathed in white, looking every inch like a black-and-white abstract painting.

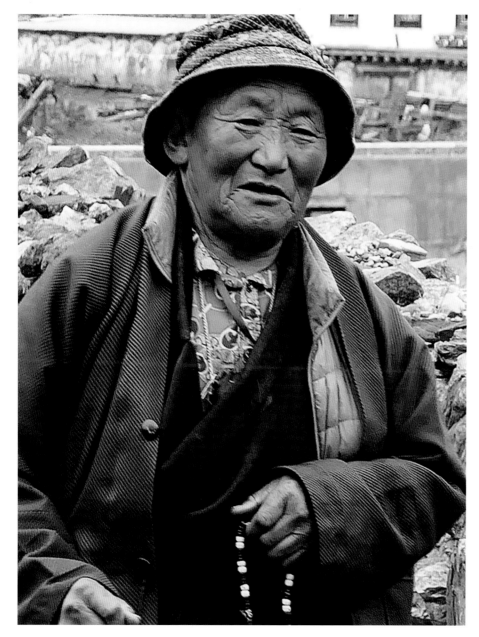

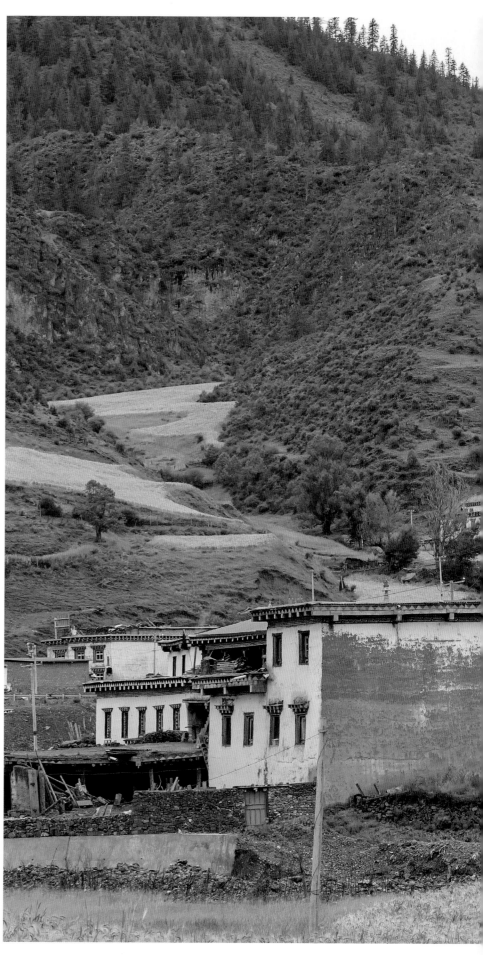

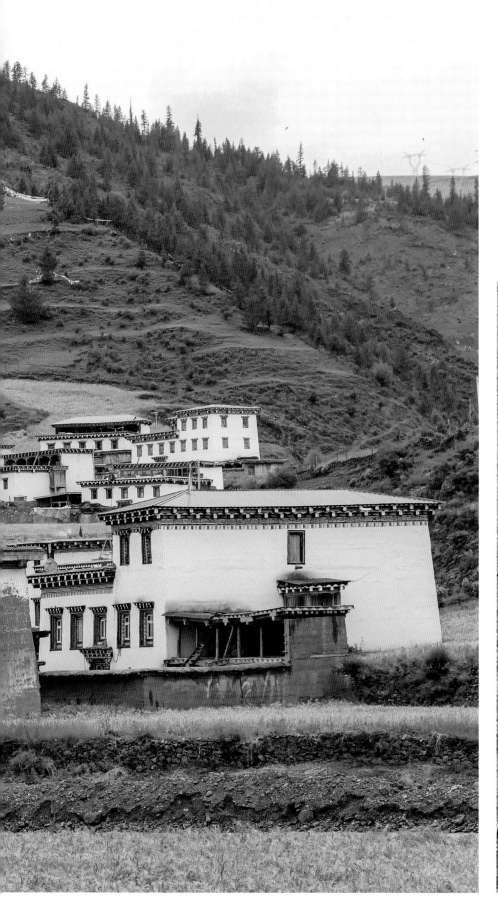

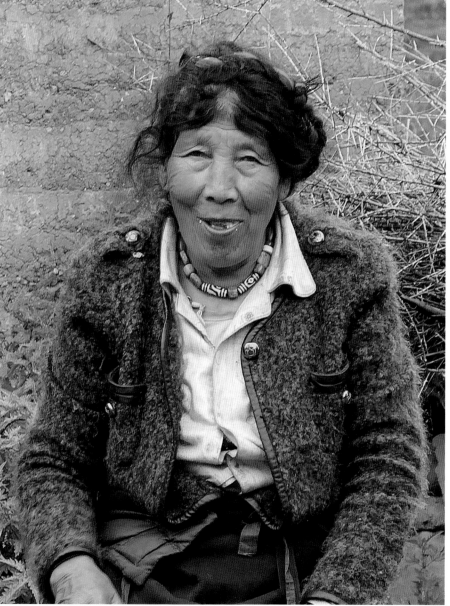

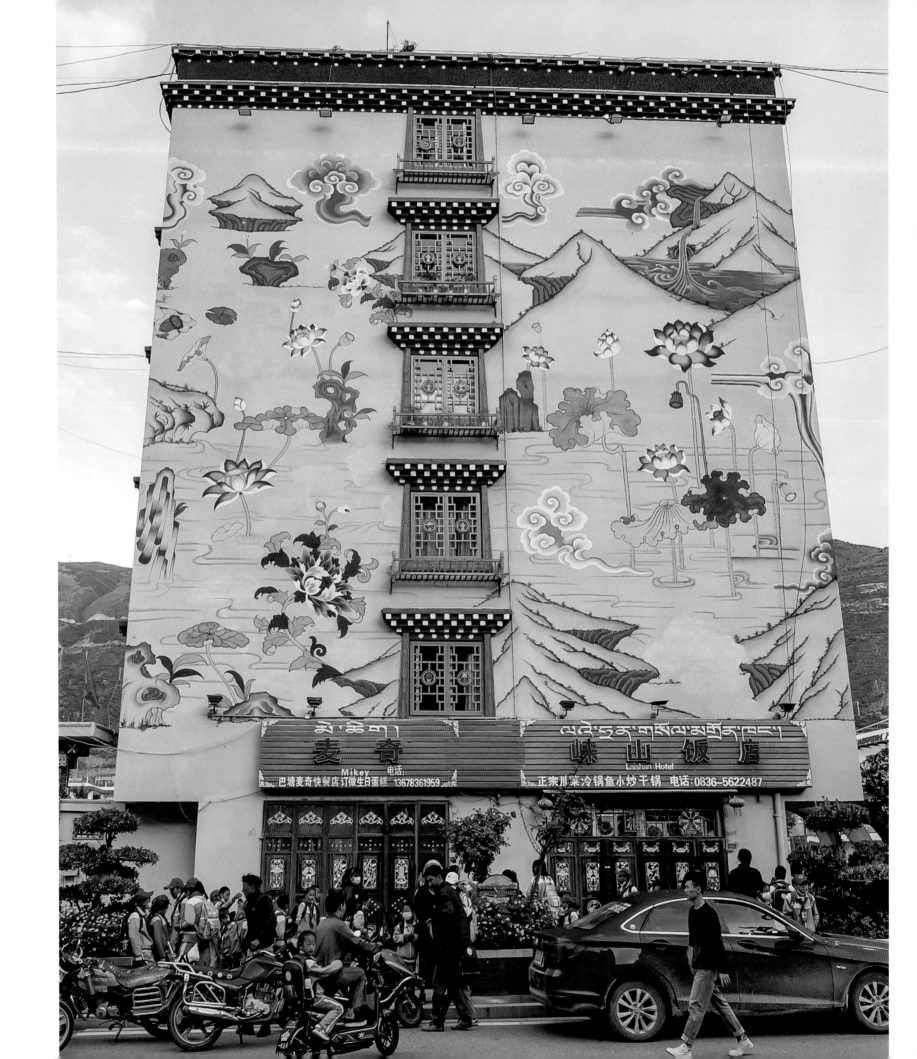

芒康县很小，不到 2 万平方公里，人口也不过 7 万多人。
城内很宁静，街道干净，居民生活悠闲，是一座典型的慢活城市。
Less than 20,000 square kilometers in area, the small county of Mangkang
is populated by scarcely 70,000 people. The quiet atmosphere,
the clean streets and the relaxed lifestyle characterize this slow-paced city.

东达山每年至少有十个月下雪，山峰铺上一层素白，
在雪雾中若隐若现，像是一幅银装素裹的黑白画面，令人陶醉。
The distant mountains against the driving snow had already dressed up in white,
the clouds and mist blurring their profiles.

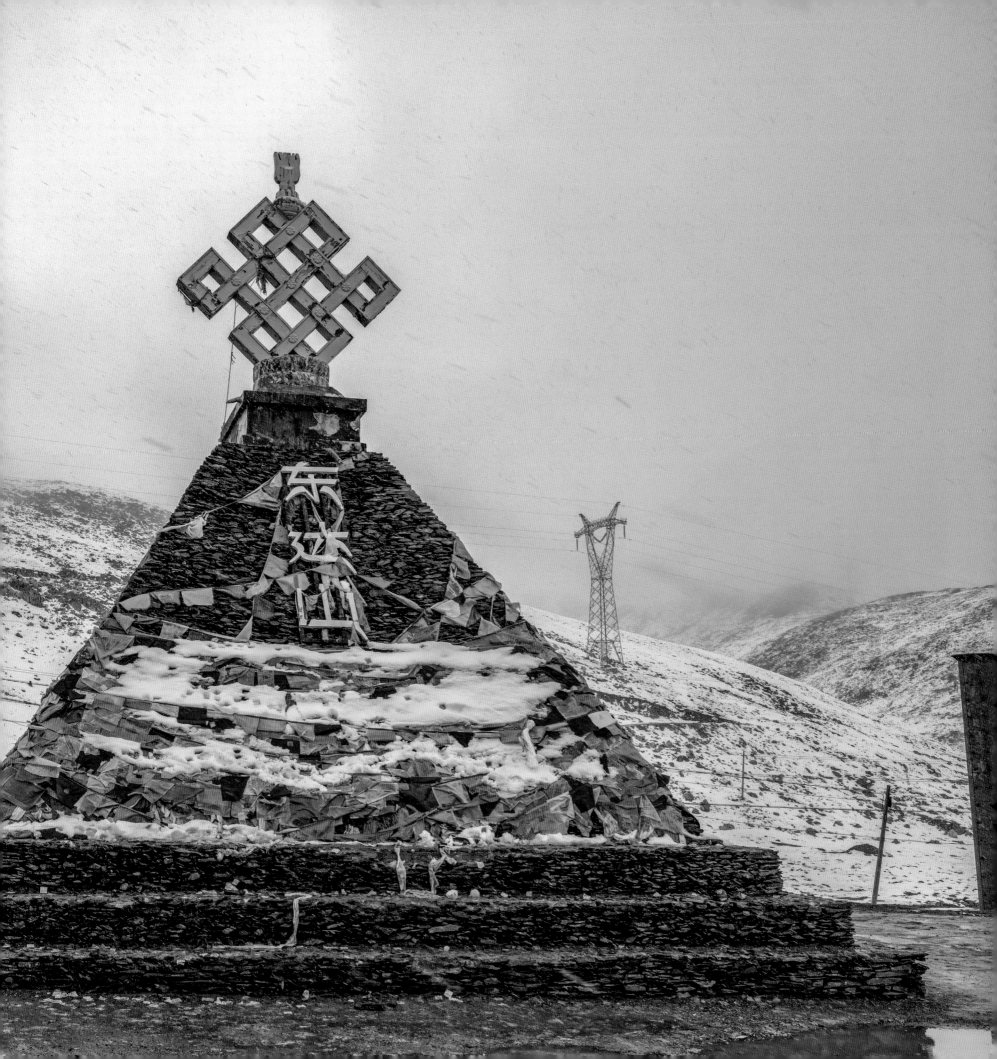

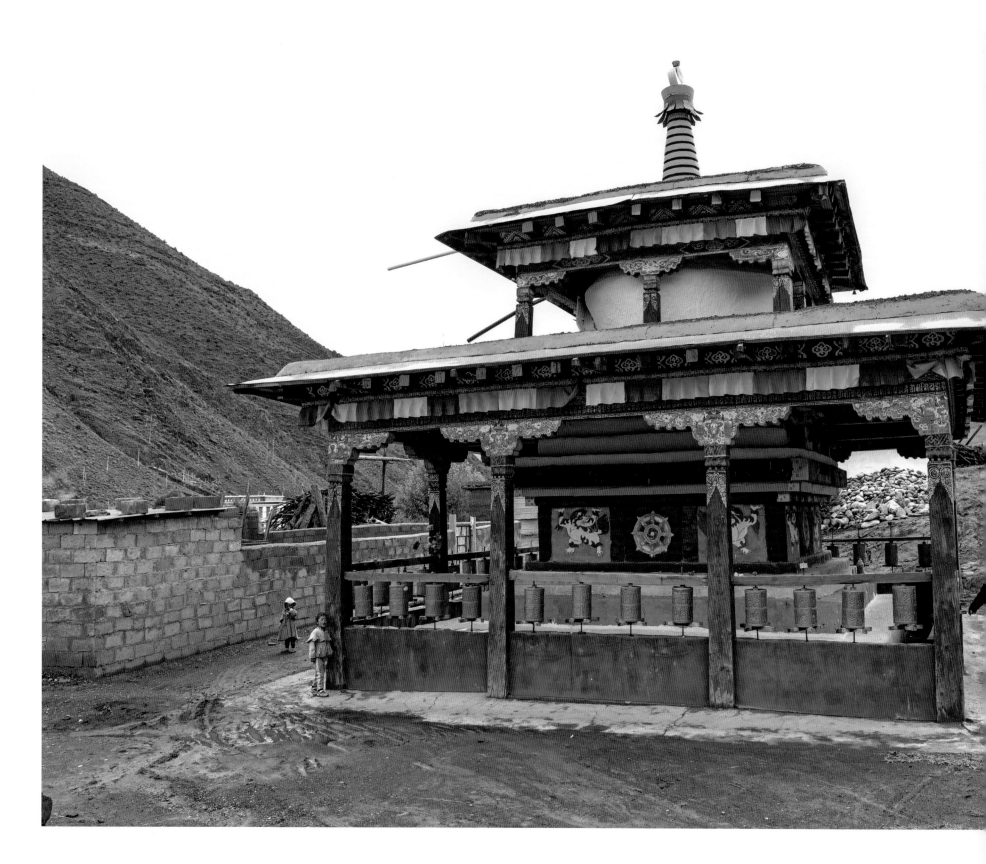

第四天

左贡 ~ 波密

"两江一河"——怒江、澜沧江和玉曲河皆流经左贡县，我们沿着蜿蜒秀丽的玉曲河展开一天的旅程。

道路两旁是峰峰相连的高山，云雾氤氲环绕，好像崇山的腰带。我们畅快地穿行于大自然的画廊中，途遇正在收割青稞的藏族居民，我们停下车挥手示意。丰收的青稞田、极具特色的藏式民居与远山相呼应，带来一种久违的、勤劳质朴的美。

在邦达镇翻越海拔 4,658 米的业拉山后，从山顶往下就是大名鼎鼎的怒江天险——七十二道拐，是一段有连续 72 个大小弯道的盘山公路，看着吓人又刺激。羊肠道曲折弯拐，直至怒江大峡谷。峡谷里的公路凿壁而成，光秃的岩壁耸立高峻，正是"壁陡崖悬、壑深万丈"。行至怒江大桥这个川藏线公路上的咽喉之地，我们同其它路过的车辆一样鸣笛致敬，缅怀在此牺牲的筑桥英雄，感谢那些把路铺到远方的人们，感谢他们为此做出的巨大牺牲和贡献。

从八宿到然乌湖的途中，巧遇几位前往拉萨的朝圣者，以"五体投地"的磕长头方式前行，用身体一步步丈量着这片土地，身体力行实践心中的信仰。对这种信仰，我们平常人很难理解，但亲眼看到他们发自内心的虔诚，很难不被打动。我们赠送了一些食物和水，祝他们一路平安。

出了八宿县界，就是然乌湖景区。然乌湖是山体滑坡或泥石流堵塞河道而形成的堰塞湖，是雅鲁藏布江支流帕隆藏布的主要源头，也是帕隆大峡谷的起源。如茵的草甸和连绵的雪山成就了然乌湖的美，湖面清晰的雪山倒影如梦似幻，每当涟漪泛起、雪山、草地随着波纹抖动，模糊的倒影颇有几分印象派的感觉，妙不可言！偶遇一群游客邀请我帮他们拍张合照，于是我在湖边替他们留下了与阳光同样灿烂的笑颜。

停车休息时，与几位当地人碰面，很多藏地居民不懂普通话，却丝毫不妨碍互相传递的友善，一句"扎西德勒"就能换来友好真诚的笑容。几乎每人都手持一串佛珠，无论在行走，抑或停下歇息，无时不在念诵经文。藏民们肤色略深，拍照时稍带羞涩，却一直笑脸相迎，清澈的目光中流露的淳朴美好而动人。

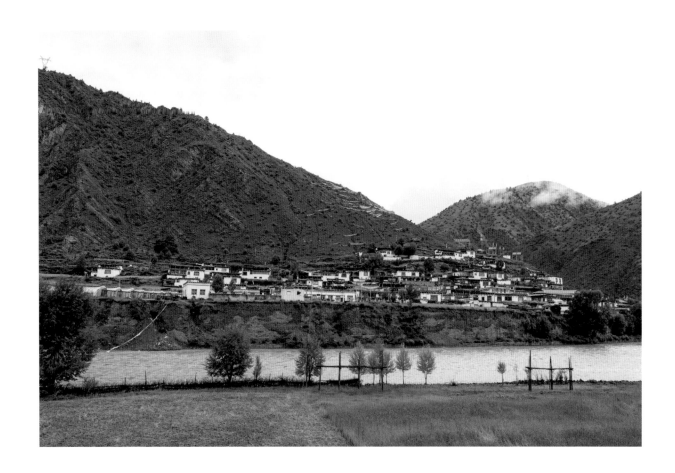

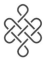

Day 4
Zogang County ~ Bome County

Three rivers, Nujiang River (also known as Salween River), Lancang River (also known as Mekong River) and Yuqu River, flow through Zogang County, from where we started a day-trip along the meandering Yuqu River.

On either side of the road stood rolling mountains belted by puffy clouds. We relished our moments wandering about the gallery given by nature, and also stopped the car and waved to the barley-reaping local Tibetans that we met on the way. The highland barley fields and distinctive Tibetan dwellings echoed the mountainous background, containing an unadorned beauty rarely seen for a long time.

After scaling the height of Mount Yela (also known as Nujiang Mountain) at an elevation of 4,658 meters in the town of Bangda, we were going to challenge the well known Natural Barrier of Nujiang River, the 72 Zigzags, which is a length of twisting mountain road with 72 large and small sharp turnings from the mountain top down to the Nujiang Grand Canyon. The road in the canyon is opened out of the mountain, which ajoins bare rock walls towering on one side and edges the formidable abyss on the other. When we drove through the Nujiang Bridge, the vital passage on the Sichuan-Tibet belt, we sounded the siren in mourning, together with other passing vehicles, for those heroes who made supreme sacrifices and contributions to construct the bridge and pave the 'sky ladder' to such a distant place.

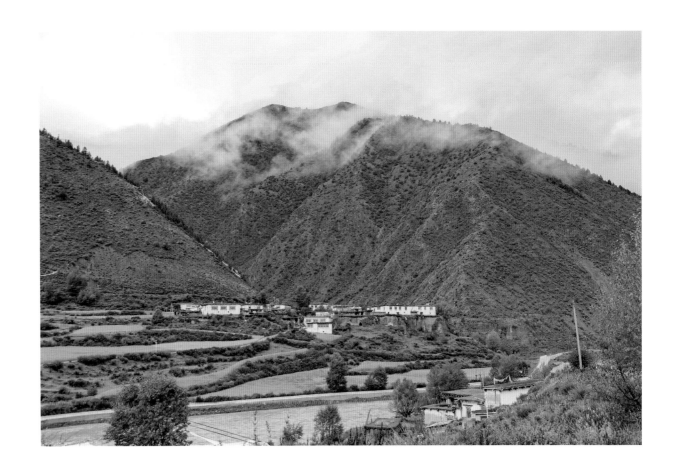

On the way from Basu County to Lake Ranwu (Rakwa Tso), I happened to meet several Lhasa-heading pilgrims who earnestly performed full-body prostrations. They were undertaking a pilgrimage by measuring the land step by step with their bodies, conveying profound reverence for their faith. Though difficult to understand their religious practice, I found it more difficult not to be moved when witnessing their heartfelt devotion to religious conviction. We gave them some food and water, as well as our best wishes for a safe journey.

Ahead from the Basu County boundary is the scenic area of Lake Ranwu, a barrier lake formed by landslides or debris flows, which is the main source of Parlung Zangbo River, a tributary of Yarlung Tsangpo River, and also the origin of the Parlung Grand Canyon. The dream-like beauty of Lake Ranwu is blessed with grassy marshland and rolling snow-capped mountains which are clearly mirrored on the surface of the lake. When the reflections of grassland and snow mountains danced with the ripples of the water, the blurred image shimmered with a tint of impressionistic glamour, too wonderful for words! I had a chance encounter with a group of tourists who asked me to take a group photo for them, and I was happy to freeze-frame their bright smiles by the lake.

When we stopped for a short break, I met with several locals. Many of them were not able to communicate in Mandarin, but the communication about friendliness was not hindered at all since a saying of 'Tashi delek' (a Tibetan expression used in greeting, congratulation, and good-luck wishes) would be rewarded by a sincere and warm smile. Almost everyone held a string of Buddhist beads, chanting scriptures all the time while walking or resting. Tibetans are of slightly-dark complexions, wearing a broad smile tinged with bashfulness in front of the camera, simple and affecting sentiments expressed in their clear eyes.

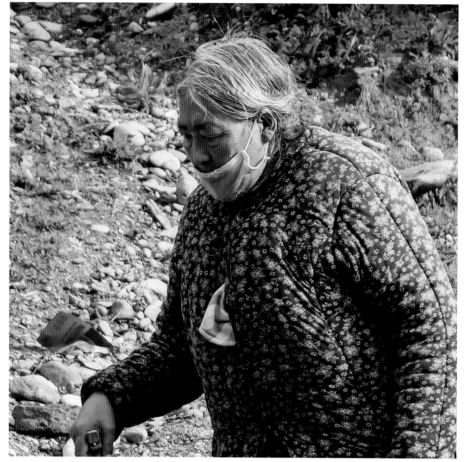

在乡间路上偶遇上几位藏族老人，她们手持佛珠，腰板硬朗，精神矍铄。

我举起相机为她们拍照，她们表现得有些羞涩，却不闪避，态度非常友善。

On the country road, I ran across some Tibetan folks.

They were ramrod straight with a string of Buddhist beads in hand,

old in age but young in spirit.

When I raised the camera to take pictures of them,

they seemed a little bashful but didn't shy away,

responding to my request with friendliness.

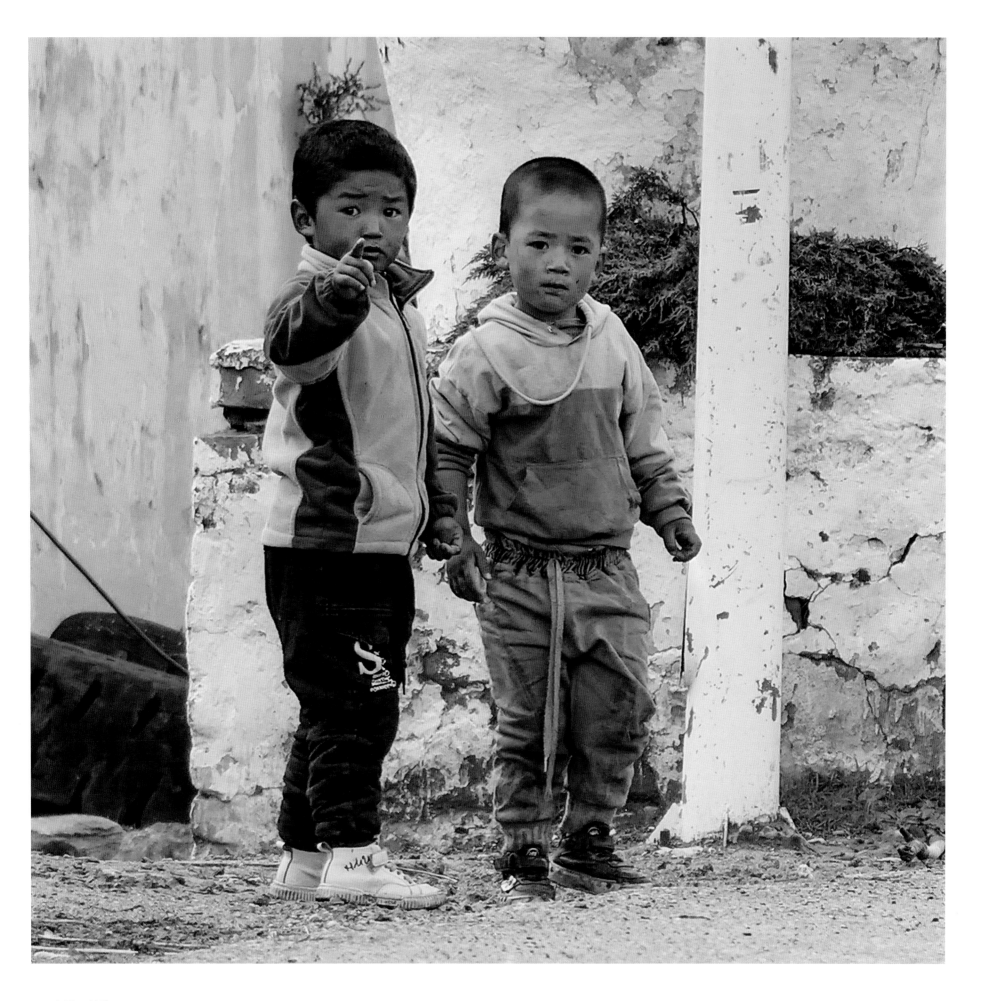

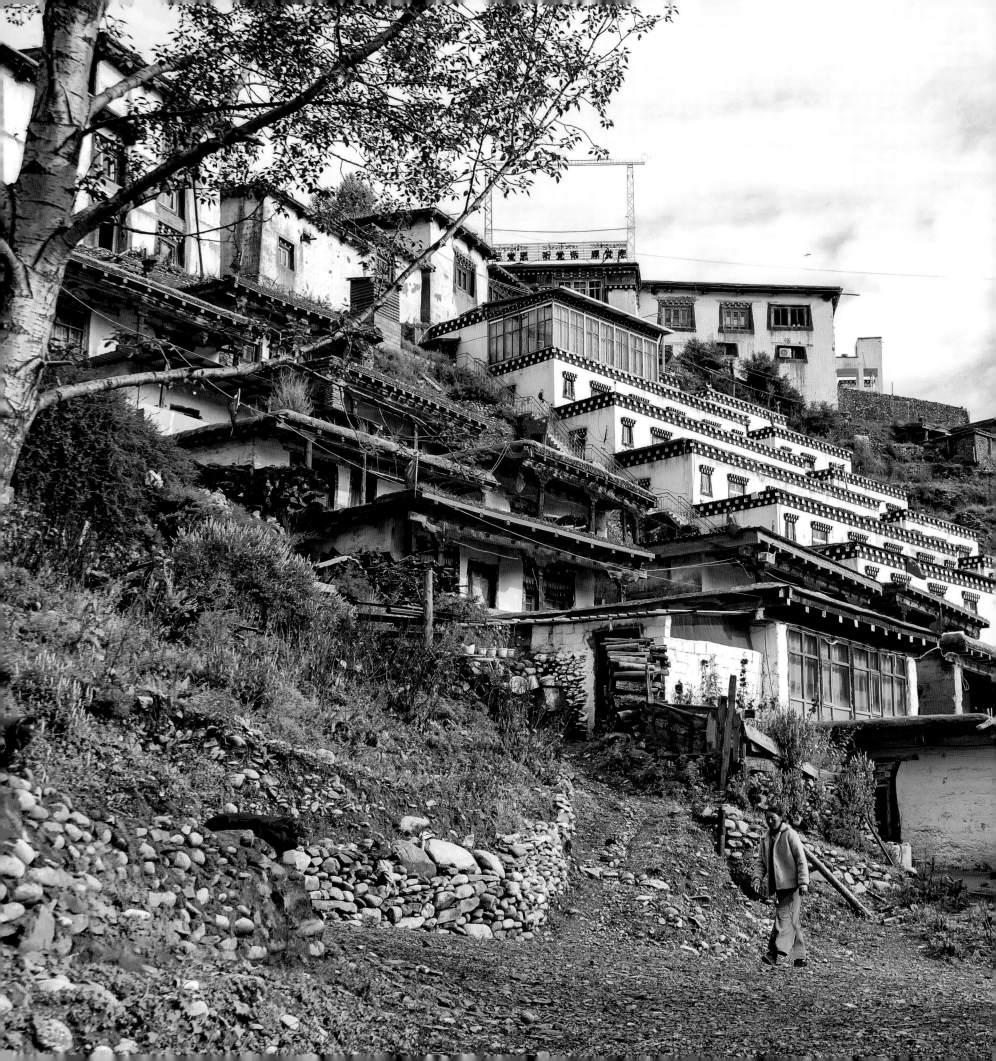

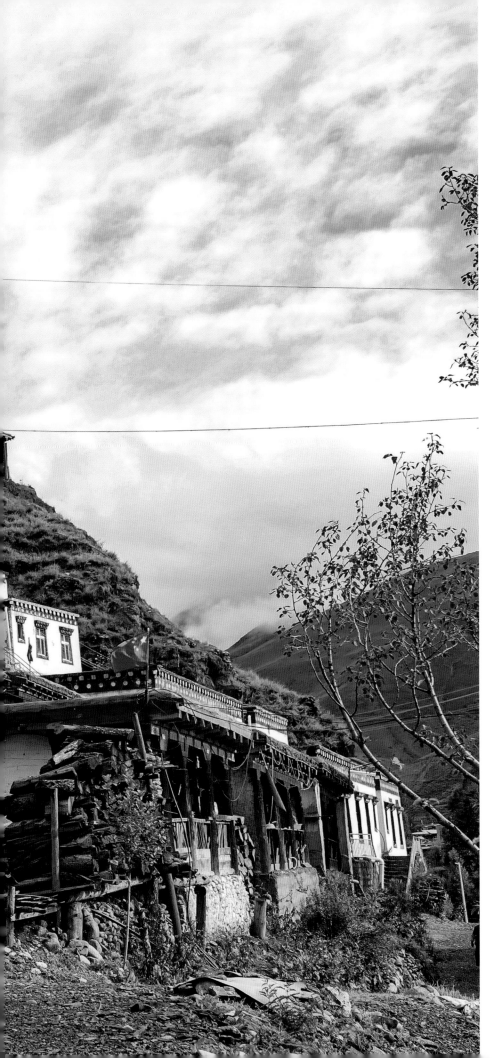

我们所经过的藏家村落栉比鳞次，
有几分与瑞士小镇相似。
The Tibetan villages we passed through were organized in orderly rows,
something of a Swiss town.

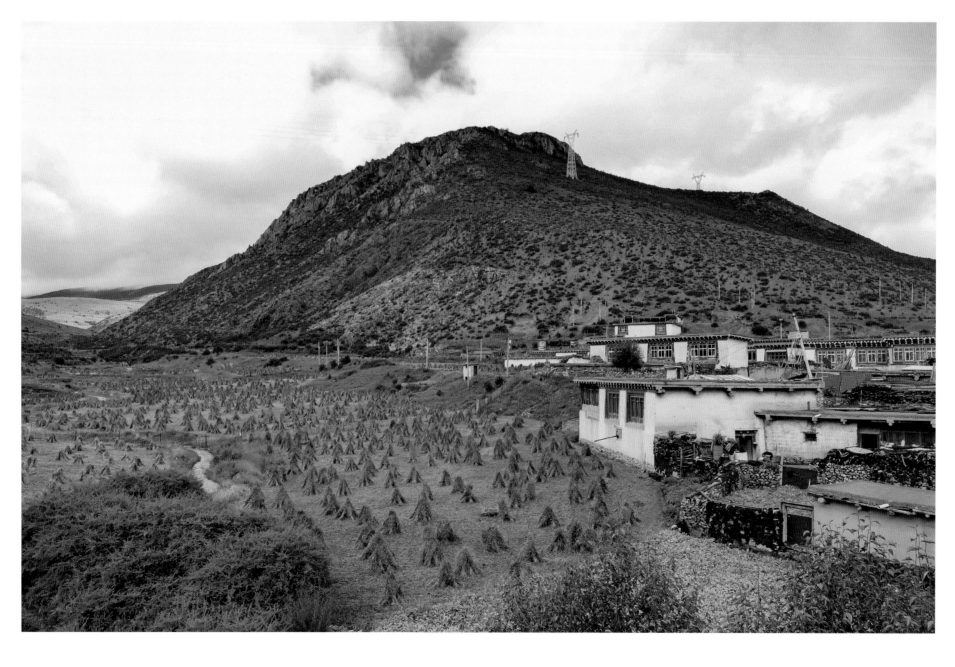

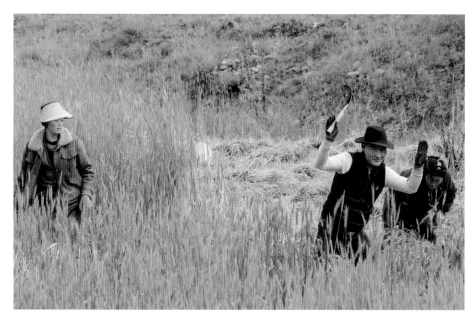
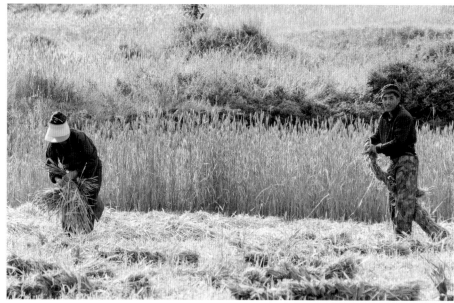
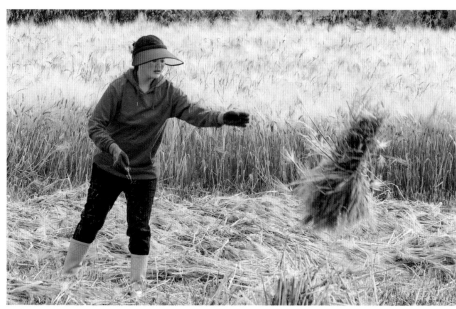
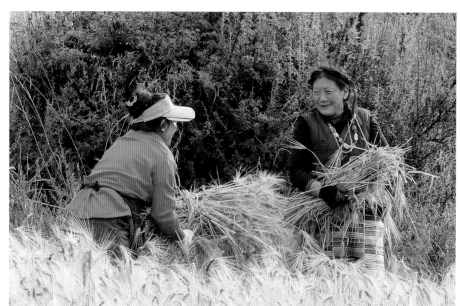

西藏被称为"青稞之乡"，收割青稞的农民们弯下腰身，
熟练地挥动镰刀，忙碌地在农地里收割，带来一种久违的、勤劳质朴的美。
Tibet is known as the 'home of highland barley'. Farmers stooped down to scythe the barley,
busy harvesting in the fields. The harvest scene exuded a long-lost beauty of hard work and simplicity.

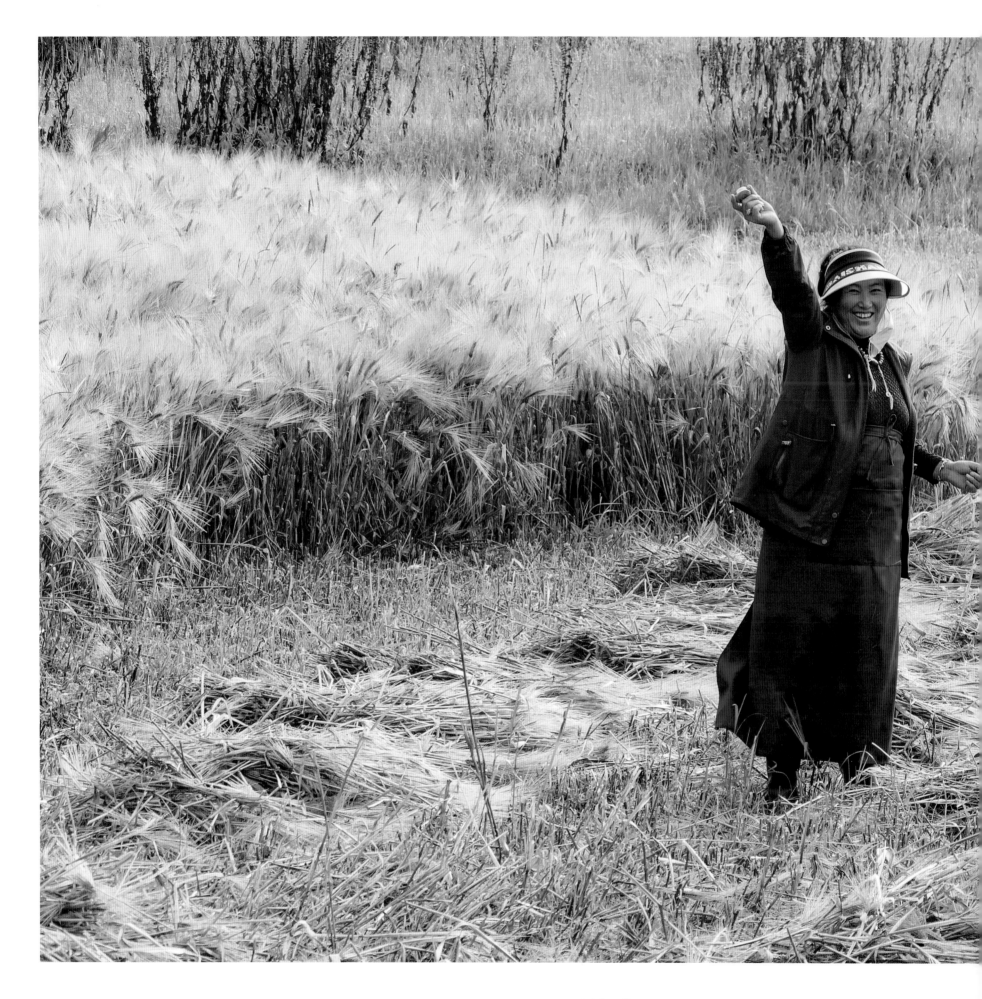

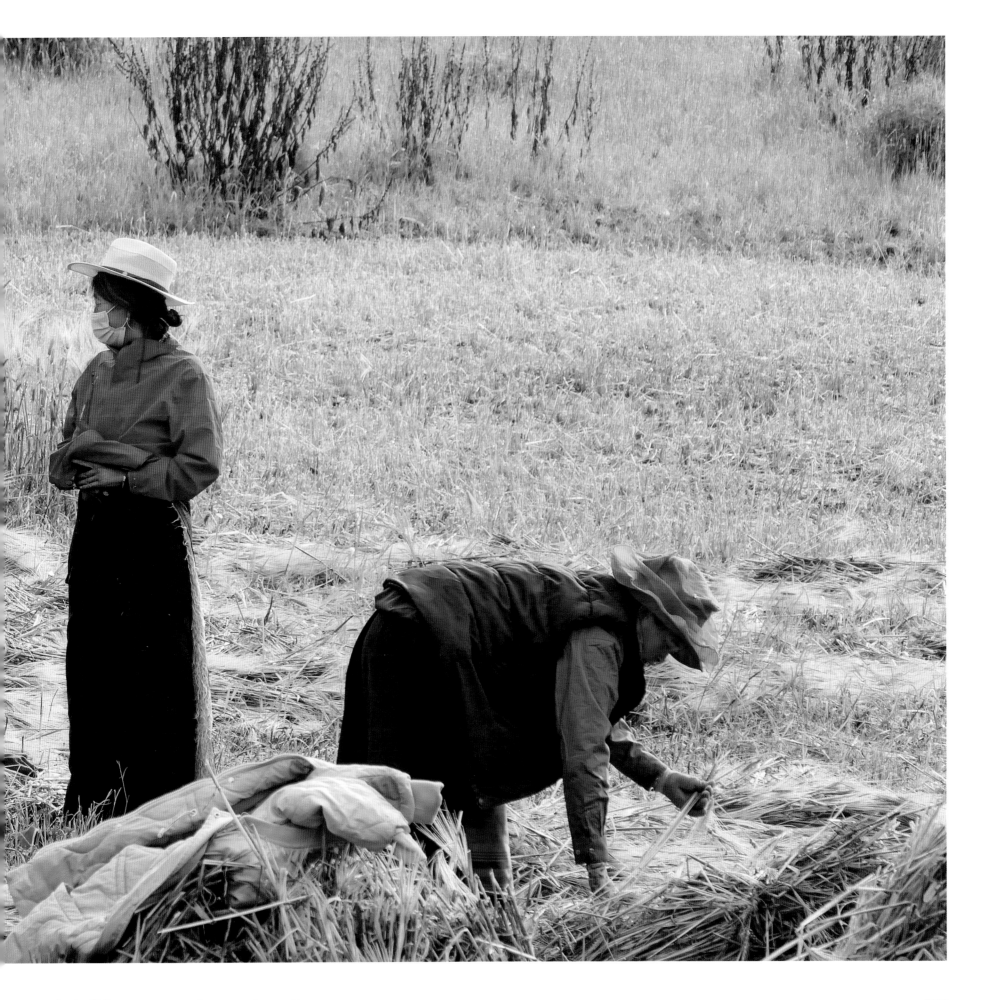

左貢 ~ 波密　　Zogang County ~ Bome County

业拉山的地质很特别，裸露的岩石经过严重风化后，变成险峻突秃、奇形怪状的灰白色，形似喀斯特地貌。

The Mount Yela (also known as Nujiang Mountain) is characterized by special geologic structure,
the exposed off-white rocks of which have been severely weathered and grotesquely shaped, resembling a karst landform.

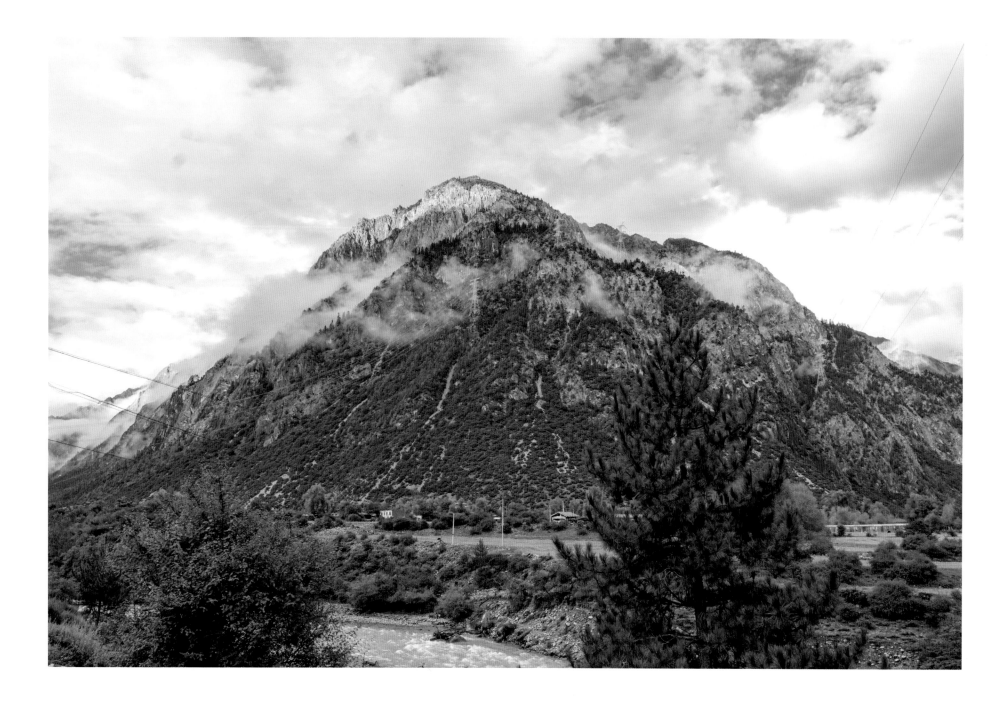

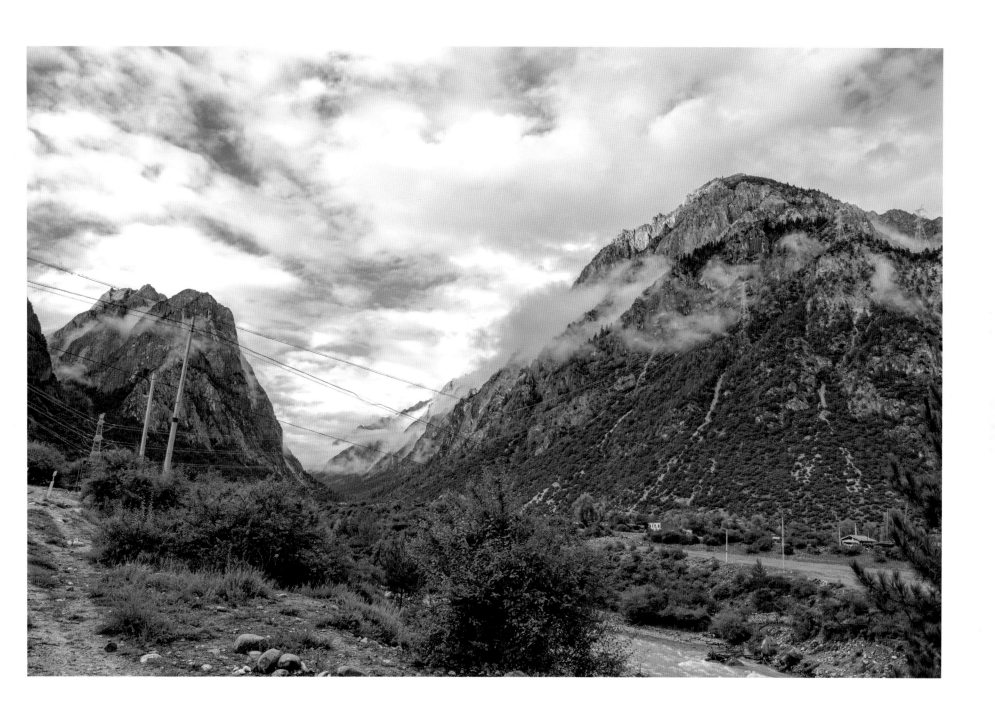

左贡~波密　　Zogang County ~ Bome County

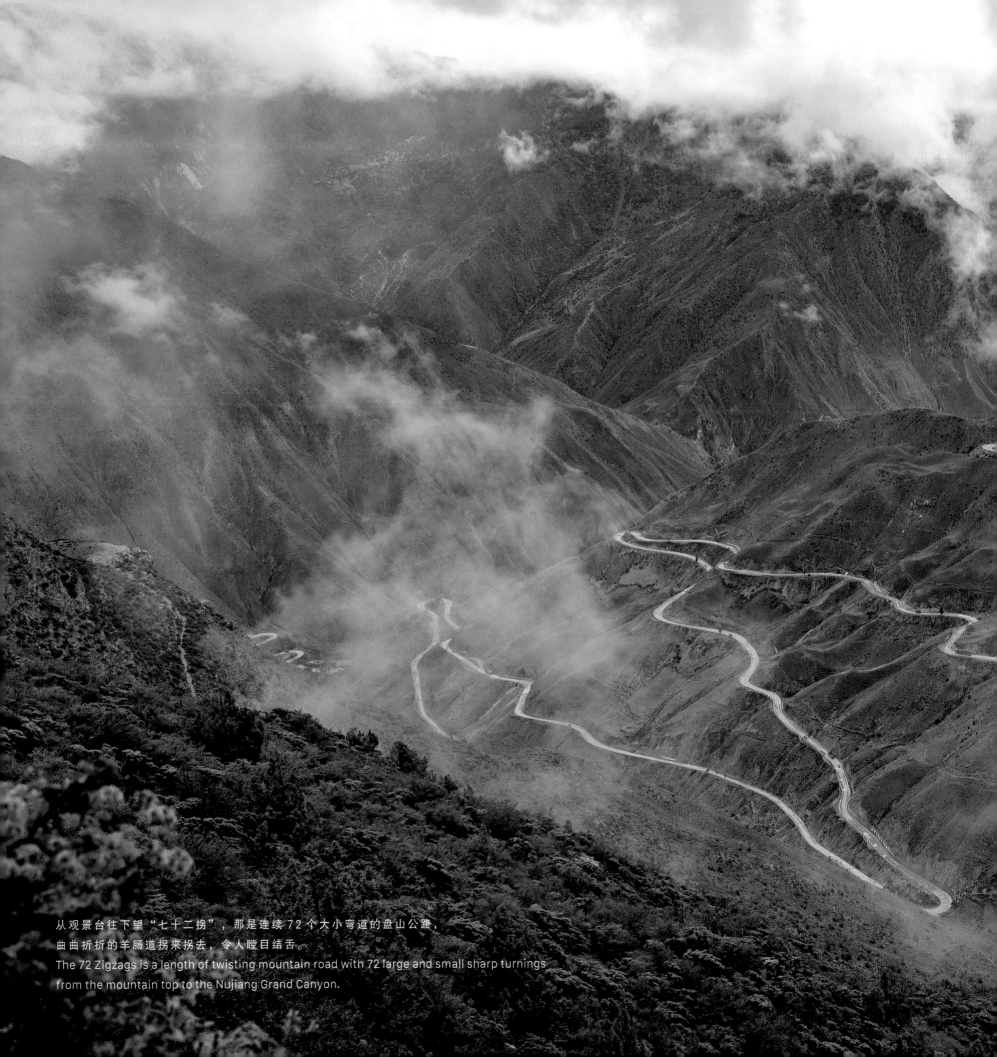

从观景台往下望"七十二拐"，那是连续 72 个大小弯道的盘山公路，
曲曲折折的羊肠道拐来拐去，令人瞠目结舌。
The 72 Zigzags is a length of twisting mountain road with 72 large and small sharp turnings
from the mountain top to the Nujiang Grand Canyon.

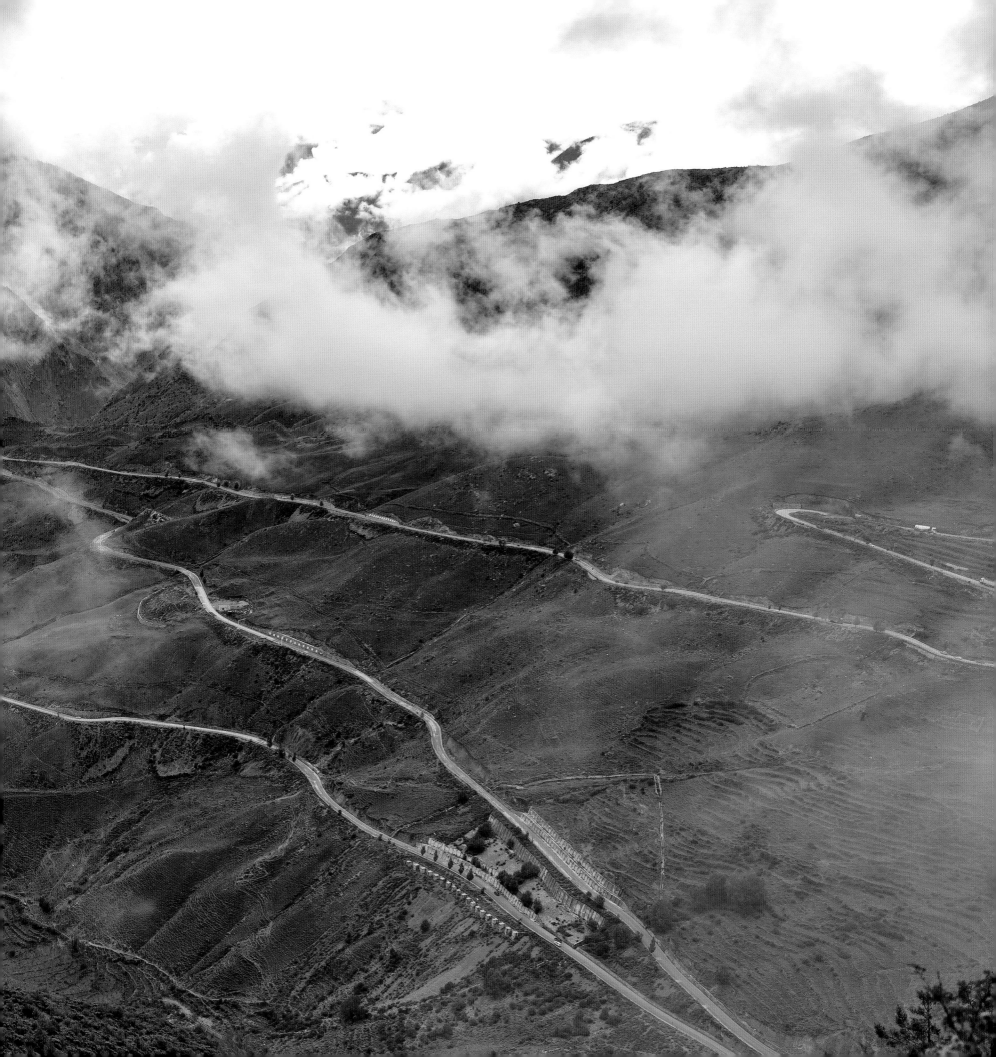

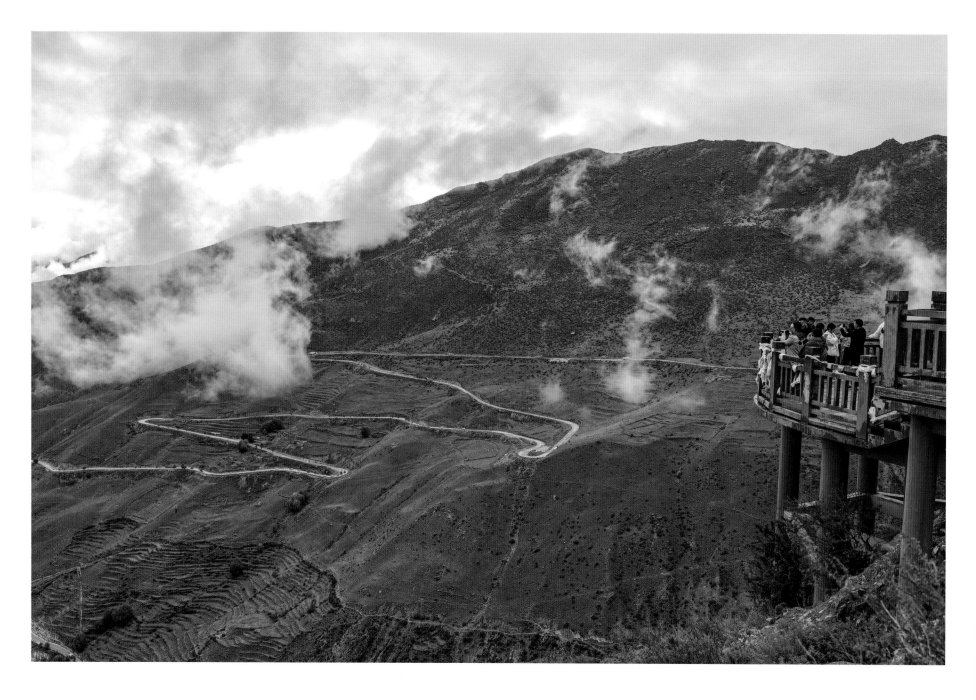

圣洁的西藏　TIBET : THE HOLY LAND　第四天　DAY 4

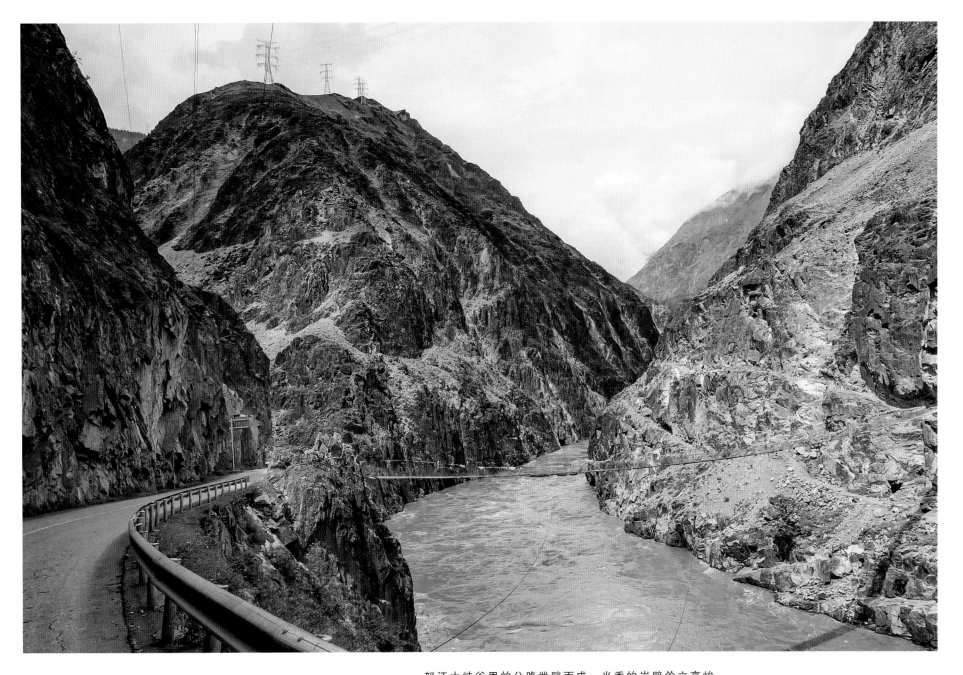

怒江大峡谷里的公路凿壁而成，光秃的岩壁耸立高峻。
The road in the Nujiang Grand Canyon is opened out of the mountain,
which ajoins bare rock walls towering on one side and edges the formidable abyss on the other.

从八宿到然乌湖的途中，巧遇几位前往拉萨的朝圣者，
以"五体投地"的磕长头方式前行，身体力行实践心中的信仰。
On the way from Basu County to Lake Ranwu (Rakwa Tso),
I happened to meet several Lhasa-heading pilgrims
who earnestly performed full-body prostrations.
They were undertaking a pilgrimage, conveying profound reverence for their faith.

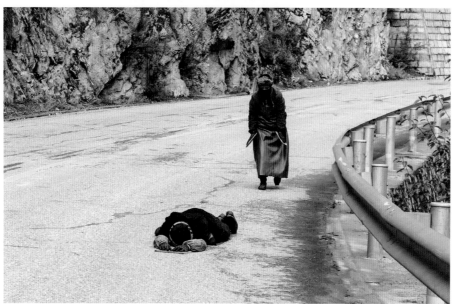

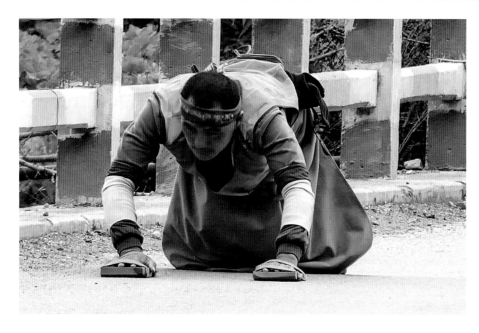

然乌湖边偶遇一群笑颜灿烂的游客。

I had a chance encounter with a group of tourists with bright smiles by the Lake Ranwu.

波密～拉萨

第五天

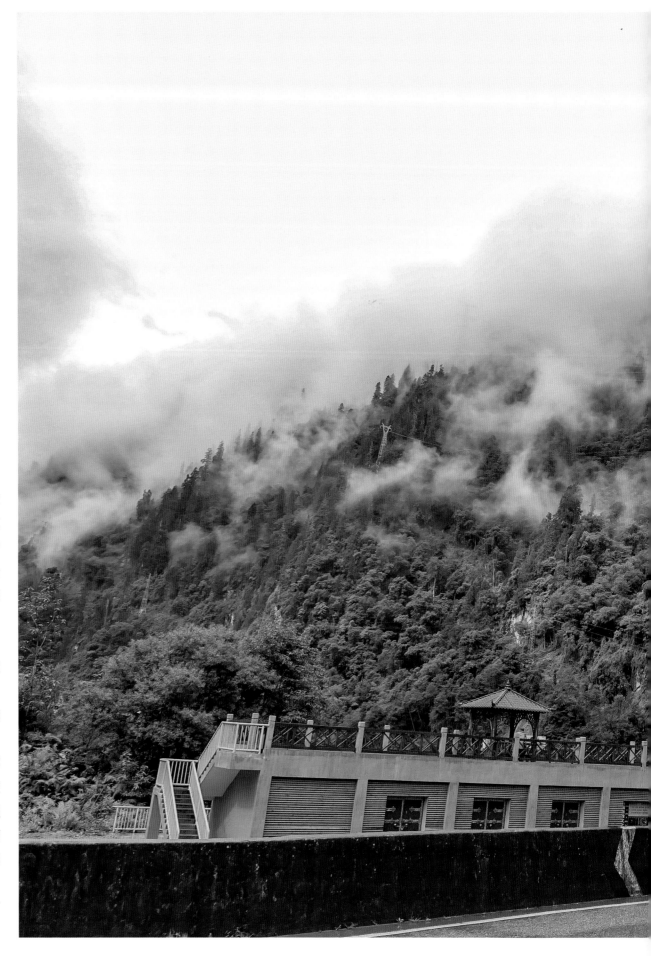

波密是个相当神奇的地方，冰川在这里聚集，皑皑雪山随处可见，更有繁茂森林，看似矛盾的几种自然景观在这里完美结合。我们沿着318国道继续前行，左手边是帕隆藏布江，远山近水笼罩在弥漫的白色晨雾中，展现出中国传统水墨画的意境。

318国道的波密段属于泥石流频发路段，通麦天险更是最为艰险的一段，全长14公里的路，平均要走两个小时。通麦是帕隆藏布江与雅鲁藏布江即将汇合的地方，此处雨水多，塌方严重，桥梁屡被山洪冲毁，又有"通麦坟场"之称。不过如今已是天险变通途，通麦特大桥的修建改变了行路难的历史，让这儿不再成为所有跑川藏线的司机心中一颤的名字。早先还有两座不同时期修建的通麦大桥，第一座已被冲毁，第二座连出事故，皆已停止通行机动车辆。三代桥、几代人，见证川藏线建设者的艰辛与辉煌，让人钦佩万分，也感慨万千。

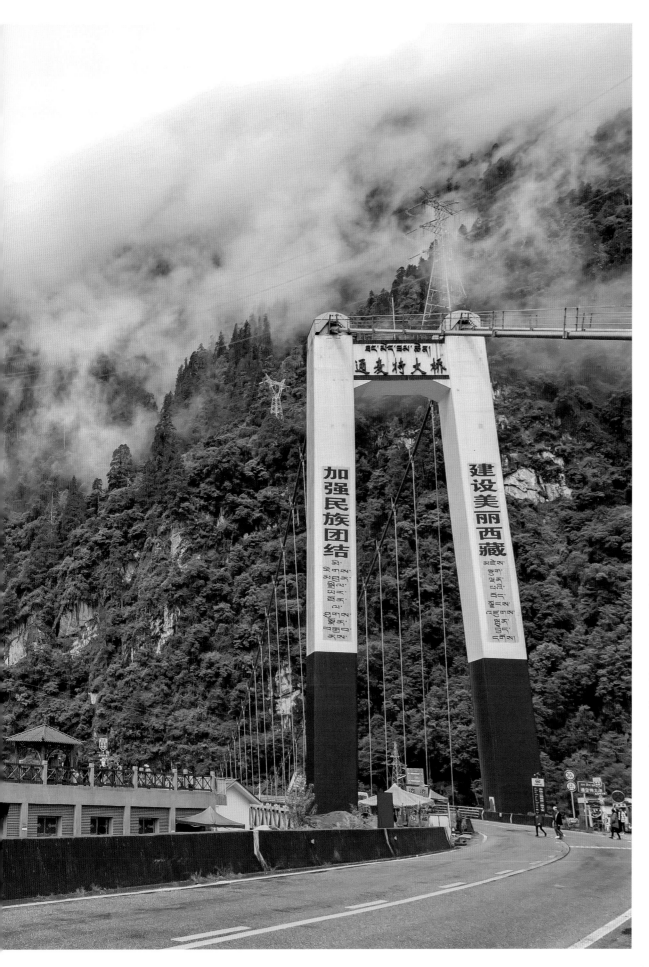

行过通麦天险，不久就到了鲁朗。在藏语中，"鲁朗"意为"龙王谷"，也是"叫人不想家"的地方。坐落在深山老林中的鲁朗，云杉、松林、草甸与点缀其间、错落有致的木屋村寨，恰如一个与世隔绝的桃花源。

我们在夜幕落下的时候抵达拉萨，乘机去了布达拉宫广场，安检后进入广场，只见夜晚的布达拉宫仿佛一幅巨大的油画，相较于白日阳光下的宫殿，不仅更显神圣和壮观，还透着一种无法言喻的魅力。

Day 5
Bome County ~ Lhasa

Bome County is quite an amazing place, where displays a perfect combination of several natural landscapes seemingly contradictory to each other, including glaciers, snowcapped mountains and lush forests. We continued along National Highway 318, the Parlung Zangbo River surging forward on our left side. The scenery of the faraway mountains and nearby water outlined a sense of poetic beauty.

The stretch crossing Bome County on National Highway 318 is a debris-flow-prone area, and the Tongmai Natural Barrier with a total length of 14 kilometers is the most treacherous section that requires an average of two hours' driving. Tongmai marks the confluence of rivers of Parlung Zangbo and Yarlung Tsangpo, which have serious landslides caused by excessive rainfall, bridges repeatedly destroyed by floods, so named 'Tongmai graveyard'. The construction of the Tongmai Bridge has now turned the natural obstacle into a thoroughfare, travelling no longer difficult, and the name of Tongmai has from then no longer frightened drivers on the Sichuan-Tibet Highway. There were two other bridges built at different times, the first of which was washed away and the second closed to all motor vehicles due to a succession of accidents. Three generations of bridges and several generations of people, history is the most telling witness of immense hardship and brilliant achievements of those Sichuan-Tibet builders, which commands our great admiration and respect.

Not far away behind the Tongmai Natural Barrier is Lulang County. In Tibetan, 'Lulang' means 'Valley of the Dragon King', a magnet for visitors to linger around. Hiding herself in the deep mountain forest, Lulang is populated by spruce, pine and meadows that are interspersed with well-arranged cabins, just like the Peach Blossom Land (the name from a fable by Tao Yuanming, one of the best-known poets during the Six Dynasties period in ancient China) enjoying peace and solitude.

When the night fell, we arrived in Lhasa and took the opportunity to visit Potala Palace Square through security checks. Compared to the bright sunlight, the clear night defined the Potala Palace as a huge oil painting, not only sacred and spectacular, but lending a certain charm beyond description.

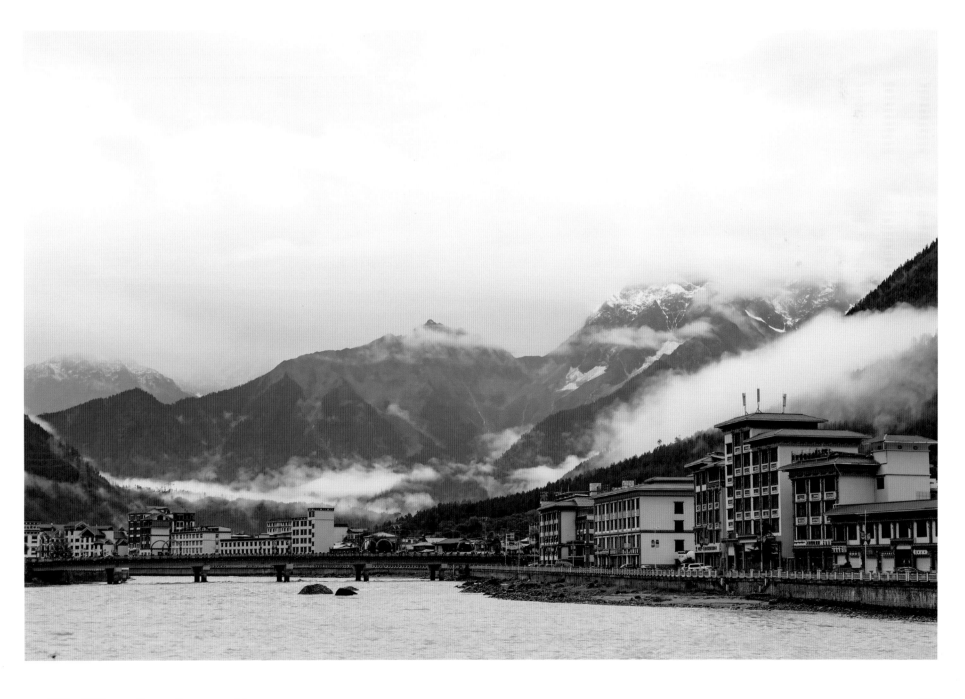

波密～拉萨　Bome County ~ Lhasa

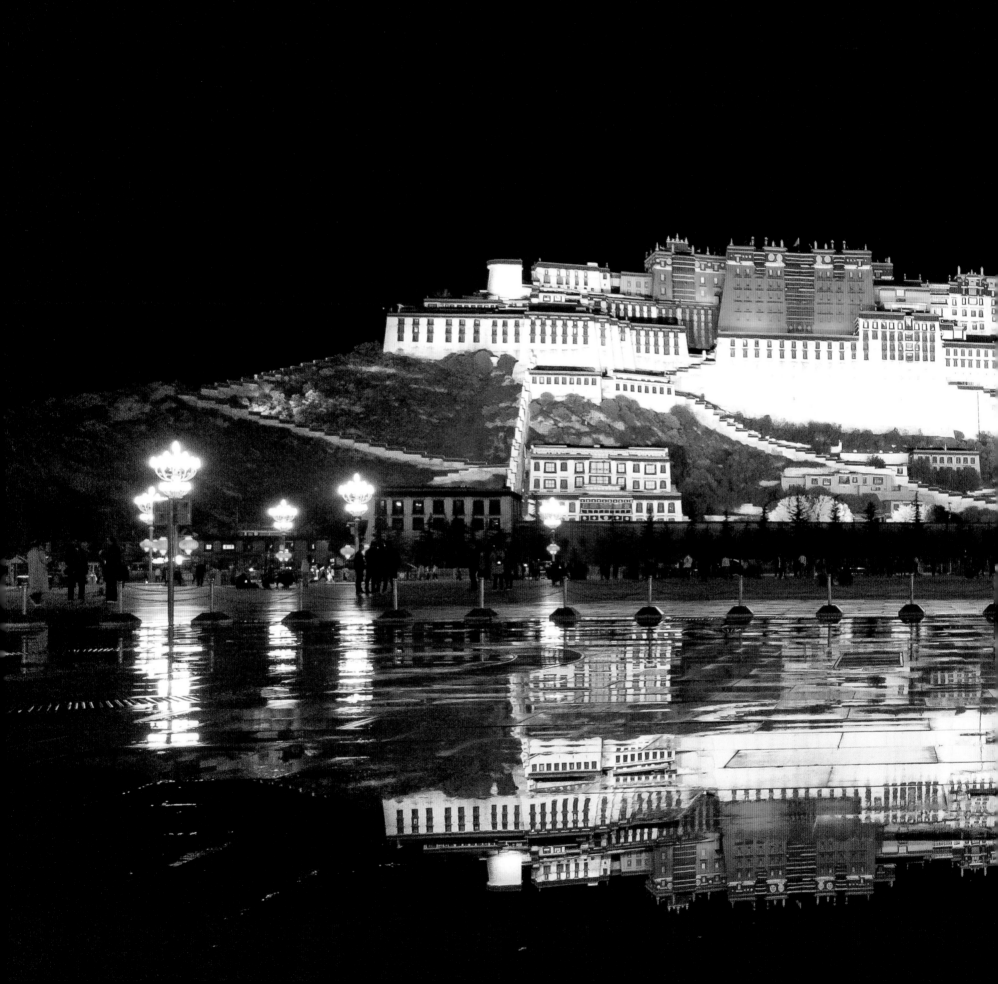

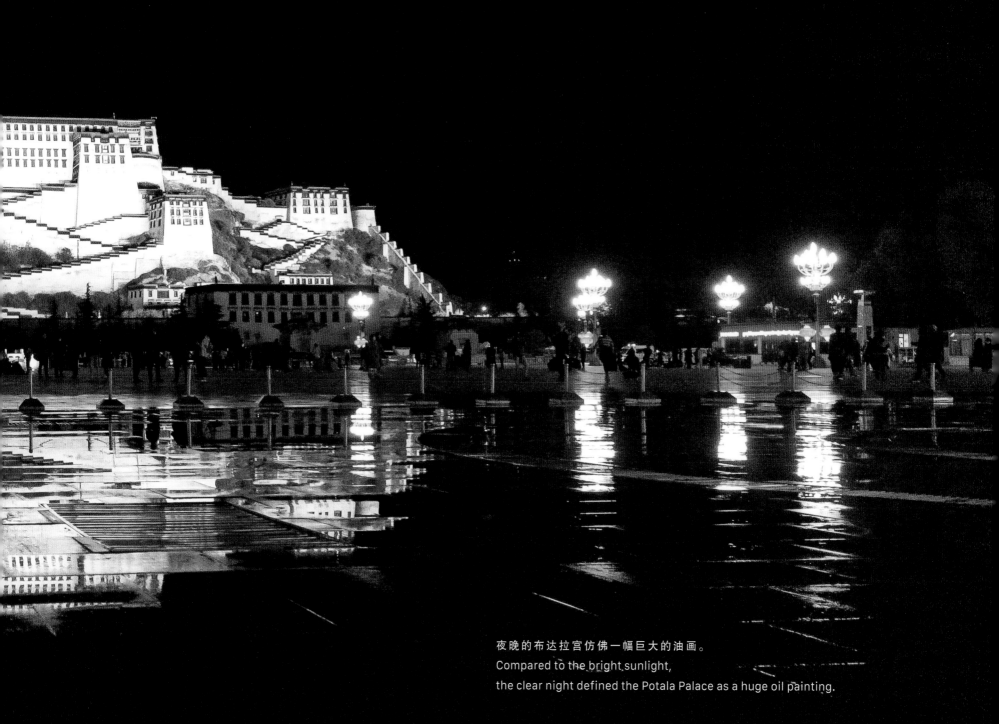

夜晚的布达拉宫仿佛一幅巨大的油画。
Compared to the bright sunlight,
the clear night defined the Potala Palace as a huge oil painting.

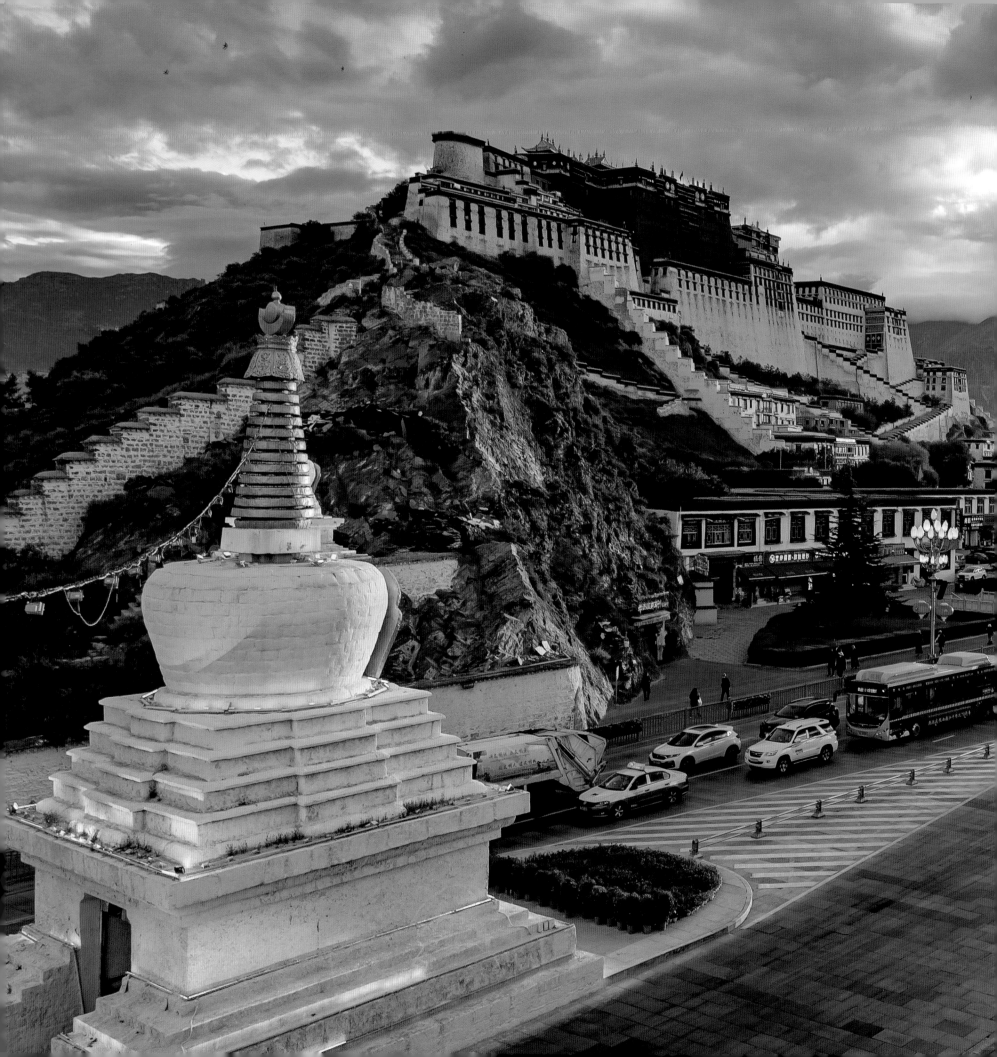

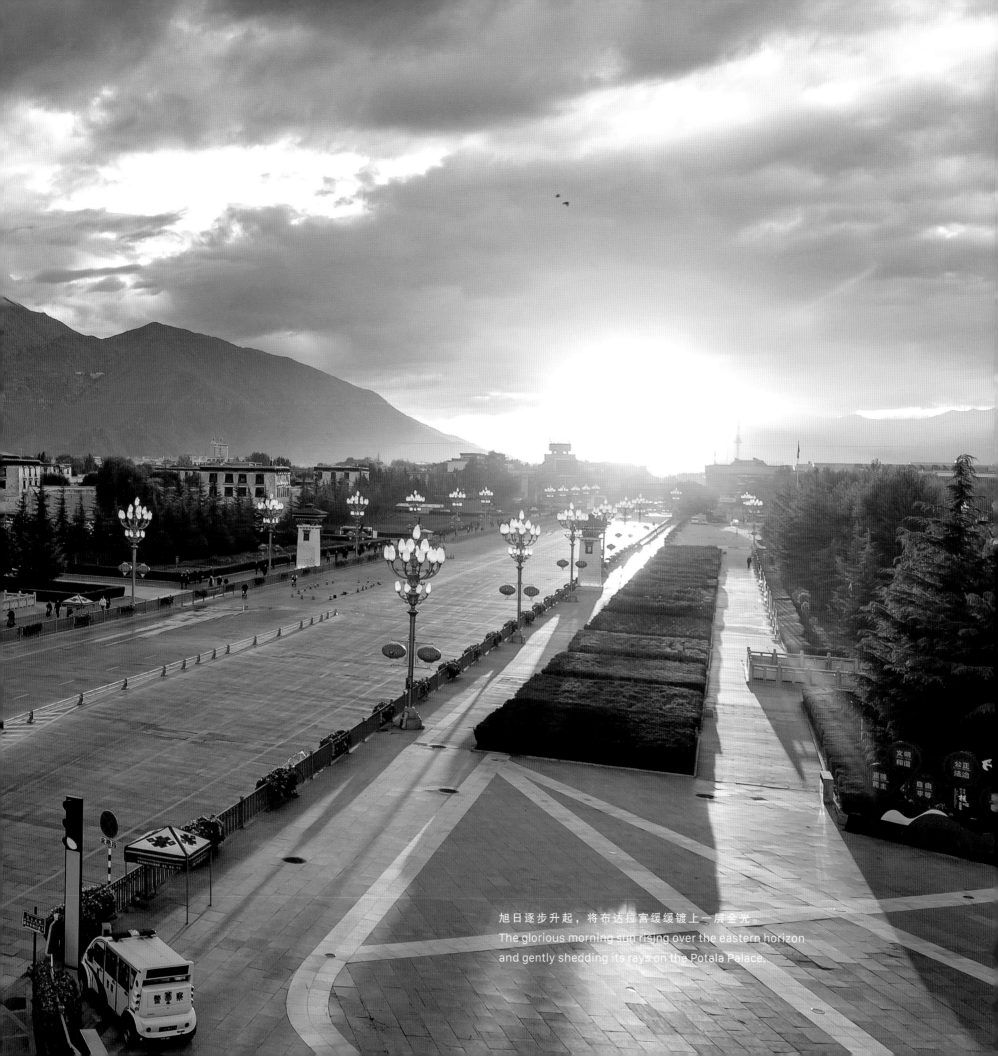

旭日逐步升起，将布达拉宫缓缓镀上一层金光。
The glorious morning sun rising over the eastern horizon
and gently shedding its rays on the Potala Palace.

拉萨 第六天

拉萨是一个被群山环绕的城市，城内的山很少，在市中心有一座玛布日山，布达拉宫就建在这座小山上。布达拉宫始建于吐蕃王朝赞普松赞干布时期，后来成为西藏政教合一的统治中心。众所周知，中国最大面值的人民币100元以人民大会堂为背景图案，而仅次于它的50元，背景图案就是布达拉宫，既是对西藏的重视，也是民族大团结的体现。

天色未明，我已登上布达拉宫对面的药王山观景台，当时辰到来，旭日逐步升起，将布达拉宫缓缓镀上一层金光，可惜当日云层较厚，未能得见太阳升起时的万丈光芒。

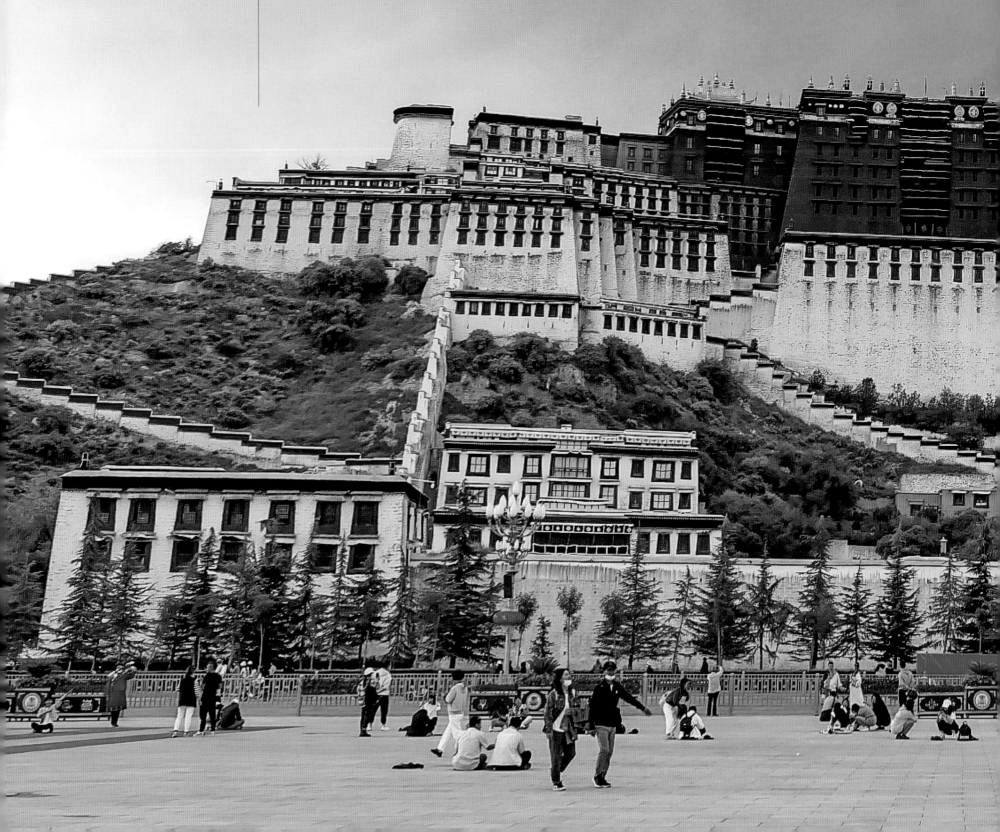

西藏民间有"先有大昭寺，后有拉萨城"的说法，大昭寺位于拉萨老城中心，在藏传佛教中拥有至高无上的地位，千百年来香火绵延不绝，是无数信众千里朝圣的终点。大昭寺前永远都有虔诚的叩拜者，即便疫情期间亦是如此。我爱走上大昭寺的平台，欣赏阳光普照下灿烂夺目的金顶，欣赏寺内的建筑与装饰细节，安静而悠闲，仿佛连时间的走动都比他处更慢一些。

　　千年八廓街位于大昭寺旁边，是著名的转经路，藏族人称其为"圣路"。东南角有一座醒目的小黄楼玛吉阿米，相传曾是六世达赖仓央嘉措与情人幽会的场所。八廓街还是拉萨的商业中心，保留古城的传统面貌。门前的台阶上，老树下的长椅上，三五成群的本地人闲话家常，在巷弄街角看见藏族百姓日复一日、年复一年的生活方式，凝结了时光。

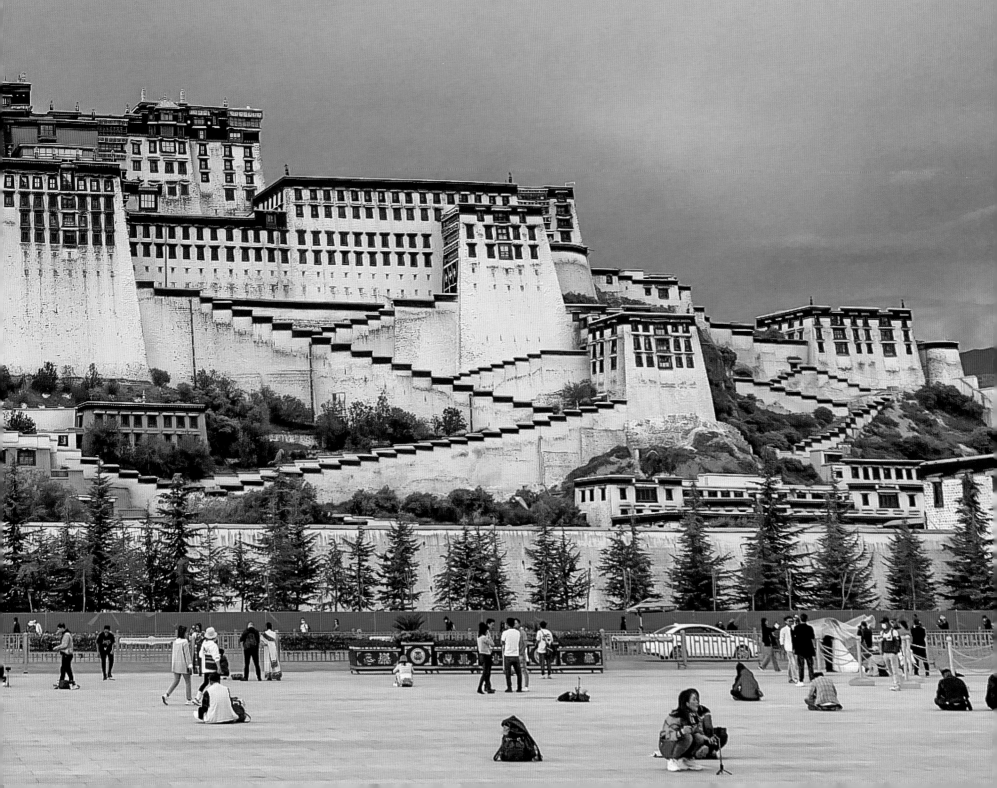

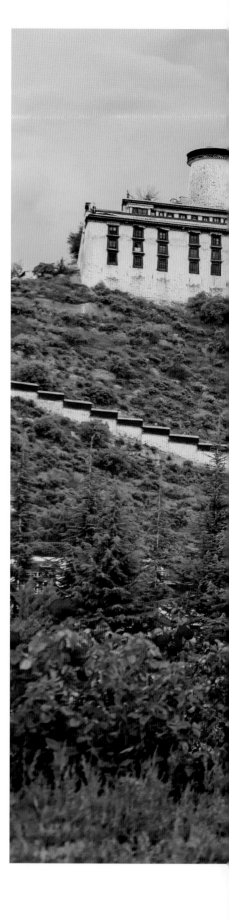

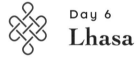

Day 6
Lhasa

Lhasa, a mountain-hemmed city, contains only a few hills inside the city. In the center is the Red Mountain crowned by the Potala Palace, which was originally constructed by Songtsen Gampo(617-650), the 33rd btsan-po (leader), has later become the center combining the political and religious powers of Tibet. It is known to all that our 100-yuan banknote of the largest denomination has the Great Hall of the People as its background pattern, and the 50-yuan banknote, which is second only to it, has the Potala Palace on the reverse. It symbolizes the great importance attached to Tibet as well as national unity.

When the sky was faintly light with the dawn, I had already climbed up the viewing platform of Mount Chokpori, literally 'King of Medicine', opposite to the Potala Palace, waiting for the glorious morning sun rising over the eastern horizon and gently shedding its rays on the palace. But the thick clouds of the day obscured its scattering splendor.

In Tibet people say, 'there exists the Temple of Jokhang first, then the city of Tibet'. Located in the city center of the old district, the Jokhang Temple, enjoys supreme status in Tibetan Buddhism, which has received an endless stream of pilgrims over thousands of years, the holy destination for all faithful believers travelling from far away. The temple never lacks devout worshipers, and neither the current epidemic could stop them. I enjoyed the pace at leisure and strolled on the temple platform, obsessed by the surrounding views including the golden roof bathed in the sun, the structures, and the exquisite craftsmanship inside the temple. Even the passage of time appeared more languid than anywhere else.

The aged Barkhor Street, also known as Pargor, is a famed circumambulation road nearby the Jokhang Temple, the holy road sacred to Tibetans. In the southeast corner stands an eye-catching small yellow building called Makye Ame, which is said to have been the rendezvous for the 6th Dalai Lama Tsngyang Gyatso and his lover. The Barkhor Street also acts as the commercial center of Lhasa, retaining much of the original charm. Sitting on the doorsteps or benches under old trees, locals chat away the time in huddles. The ordinary lifestyle of Tibetans is a common sight everywhere. Day after day, year after year, the ticking time is paused at that.

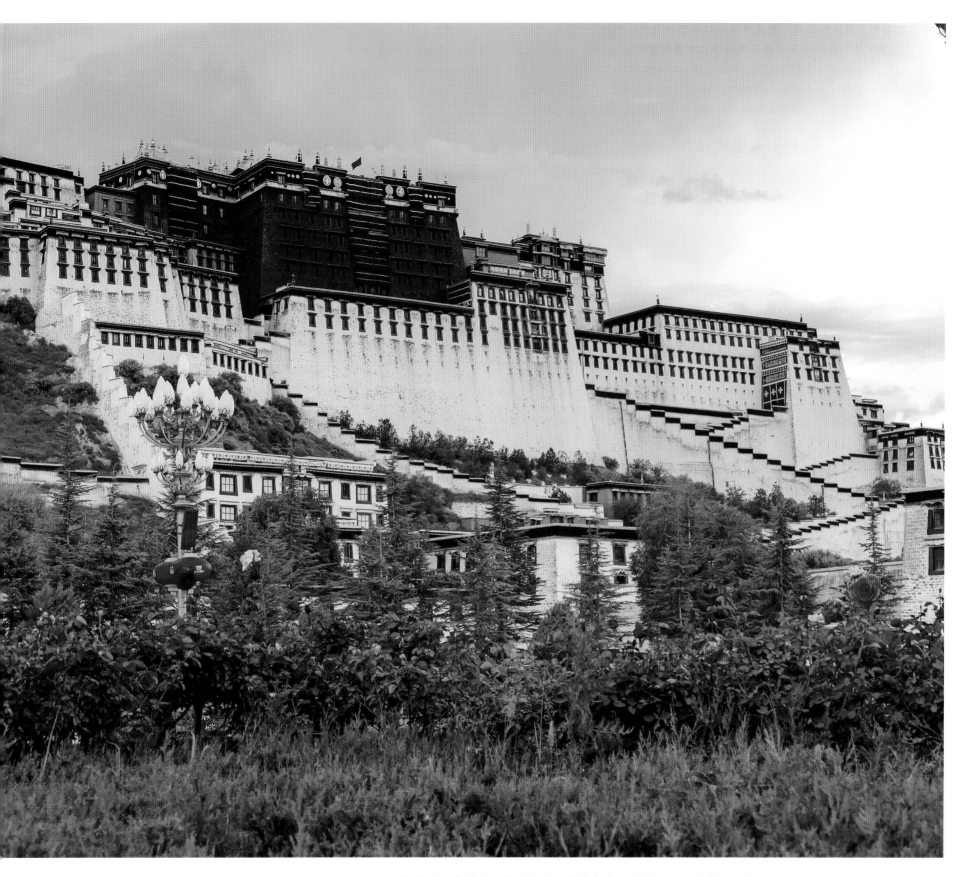

拉萨是一个群山环绕的城市，城内山少，市中心有一座玛布日山，
宏伟庄严的"圣宫"布达拉宫就建在这座小山上。
The mountain-hemmed Lhasa contains only a few mountains inside.
In the city center there is the Red Mountain crowned by the magnificent 'Holy Palace', Potala Palace.

"先有大昭寺，后有拉萨城"是西藏民间的说法，
它是西藏地区最古老的一座仿唐式汉藏结合木结构建筑。
In Tibet people say, 'there exists the Temple of Jokhang first,
then the city of Tibet'. Among the entire region,
this temple in the manner of the Tang Dynasty is the oldest wooden building
compromising the merits of Han and Tibetan styles.

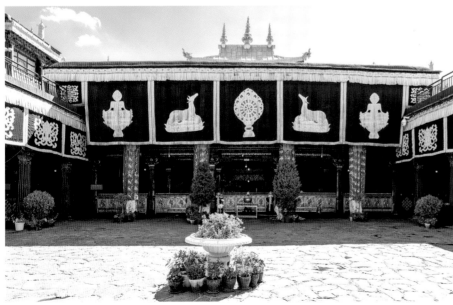

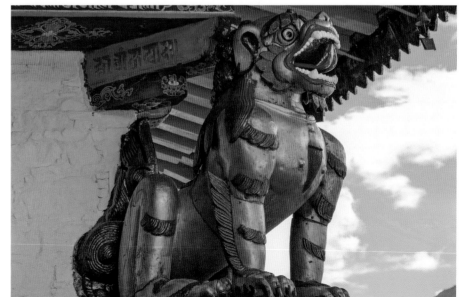

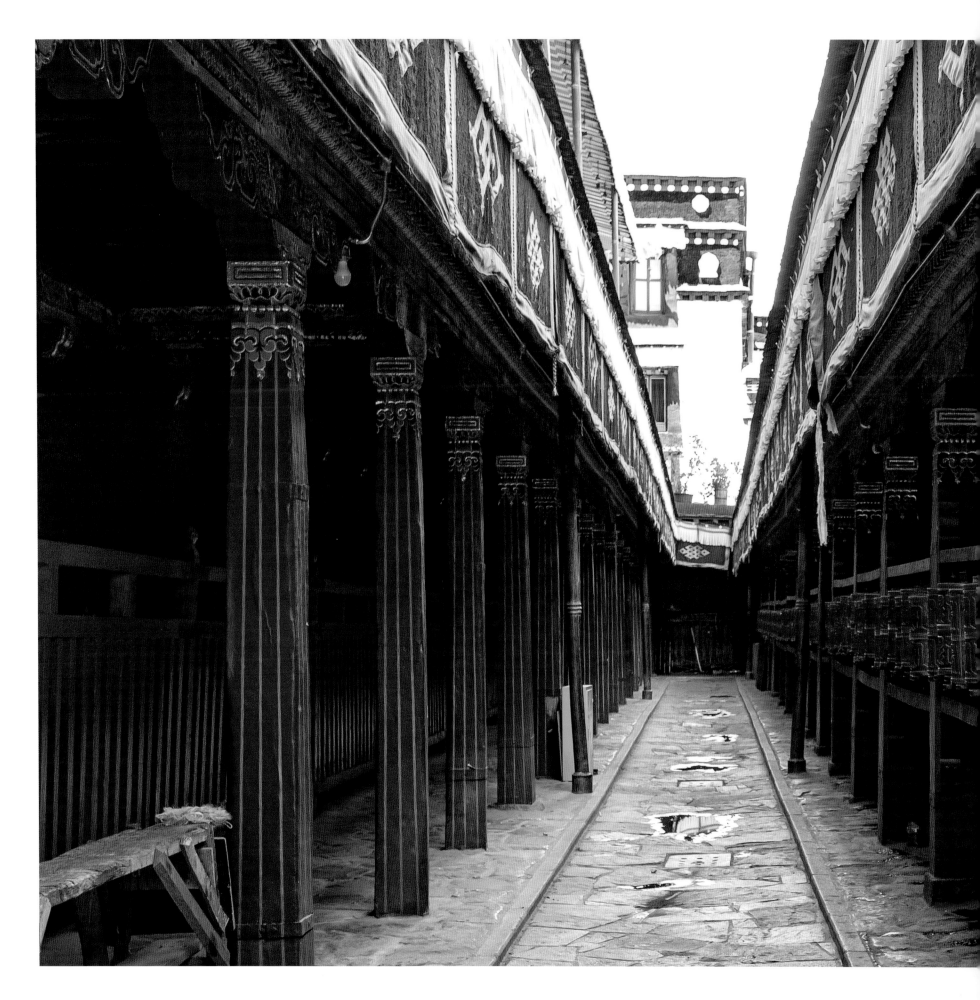

圣洁的西藏 TIBET : THE HOLY LAND 第六天 DAY 6

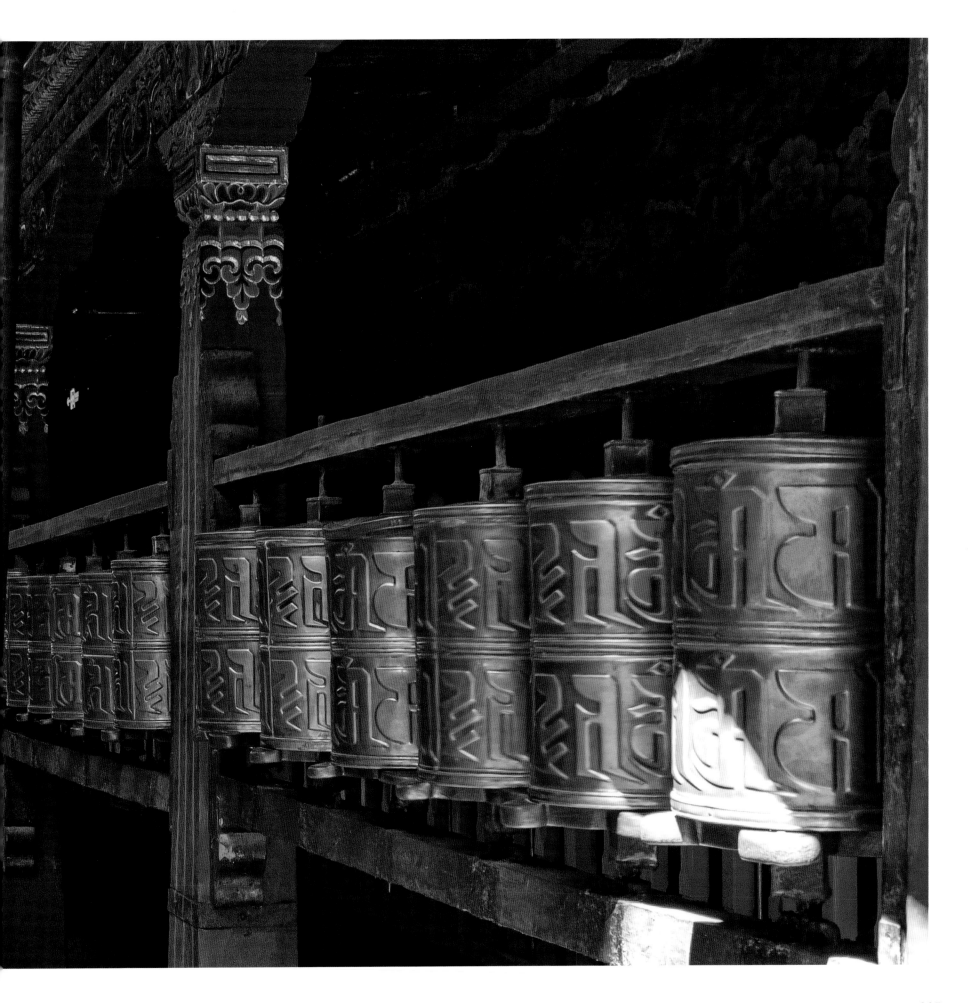

拉萨　Lhasa

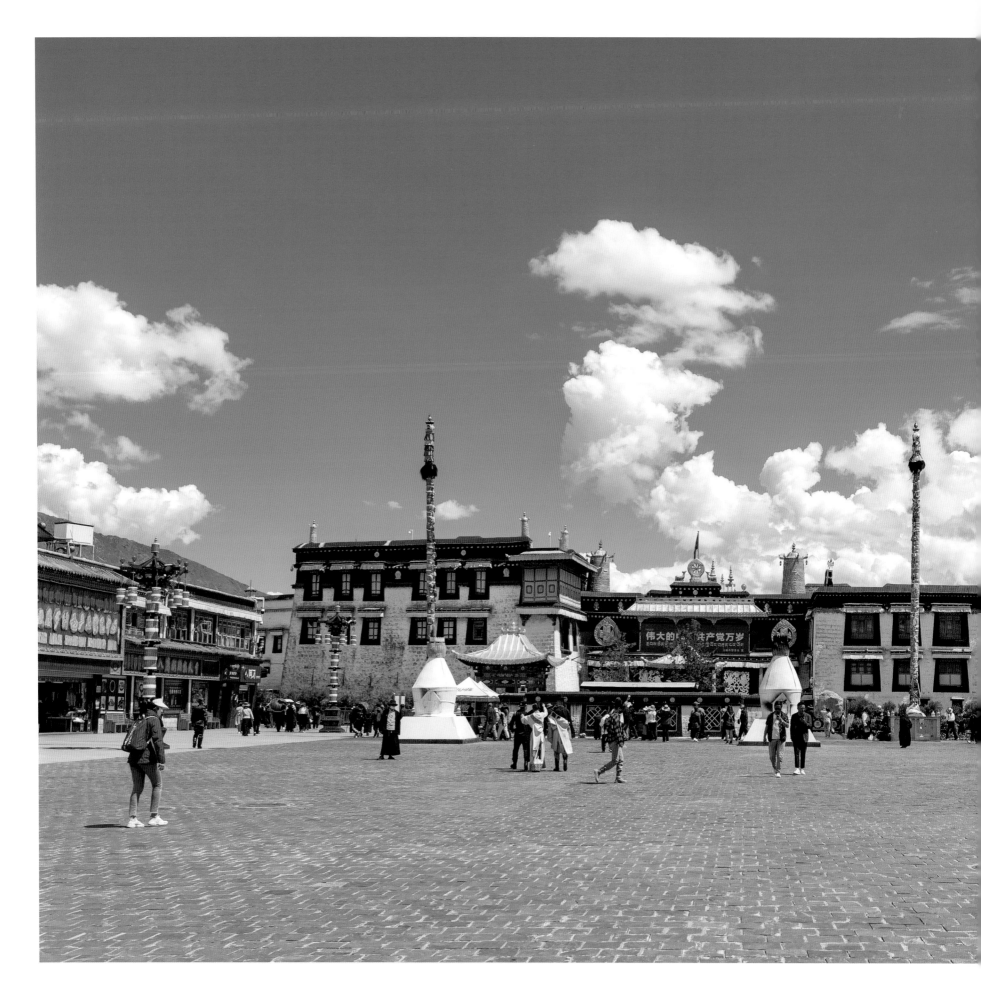

圣洁的西藏 TIBET : THE HOLY LAND 第六天 DAY 6

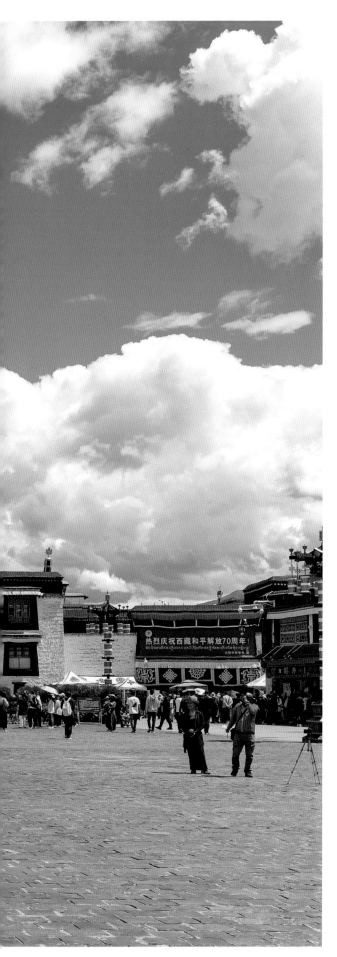

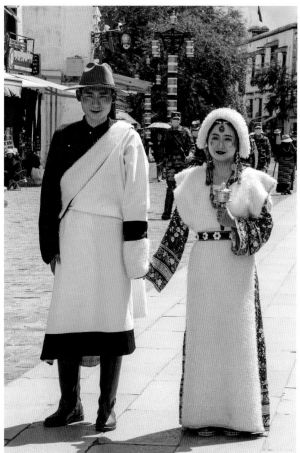

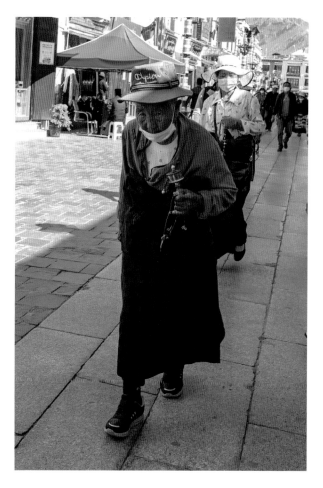

千年八廓街，藏族人称其为"圣路"，这是一条众多朝圣者用脚步和身体俯仰之间走成的千年转经路。
The Barkhor Street of great antiquity, the 'Holy Road' sacred to Tibetans,
is an aged circumambulation road paved by footsteps and prostrations of innumerable pilgrims.

小黄楼玛吉阿米，
相传曾是六世达赖仓央嘉措与情人幽会的场所。
In the southeast corner stands an eye-catching
small yellow building called Makye Ame,
which is said to have been the rendezvous
for the 6th Dalai Lama Tsngyang Gyatso and his lover.

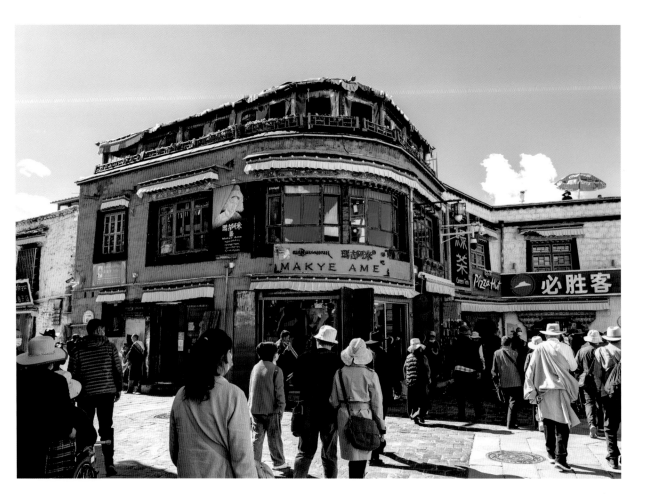

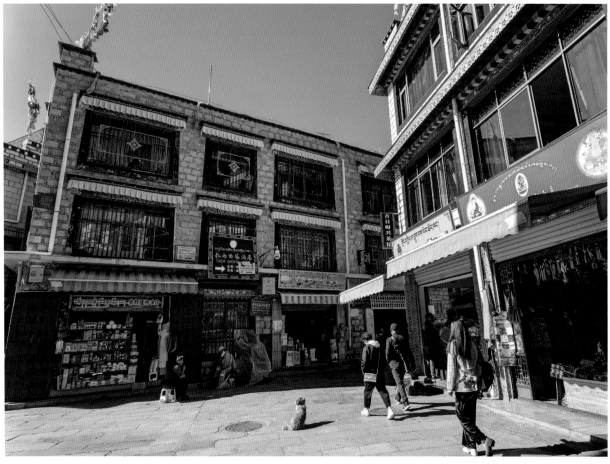

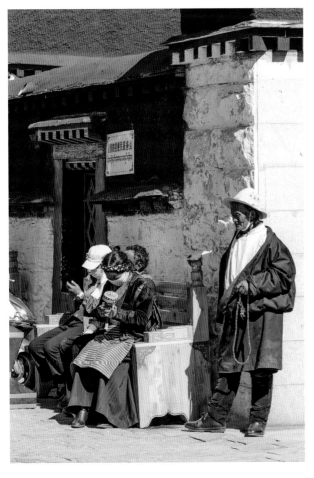
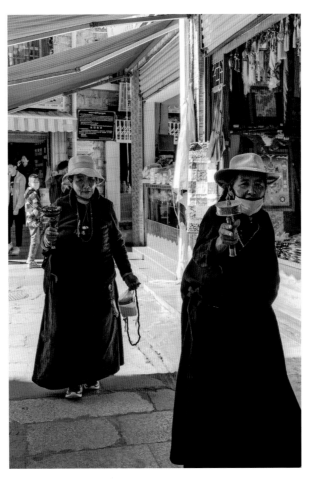
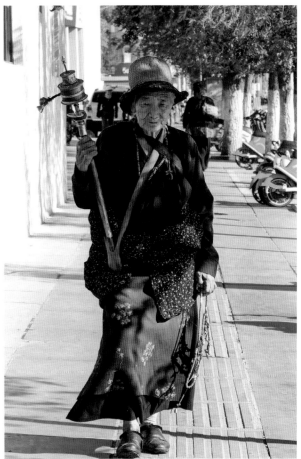
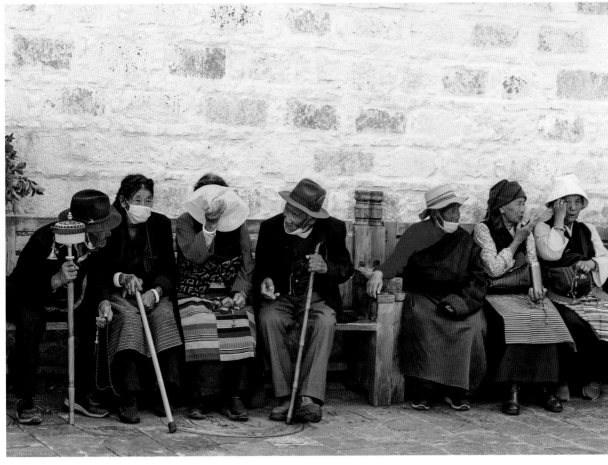

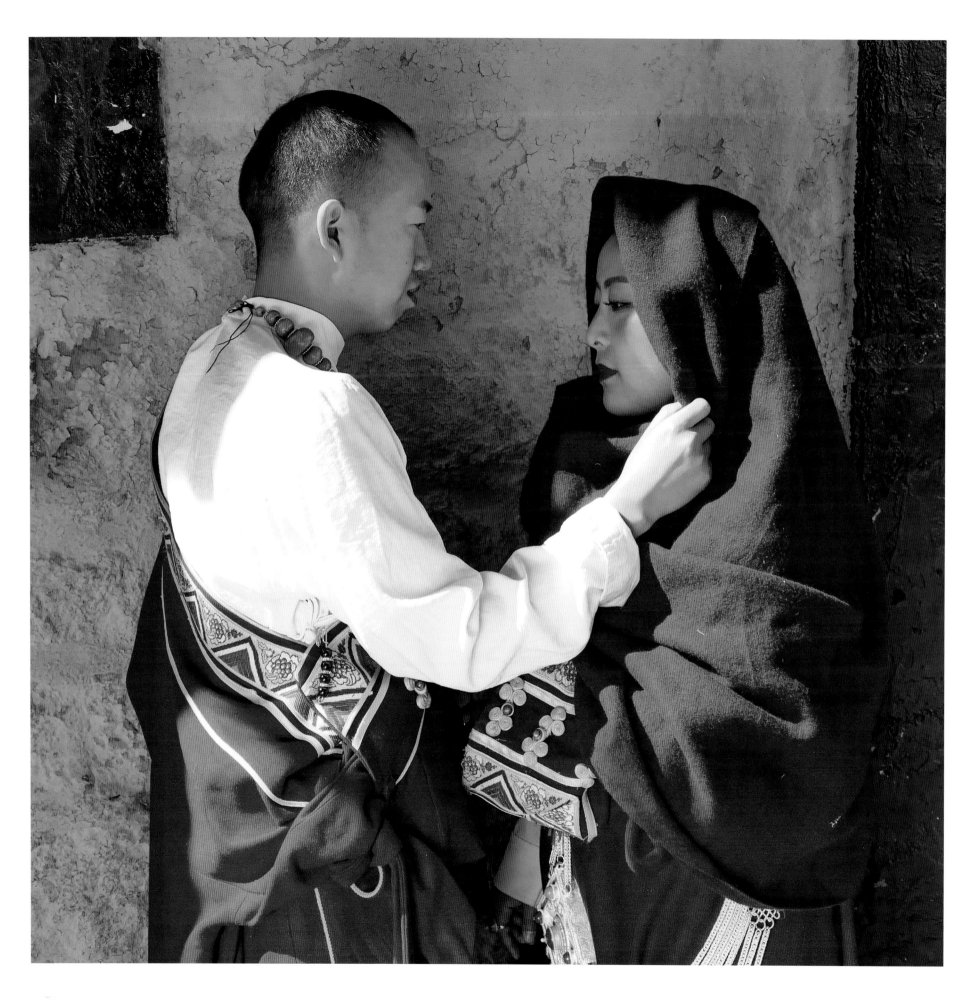

圣洁的西藏　TIBET : THE HOLY LAND　　第六天　DAY 6

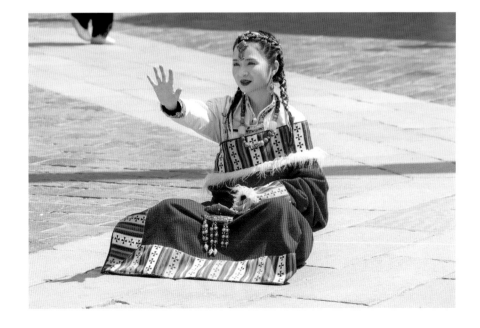

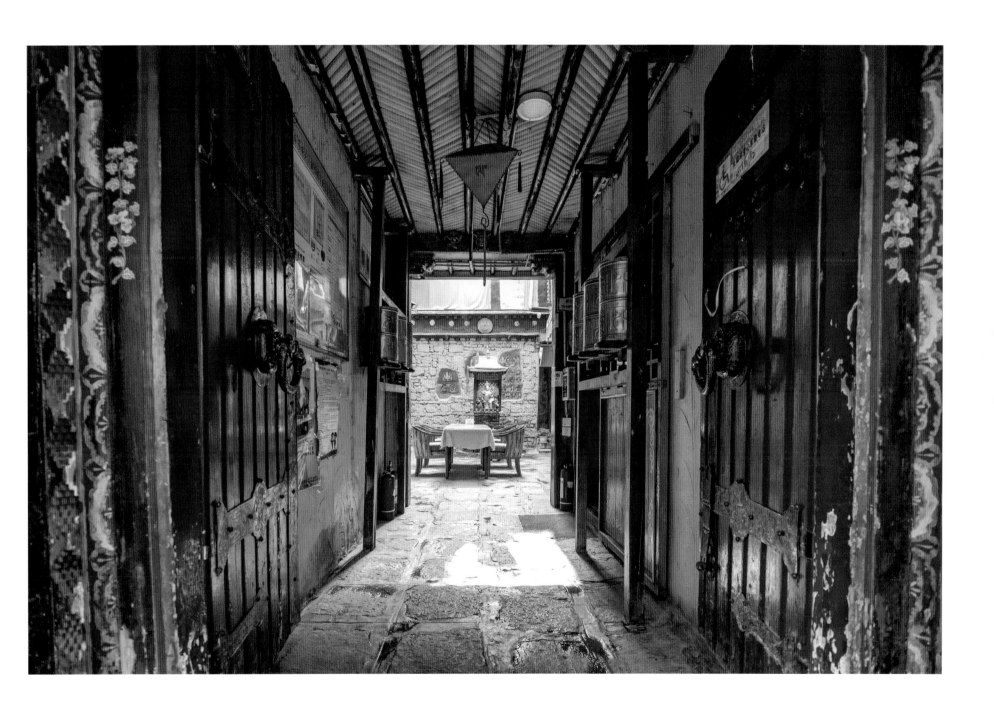

在巷弄街角看见藏族百姓日复一日、年复一年的生活方式，凝结了时光。
The ordinary lifestyle of Tibetans is a common sight everywhere.
Day after day, year after year, the ticking time is paused at that.

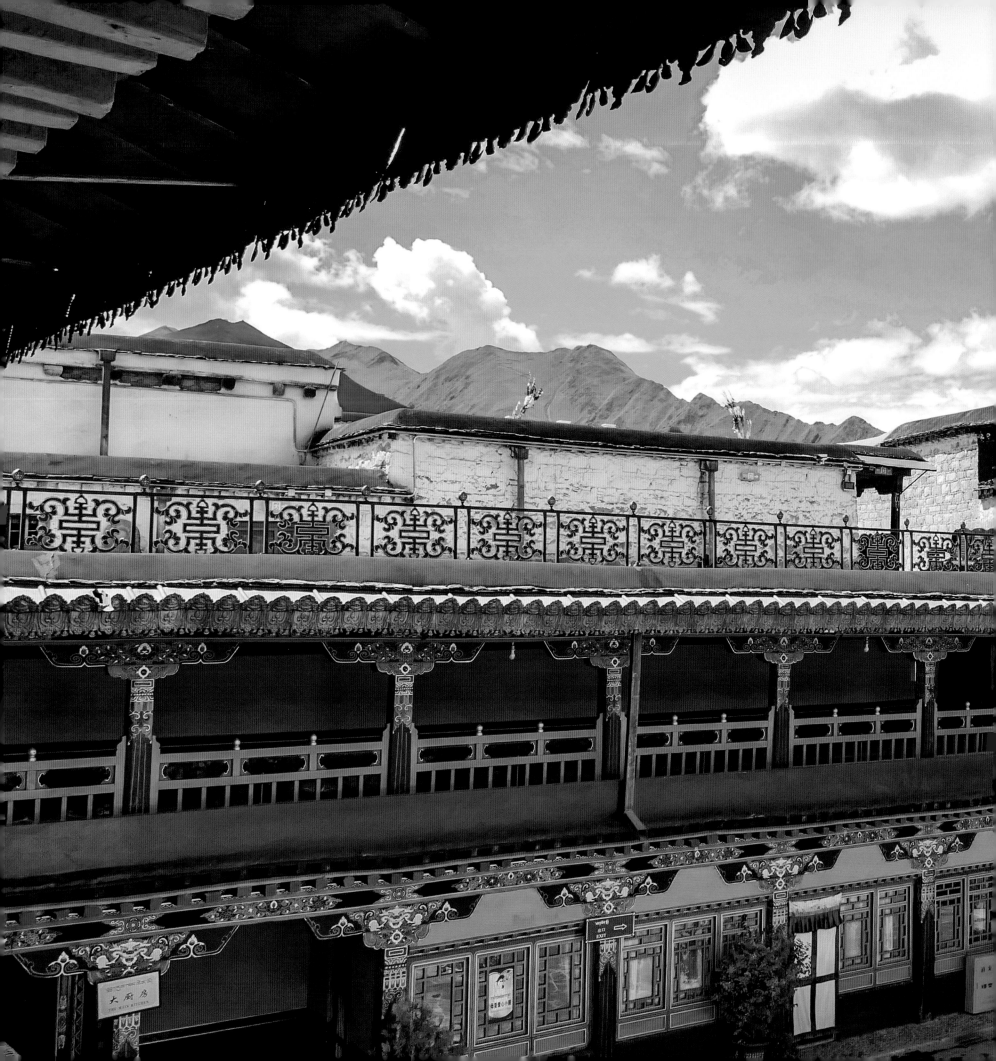

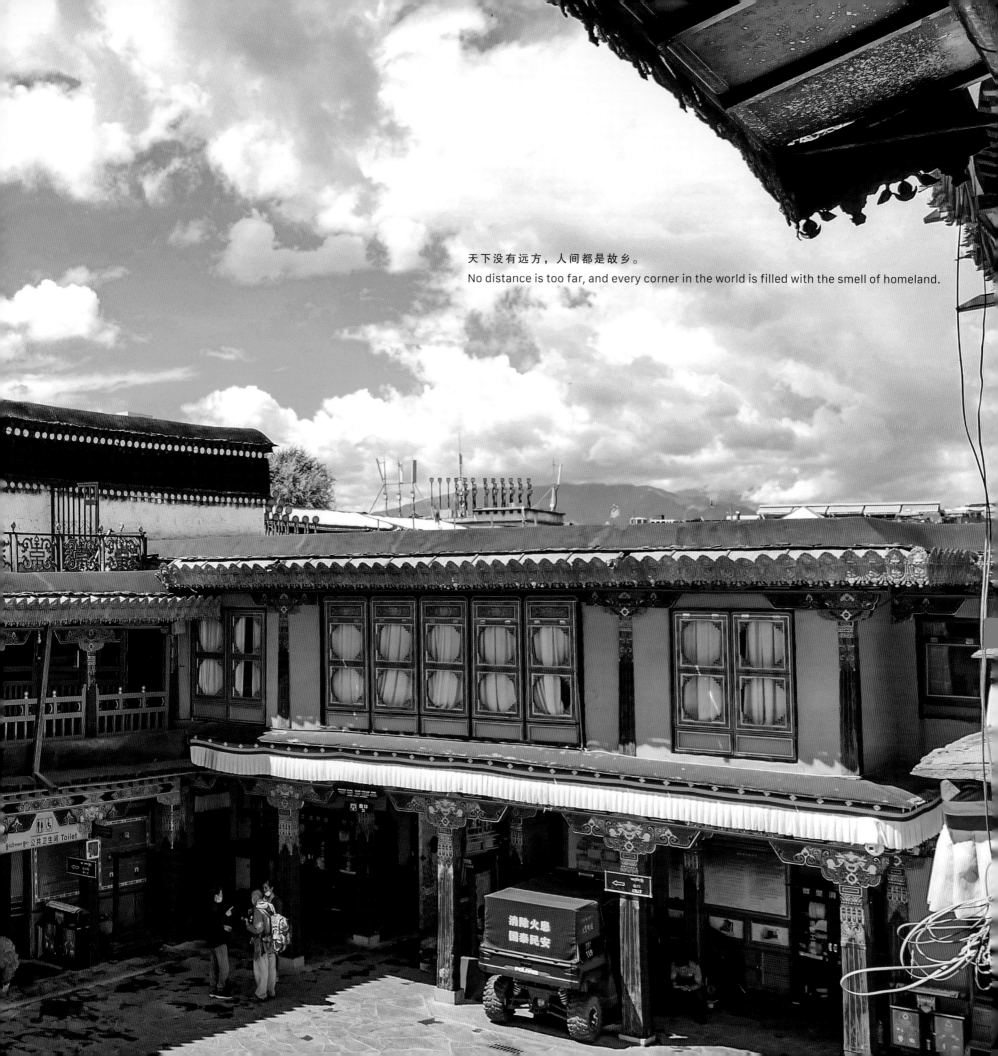

天下没有远方，人间都是故乡。
No distance is too far, and every corner in the world is filled with the smell of homeland.

第七天

拉萨～江孜

今日告别拉萨，前往拉孜县，一路上有无数风景等待我们去欣赏，而心之所向就是最好的旅行。

海拔 4,280 米的雅江河谷观景台相当开阔，即便两旁满是摊贩，以及排队等着拍照的游客，站在此处依然有豁然开朗的感觉。身穿彩衣的小羊羔还有藏獒吸引了我的注意力，但我心里明白，牠们出现在这里也仅仅是为了供游人拍照而已。

有种颜色叫做"湖蓝"，如湖水一般、溶入了绿色的蓝。直至到了圣湖羊卓雍措，这个颜色才有了具象。羊湖之美，美在水色，不同时间呈现出不同层次的蓝，绝非写下几句文辞、拍摄几张图片就能够加以诠释的。

过了浪卡子县，卡若拉冰川就在眼前，它位于公路旁，是宁金抗沙峰冰川向南漂移后形成的悬冰川，好像大量的水横空倾泻下来，却在刹那间被冰冻住，又有如一幅巨型唐卡悬挂于山壁上，大自然如此鬼斧神工，给人巨大的视觉冲击。惜因气候变暖，卡若拉冰川正在慢慢后退，教人不禁暗叹，多年以后还能否见到这美丽的冰川？

满拉水库给了我们当天最大的惊喜。为了一睹全貌，我登上海拔 4,300 多米的斯米拉山观景台，高山氧气稀薄，让人呼吸沉重、举步维艰，更别说走上一段长长的楼梯，幸而努力之后的果实是甘美的，满拉水库号称"西藏第一坝"，尽管是人为景观，却依旧让人惊艳，翡翠绿的水面与羊卓雍措相比，有过之而无不及。

Day 7
Lhasa ~ Gyantse County

We took leave of Lhasa today for Lhatse County. If there are numerous breathtaking views dazzling your eyes on the way, follow your heart and you will be amply rewarded with the best journey.

The Yajiang River Valley provides a sizeable viewpoint at an altitude of 4,280 meters, and neither the crowds of vendors at both sides nor visitors waiting to take pictures could narrow the feeling of spaciousness. Little lambs in colorful clothes and Tibetan mastiffs attracted my attention, but I knew that they were just photography props for visitors.

There is a color called lake blue, a greenish blue like lake waters. It didn't make sense to me until I met the sacred Lake Yamdrok. Her beauty lies in the color of water, gradations of the blue color varying at different times, beyond description with merely words or photos.

Kharola Glacier stands right behind Nagarze County by the road, a hanging glacier formed by a southward drift of the Noijin Kangsang Glacier, which looks like a huge amount of pouring water being frozen in a split second or a giant Thangka hanging on the mountain. The visual impact created by the uncanny workmanship of nature is undoubtedly massive. As the glacier is gradually melting with the climate warming, I couldn't help wondering whether this beautiful glacier would still be able to stand there in years.

Manla Reservoir was the best surprise of the day. I mounted the viewing platform of Mount Simila to savor the superb view, but before that, conquering an oxygen-deprived height of over 4,300 meters was an arduous task, not to mention climbing up a long stairway. Happily, the gain was very generous after the pain. Manla Reservoir, known as the First Dam of Tibet, is an artificial lake with a stunning view, its translucent green water even superior to that of Lake Yamdrok.

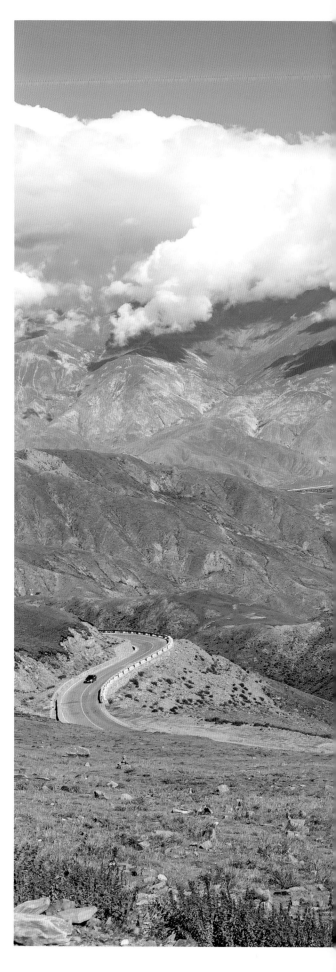

心之所向，就是最好的旅行。
Follow your heart and you will be amply rewarded with the best journey.

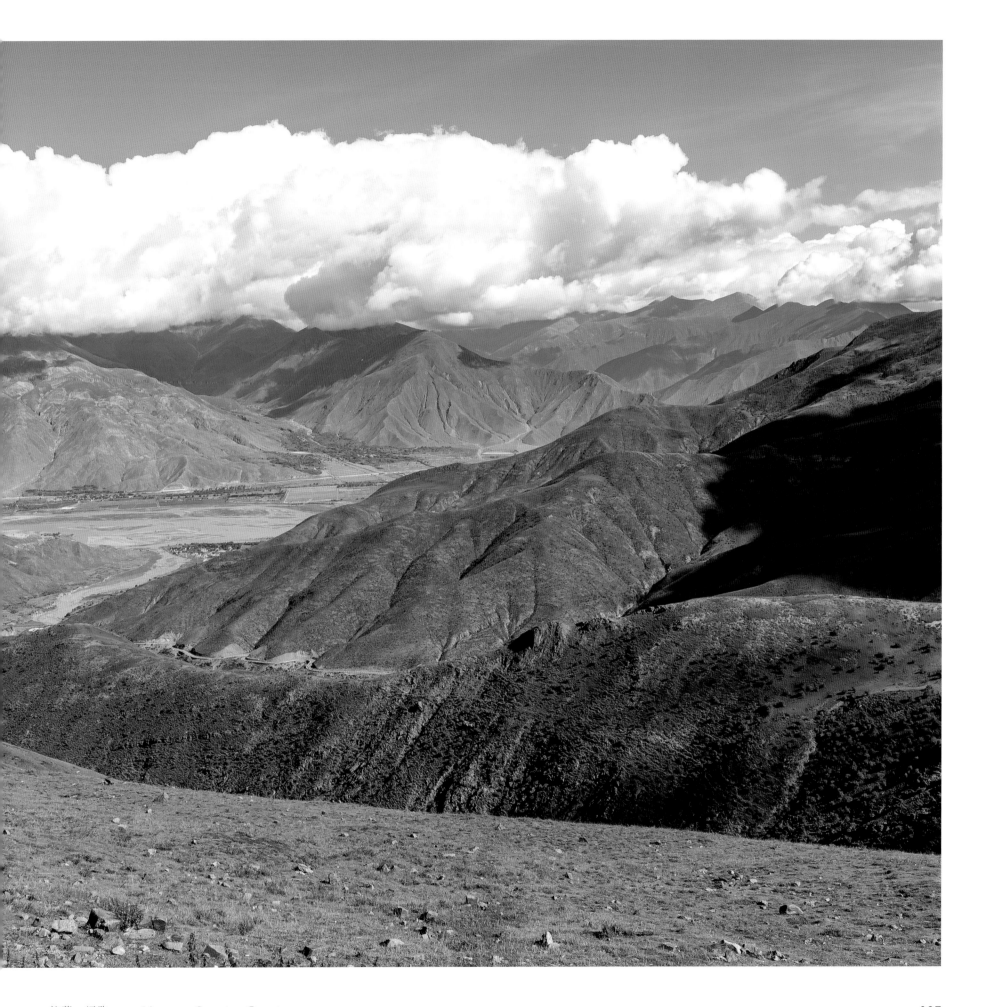

拉萨～江孜　　Lhasa ~ Gyantse County

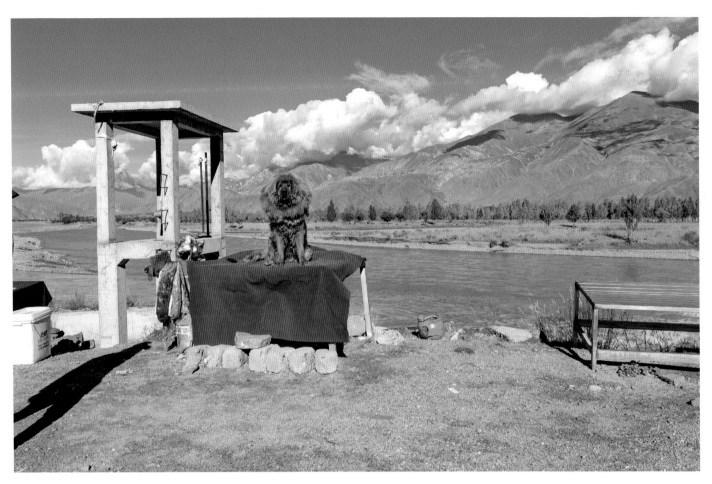

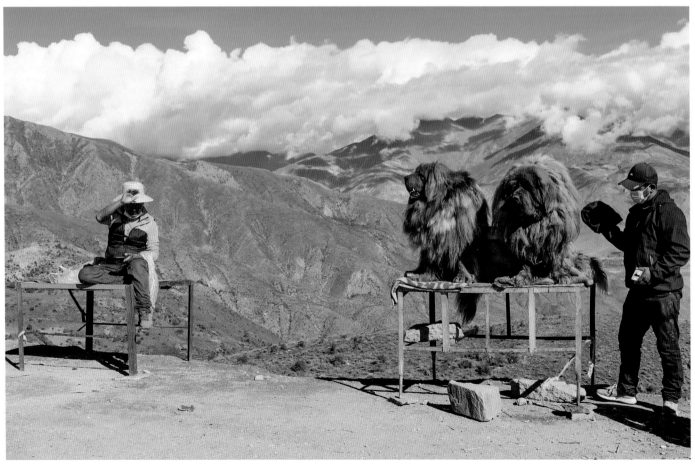

　　　　　　　　　　　圣洁的西藏　TIBET：THE HOLY LAND　　　第七天　DAY 7

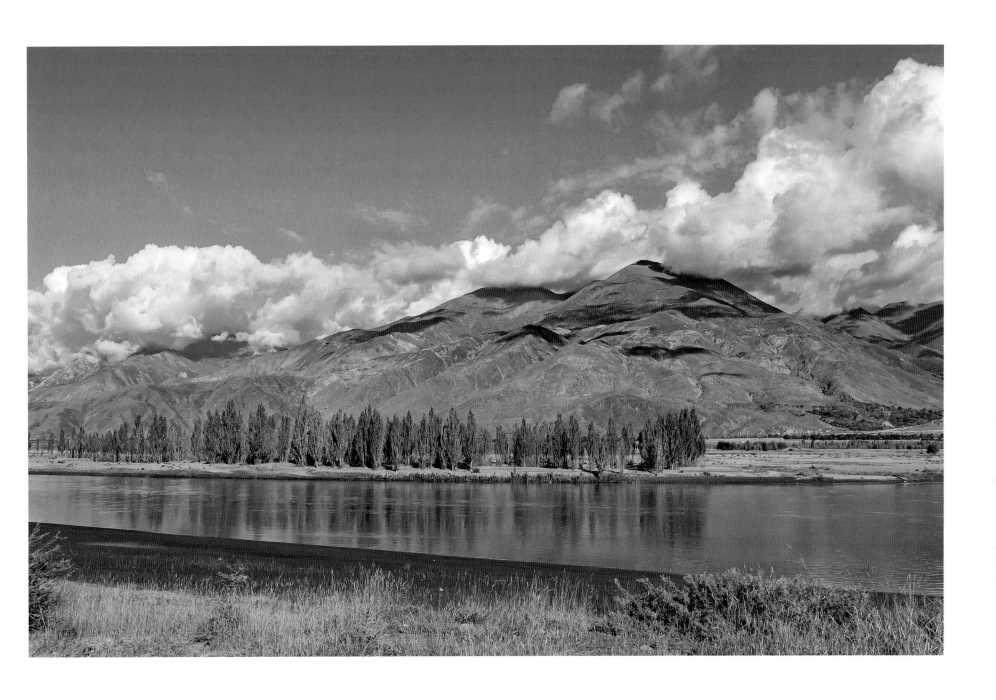

拉萨～江孜　　Lhasa ~ Gyantse County

天上的仙景，人间的羊湖。一般人形容湖水最美就是"湖蓝"，
到了羊湖（羊卓雍措），这个"湖蓝"之词真让文人作家词拙了。
Lake Yamdrok rivals paradise in beauty. Generally, the 'lake blue' is the most elegant expression for lake waters,
but when it comes to Lake Yamdrok, its view is stunning beyond any literary words.

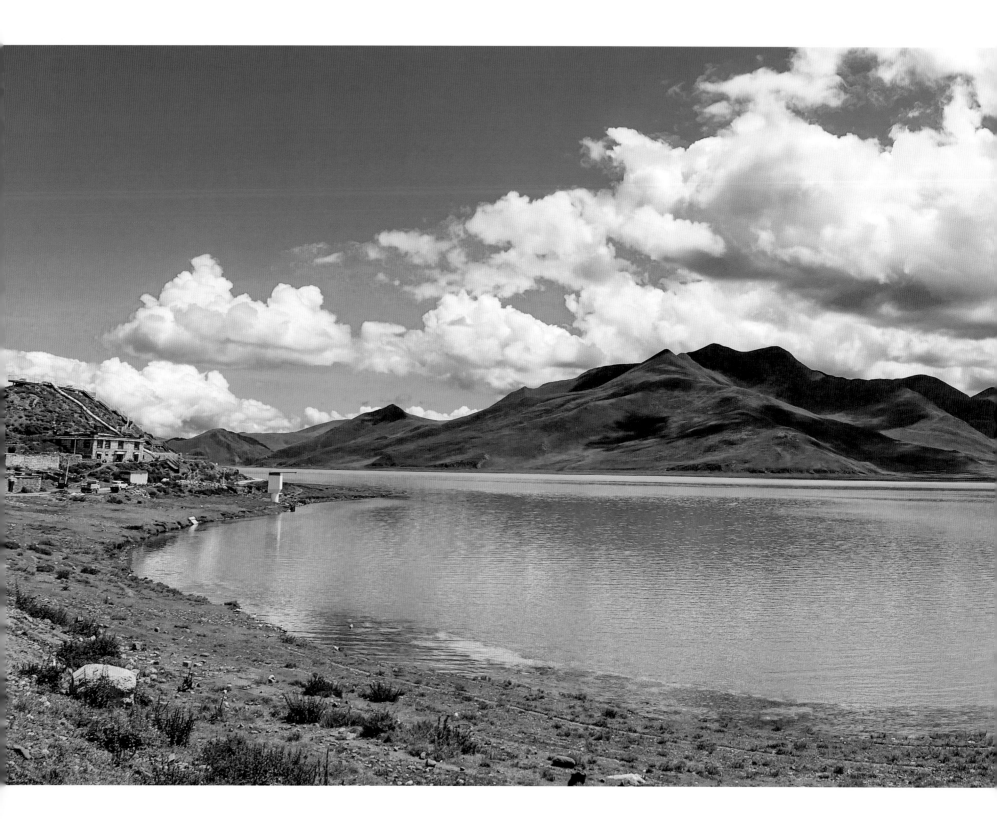

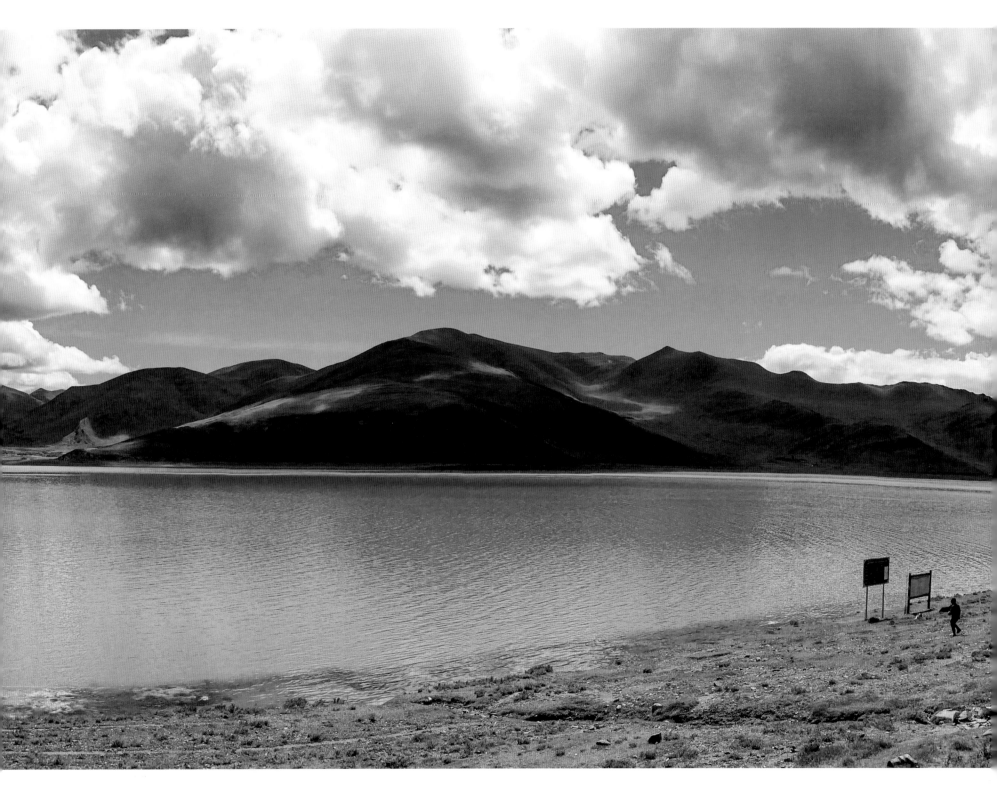

拉萨～江孜　Lhasa ~ Gyantse County

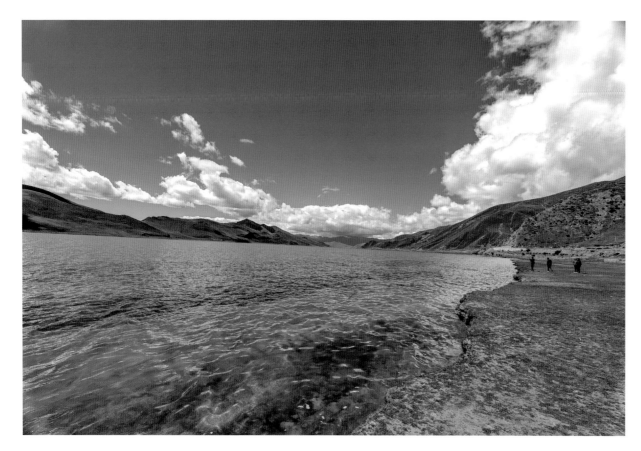

羊湖又叫羊卓雍措，
即藏语的"碧玉湖"、"天鹅湖"。
Lake Yamdrok, also known as Yamdrok Yumtso,
means 'Jasper Lake' or 'Swan Lake' in Tibetan.

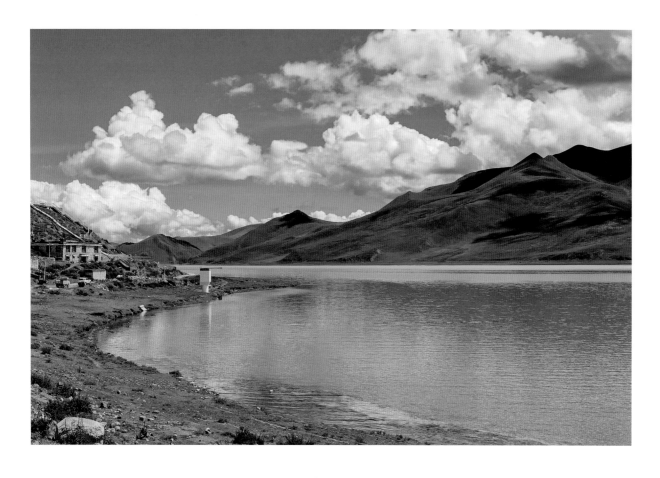

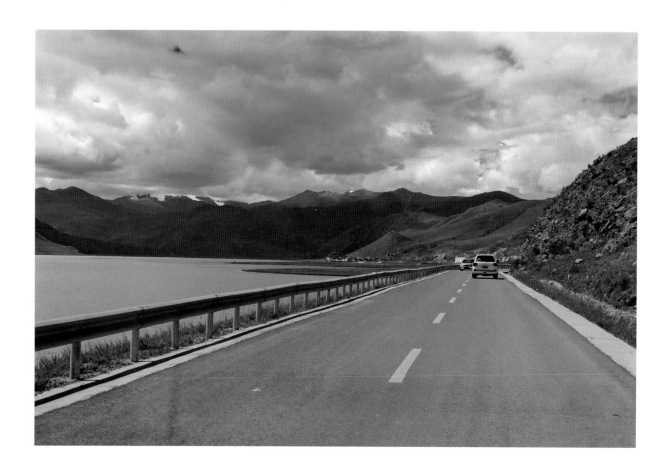

拉萨～江孜　Lhasa ~ Gyantse County

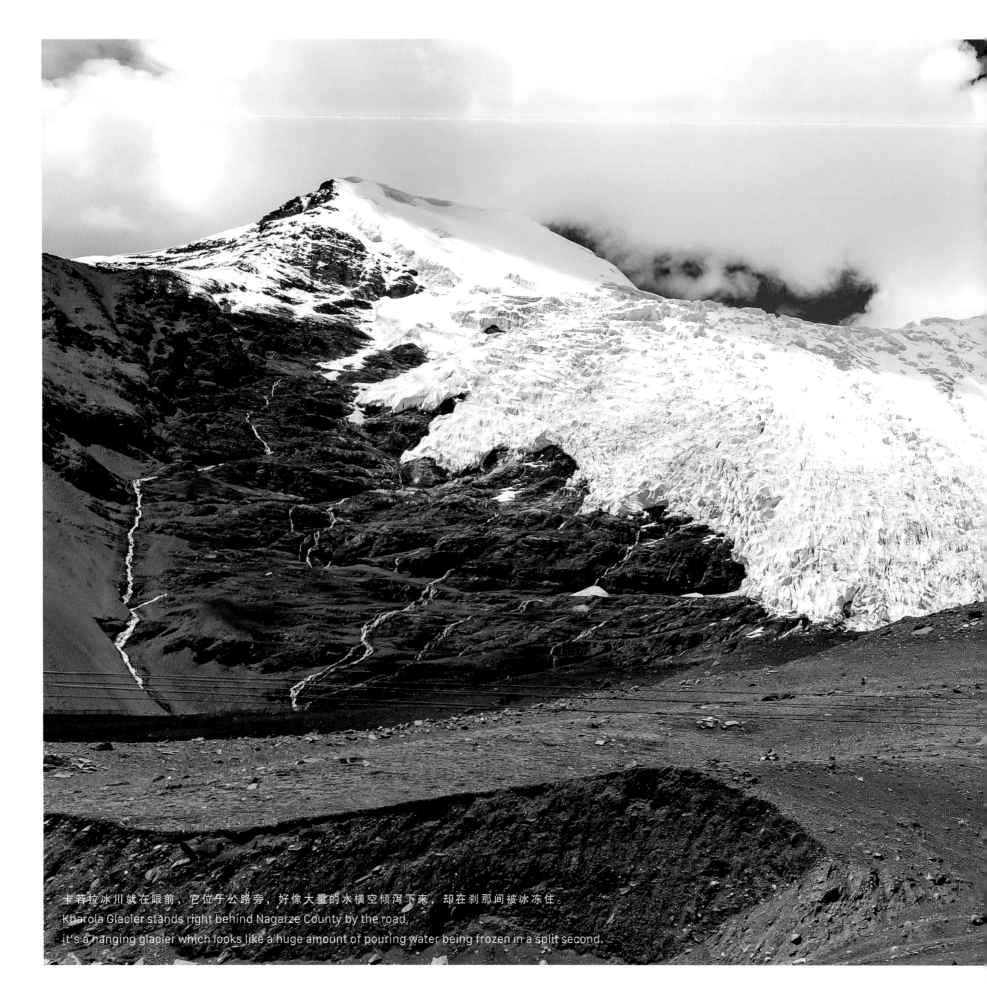

卡若拉冰川就在眼前，它位于公路旁，好像大量的水横空倾泻下来，却在刹那间被冰冻住。
Kharola Glacier stands right behind Nagarze County by the road,
it's a hanging glacier which looks like a huge amount of pouring water being frozen in a split second.

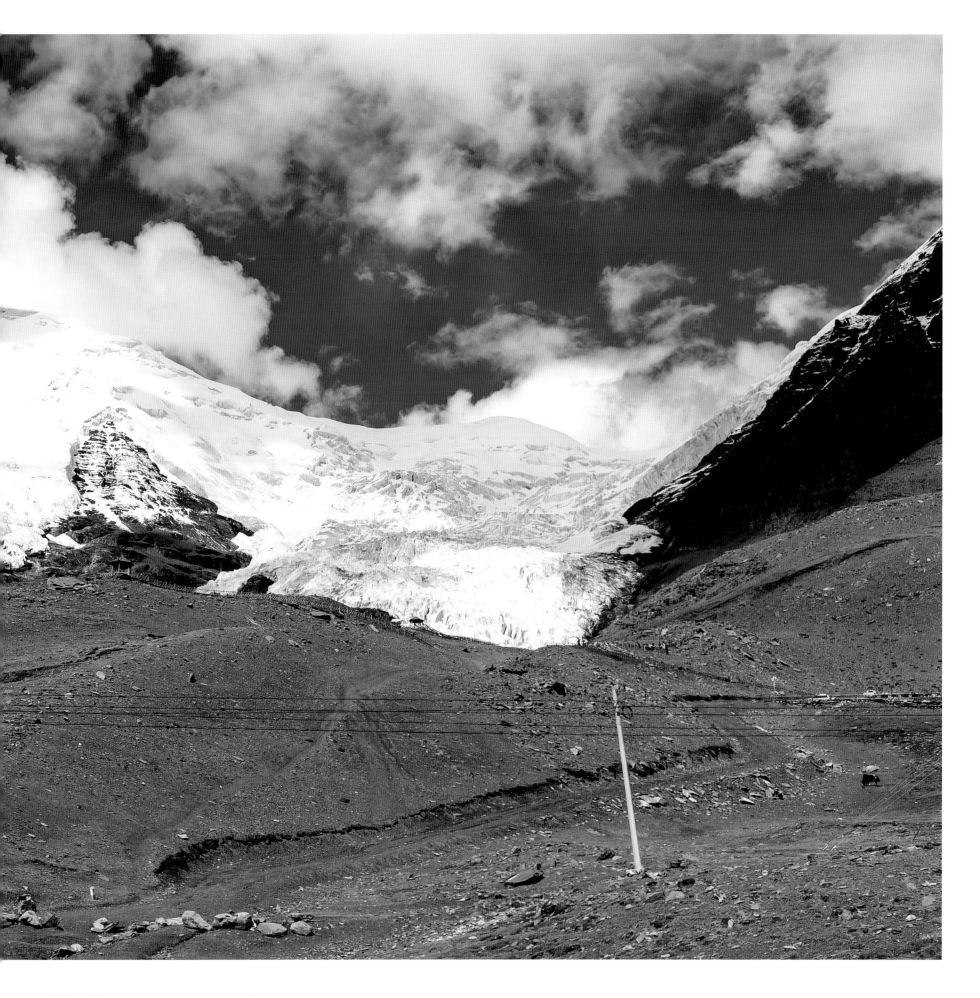

拉萨~江孜　　Lhasa ~ Gyantse County

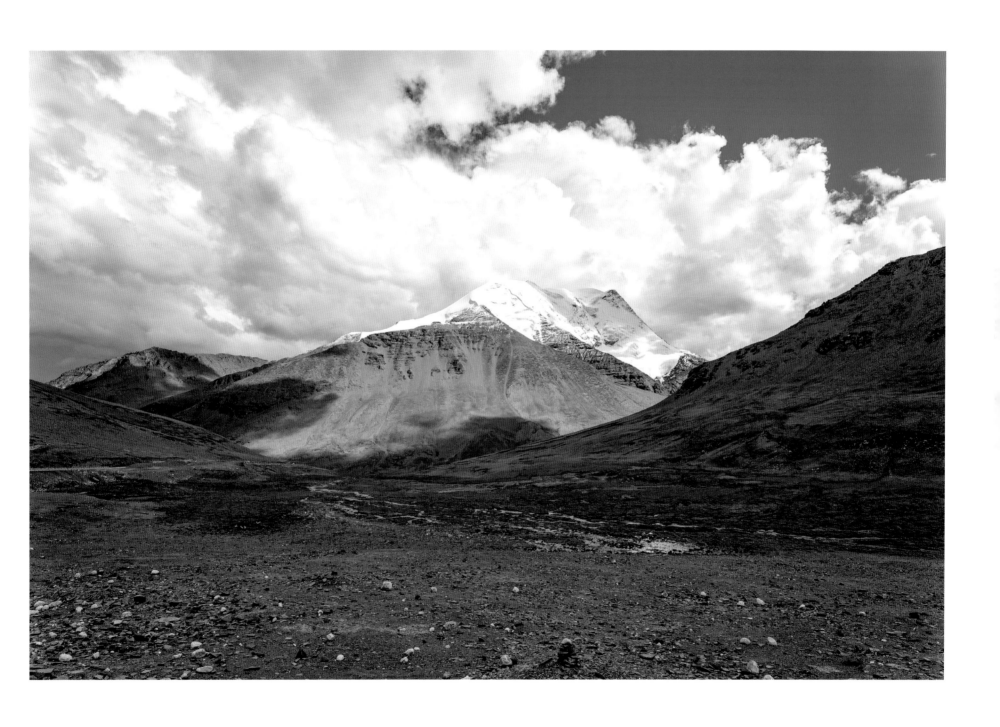

拉萨～江孜　　Lhasa ~ Gyantse County

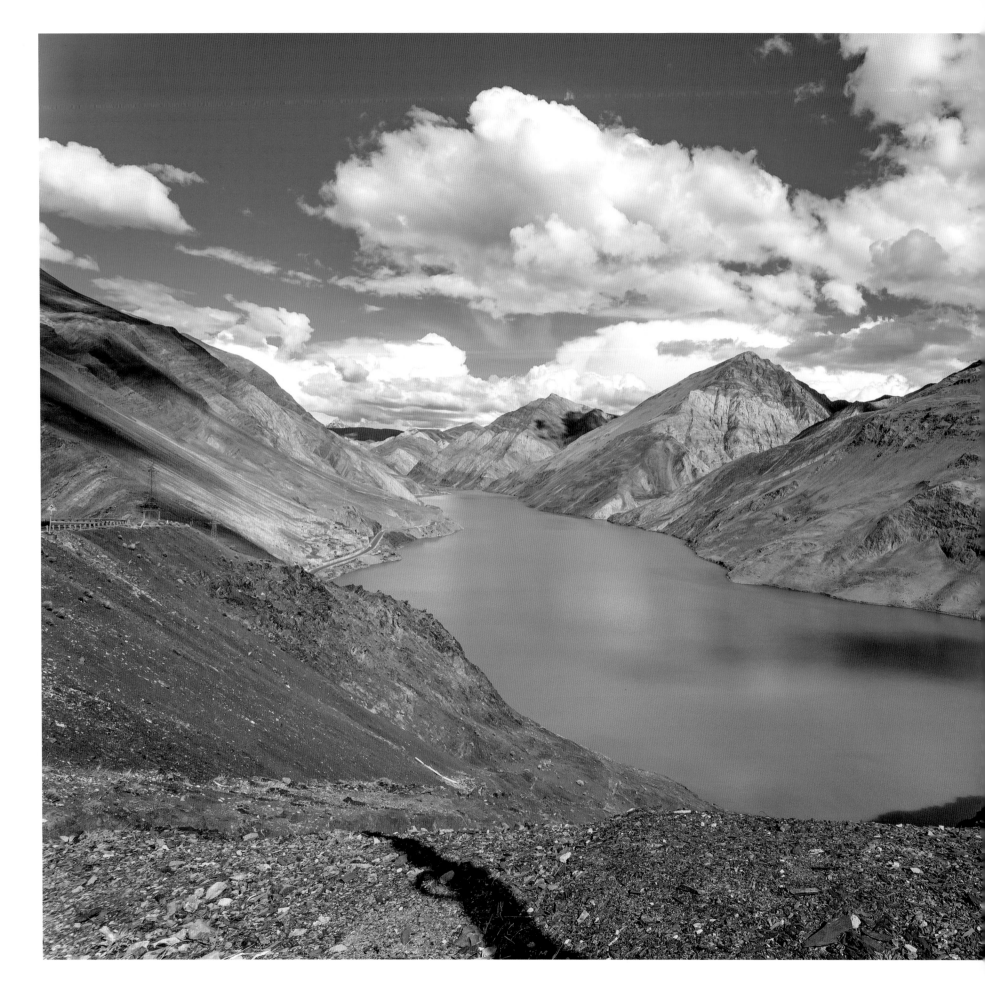

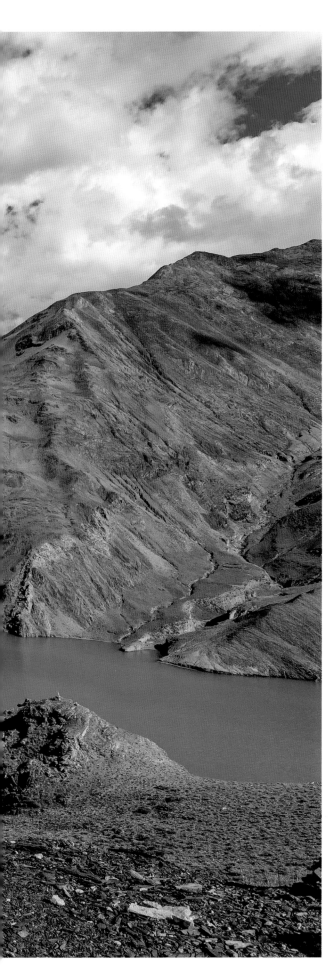

满拉水库号称"西藏第一坝",是自然风景结合人工建造形成的景观;
翡翠绿的水面平静如丝帛一般,让人惊艳。
Manla Reservoir, known as the First Dam of Tibet,
is an artificial lake blending into natural scenery;
its emerald-green water is as placid as silk, quite amazing.

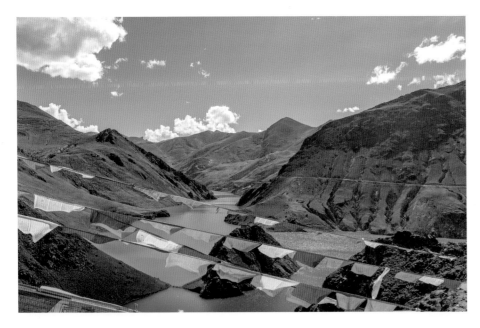

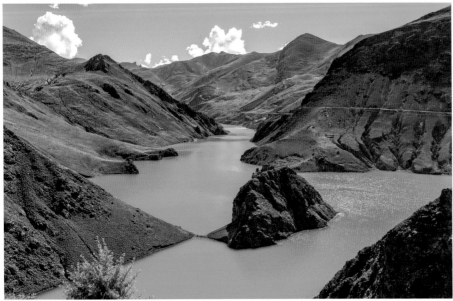

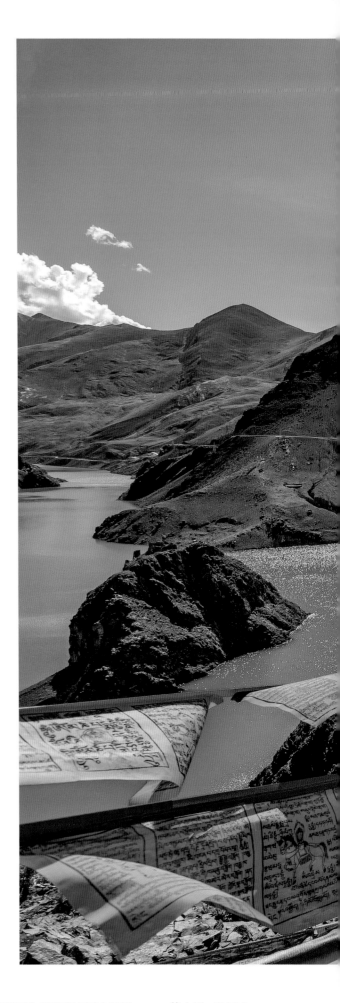

挂在山上的五彩经幡迎风在空中逍遥飘荡，目光所及皆是风景。
Colorful Tibetan prayer flags on the mountain fly back in the wind, numerous breathtaking views dazzling your eyes on the way.

拉萨～江孜　　Lhasa ~ Gyantse County

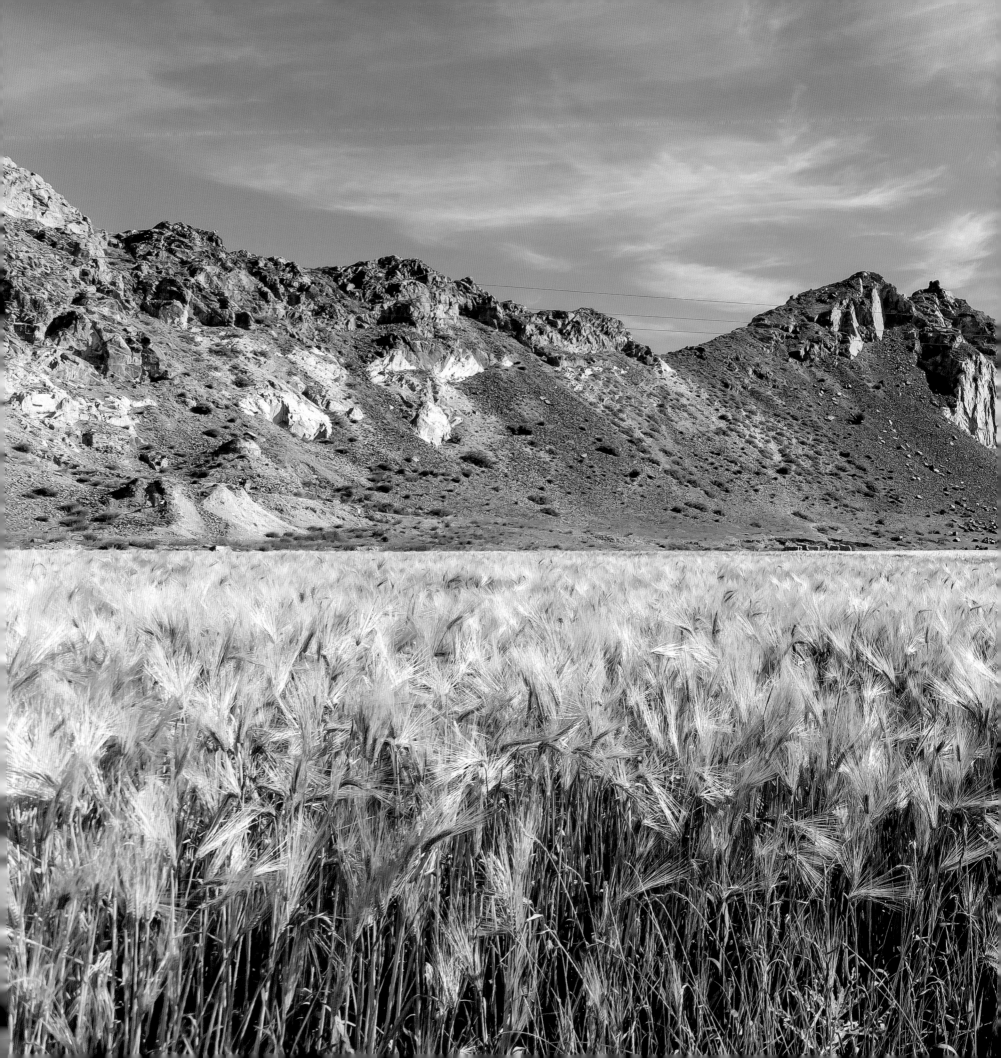

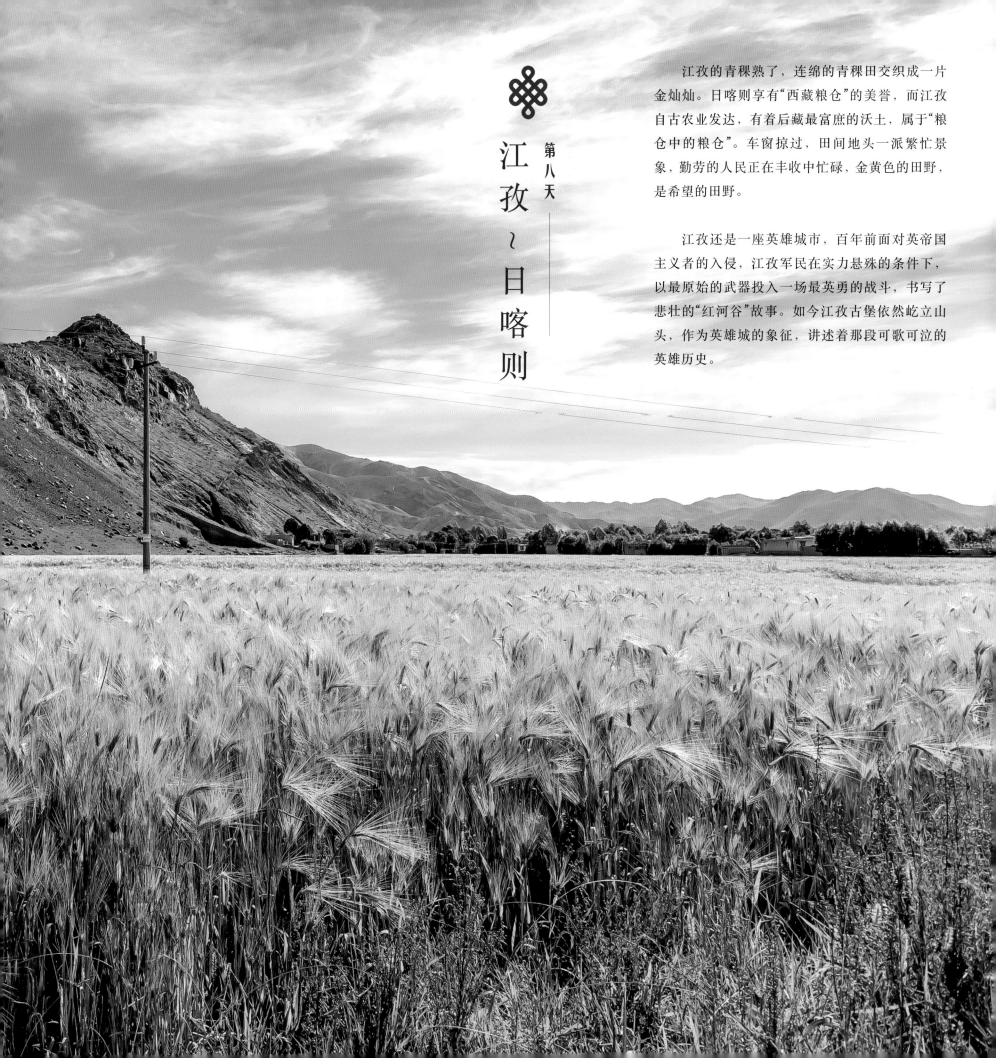

江孜～日喀则

第八天

江孜的青稞熟了，连绵的青稞田交织成一片金灿灿。日喀则享有"西藏粮仓"的美誉，而江孜自古农业发达，有着后藏最富庶的沃土，属于"粮仓中的粮仓"。车窗掠过，田间地头一派繁忙景象，勤劳的人民正在丰收中忙碌，金黄色的田野，是希望的田野。

江孜还是一座英雄城市，百年前面对英帝国主义者的入侵，江孜军民在实力悬殊的条件下，以最原始的武器投入一场最英勇的战斗，书写了悲壮的"红河谷"故事。如今江孜古堡依然屹立山头，作为英雄城的象征，讲述着那段可歌可泣的英雄历史。

江孜古堡脚下有一座白居寺，依山而建，最特别在于这是一座藏传佛教萨迦派、夏鲁派、格鲁派三教派共存的寺院，实属罕见。寺内的白居塔内藏有十万余尊佛像和近千幅精美壁画，被誉为"十万佛塔"。身处白居寺的氛围，是让我觉得最舒服的，正如它"一寺容三派"的开放格局，相容并包，不同教派的信徒以虔诚之心供奉各自的信仰。

扎什伦布寺位于日喀则尼色日山下，是很多人来到日喀则的理由。这里是四世班禅之后历代班禅驻锡之地，寺中的灵塔是历代班禅的舍利塔，它的宗教地位可与布达拉宫比肩，在藏区享有崇高地位。扎什伦布寺是后藏的心脏，这说法一点也不夸张。尽管朝拜者众多，扎什伦布寺却极为安静，且不时见到三两信徒倚着墙晒太阳，一派悠然自得。

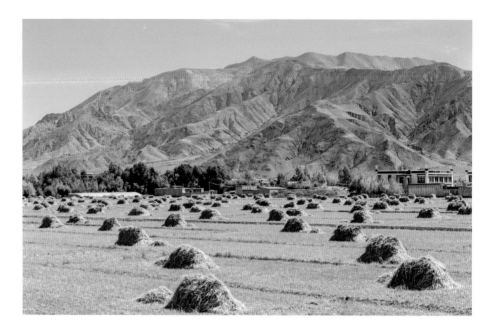

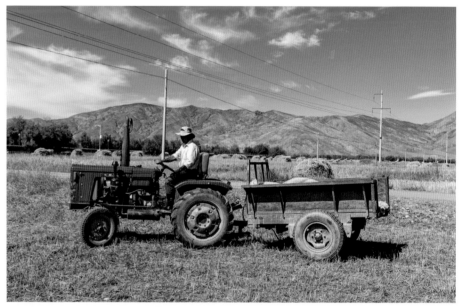

江孜的青稞熟了，连绵的青稞田交织成一片金灿灿。
Highland barley in Gyantse County was ripe,
a vast patchwork of barley fields glittering in the sun.

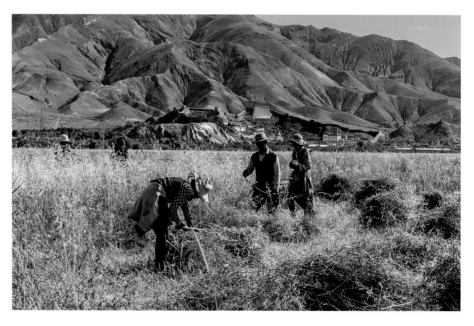

Day 8
Gyantse County ~ Shigatse

Highland barley in Gyantse County was ripe, a vast patchwork of barley fields glittering in the sun. Shigatse enjoys the reputation of 'the Granary of Tibet' and agriculture has been flourishing since ancient times in Gyantse, which owes a good deal to the most fertile land of the region, so named 'the granary of the best'. Our car passed by bustling scenes in the fields, where hardworking people were busy reaping their harvest. The golden field is the field of hope.

Gyantse is also a heroic place. Over a hundred years ago, the army and people of Gyantse fought the most heroic battle with the most primitive weapons under the condition of great disparity in strength against the British invaders, which is the origin of the solemn and stirring story, Red River Valley. Today, Gyantse Fortress still stands on the hill as a symbol of the heroic city, recounting the epic story of its history.

At the foot of Gyantse Fortress is the Palcho Monastery built against a mountain, the rarely-seen feature of which is its harmonious combination of Tibetan Buddhism Sakya school, Charu school and Gelug school. The pagoda inside treasures hundreds of thousands of Buddha statues and nearly 1,000 exquisite murals, praised as 'the pagoda with 100,000 statues'. The temple's atmosphere relaxed me the most, for its multi-denominational tolerance while reserving differences allows devout believers to practice their own religions respectively.

Tashilhunpo Monastery, sitting at the foot of Mount Nisse of Shigatse, is the intended destination for many people to come to Shigatse, inhabited by the following generations of Panchen Lama after the 4th. The holy pagoda inside is a Buddhist shrine dedicated to Panchen Lamas through the ages, the religious status of which is sublime in Tibet and comparable to that of the Potala Palace. It is no exaggeration to say that Tashilhunpo Monastery is the heart of Shigatse. Absolute silence reigned in the temple, despite crowded pilgrims around. People in twos and threes came into sight. They leaned against the wall basking in the sun, happy and content.

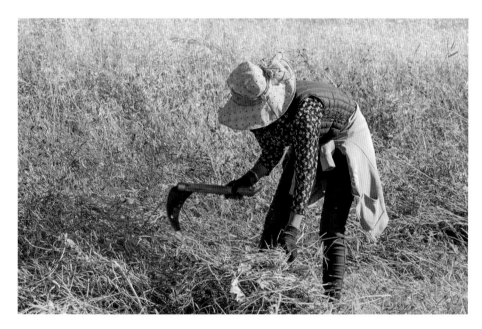

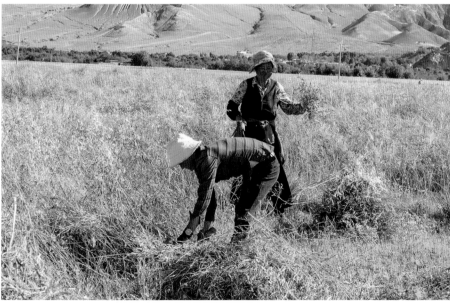

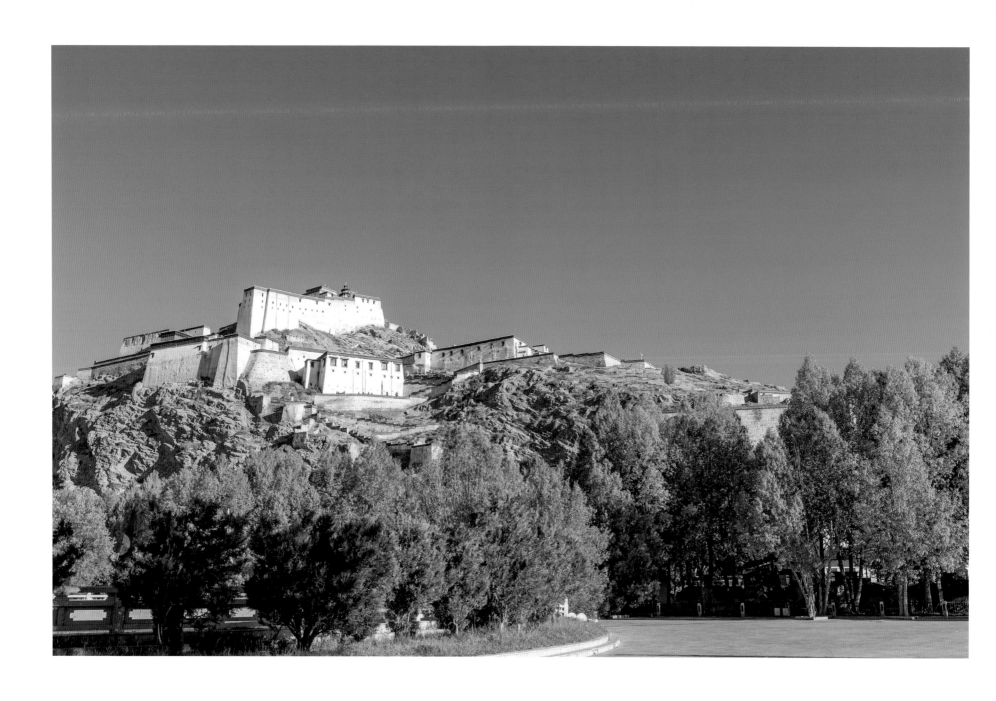

圣洁的西藏 TIBET : THE HOLY LAND 第八天 DAY 8

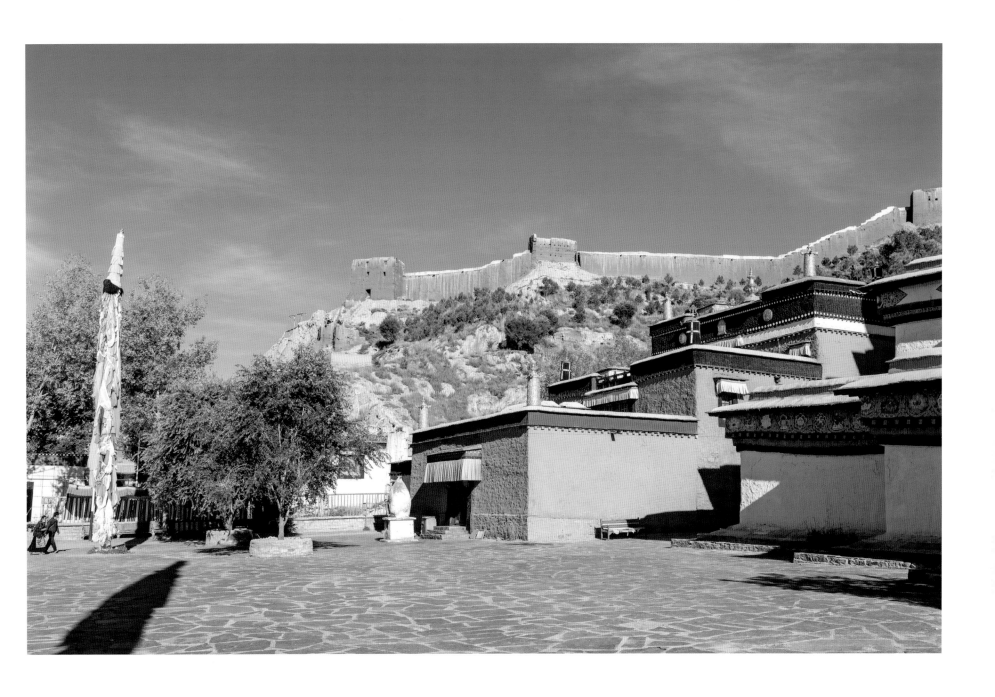

江孜古堡脚下有一座白居寺， 依山而建。白居寺最主要的是一座措钦大殿和白居塔。
白居塔的建筑风格在中国建筑史上极其罕有，
塔的上面四层采用尼泊尔风格，而下面五层则属于印度风格。
At the foot of Gyantse Fortress is the Palcho Monastery built against a mountain,
the major structures of which are the main assembly hall and the Palcho Pagoda.
The architectural style is extremely rare in the history of Chinese architecture,
with the upper four floors of the pagoda in the Nepalese style
and the lower five floors in the Indian style.

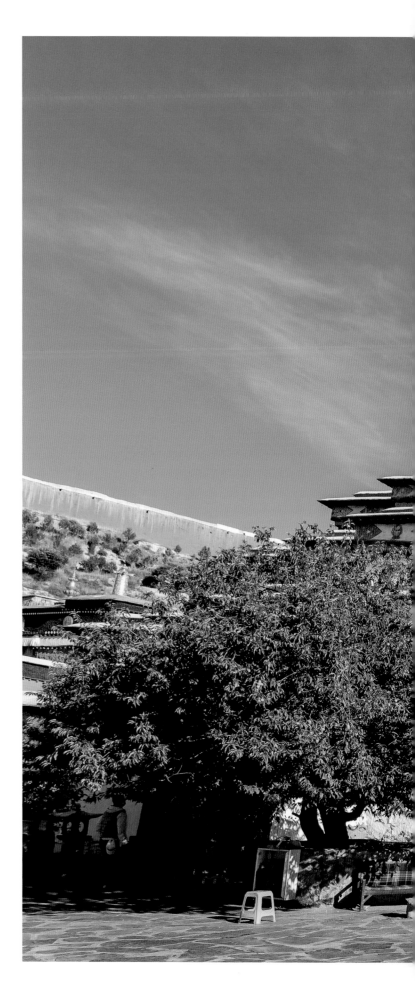

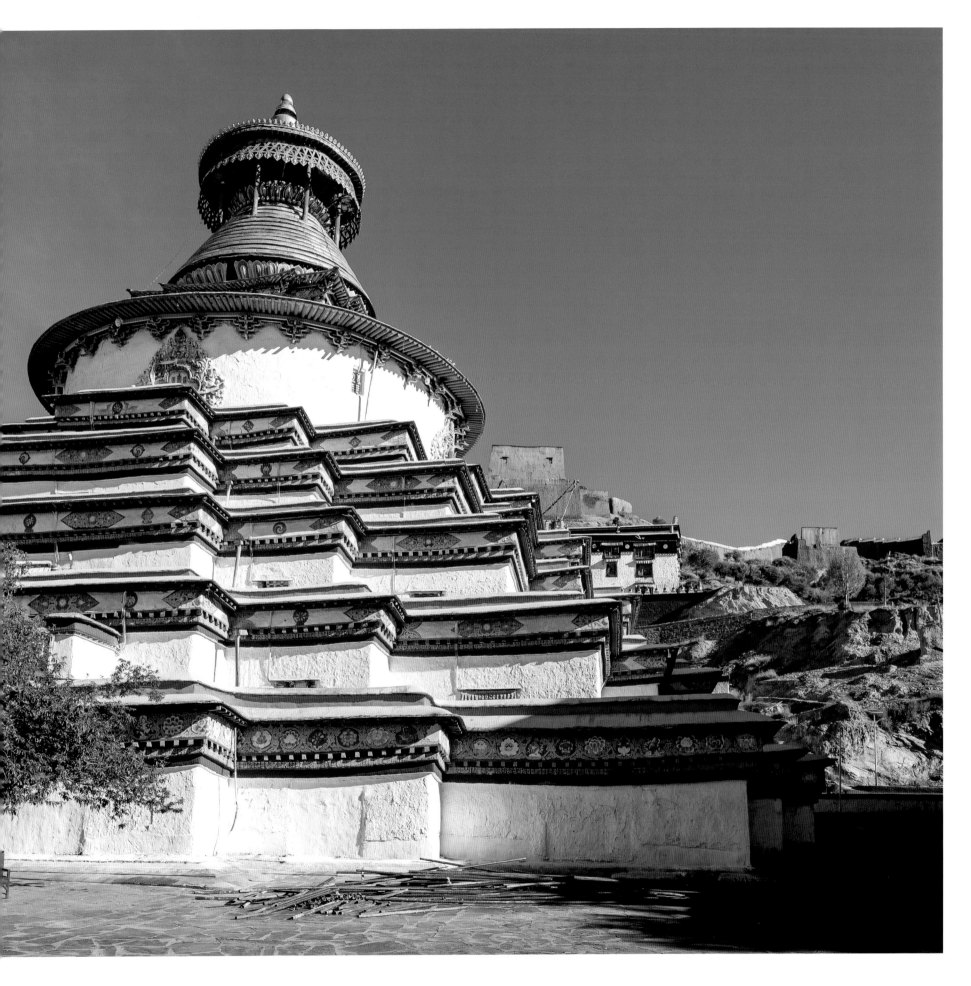

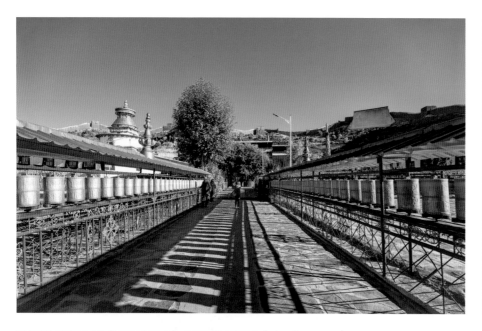

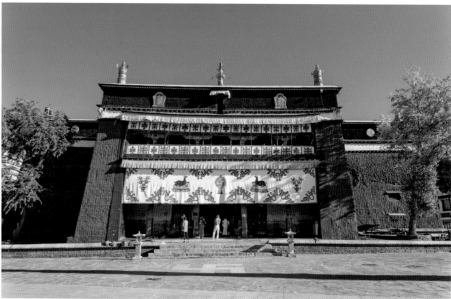

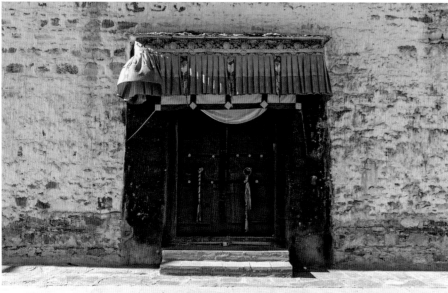

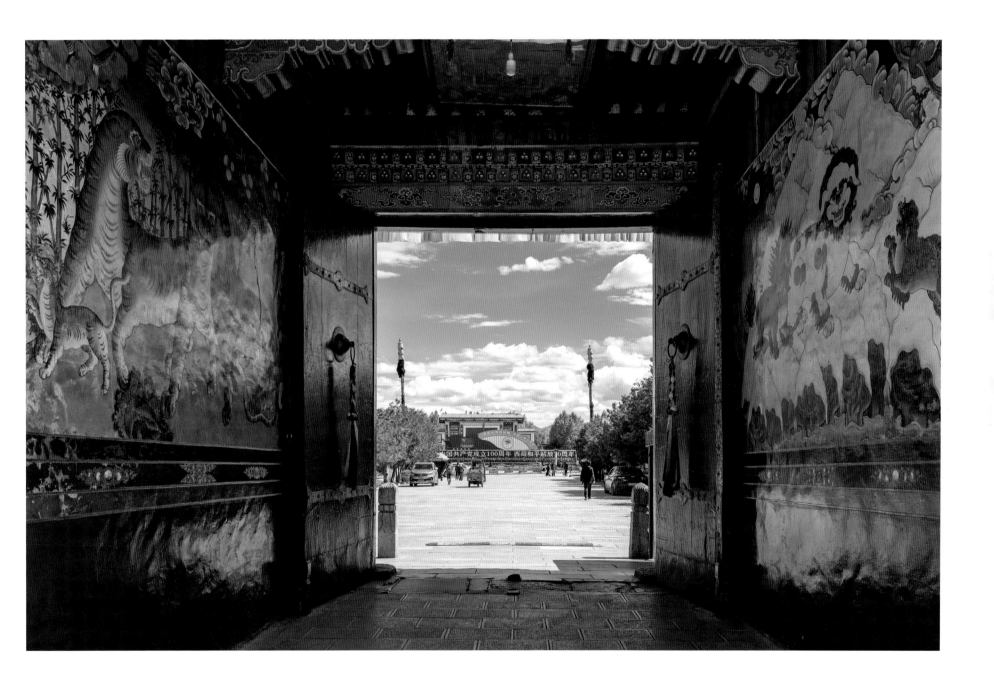

扎什布伦寺是四世班禅之后历代班禅驻锡之地，历代班禅在任期内都对寺院进行过修葺和扩建。
Tashilhunpo Monastery is inhabited by the following generations of Panchen Lama after the 4th.
Successive generations of Panchen have repaired and expanded the monastery during their tenure.

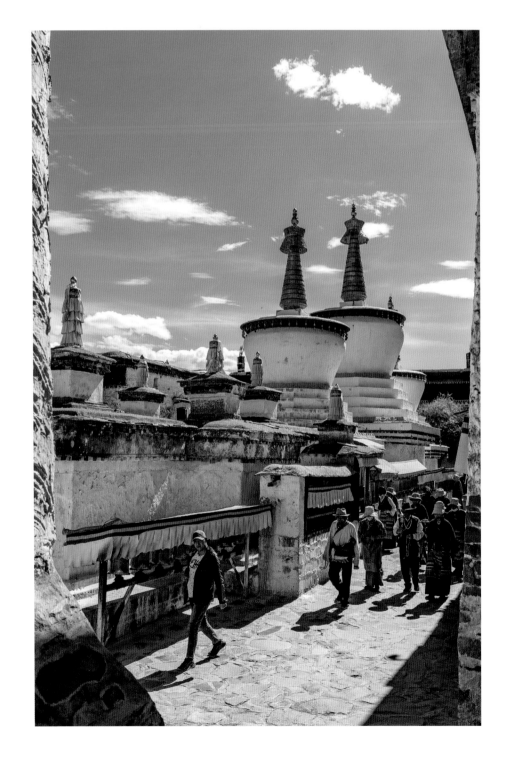

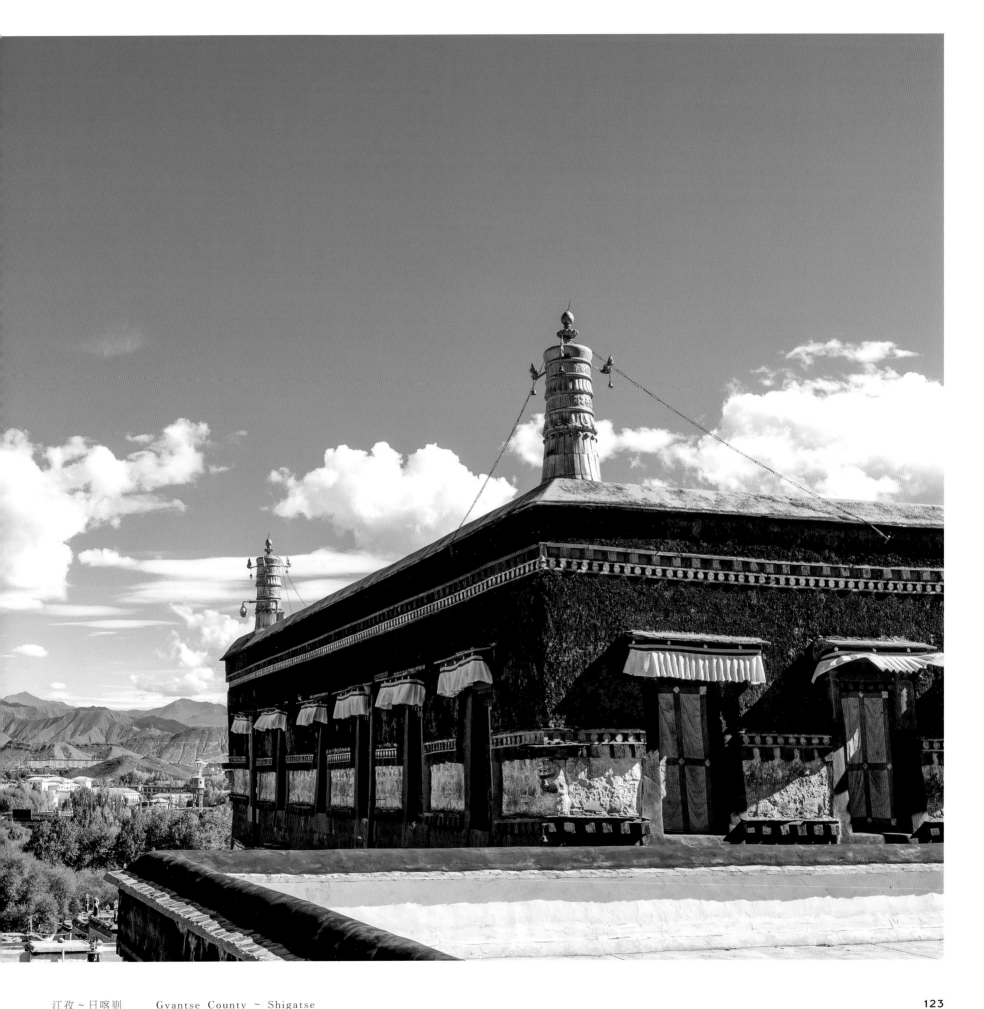

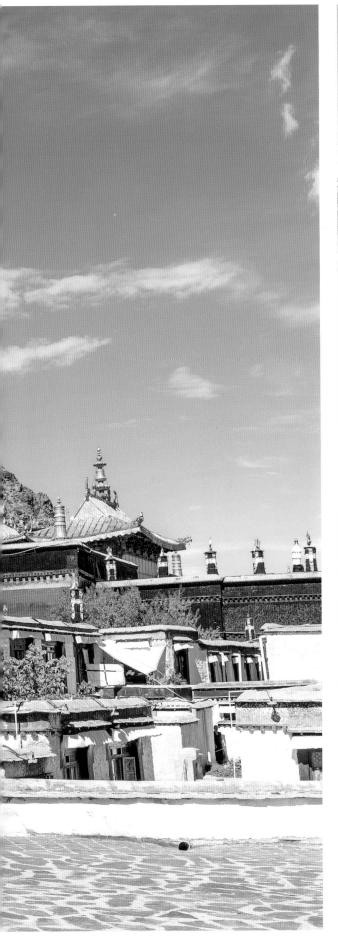

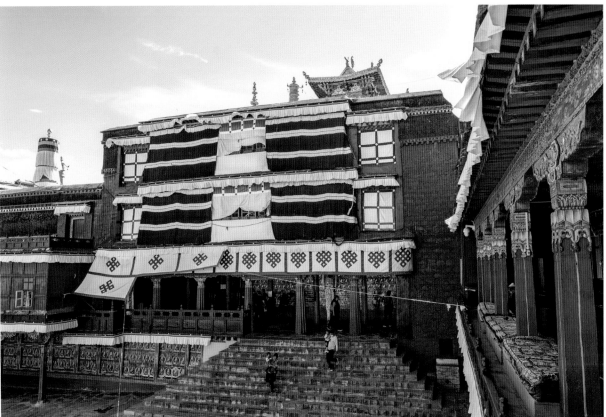

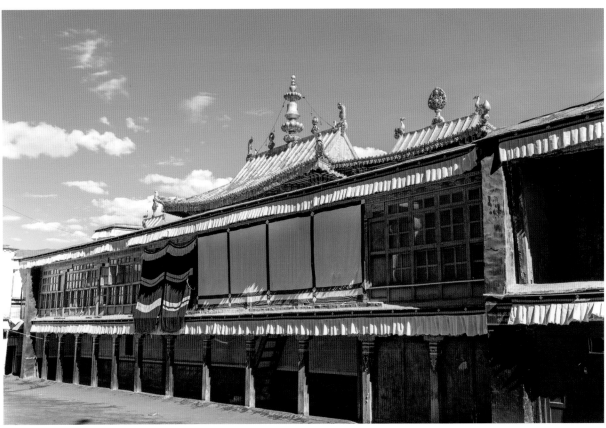

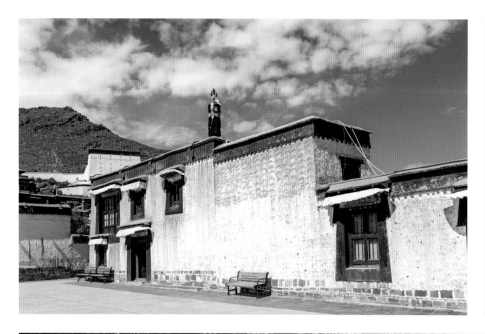

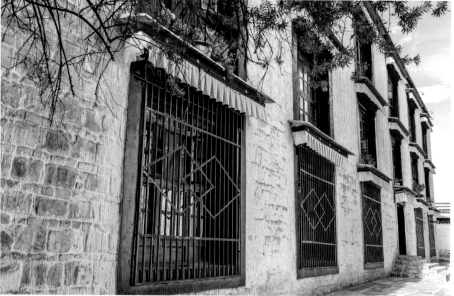

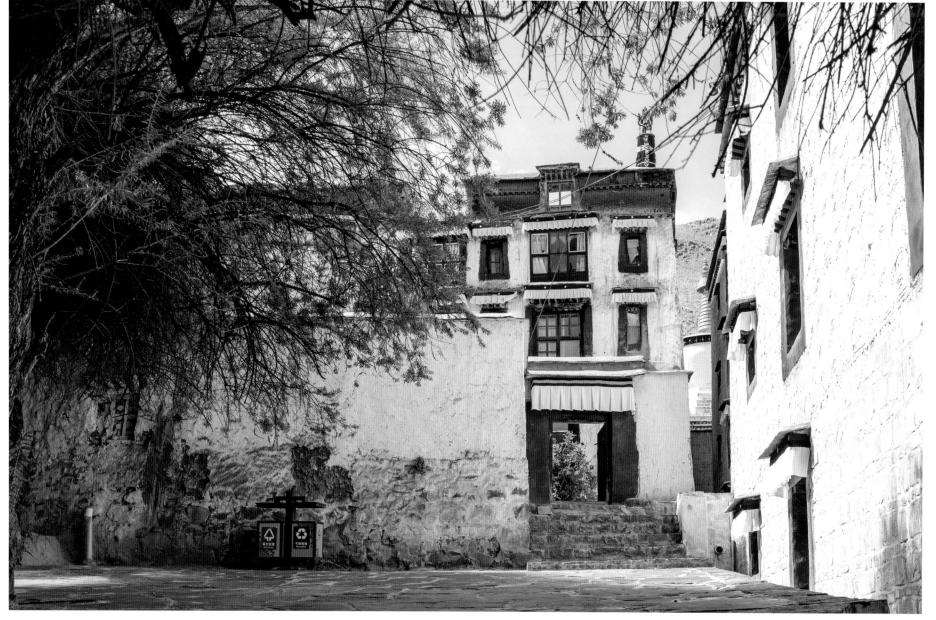

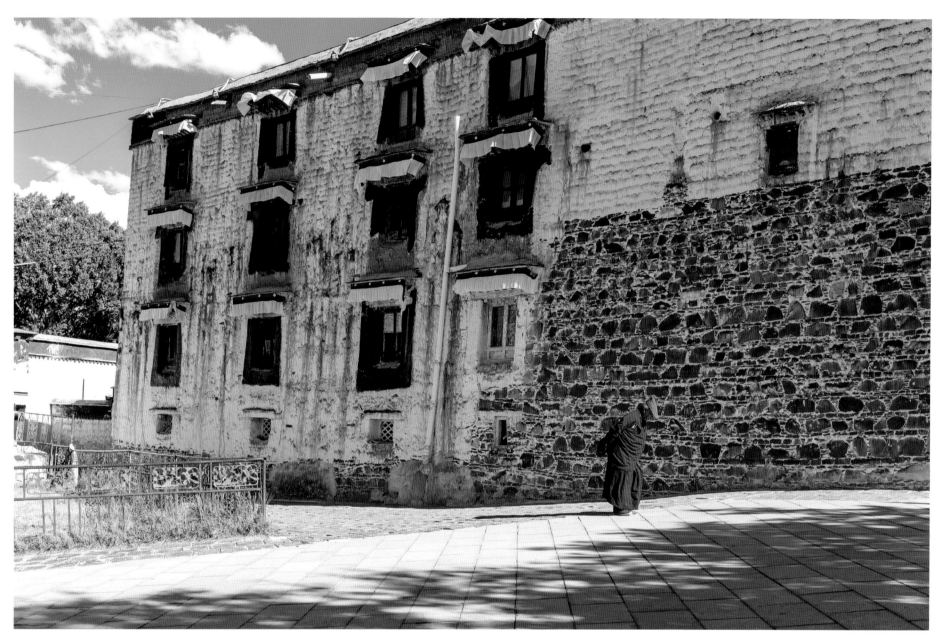

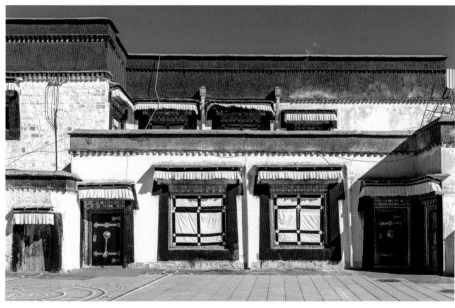

不管是不是信众，总能感觉到一种无形的佛教氛围。
Whether believers or not,
you can always soak up an invisible atmosphere of Buddhism.

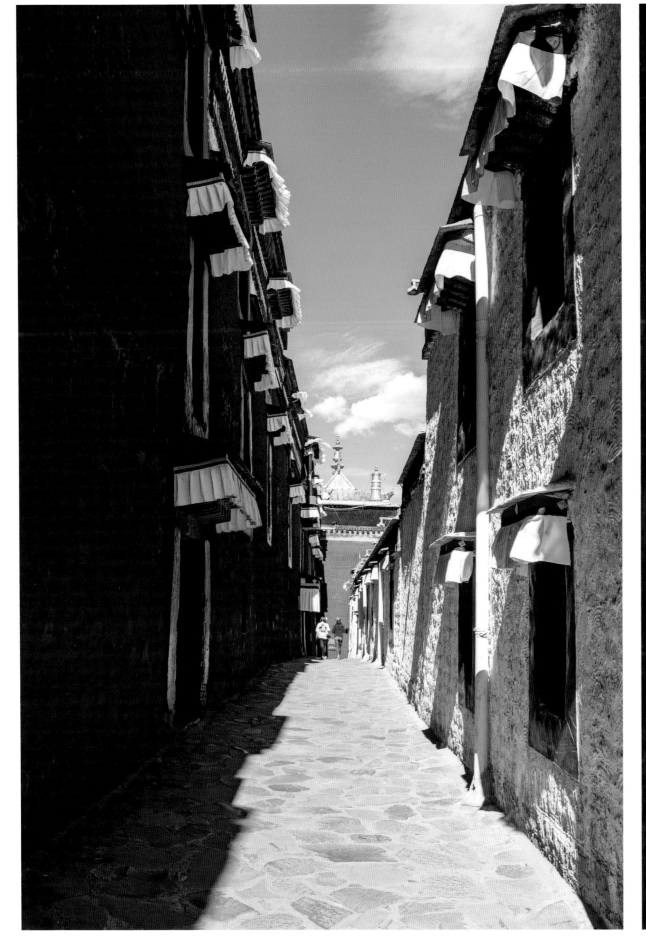

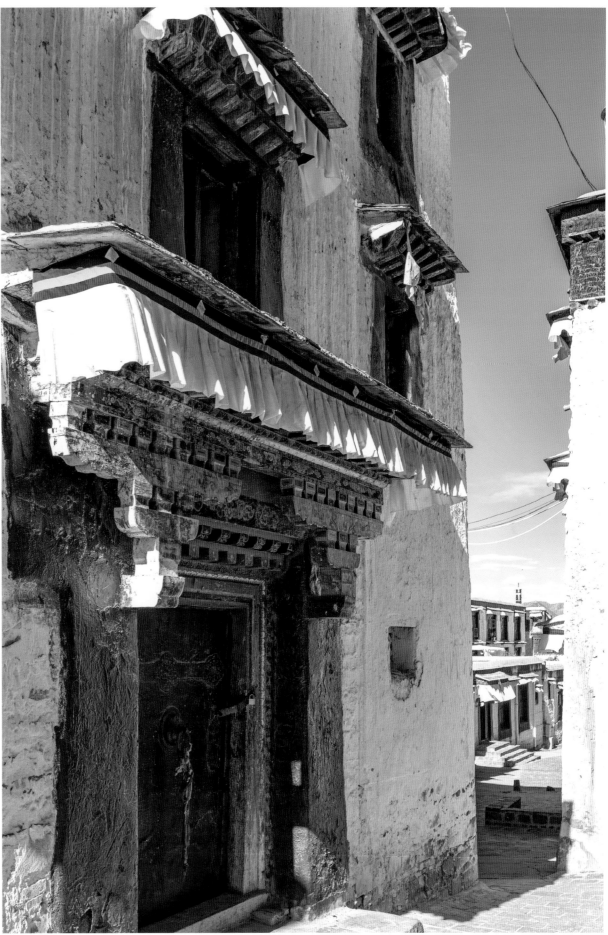

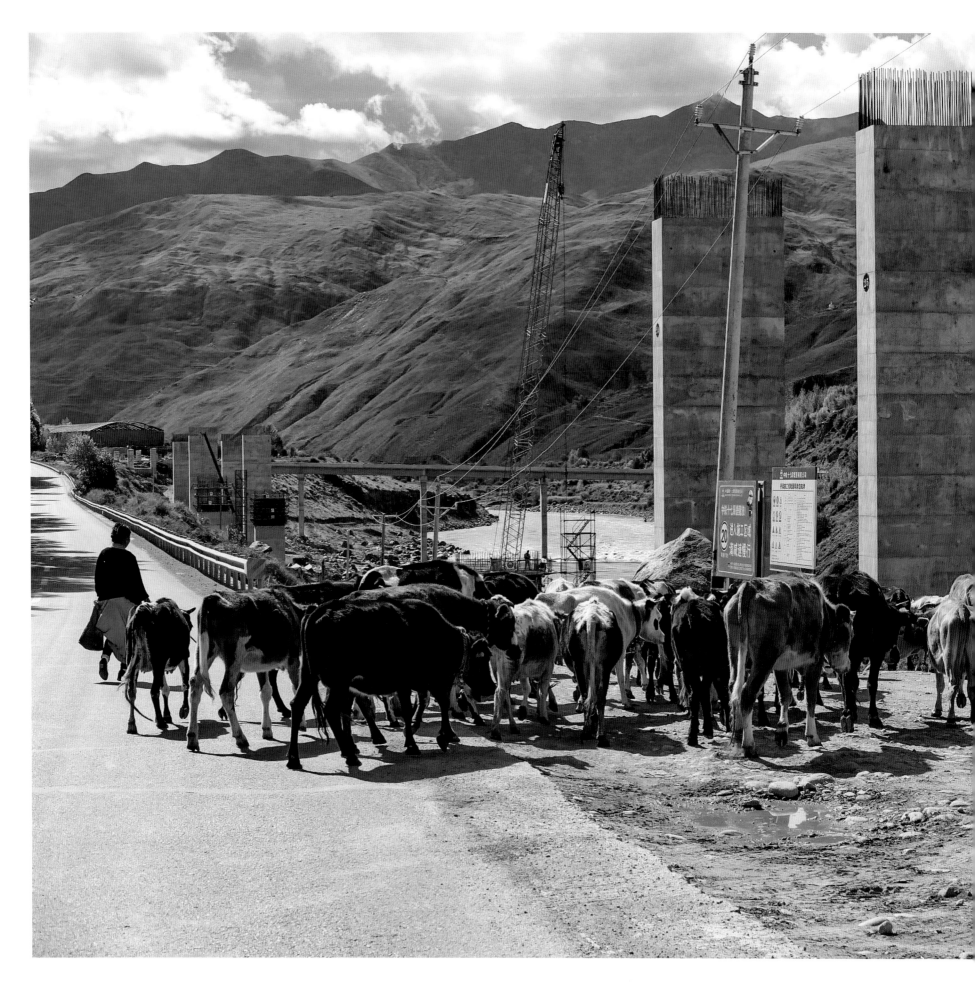

圣洁的西藏 TIBET : THE HOLY LAND 　　第九天 DAY 9

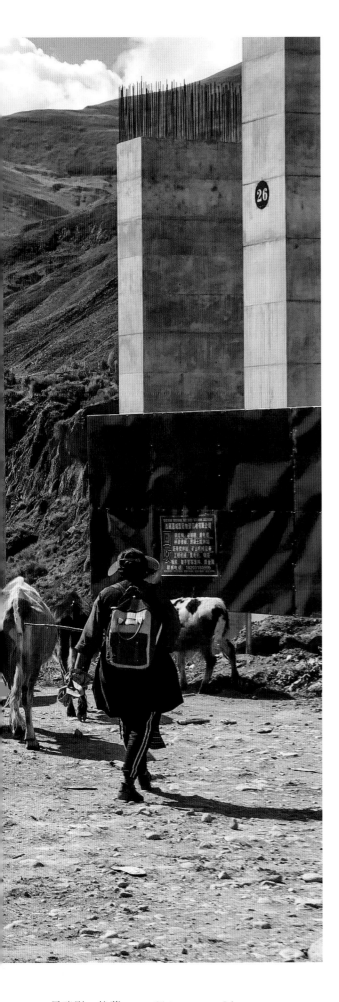

日喀则～拉萨

由于行程临时调动，一行人从日喀则折返拉萨办理边防证。

从日喀则到拉萨，驱车走318国道和雅叶高速，距离不到300公里，再次行驶在"西藏粮仓"的路上，沿途不断见到在青稞田里忙碌的藏民，驾着拖拉机从田间驶过，收割完的青稞一垛垛整齐地堆放在田间，洋溢着丰收的喜悦。日喀则的平均海拔在4,000米以上，看着窗外掠过的风景，偶有牛群悠然走过，一时之间竟忘了这里还是高原地带。

到达拉萨已是中午时分，庆幸的是边防证的办理过程异常顺利。

我再次来到八廓街，虔诚的藏民依旧不知疲倦地按着顺时针方向在这条道路上转经，日复一日。也见到许多租借藏族服饰拍摄写真的游客，欢欣地假扮一回藏族的青年男女。在城市中，有这样一条街区，不仅展示当地的历史文化，也在游客和当地居民的互动中，焕发新的生机，是很有价值的，让城市如同流动的活水般，生生不息。

Day 9
Shigatse ~ Lhasa

Due to some adjustments to the itinerary, we returned to Lhasa from Shigatse to apply for the frontier-pass certificate.

The distance between Shigatse and Lhasa is less than 300 kilometers through National Highway 318 and the Ya'an–Yecheng Expressway. On the return trip from 'the Granary of Tibet', I was constantly greeted by the cheerful scenes of local Tibetans busy in the highland barley fields. They drove tractors on the farmland and harvested barley were stacked orderly on the ground. The average altitude of Shigatse is above 4,000 meters, but the passing scenery and the rambling cattle that occasionally appeared in sight made me forget for a moment that I was right on the plateau.

It was noon when we arrived in Lhasa. Fortunately, the application for frontier-pass certificate went exceptionally smoothly.

It was the second time for me visiting Barkhor Street and the daily routine for devout Tibetans spinning their prayer wheels and walking along the street in a clockwise direction. There were many tourists in rented Tibetan costumes taking photos, making a happy try to dress up like a young Tibetan. Other than displaying regional history and culture, such a street in Tibet also radiates renewed vitality through the exchange between locals and visitors from afar, boundless energy woven into every facet of the city.

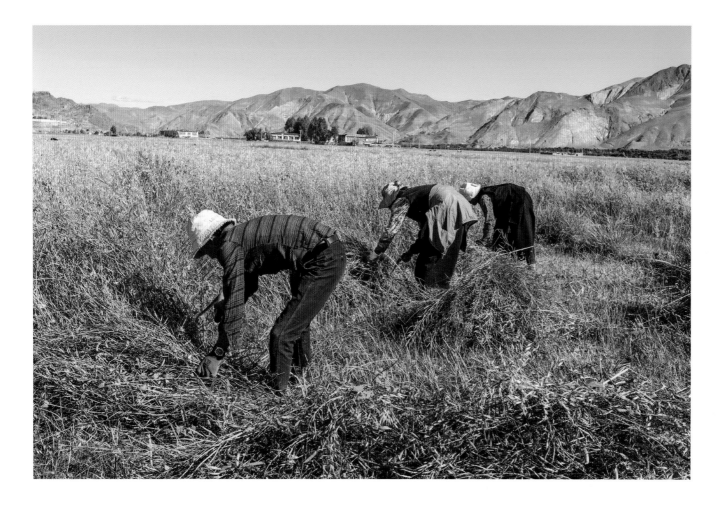

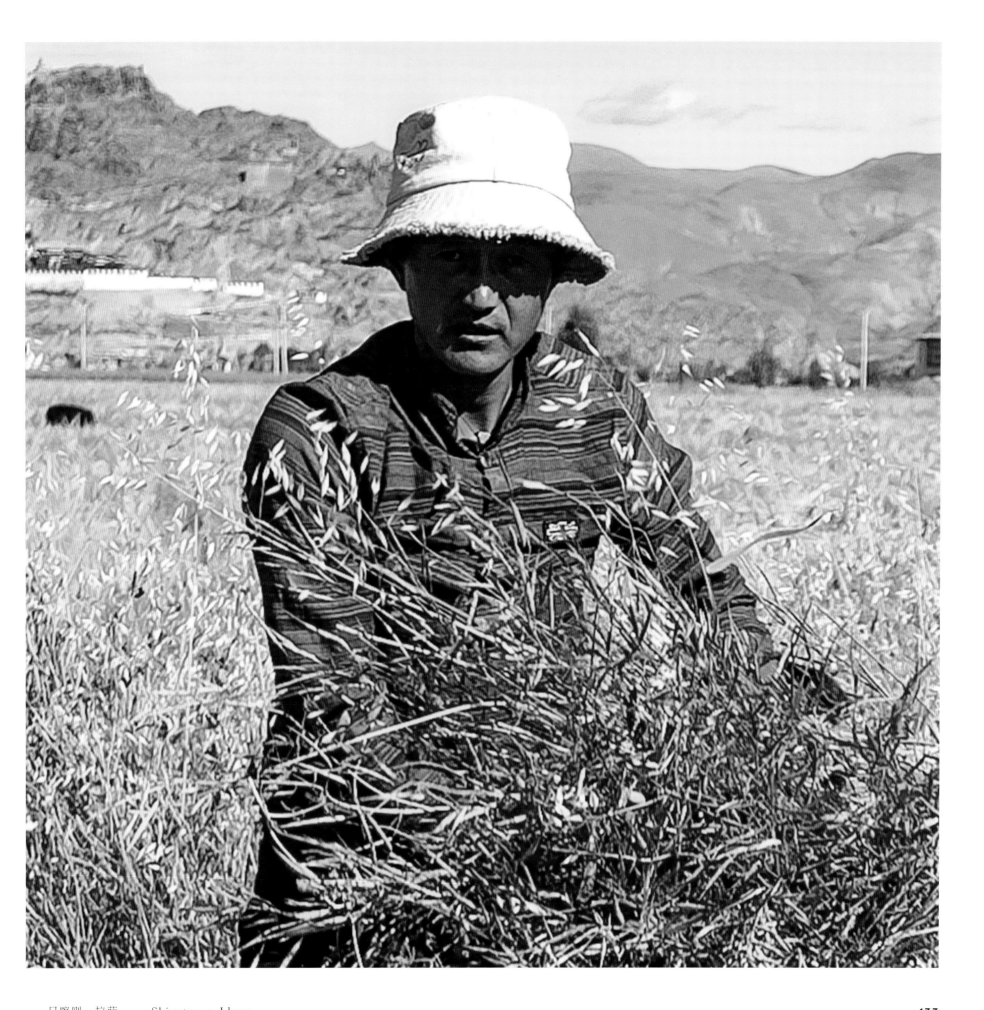

日喀则~拉萨　　Shigatse ~ Lhasa

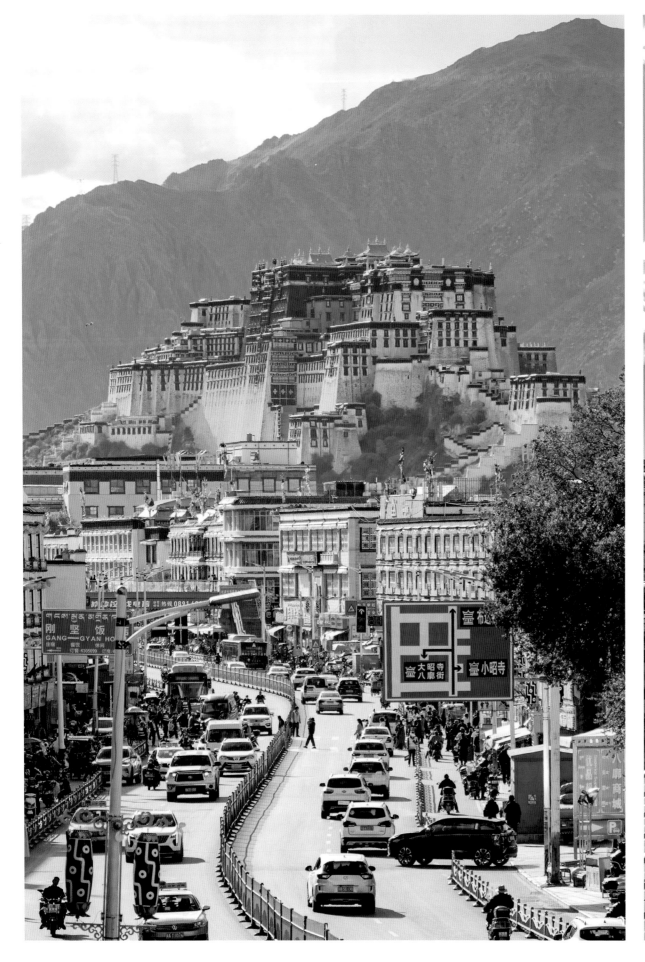

　　　　　　　　　　　　　　　　　　　　　　　　　圣洁的西藏　TIBET : THE HOLY LAND　　第九天　DAY 9

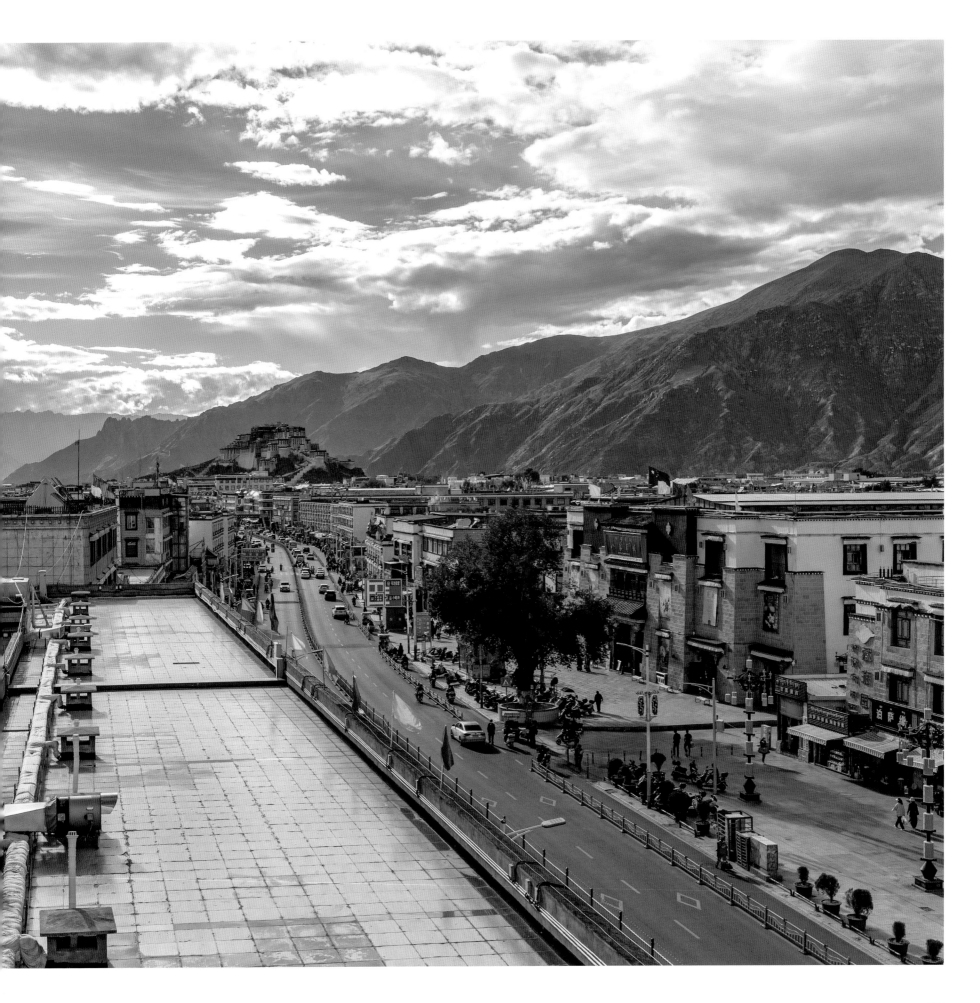

待边防证办好后，大伙的心情也随即放松下来，
剩下来的时间我又来到了八廓街。
The successful application for frontier-pass certificate let us relax,
so I came back to Barkhor Street to kill the rest of the time.

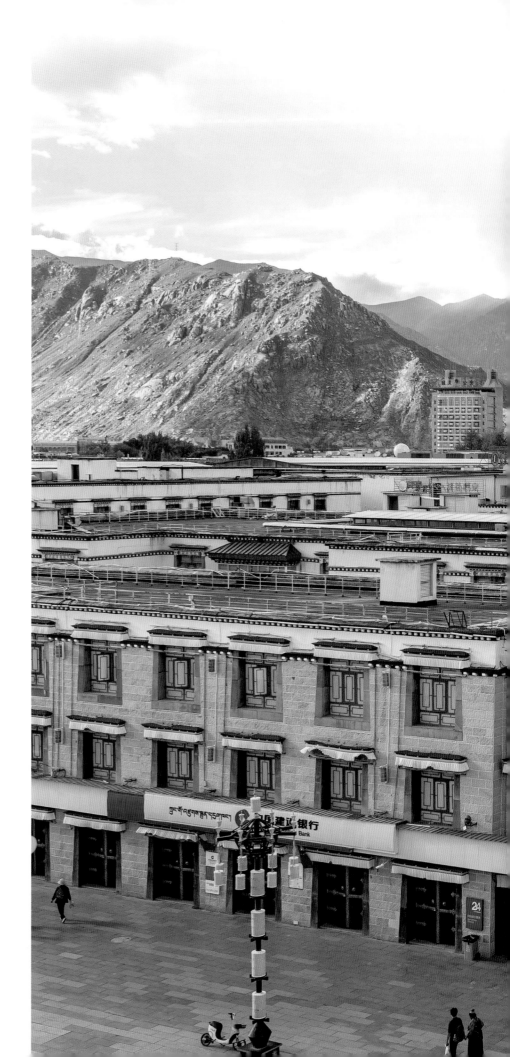

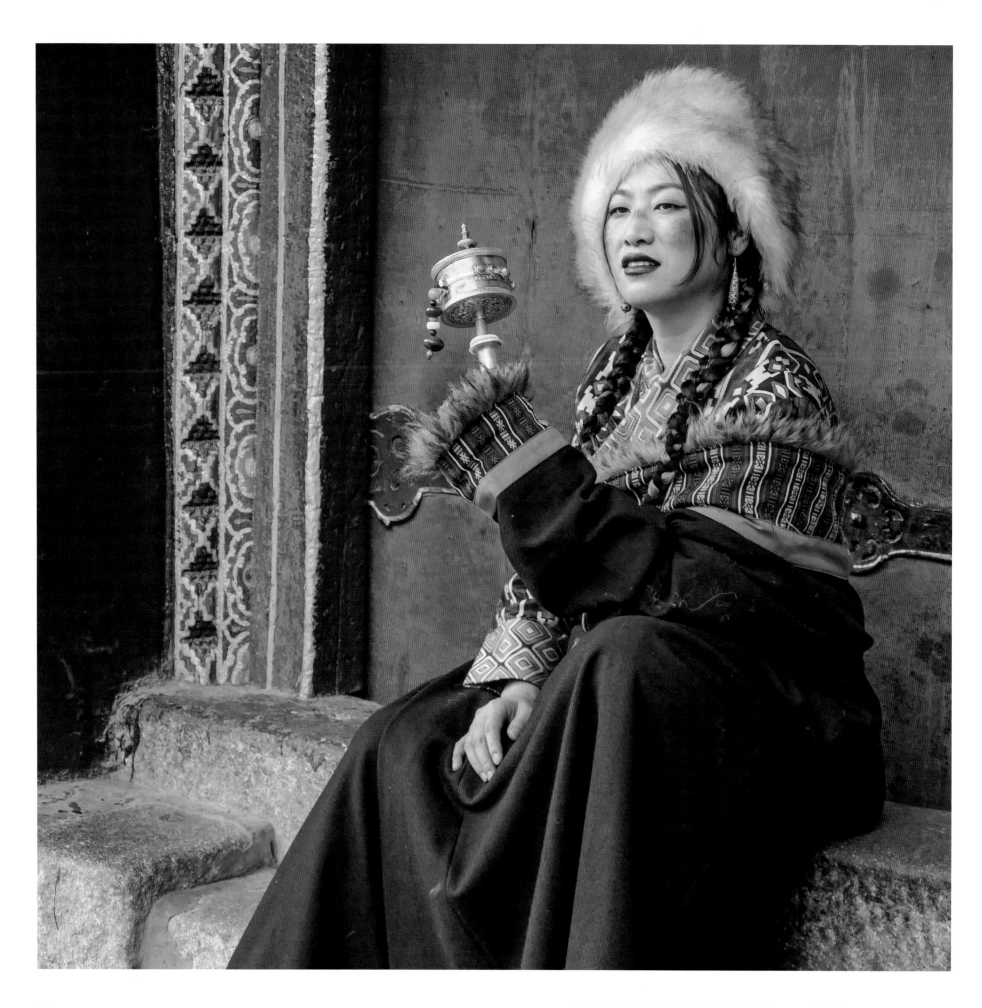

圣洁的西藏 TIBET : THE HOLY LAND 第九天 DAY 9

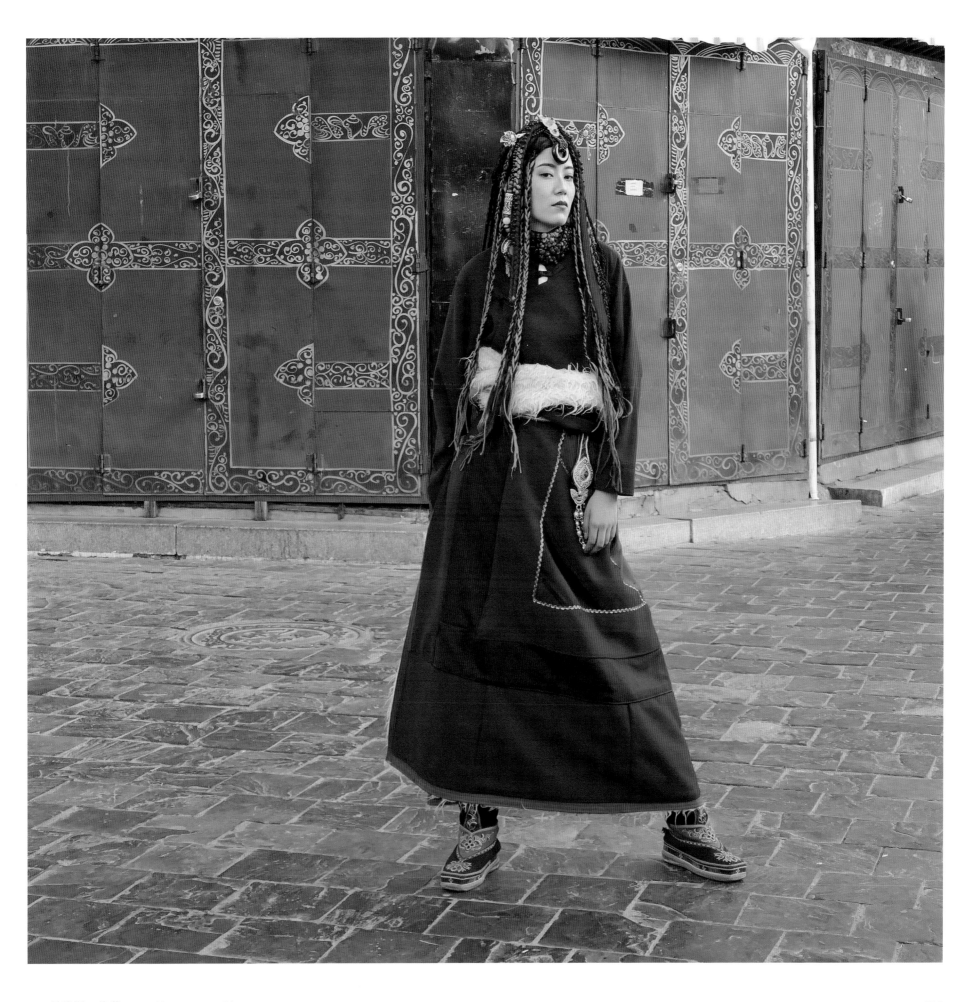

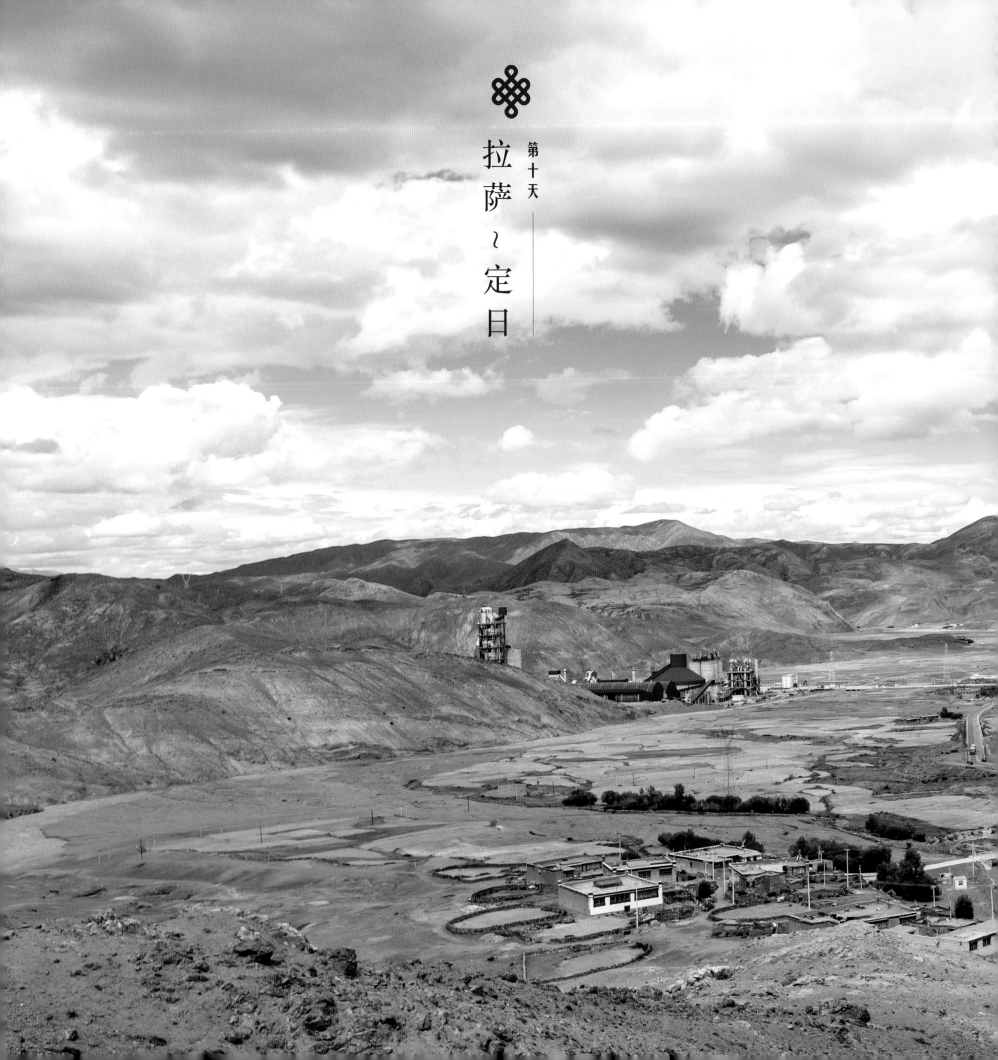

第十天

拉萨～定日

西藏，一辈子一定要去一次的地方。有些人喜欢原始的自然景观，或想要感受那里的淳朴，又或是被其神秘感吸引，想要寻找一个精神圣地。西藏被人为地赋予了太多特殊的意义，拉萨、大昭寺，还有布达拉宫，大多数人将这些与西藏画上等号。但事实上，不为众人所知的藏北高原——阿里地区才是青藏高原文明的真正起源，被称为"西藏的西藏"、"世界屋脊的屋脊"，也因此有了"不到阿里不算到西藏"的说法。

怀揣着边防证，开始正式踏上阿里大环线的旅途。自拉萨出发，一整天近 500 公里的车程，直达珠峰脚下的定日县。途经 318 国道的 5000km 纪念碑广场，这是从上海人民广场到西藏拉孜的距离。有一些藏族人在此售卖小饰品，一般骑行或是自驾的游客都会在这里稍作停留，拍照留念。

为了保护珠峰，中国设立了世界海拔最高的自然保护区——珠穆朗玛峰国家级自然保护区，我在海拔 5,260 米的牌楼前跳跃留念，也算是挑战了我的体力极限。沿途风光依旧美好，却已不再是单调的绿色，配着西藏特有的蔚蓝晴空还有轻柔浮云，又是在画中行的一天。

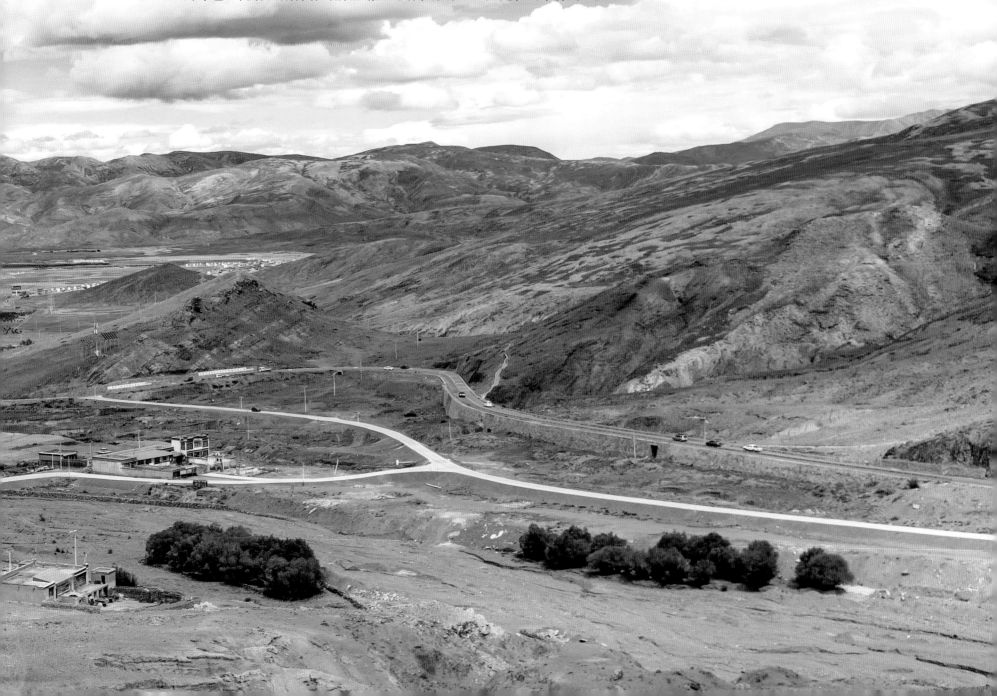

Lhasa ~ Tingri County

Tibet, a must-go place for a lifetime. Some are fond of its pristine nature, some crazy for primitive simplicity or mystery, and some in search of a spiritual ballast. Tibet bears so many special significances, and to many people, it is symbolized by Lhasa, the Jokhang Temple and the Potala Palace. In fact, the Northern Tibetan Plateau in obscurity, the Ngari Prefecture, is indisputably the genuine civilized origin of the Qinghai-Xizang Plateau. Given Ngari Prefecture's laudatory titles, such as the Cream of Tibet and the Roof of the World, people always say that 'your Tibet journey loses the quintessence if the Ngari Prefecture is not visited'.

Endorsed by the frontier-pass certificate, we started the circuit travel of the Ngari Prefecture. A whole day's drive covering nearly 500 kilometers took us from Lhasa straight to Tingri County at the foot of Mount Everest. On the way, we passed by the '5,000km Monument Square' on National Highway 318, the number of which represents the total length linking People's Square in Huangpu District, Shanghai, and the Lhatse County of Tibet. Some local Tibetans sell trinkets here, and bike riders or self-driving tourists would stop here for a while to take photos.

In order to protect Mount Everest, China has established the highest nature reserve in the world - Mount Everest National Nature Reserve. I took a jumping photo in front of the memorial gate at an altitude of 5,260 meters, which was admittedly a challenge to my physical limit. The scenic views on the road were still a feast to eyes, but green was no longer the dominant hue. The picturesque landscape with azure sky and puffy clouds typical of Tibet presented another pleasant journey for us.

我们一路都在寻找 "5000公里" 处那块小小的标志碑石，却始终没看到。
直到到达 "5000km" 纪念碑广场，才恍然发觉小碑石已被升级了。
We were looking for the small stele marking the '5000km' all the way but didn't see it.
It was not until we reached the '5000km Monument Square' that
we realized that the small monument had already been upgraded.

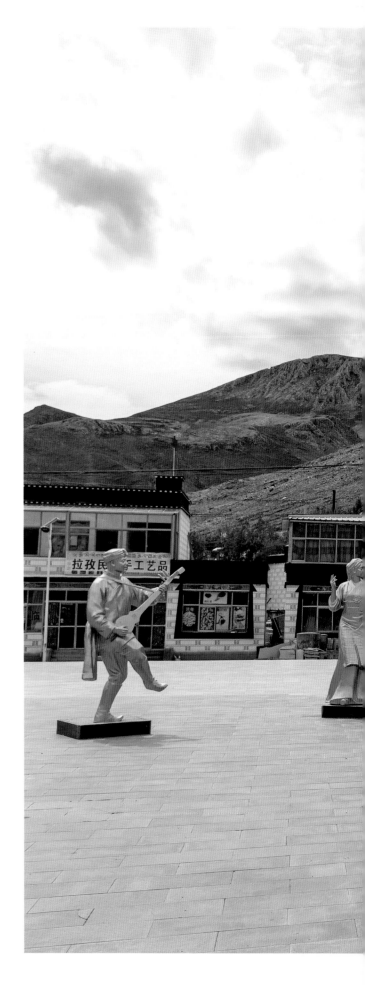

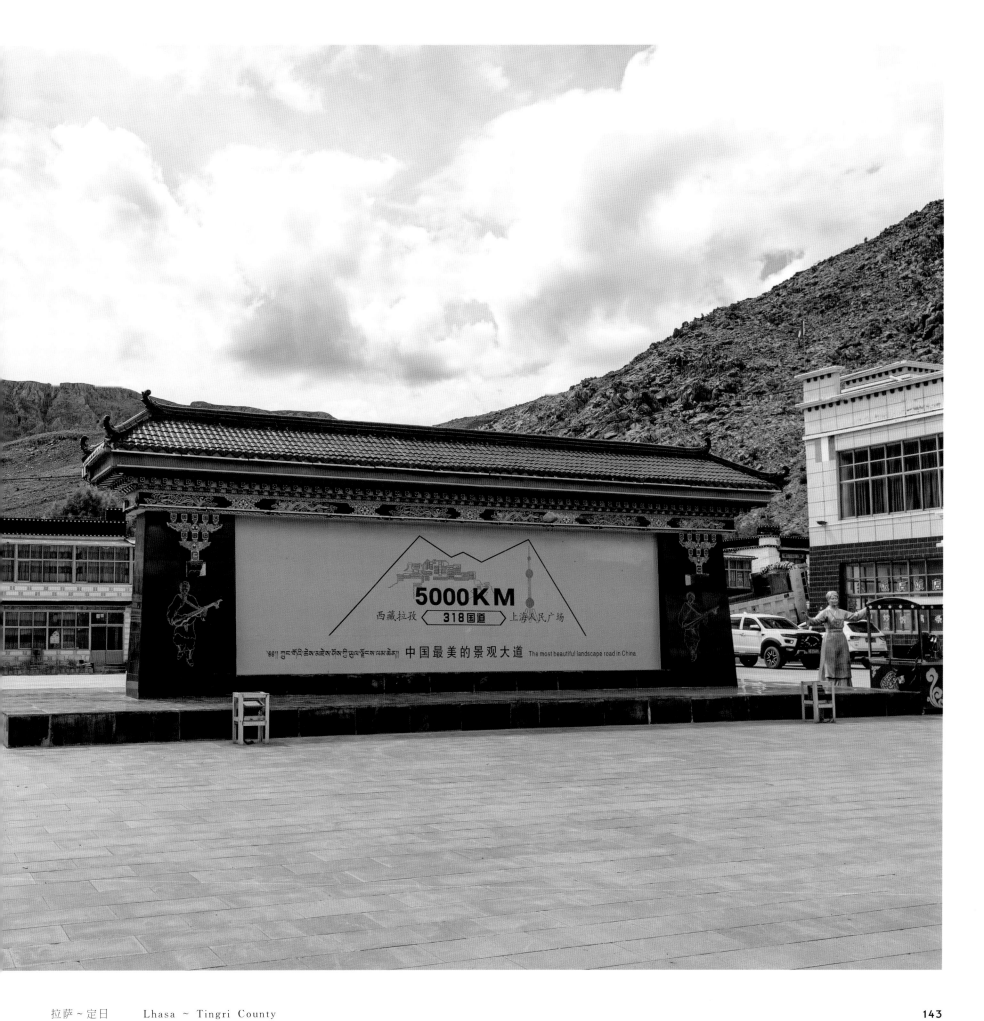

5000 KM

西藏拉孜 〈318国道〉 上海人民广场

中国最美的景观大道 The most beautiful landscape road in China

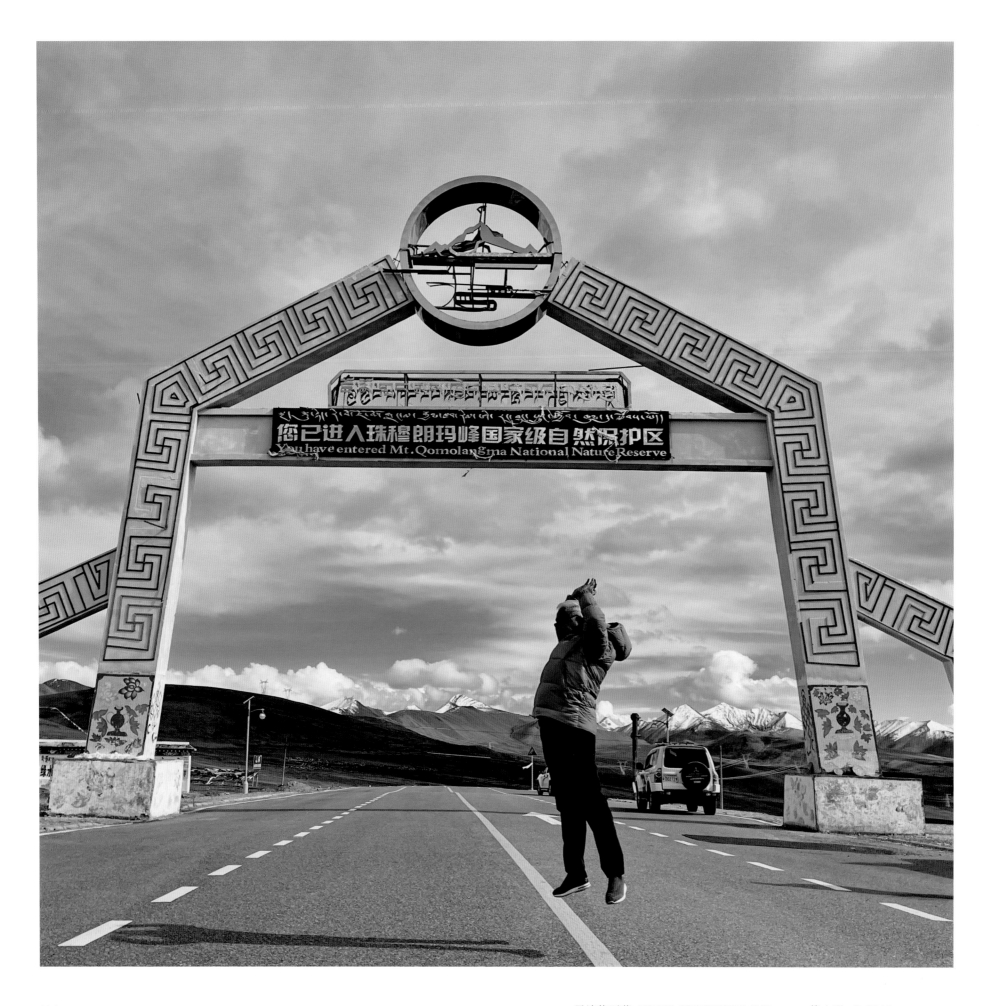

我在海拔 5,260 米的牌楼前跳跃留念，也算是挑战了我的体力极限。
I took a jumping photo in front of the memorial gate at an altitude of 5,260 meters,
which was admittedly a challenge to my physical limit.

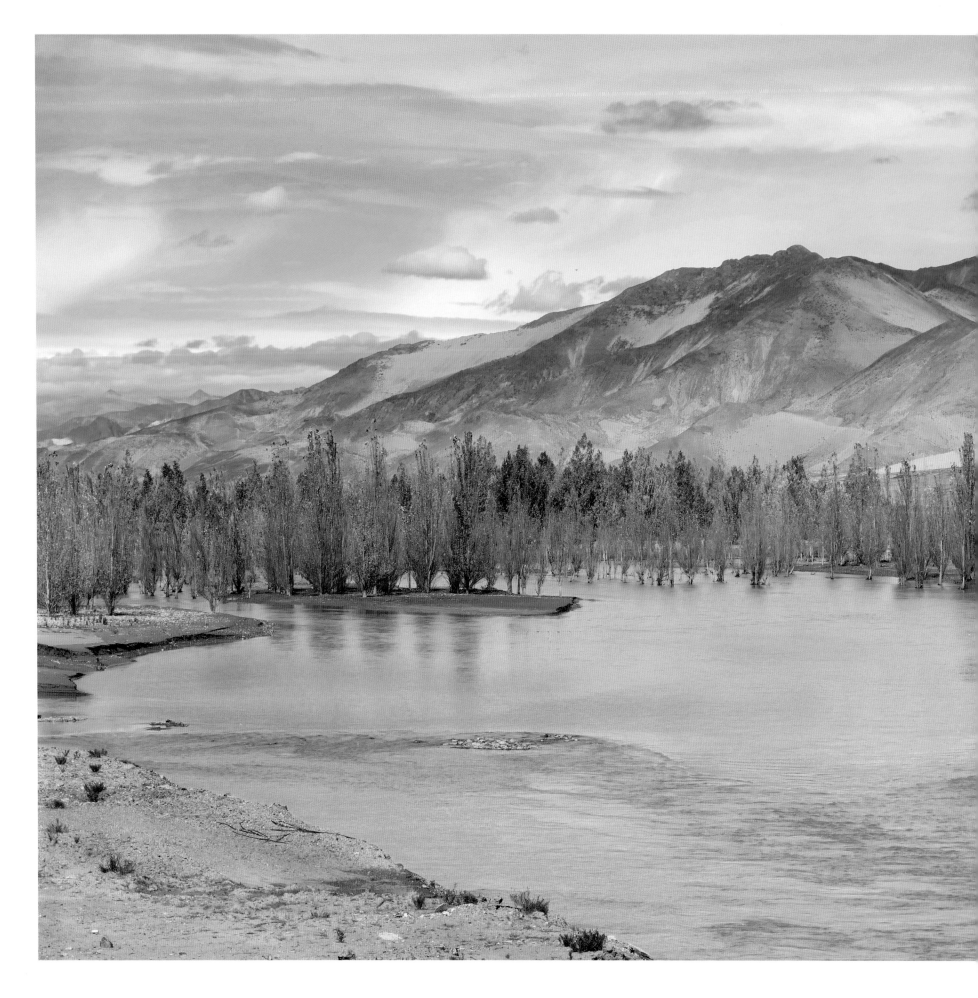

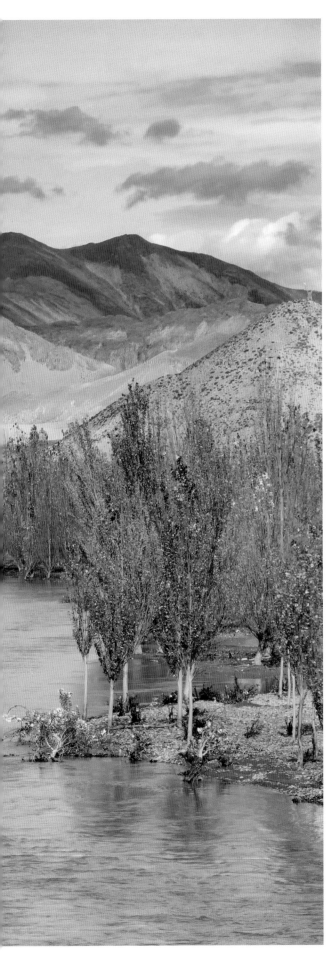

沿途风光依旧美好，却已不再是单调的绿色。

The scenic views on the road were still a feast to eyes, but green was no longer the dominant hue.

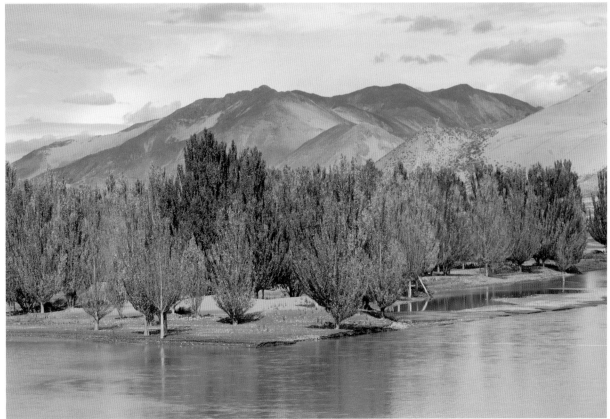

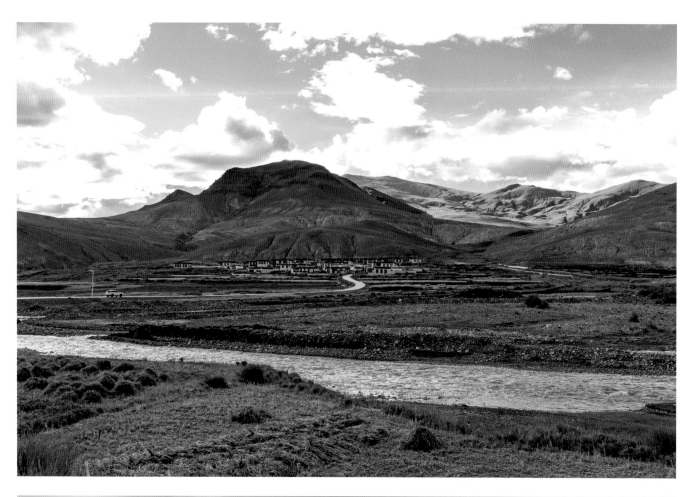

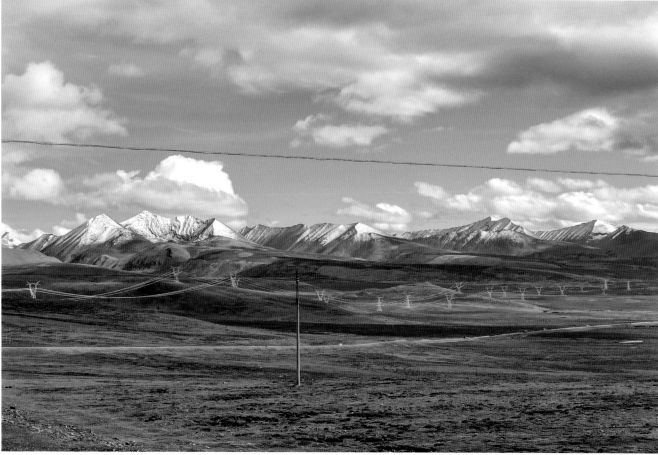

景乃天造，路是人为。
感谢时代为我们创造了通行世界的条件，
更感谢无数的筑路人。
God creates nature and humans construct
the road. Great thanks are due to the times
that allow us to journey around the world
and more due to those road builders.

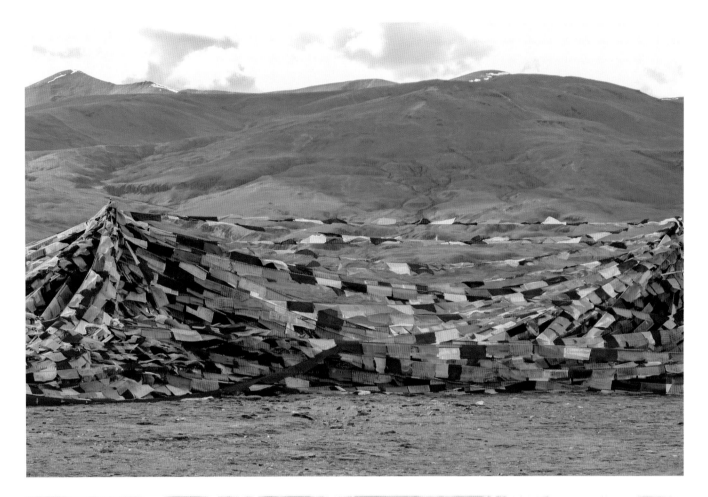

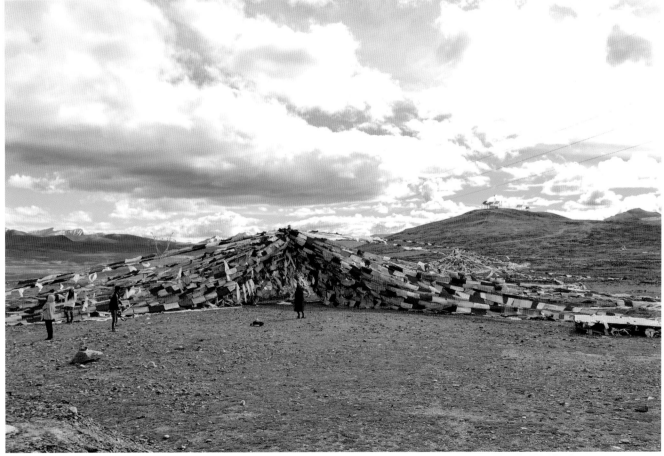

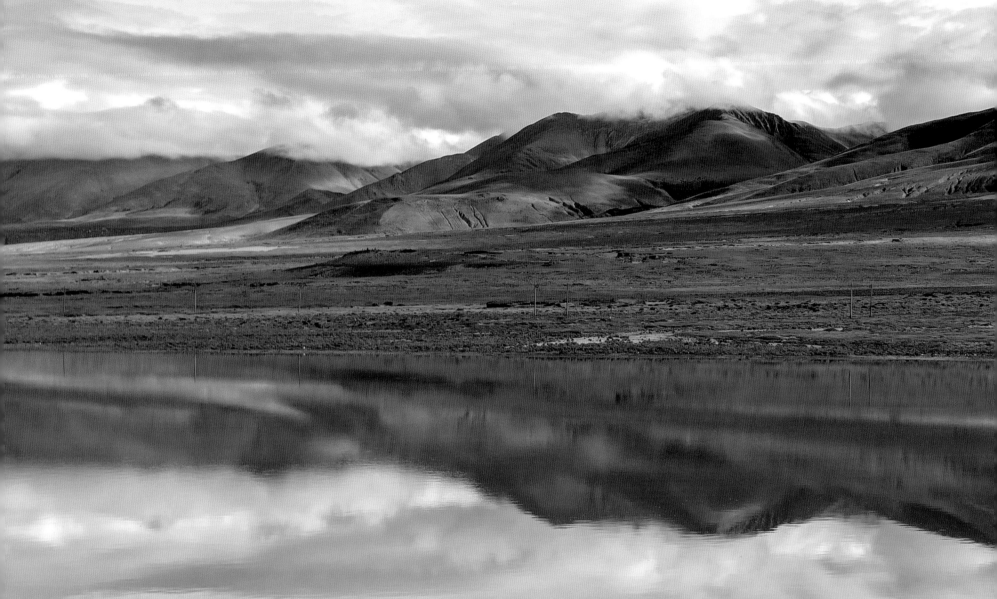

沿着阿里大环线南线继续前行，距离定日县城 250 公里处，有座日喀则地区最大的湖泊——佩枯措，这里三面环山，地形开阔，车子甚至可直接开到湖边。湖区生态丰富，可见到西藏高原特有的藏野驴、黑颈鹤、斑头雁、赤嘴鸥等。

佩枯措的湖水是一种流动的蓝，清澈见底，被誉为珠峰下的蓝宝石，但成就它名声的还有希夏邦马峰的倒影。世界上海拔超过 8,000 米的山峰一共有 14 座，海拔 8,013 米的希夏邦马峰是其中最矮的一个，却也是唯一一座完全在中国境内的高峰。佩枯措就像一面梳妆镜，倒映着希夏邦马峰，神山配圣湖，还有天空中大片大片的白云，一起构成西藏独有的风景。

路上遇到前往神山冈仁波齐朝圣的藏族人家，两床棉被捆在一起，父亲和小孩站在一边，不远处是供临时休息的帐篷。他们会像电影中纪录的那样，走走停停，一路跪拜下去。藏民这种苦行僧般的朝圣之路，到底是信仰还是愚昧，近年来人们为此争议不休。但我认为，每个人都有自己坚持的东西，并愿意为此努力践行，为什么要拿自己习惯的标准去评判他人呢？我们送出一些食物，真诚祝福他们的朝圣路途一切顺遂。

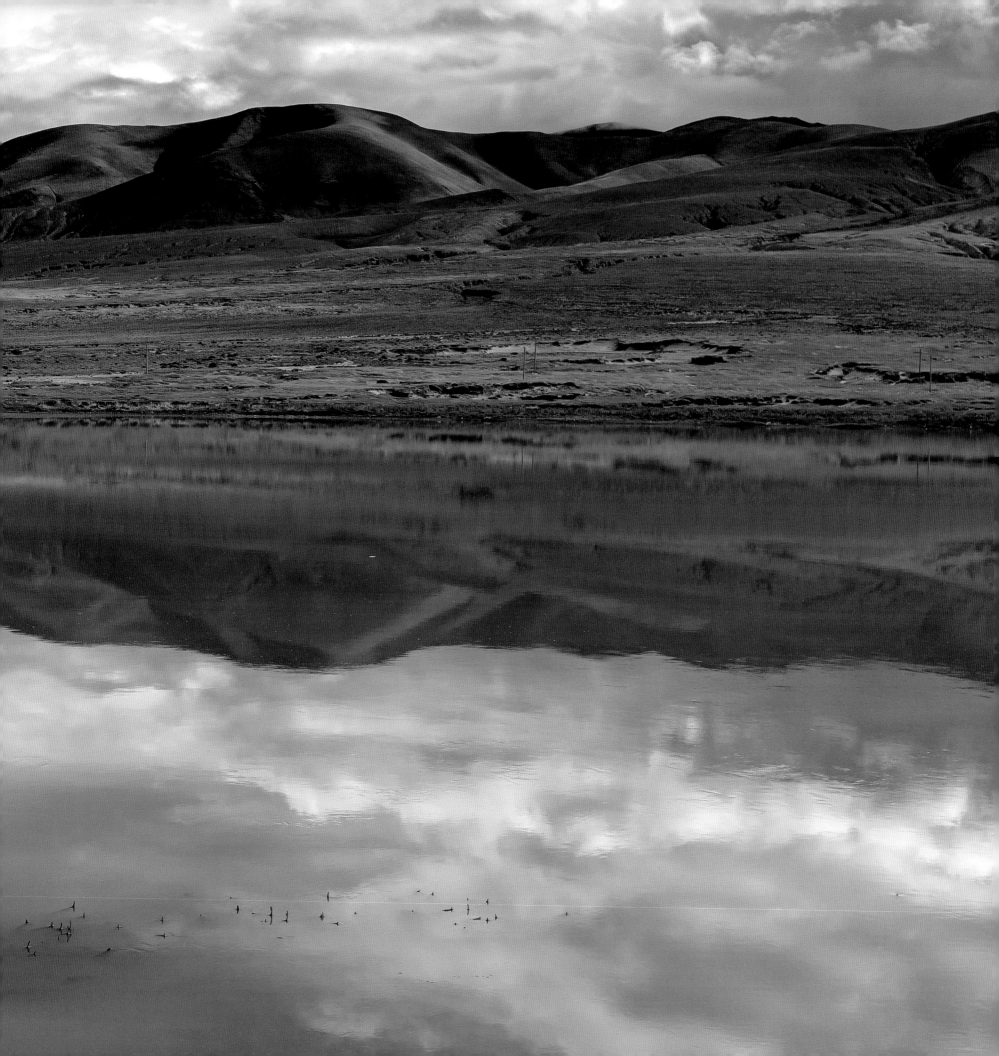

Tingri County ~ Zhongba County

The journey continued along the southern line of the Ngari Prefecture circuit. The largest lake of Shigatse, Lake Paikutso, is 250 kilometers from Tingri County. The spacious region is embraced by mountains from three sides, which allows cars to drive straight to the lakeside. As the lake region supports a diversified ecosystem, animals unique to the Tibetan plateau, such as Tibetan wild asses, black-necked cranes, spotted geese and red-beaked gulls, could be spotted.

As the limpid water glistens in a lively shade of blue, the lake is acclaimed as the sapphire under Mount Everest, and the reflection of Peak Shishapangma also gives the lake an added fame. There are 14 peaks in the world with altitude over 8,000 meters, and the 8,013-meter-high Shishapangma is the dwarf of them all, yet it is the only one that is entirely within China. Lake Paikutso is like a dressing glass mirroring Shishapangma. When the sacred mountain is coupled with the sacred lake under fluffy bands of clouds, there composes a wonderful scenery exclusive to Tibet.

We run into a Tibetan family on a pilgrimage to the sacred Mount Kailash (or Kangrinboqe). Two quilts were bundled together, the father and the child standing on one side, and not far away was a tent for temporary rest. They were going to move forward in a continuous repetition of prostrating themselves all the way just as recorded in the movie, *Paths of the Soul*. Whether this ascetic pilgrimage of Tibetans represents faith or ignorance has been a debate in recent years. In my opinion, there are always things which one would believe and insist upon, and who are willing to take persistent efforts to practice. Hence it is unreasonable to make judgment on these actions and practices merely based on own narrow standards. We gave them some food and sincerely wished them all the best on the pilgrimage.

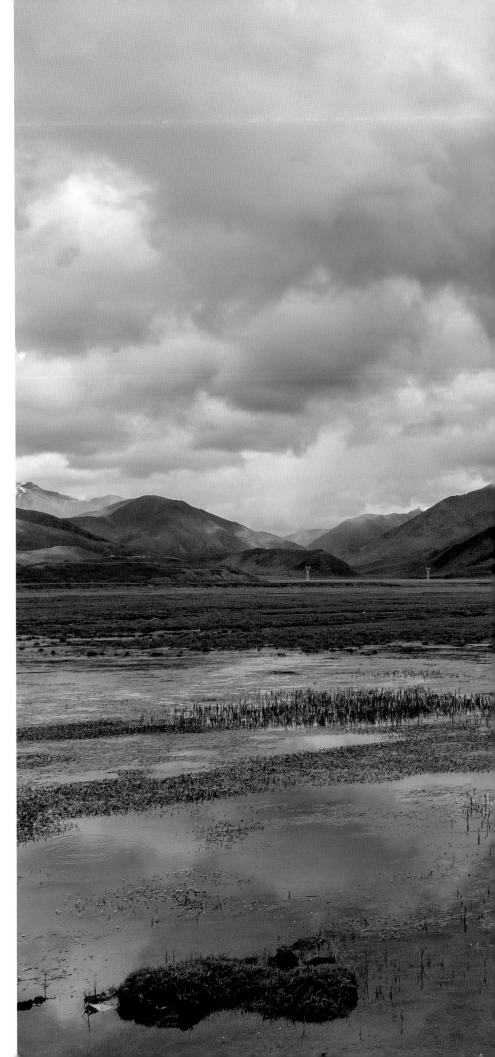

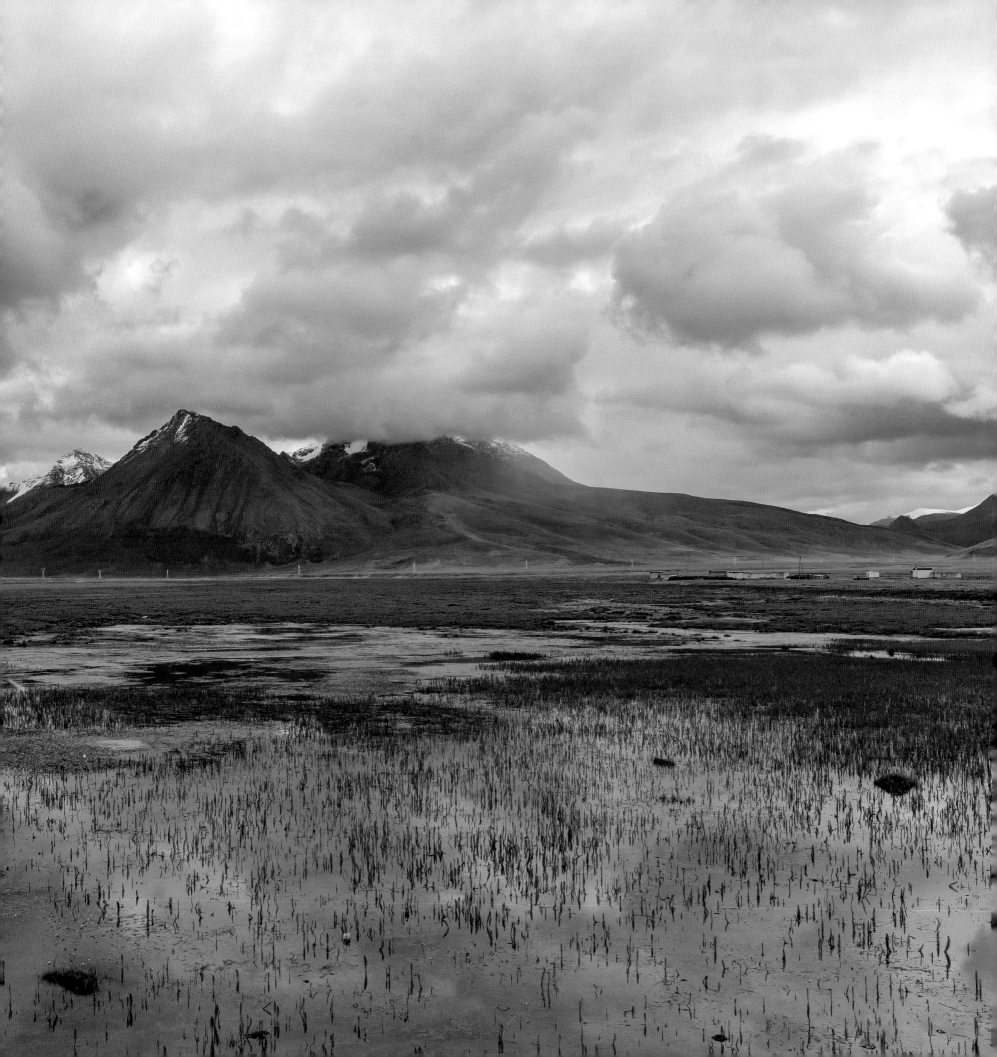

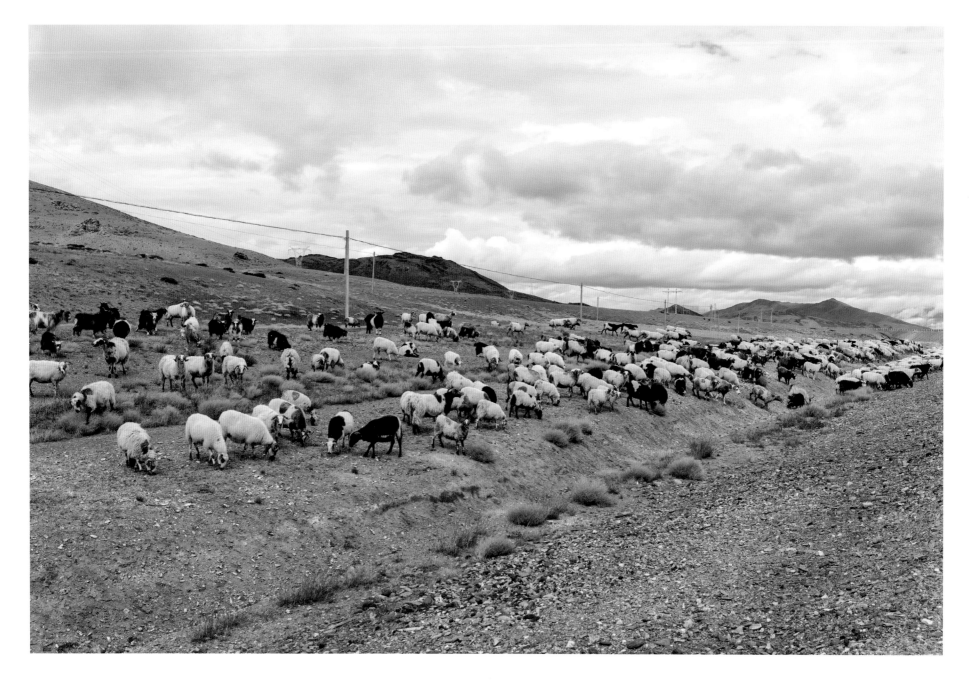

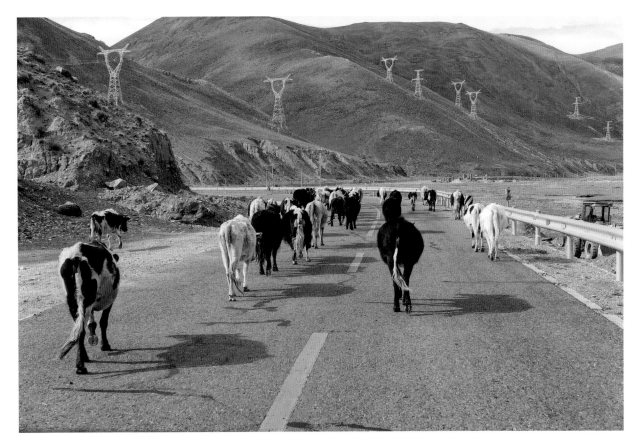

唯有自驾游阿里，方能体验到"天上阿里，人间天堂"是如何让人魂牵梦绕。
Only by taking a self-driving tour around the Ngari Prefecture
can you really appreciate how captivating the 'paradise-like landscape' is.

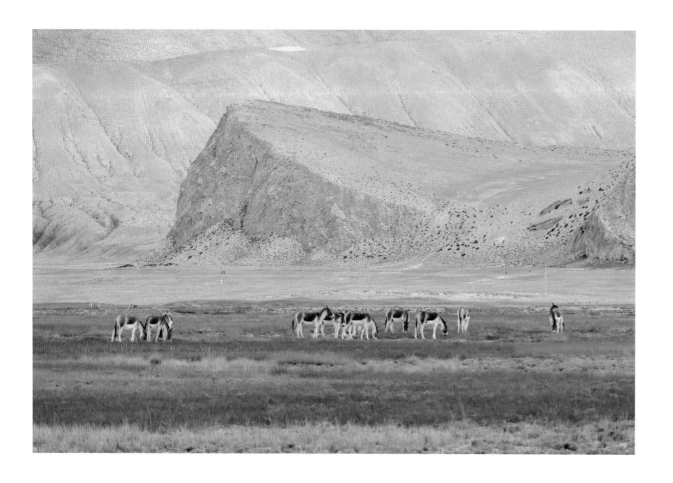

路上遇到前往神山冈仁波齐朝圣的藏族人家，
两床棉被捆在一起，父亲和小孩站在一边，不远处是供临时休息的帐篷。
We run into a Tibetan family on a pilgrimage to the sacred Mount Kailash (or Kangrinboqe).
Two quilts were bundled together,
the father and the child standing on one side and not far away was a tent for temporary rest.

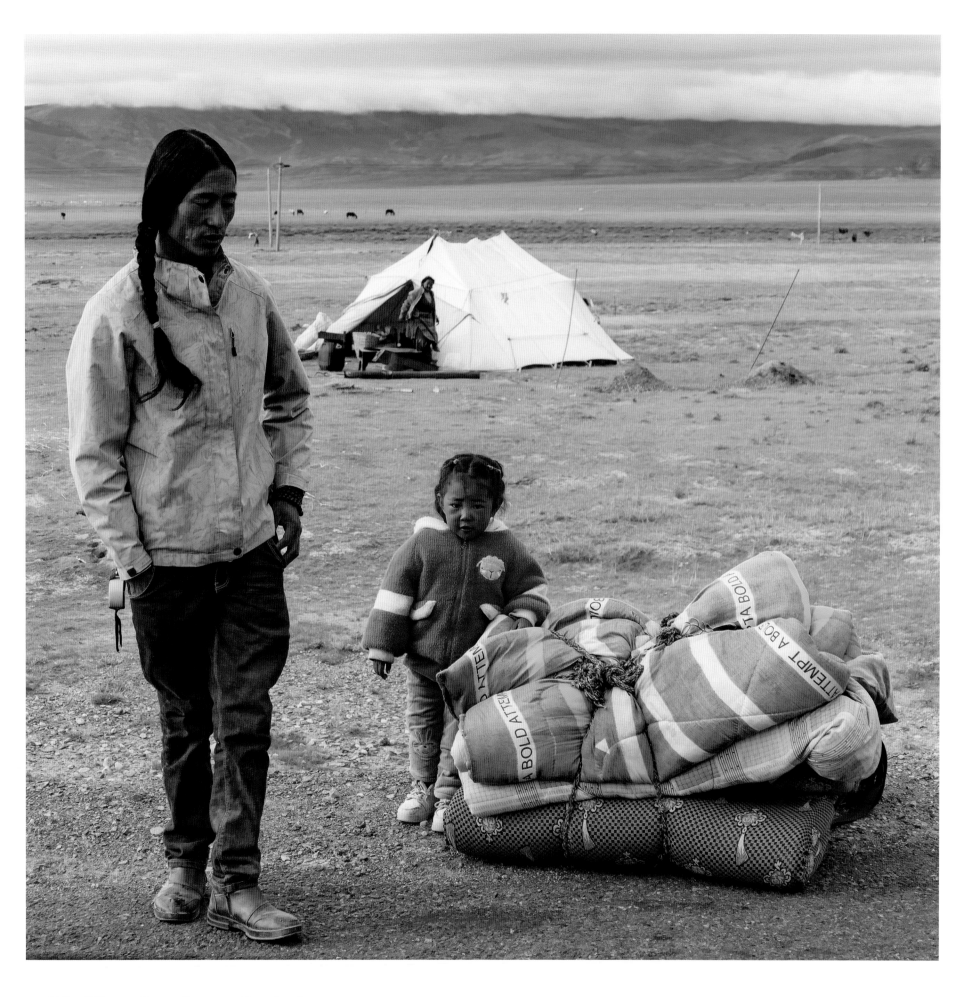

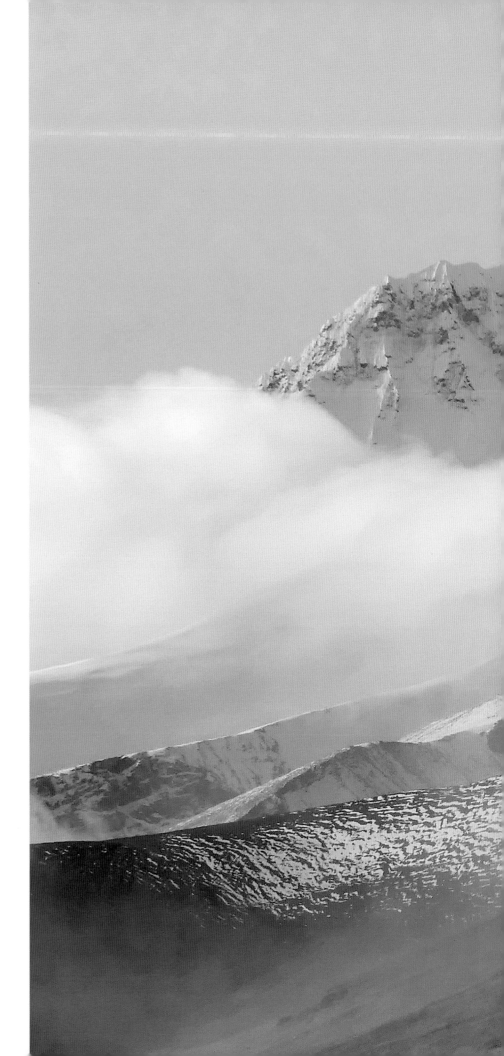

希夏邦马峰是世界上海拔超过 8,000 米的 14 座山峰的其中之一，
也是唯一一座完全在中国境内的高峰。
There are 14 peaks in the world with altitude over 8,000 meters,
and Peak Shishapangma is the dwarf of them all,
yet it is the only one that is entirely within China.

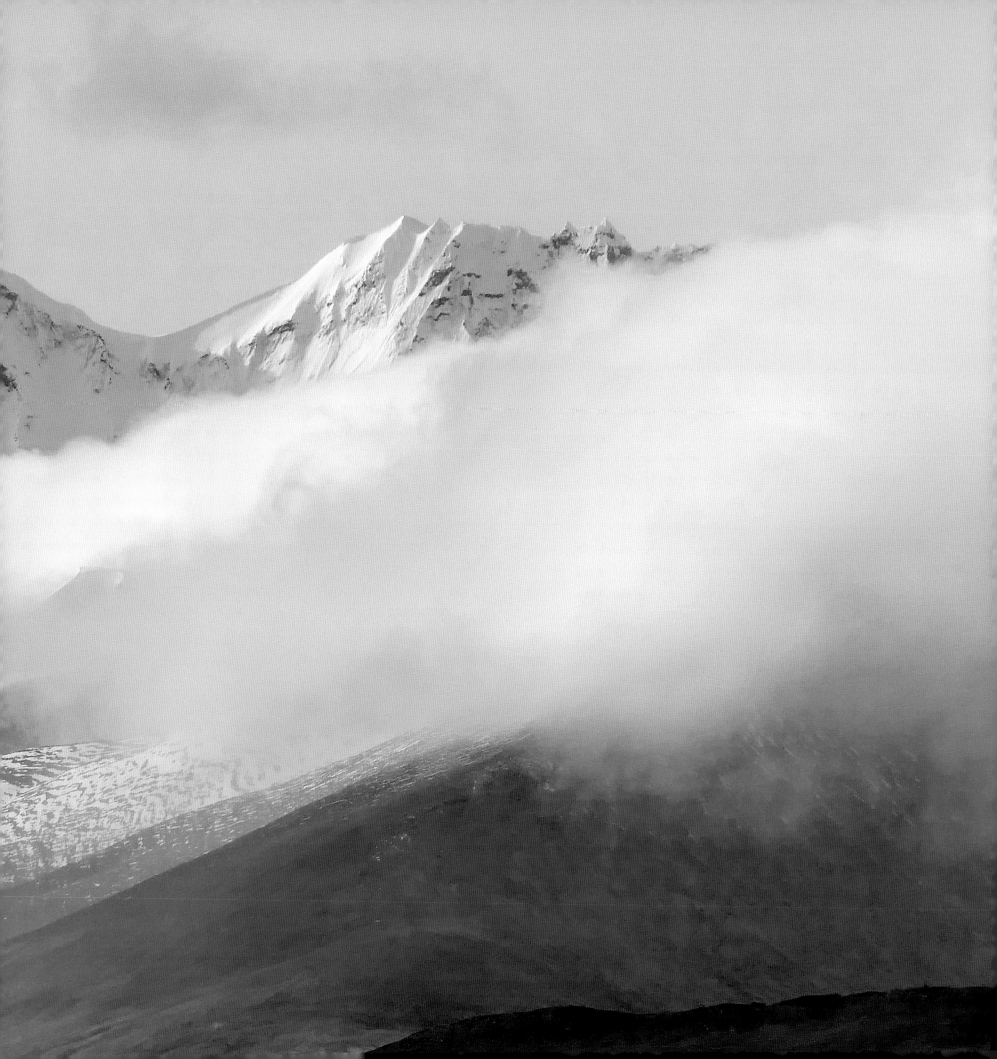

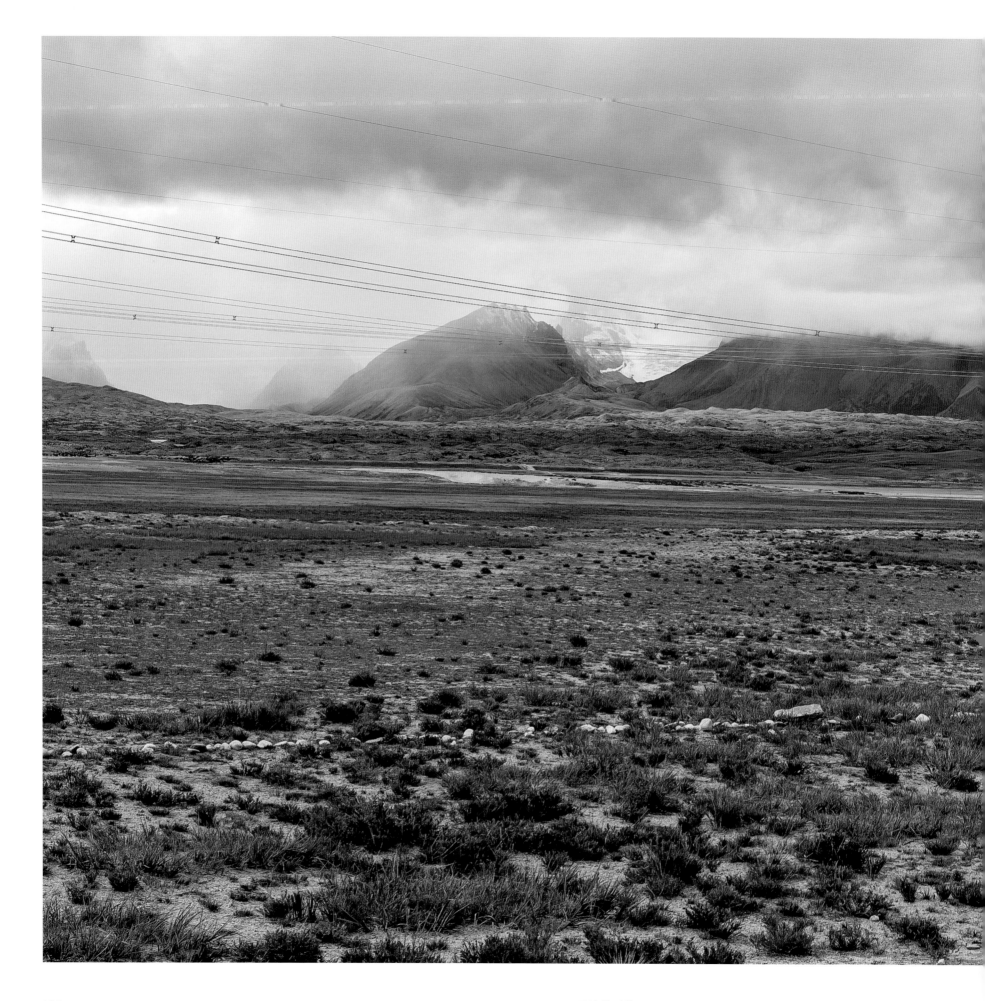

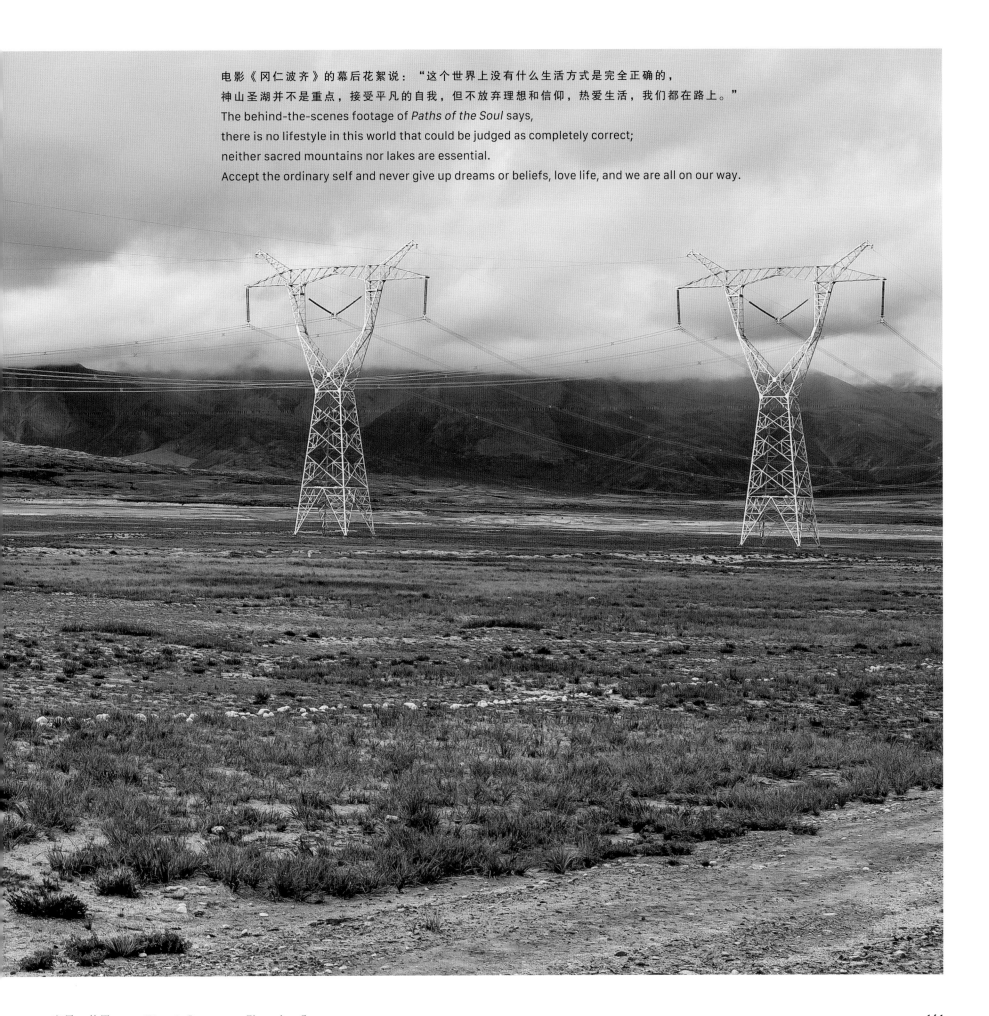

电影《冈仁波齐》的幕后花絮说："这个世界上没有什么生活方式是完全正确的，
神山圣湖并不是重点，接受平凡的自我，但不放弃理想和信仰，热爱生活，我们都在路上。"
The behind-the-scenes footage of *Paths of the Soul* says,
there is no lifestyle in this world that could be judged as completely correct;
neither sacred mountains nor lakes are essential.
Accept the ordinary self and never give up dreams or beliefs, love life, and we are all on our way.

仲巴～札达

第十二天

雅江源是为最壮丽的大河故乡，在这里，黄沙、湿地、河流、雪山奇妙地组合在一起，化为一幅绚丽多彩的画卷。然而背后却是不容忽视的环境恶化，造成了这异常的风沙地貌。

过了仲巴就正式进入了阿里地区，感觉天与地都变得更为辽阔。翻越了5,211米的马攸木拉达坂，达坂来自于蒙古语，是山口、垭口的意思。行经进入阿里后遇到的第一座高原湖泊——公珠措，海拔4,877米，狭长型的湖面如一条直线向前延伸。

继续前进，西藏三大圣湖之一的玛旁雍措出现在眼前，它位于冈底斯山脉和喜马拉雅山之间，有"世界江河之母"的美誉。与玛旁雍措仅有一山之隔的拉昂措，湖中没有任何的生命色彩，且人畜不饮。两者一为淡水湖，一为咸水湖；一个是圣湖，一个是"鬼湖"。两湖相依，却有天壤之别。

此次非常幸运，能同时亲眼目睹冈仁波齐和纳木那尼的真容，两座山遥遥相对，中间以玛旁雍措相隔。两山一湖在藏族人民心目中都有着极高的地位，特别是冈仁波齐，山腰间一条天梯直通山顶。对于转山的朝圣者而言，高山不只是古老的原始崇拜，他们相信神山可以联系天上人间，山是他们信仰的居所，而冈仁波齐就是信仰的终点。

途中在土林观景台和龙嘎拉达坂停留，虽赶不上观赏土林日落，但并未影响壮观的土林地貌和斑斓的"五彩山"，像是颜料泼洒上去自然成就的一卷油画，其瑰丽令人惊叹。五颜六色的山峦间有一个碧绿的小水塘，终年不干涸，名叫"龙嘎措琼"，被誉为"天使之泪"。

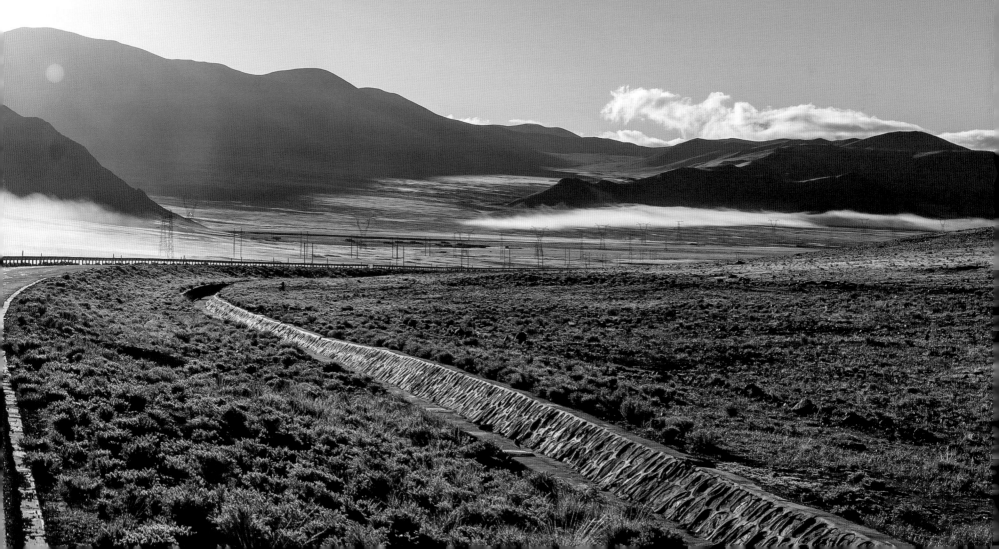

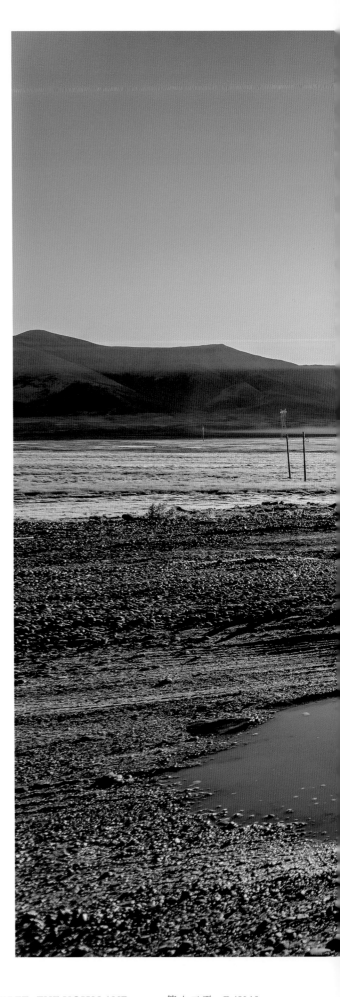

Day 12
Zhongba County ~ Zanda County

The source of the Yajiang River is the magnificent homeland for rivers. Here, a brilliant landscape painting is marvelously composed by yellow sand, wetlands, rivers and snow-capped mountains. However, it is the deteriorating environment as the significant cause for this abnormal land feature.

Crossing Zhongba County means the official entry to the Ngari Prefecture, where the expanse of land stretches boundlessly under the huge sky. We climbed over the Dabaya Mayoumyla 5,211 meters high. Dabaya means 'mountain pass' in the Mongolian language. The first plateau lake we met in the Ngari Prefecture was Lake Gongzhutso, 4,877 meters above sea level, the narrow stretch of which extends forward like a straight line.

Ahead was Lake Manasarovar, one of the three sacred lakes of Tibet, flanked by the Kailash Range and the Himalayas, respected as the mother of all rivers in the world. Lake Rakshas is on the other side of the mountain, with no life in the lake. Neither men nor animals drink it. One is freshwater while the other is saltwater; one is sacred while the other is haunted. They lie side by side, but as far apart as heaven and earth.

We were lucky enough to admire Mount Kailash (Kangrinboqe)and Gurla Mandhata at the same time, two mountains looking at each other across Lake Manasarovar. These two mountains and the lake enjoy the most notable status in the minds of Tibetan people, especially Mount Kailash (Kangrinboqe) with a ladder path linking the mountainside and the top. To those pilgrims who make circumambulation around the mountain as the most venerated rituals direct, sacred mountains, in addition to primitive worship from ancient times, have a close association with heaven. They are the abode of faith, and Mount Kailash (Kangrinboqe) is the terminal point.

We stopped at the observation deck of the Tulin (meaning Earth Forest, a form of geological clay formation, which takes the form of pillars and gives the impression of a forest) and Mount Longgada. Though it was not the right time to catch the sunset at Tulin, we were delighted to appreciate the grandeur of the Earth Forest and the gorgeous 'colorful mountain' that looked like an oil painting of magnificence naturally created by splashing colored inks. The mountains riotous with colors breed a small, turquoise-colored pond called Lake Longgatso that never dries up all year round, hailed as 'an angel's tear'.

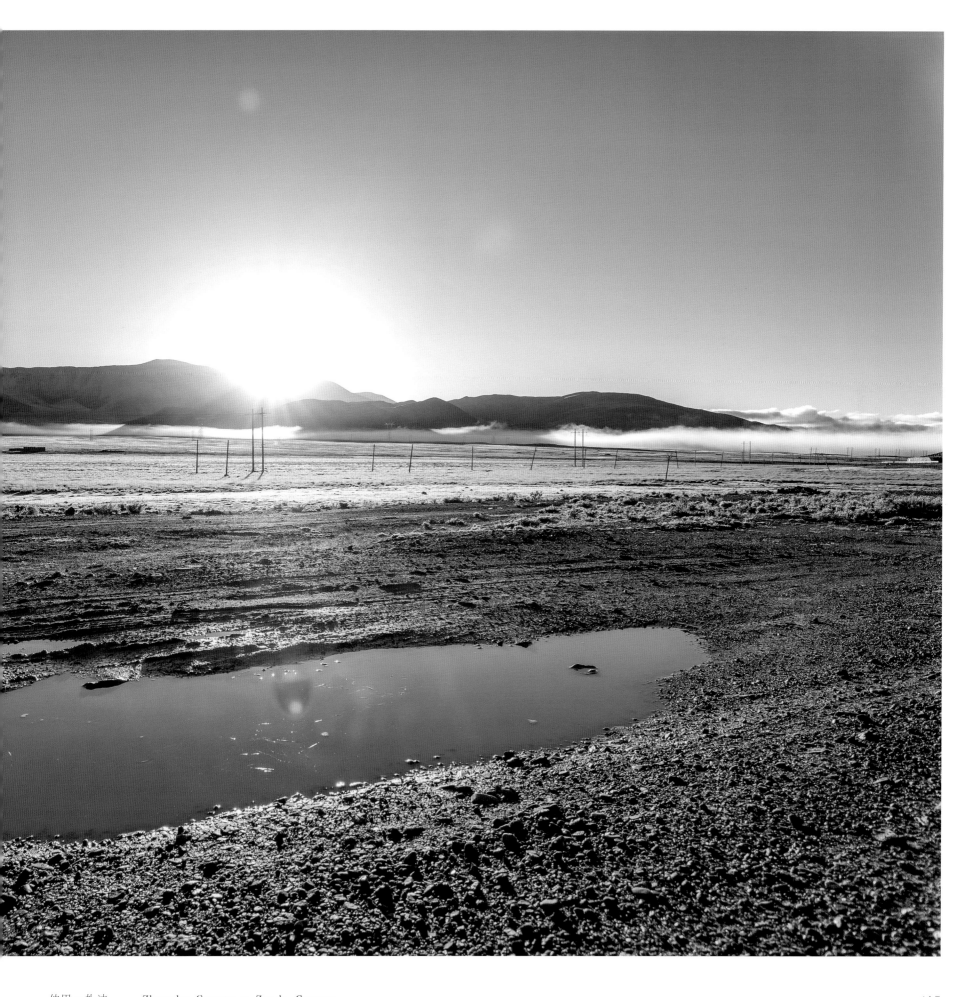

仲巴～札达　　Zhongba County ~ Zanda County

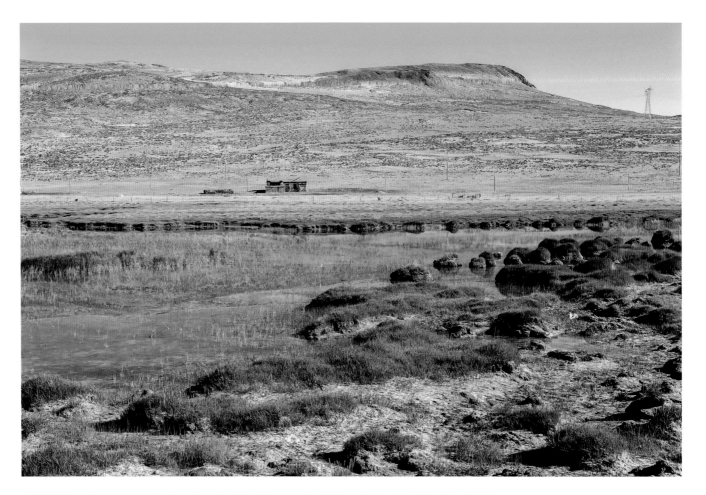

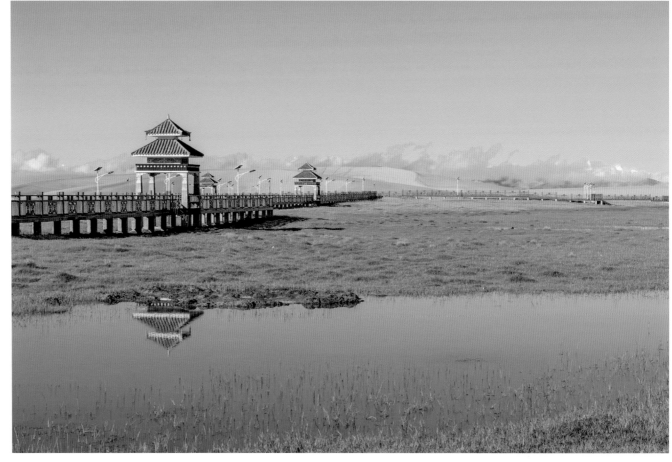

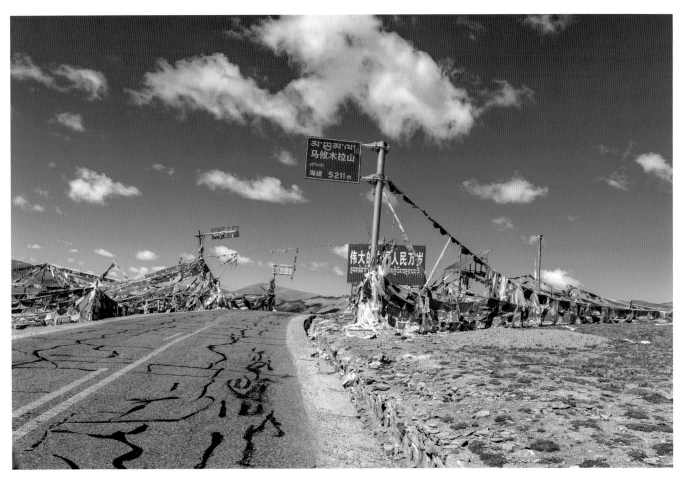

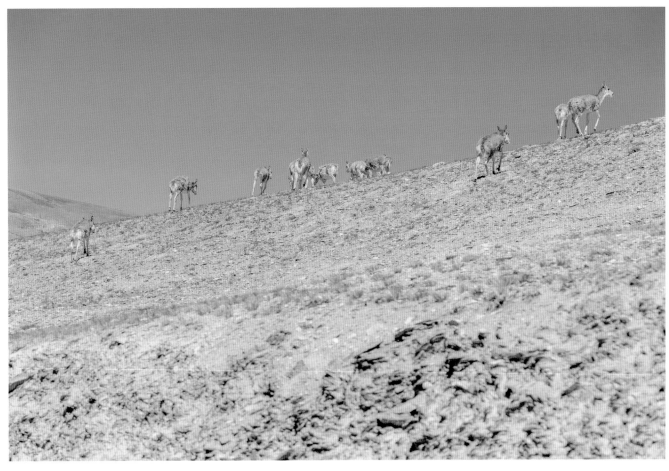

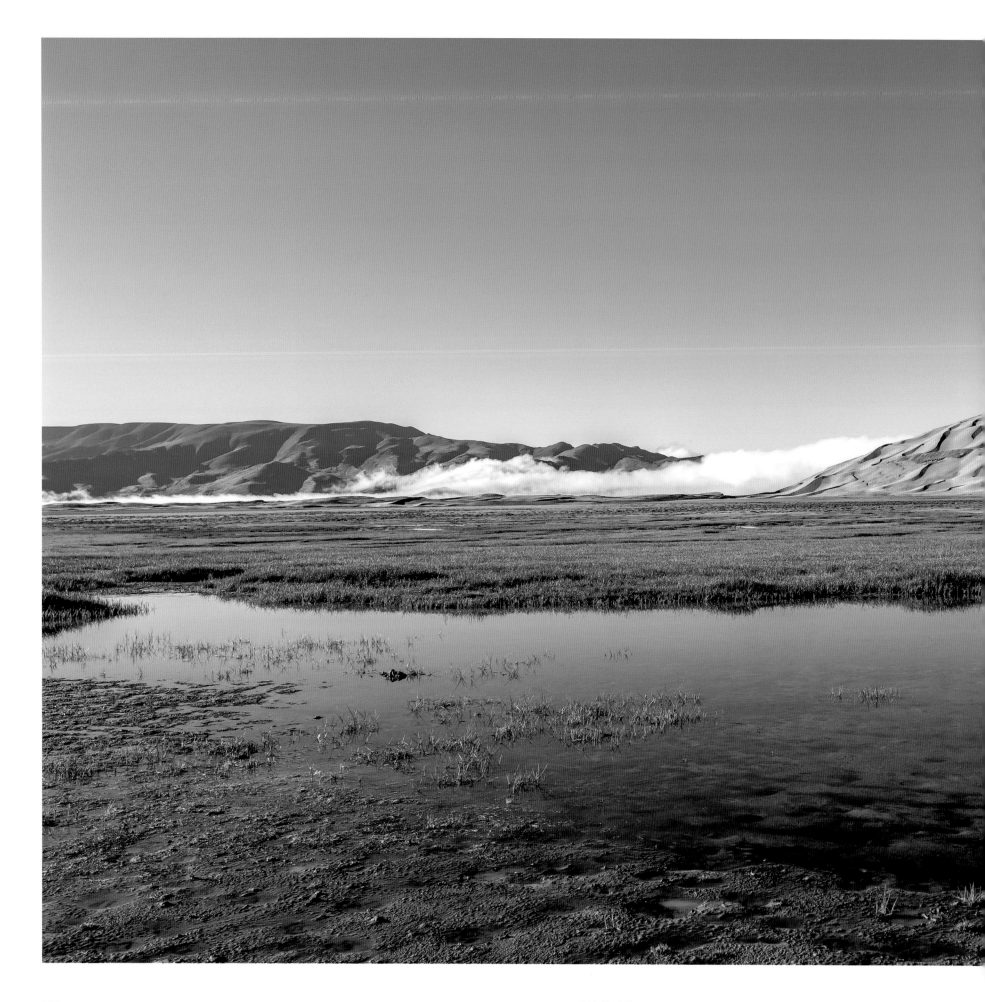

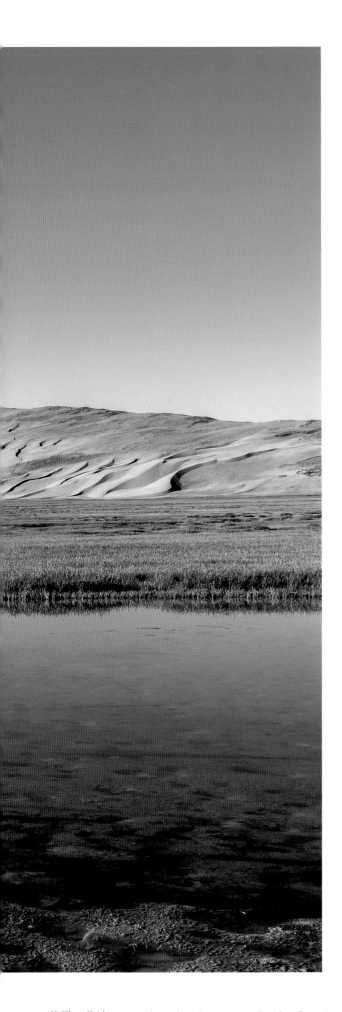

黄沙、湿地与河流、雪山奇妙地组合在一起，
构筑成一幅绚丽多彩的画卷，真是世间少见。
The yellow sand, wetlands, rivers and snow-capped mountains
are wonderfully combined together to form such a splendid and colorful picture,
which is really rare in the world.

西藏三大圣湖之一的玛旁雍措位于冈底斯山脉和喜马拉雅山之间，
它是亚洲四大河流（恒河、印度河、萨特累季河和雅鲁藏布江）的发源地，
因此有"世界江河之母"的美誉，唐朝高僧玄奘在《大唐西域记》中称赞此湖是西天王母瑶池之所在。
Lake Manasarovar, one of the three sacred lakes of Tibet, is flanked by the Kailash Range and the Himalayas,
respected as the mother of all rivers in the world, and breeds Asia's Four Rivers (the Ganges River, the Indus River,
the Satluj River and the Yarlung Tsangpo River). Xuanzang, the eminent monk of the Tang Dynasty,
praised the lake as 'the abode of the Queen Mother of the West' in his Book, *Great Tang Records on the Western Regions*.

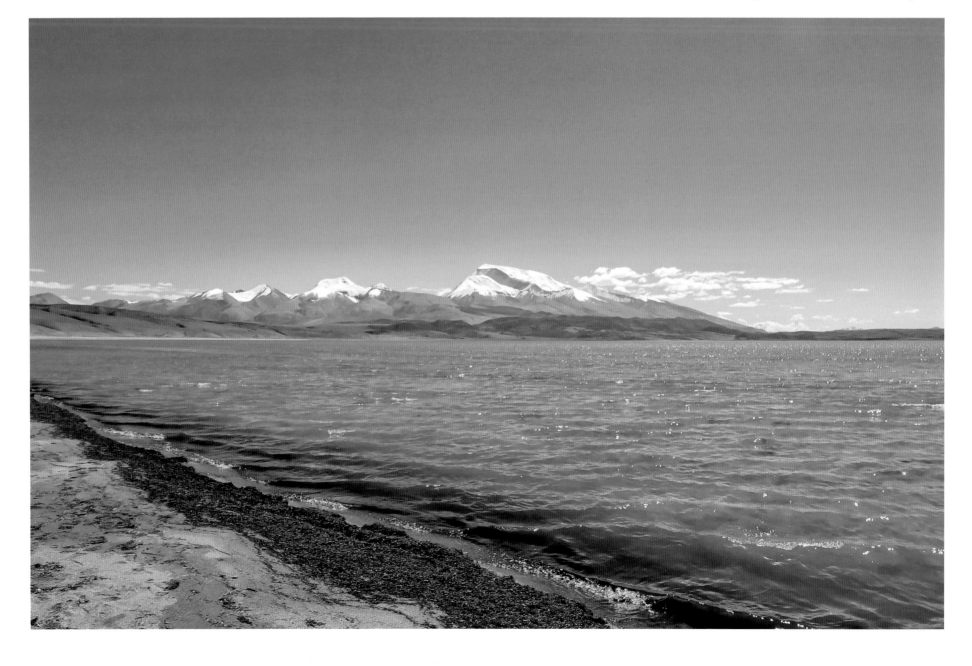

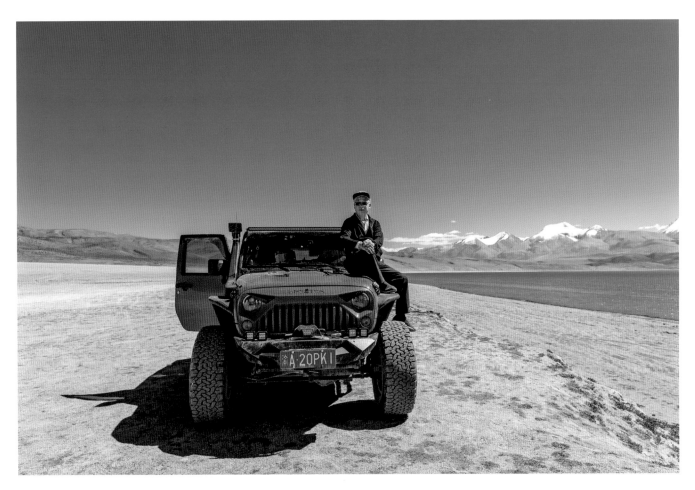

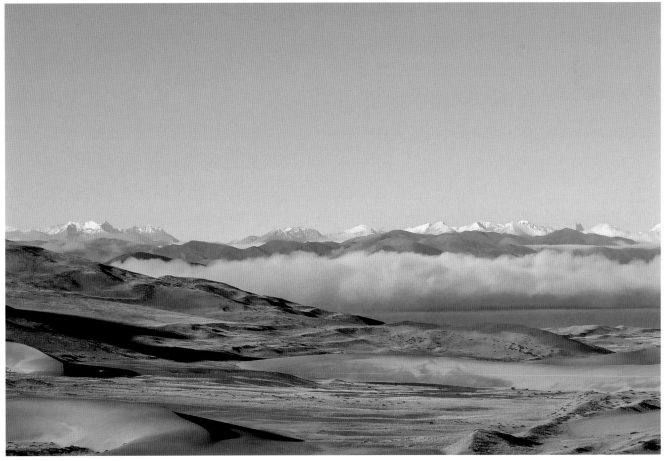

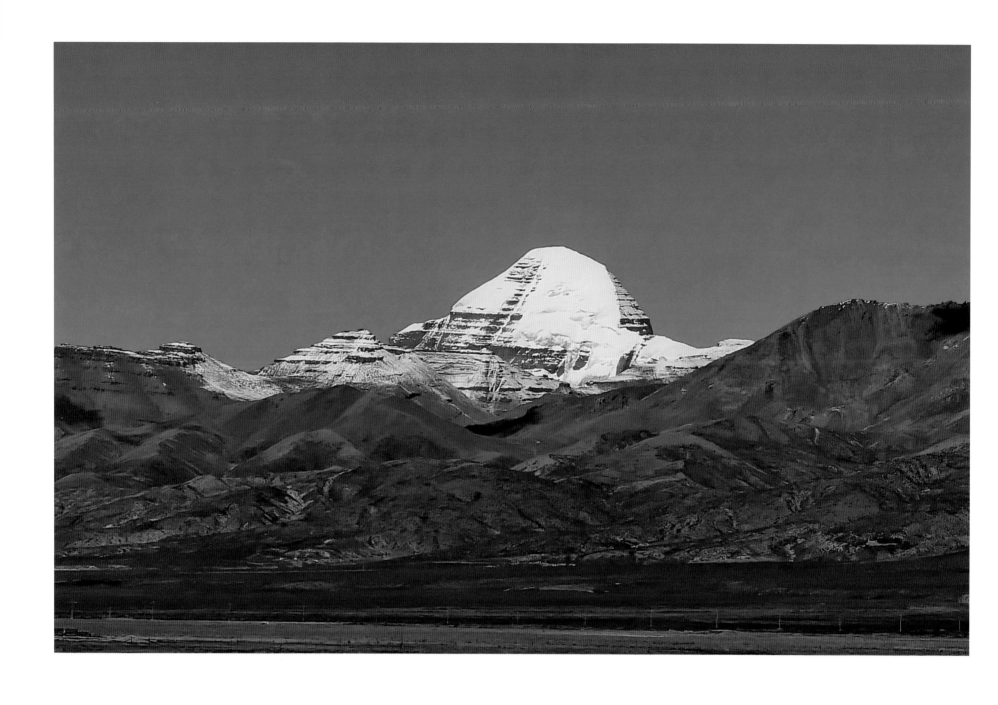

对于转山的朝圣者而言，山是他们信仰的居所，而冈仁波齐就是信仰的终点。

To those pilgrims who make circumambulation as the most venerated rituals direct,
sacred mountains are the abode of faith, and Mount Kailash (Kangrinboqe) is the terminal point.

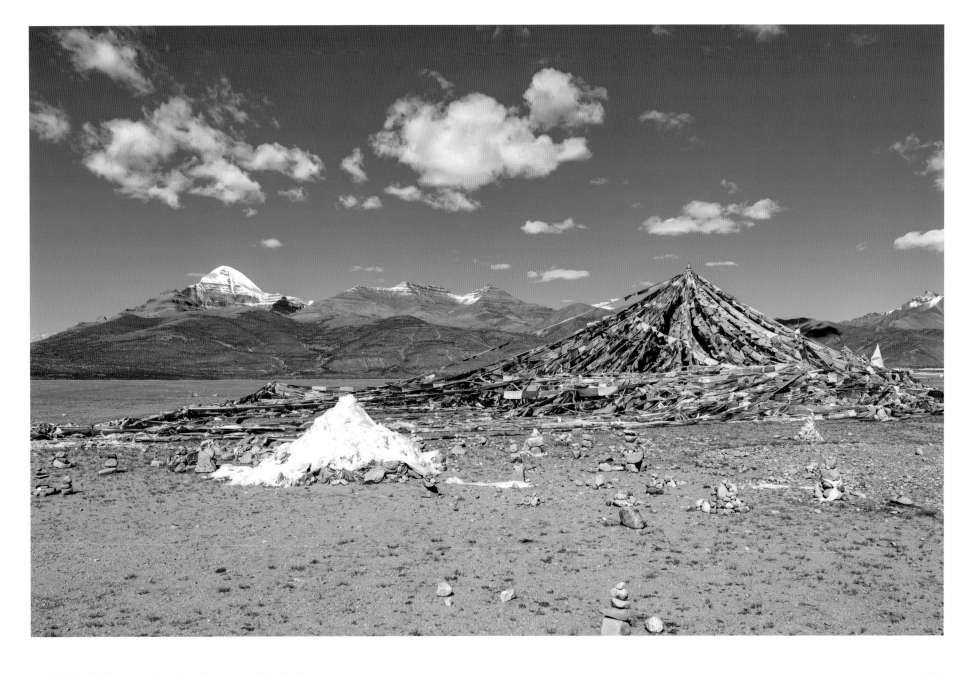

仲巴～札达　　Zhongba County ~ Zanda County

"神山"冈仁波齐就如一座"法器",又像一个白色金字塔,兀然挺立在高原上。
The sacred Mount Kailash seems like a 'dharma ware' or a white pyramid, towering on the plateau.

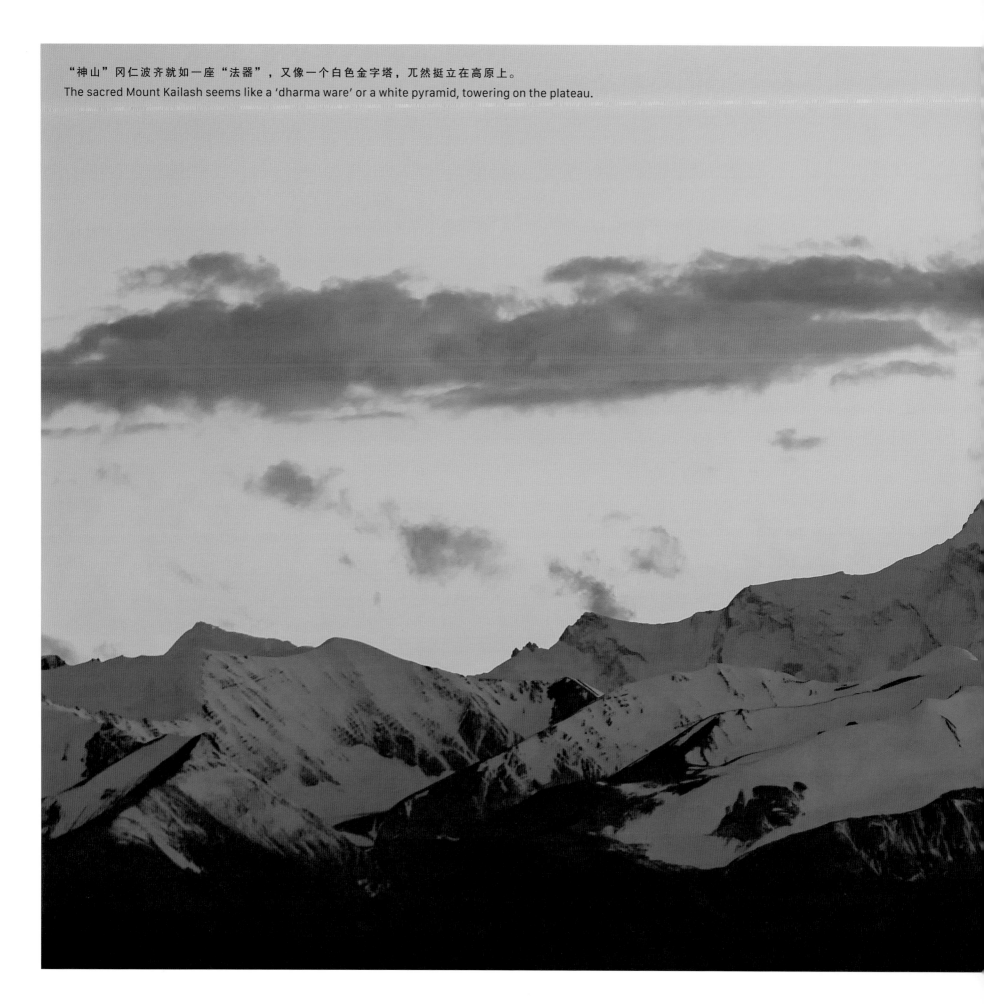

仲巴~札达　　Zhongba County ~ Zanda County

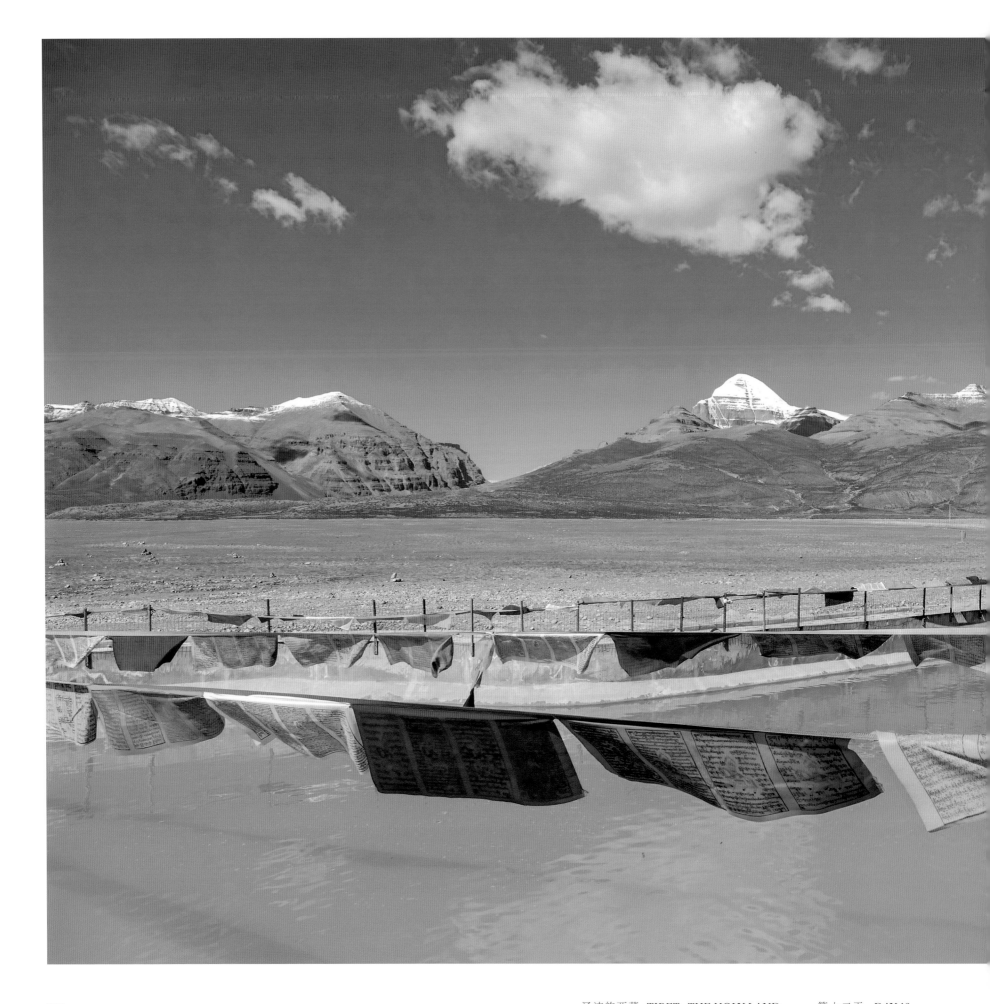

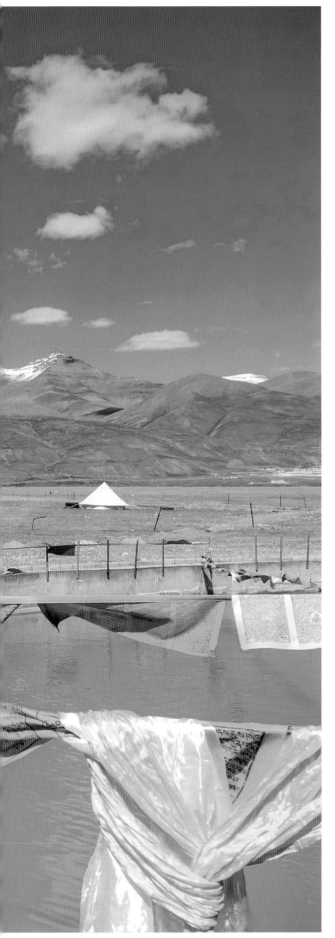

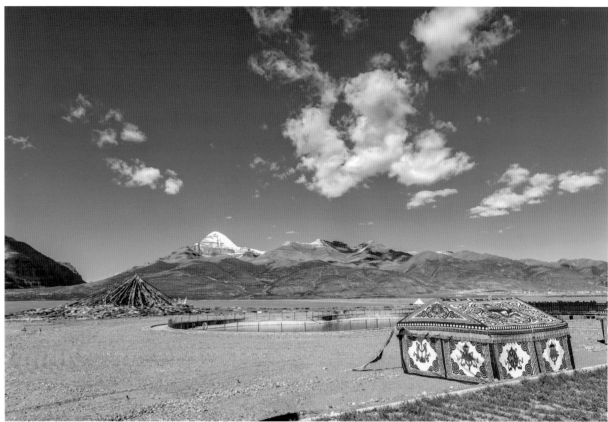

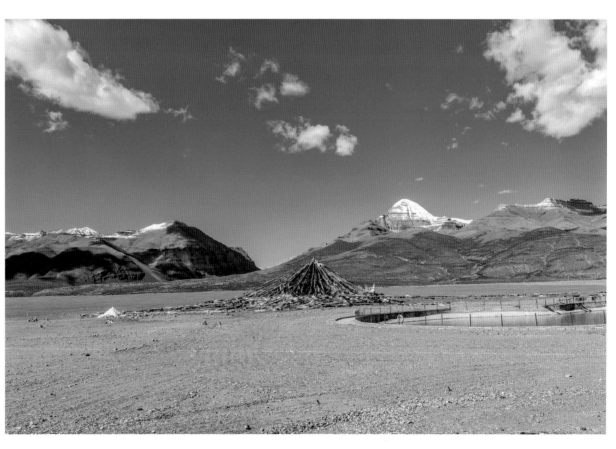

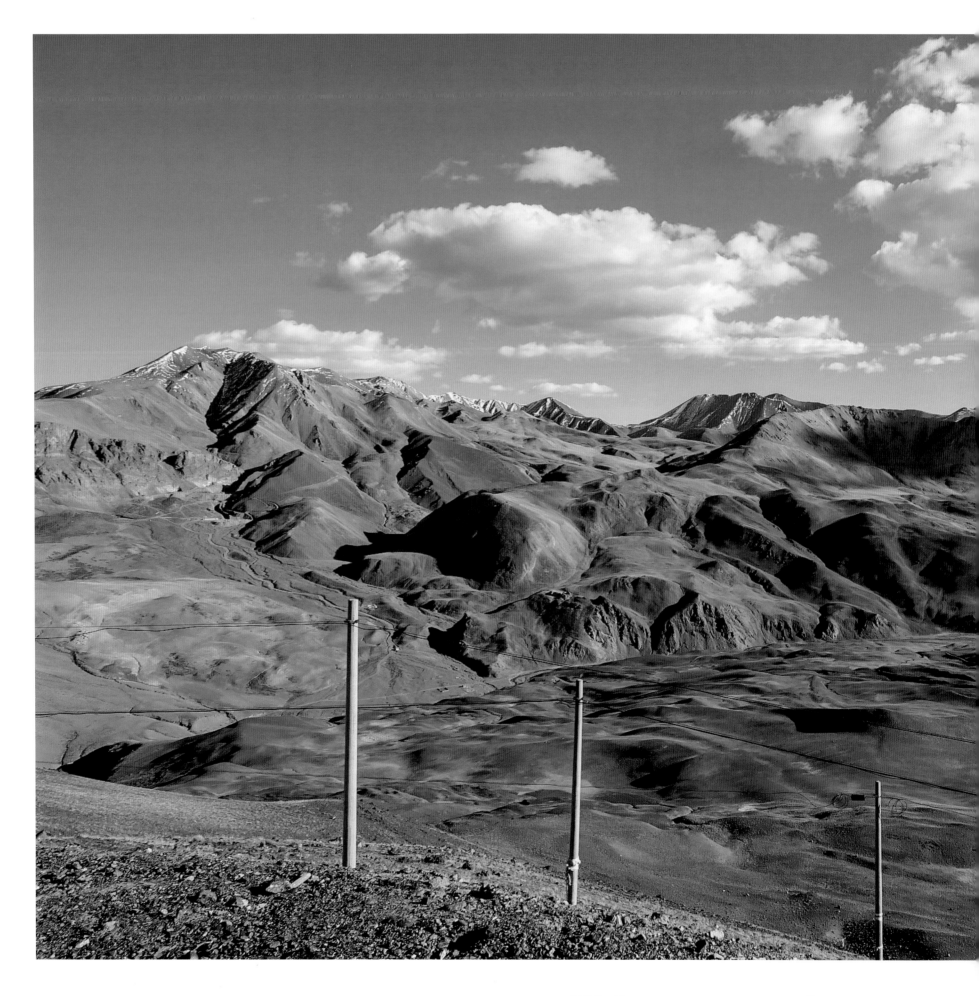

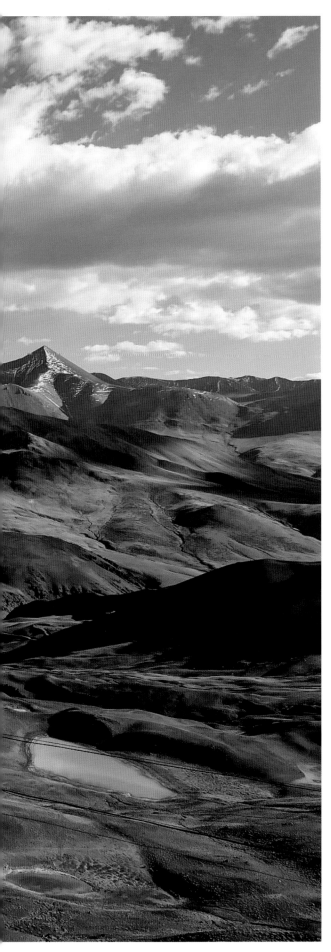

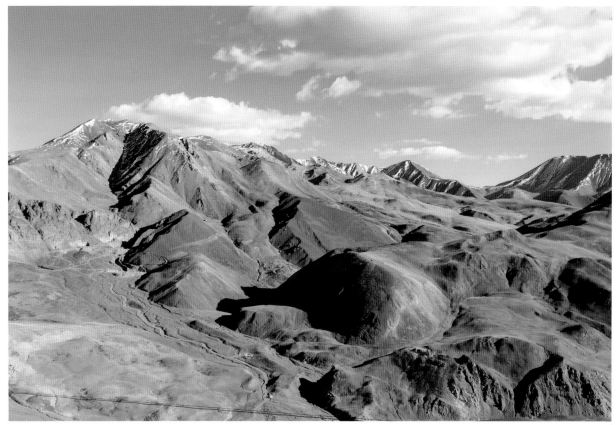

五颜六色的山峦间静卧着一个碧绿的小水塘，名叫"龙嘎措琼"，
被誉为"天使之泪"，也有人称之为"珍珠措"。
The mountains riotous with colors house a small, turquoise-colored pond called Lake Longgatso,
hailed as 'an angel's tear', also known as 'Pearl Lake'.

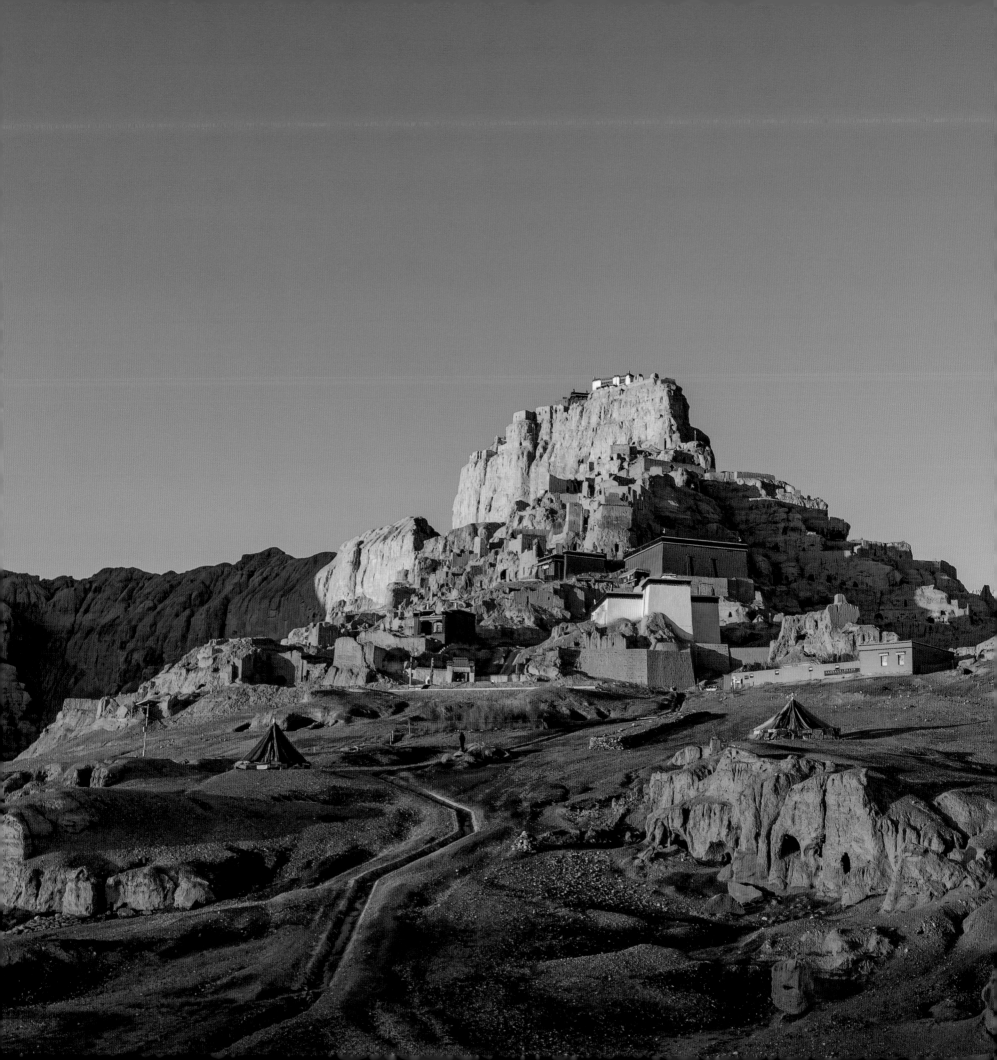

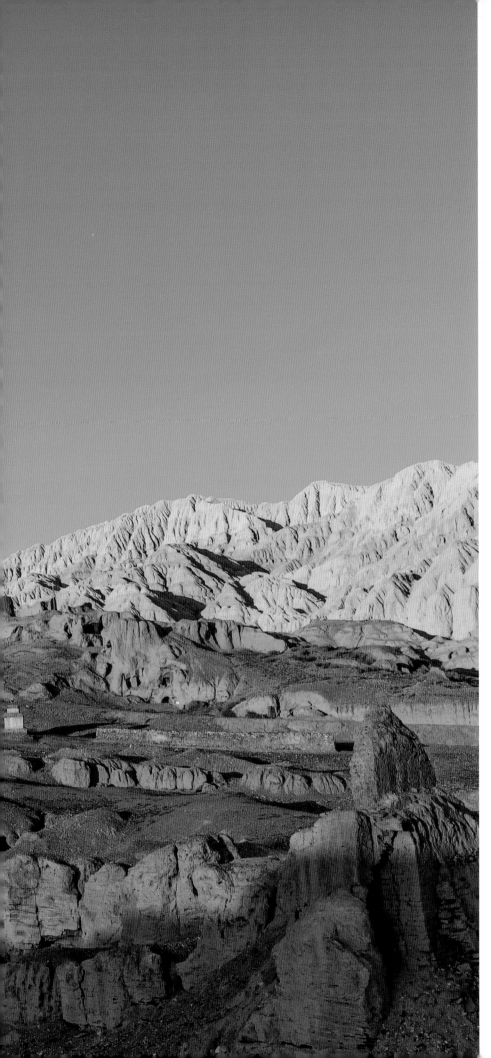

札达～日土

　　札达位于西藏西部、象泉河流域，一千多年前这里曾有一个喜马拉雅山区最繁盛的王国——古格王朝，鼎盛时期领地遍及阿里全境。这样一个有着灿烂文明的王朝，却在三百多年前一夜消失，再无踪迹。直至十九世纪，随着西方探险家、旅行者的进入，才得以重现于世，但其消失的原因至今仍是一个未解之谜。

　　古格王朝的遗址位于县城以西约18公里处的象泉河畔，一大早便已有很多人在此聚集。等待日出的这段空档，我仔细打量这座曾被誉为"东方佛罗伦萨"的王城残迹，依山而建的殿堂、寺庙与屋舍静静矗立，仿佛弥漫一种悲怆的氛围，这也许来自于人们面对任何一个辉煌存在过的文明突然消失而留下的慨叹。今日天气正好，太阳升起时给整个王城遗址洒上了耀眼的金光，有那么一瞬间，眼前的废墟好似在晨曦下重焕生机。可惜繁华早已逝去，徒留日升日落，循环往复。天色大明，我在遗址间拾级而上，这儿曾经的光荣和悲壮，都散成脚下的碎土，或是残破不全的断壁颓垣。曾经的藏尸洞内已不见尸体，只有殿堂里的壁画一直记录着当年的繁盛，给世人留下无限遐想。

　　离开古格王朝遗址后，车子开始穿梭在错落参差、浩浩荡荡几十公里的土林中，此时才真切地意识到土林才是札达的主宰。札达土林是百万年前大湖湖盆及大河河床经历造山运动抬起，再由风雨长期的侵蚀雕琢，才成为现今的特殊地貌。漫山遍野的土林呈现各种各样的姿态，如列兵般注视着远方来客，驱车其间，仿若进入一个异世界，不由感叹大自然的神奇！

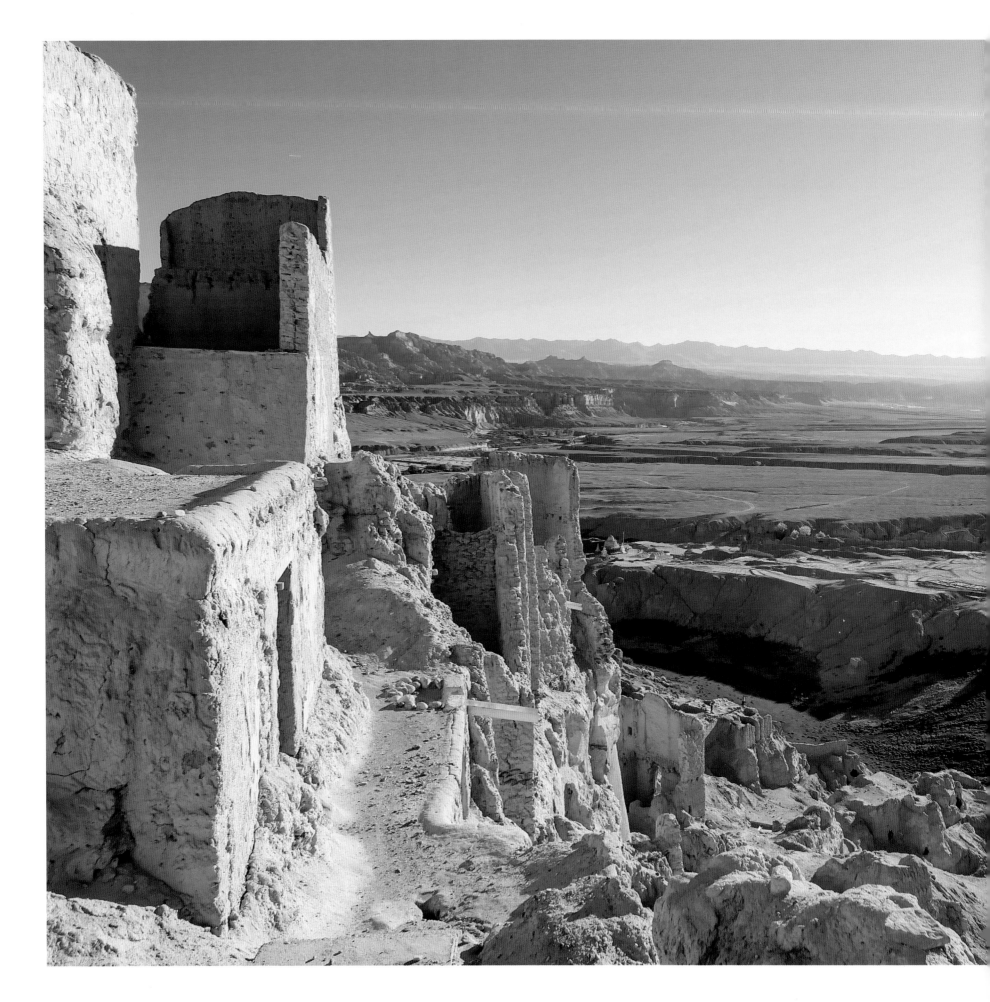

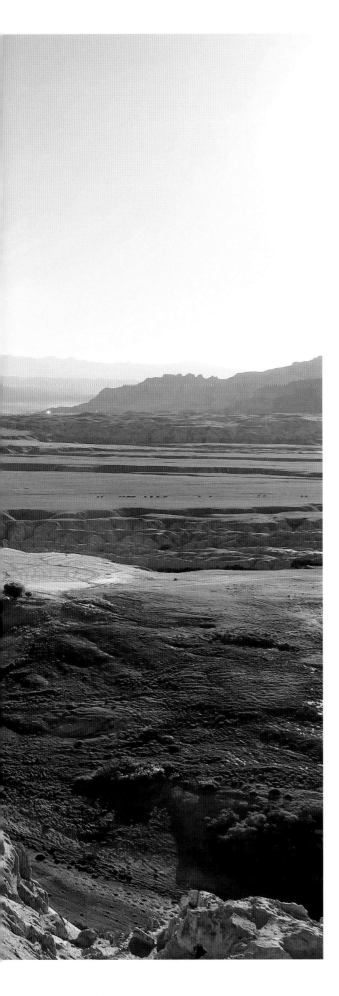

Day 13
Zanda County ~ Rutog County

Zanda County lies in the Sutlej River Valley of western Tibet. More than 1,000 years ago there used to be a kingdom the most prosperous across the Himalayas - the Guge kindom, occupying the whole territory of the Ngari Prefecture in its heyday. But 300 years ago, such a flourishing dynasty with a brilliant civilization suddenly vanished without trace, the historical site of which has been unearthed with the entry of Western explorers and travellers in the 19th century. Its disappearance remains a complete mystery.

The ancient ruins of the Guge kingdom are located about 18 kilometers west of the county town by the Sutlej Valley, where a crowd of early risers had already collected here this morning. Before the sun climbed over the horizon, I looked around the remaining relics of the previous 'Florence of the East', a silence hanging over the palaces, temples and houses with the mountain at the back, a sorrowful atmosphere prevailing among the space. Perhaps no one would remain unmoved when any glorious civilization vanishes off in such an unexplained way. It was a lovely day, and the whole ruins glowed in the light of the rising sun, as if it had come back to life for a brief second. Now previous glory turned out vain, leaving only the remaining ruins accompanied by the endless repetition of sunrise and sunset. I walked up along the stairs as dawn broke, successes and failures in those days all reduced to the heavy dust underneath my feet or dilapidated walls around. Bodies in the charnel cave were nowhere in sight, but the preserved frescoes in the hall have been narrating the long-gone prosperity, attracting deep thoughts about the past.

We departed from the ruins of the Guge kingdom and drove through a wild expanse of the rolling Earth Forest (Tulin) stretching to dozens of kilometers, where I realized for the first time that the Earth Forest was the genuine master of Zanda. The Zanda Earth Forest (or Zha Da Tulin) was the elevation of grand lake basins and riverbeds by the orogenic movement millions of years ago, the special landform of which has been engraved by the water and wind erosion year after year. The Earth Forest covering all around showed a variety of postures, saluting the visitors from afar like soldiers. Driving through the forest was like exploring a wondrous world created by the omnipotent nature.

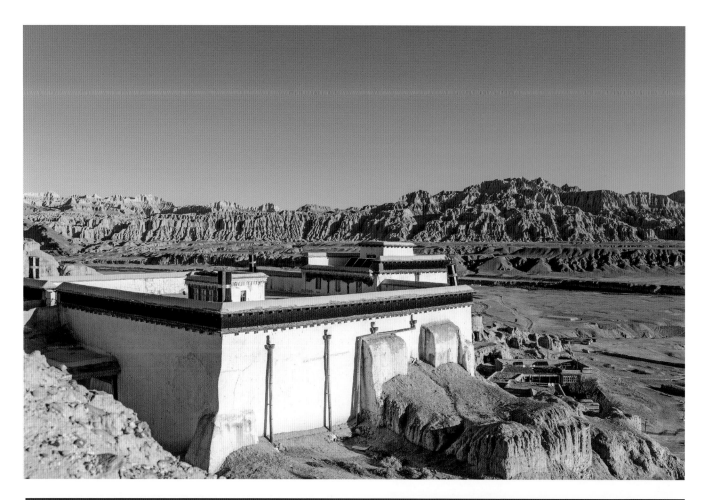

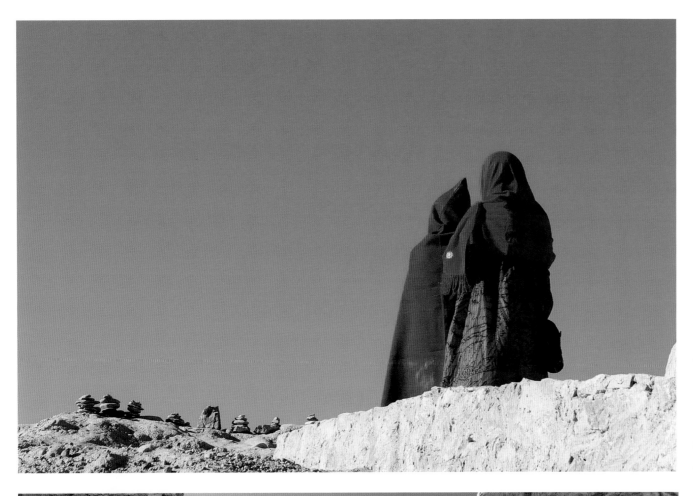

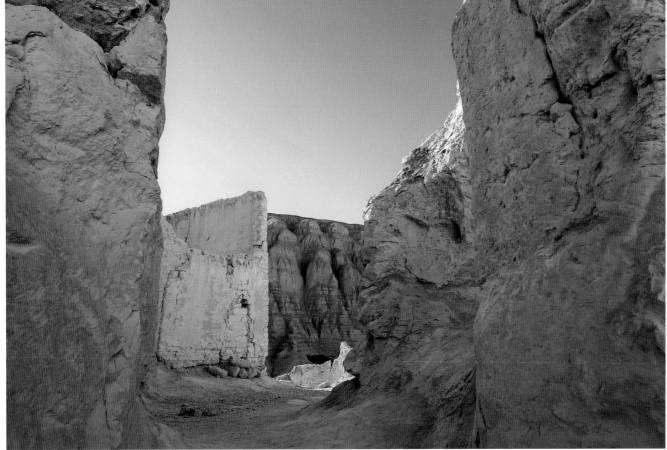

沿着古城遗址拾级而上，
攀爬过程中指点哪些是防御外敌的围墙，
哪些是王室贵族的殿堂，
哪些是供平民百姓居住的，
哪里是红庙、白庙以及轮回庙，
还有著名阴森恐怖的藏尸洞。

As I walked up along the stairs of the ancient ruins, I pointed to the places that used to be the defensive walls against foreign enemies, the palaces for the royal family, the dwellings for the common people, the Red Temple, the White Temple, the Temple of Reincarnation, as well as the famous eerie cave where the corpses were hidden.

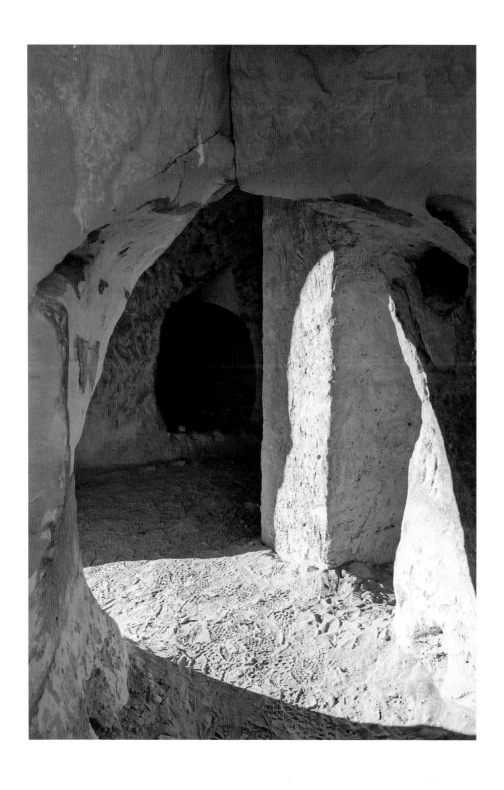

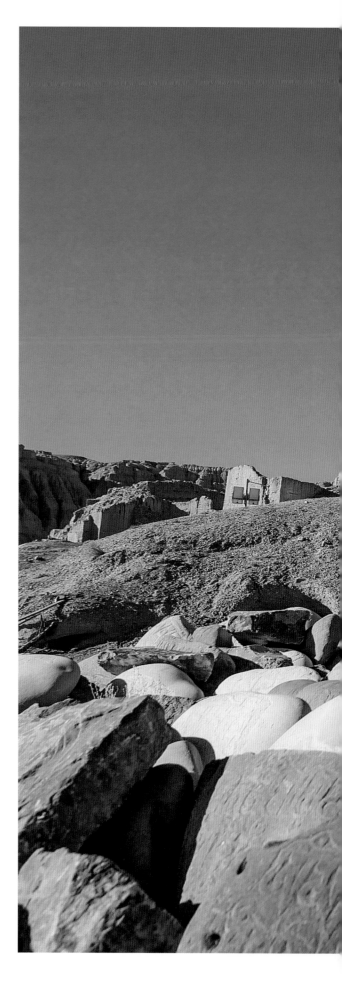

这儿曾经的光荣和悲壮，都散成脚下的碎土，或是残破不全的断壁颓垣，给世人留下无限遐想。
Now previous glory turned out vain,
leaving only the remaining ruins accompanied by the endless repetition of sunrise and sunset,
attracting deep thoughts about the past.

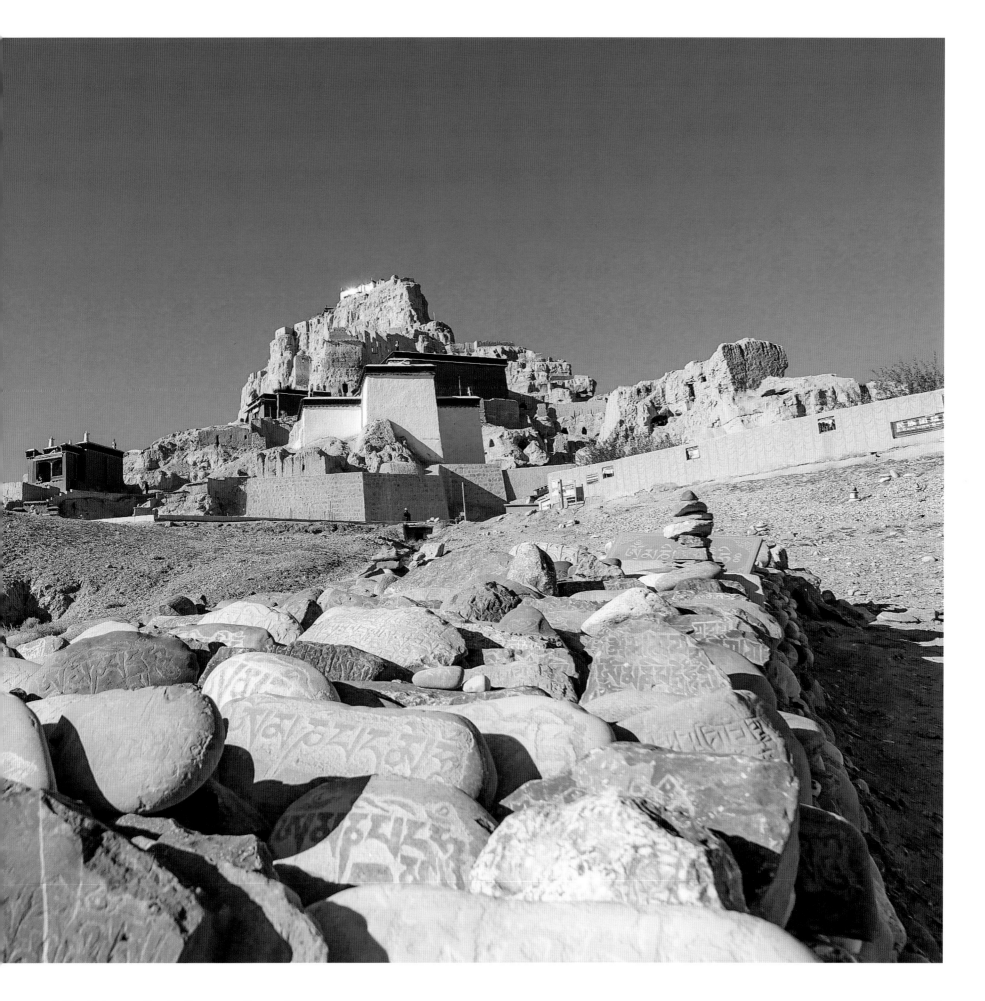

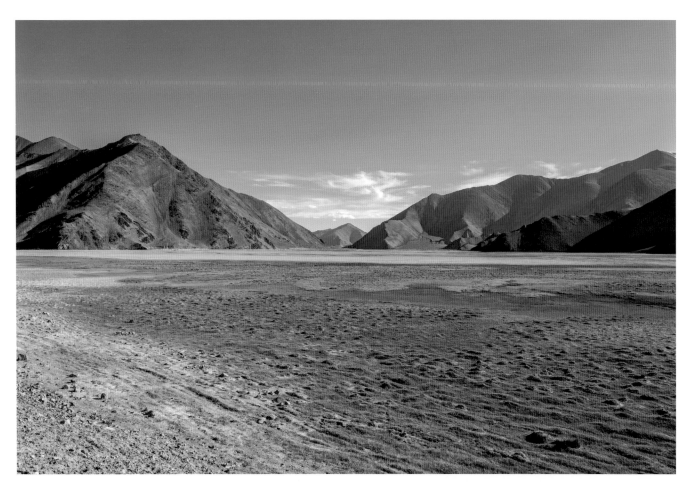

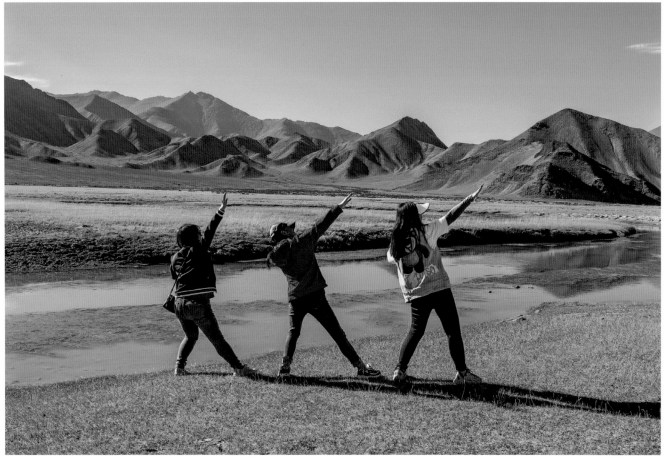

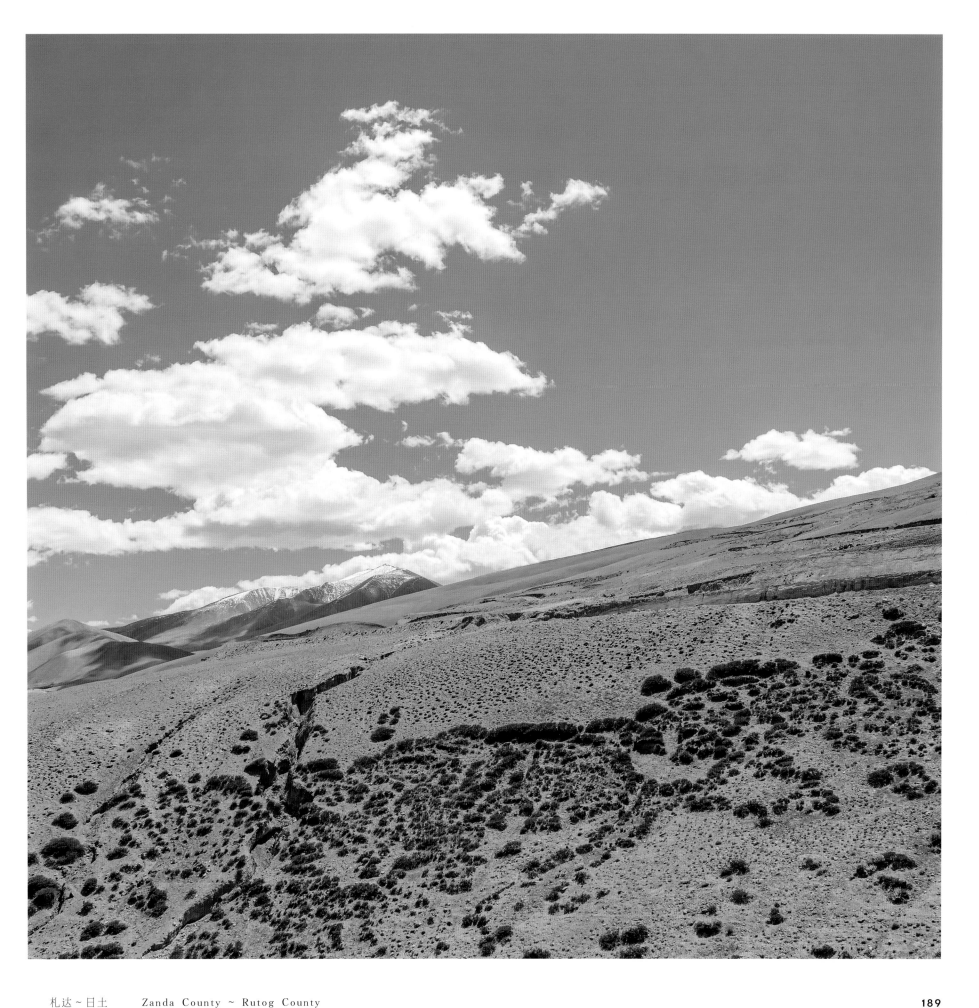

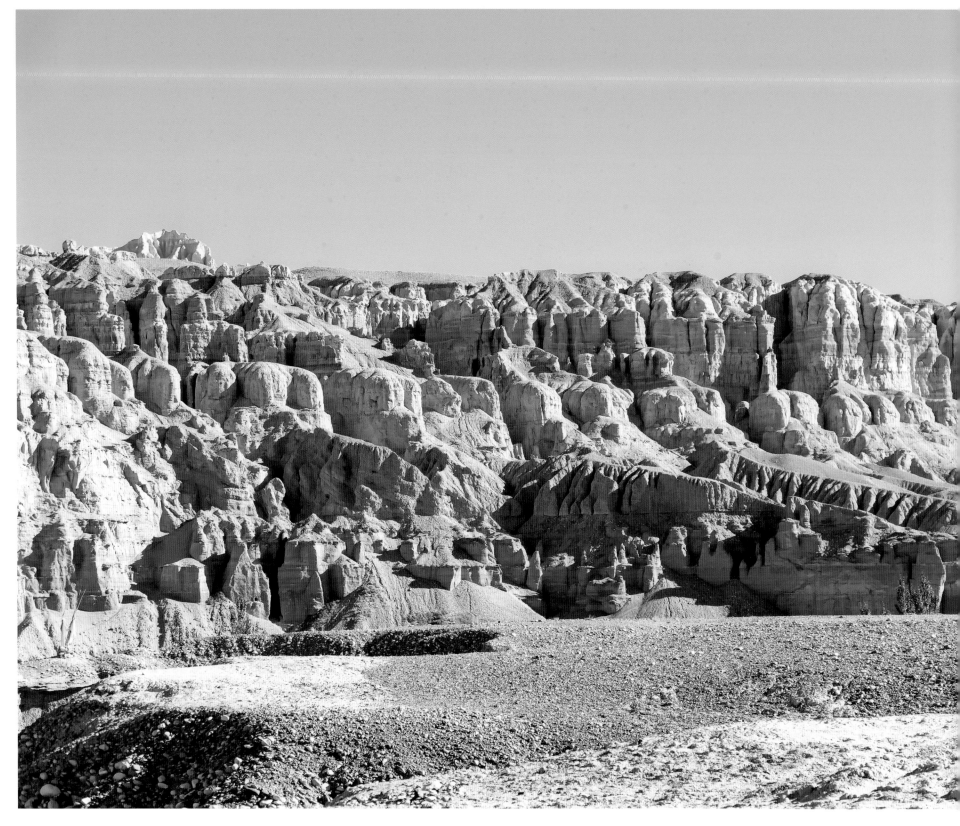

土林与峡谷被大自然的变迁雕琢成各种各样的姿态，层层叠叠，延绵不绝。

A rolling stretch of Earth Forest (Tulin) and canyons have been sculpted by the great nature into various forms.

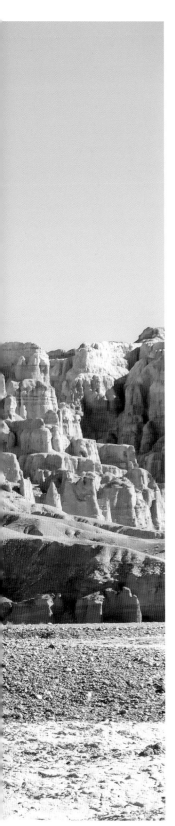

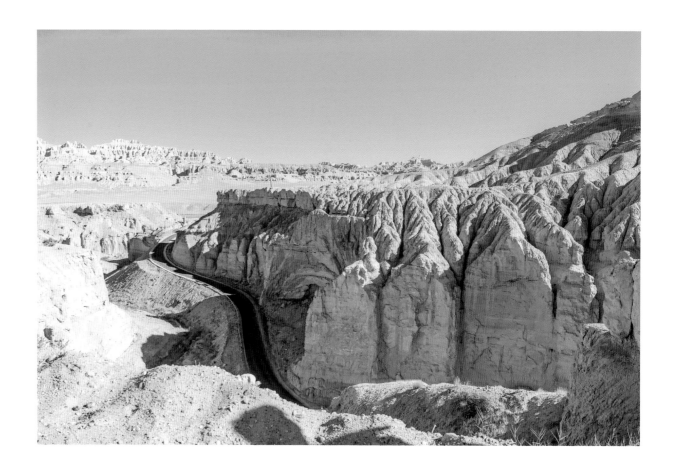

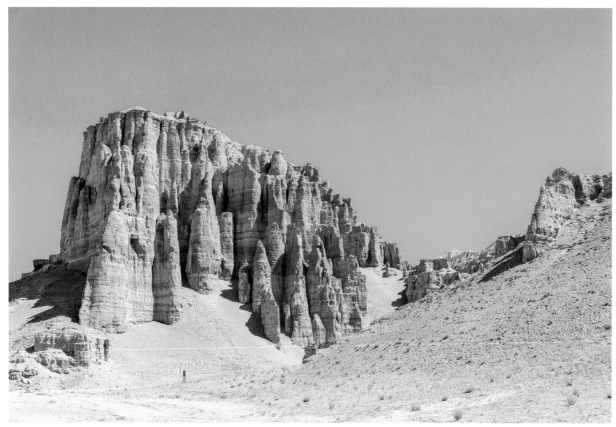

札达～日土　　Zanda County ~ Rutog County

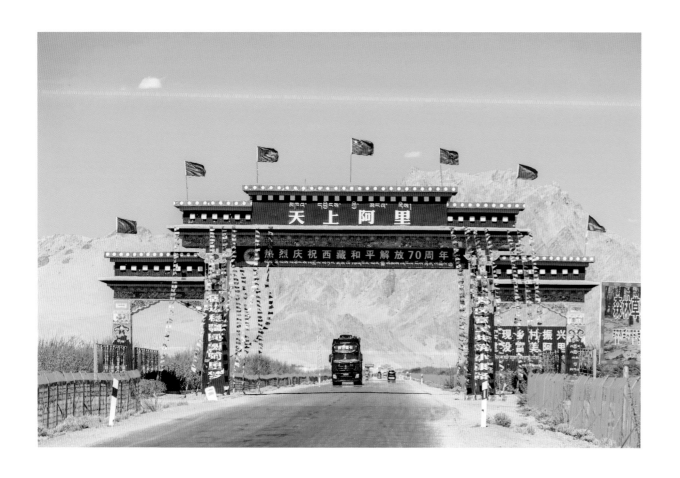

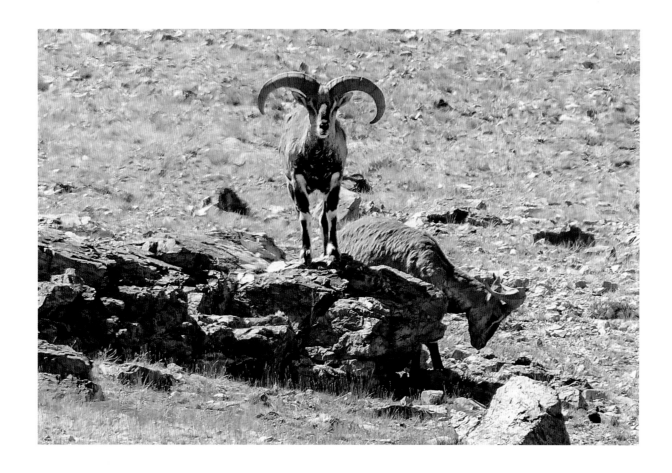

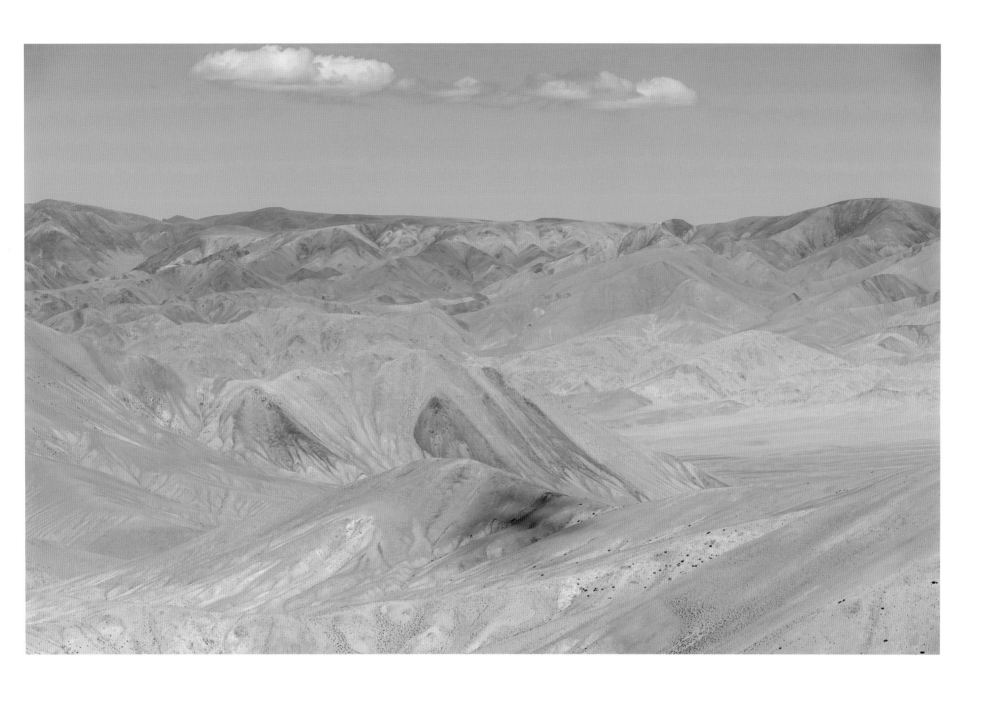

札达～日土　　Zanda County ~ Rutog County

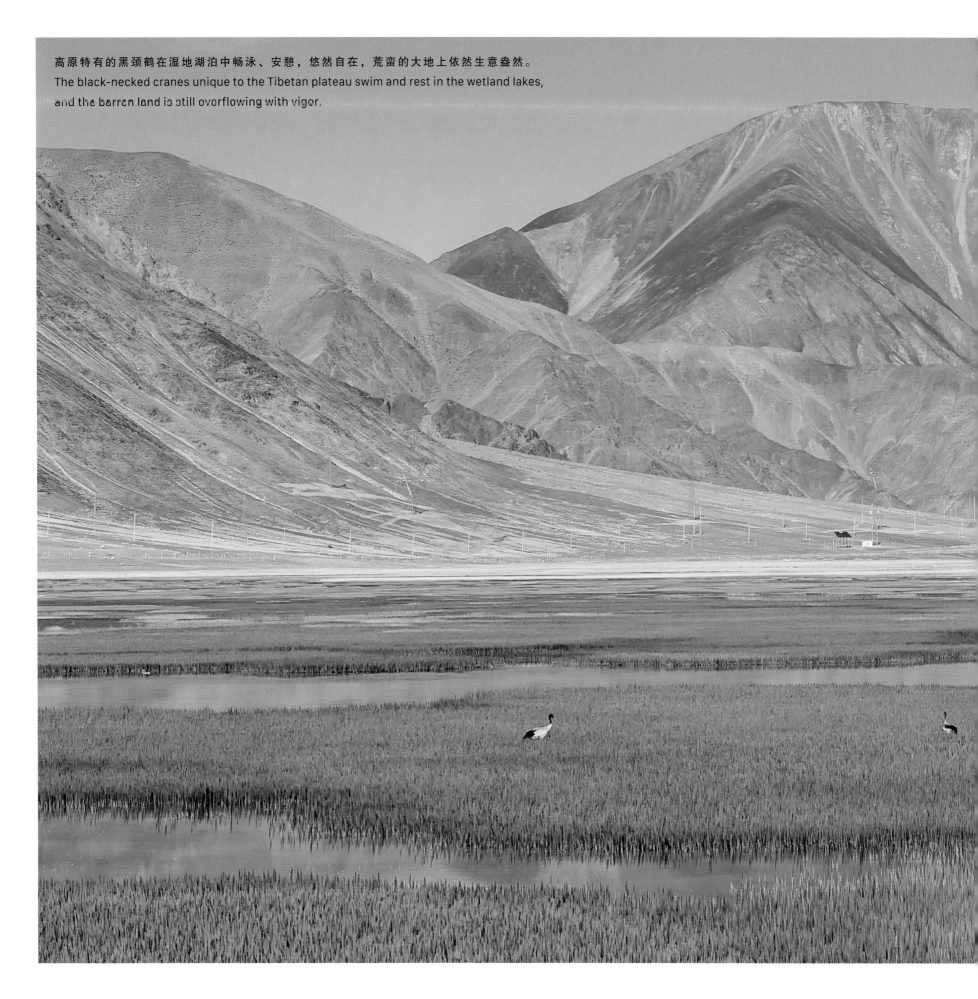

高原特有的黑颈鹤在湿地湖泊中畅泳、安憩，悠然自在，荒蛮的大地上依然生意盎然。
The black-necked cranes unique to the Tibetan plateau swim and rest in the wetland lakes, and the barren land is still overflowing with vigor.

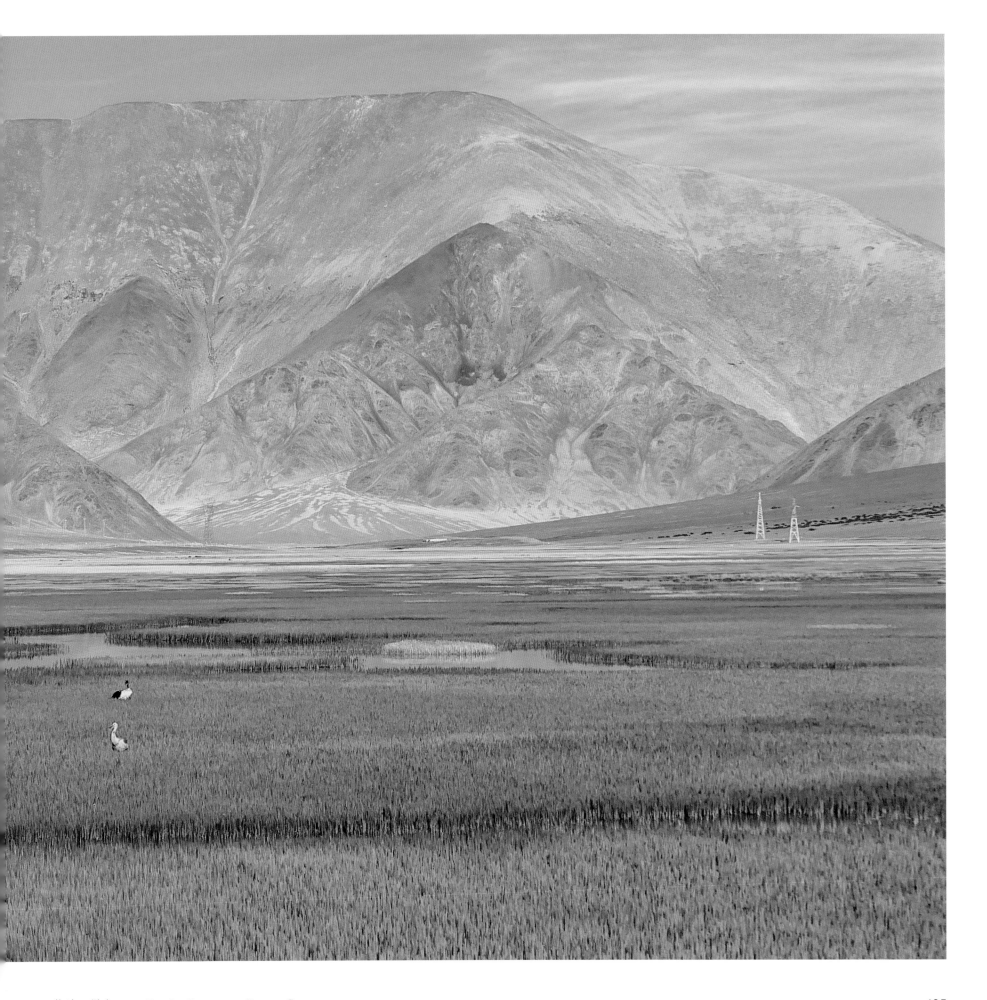

札达～日土　　Zanda County ~ Rutog County

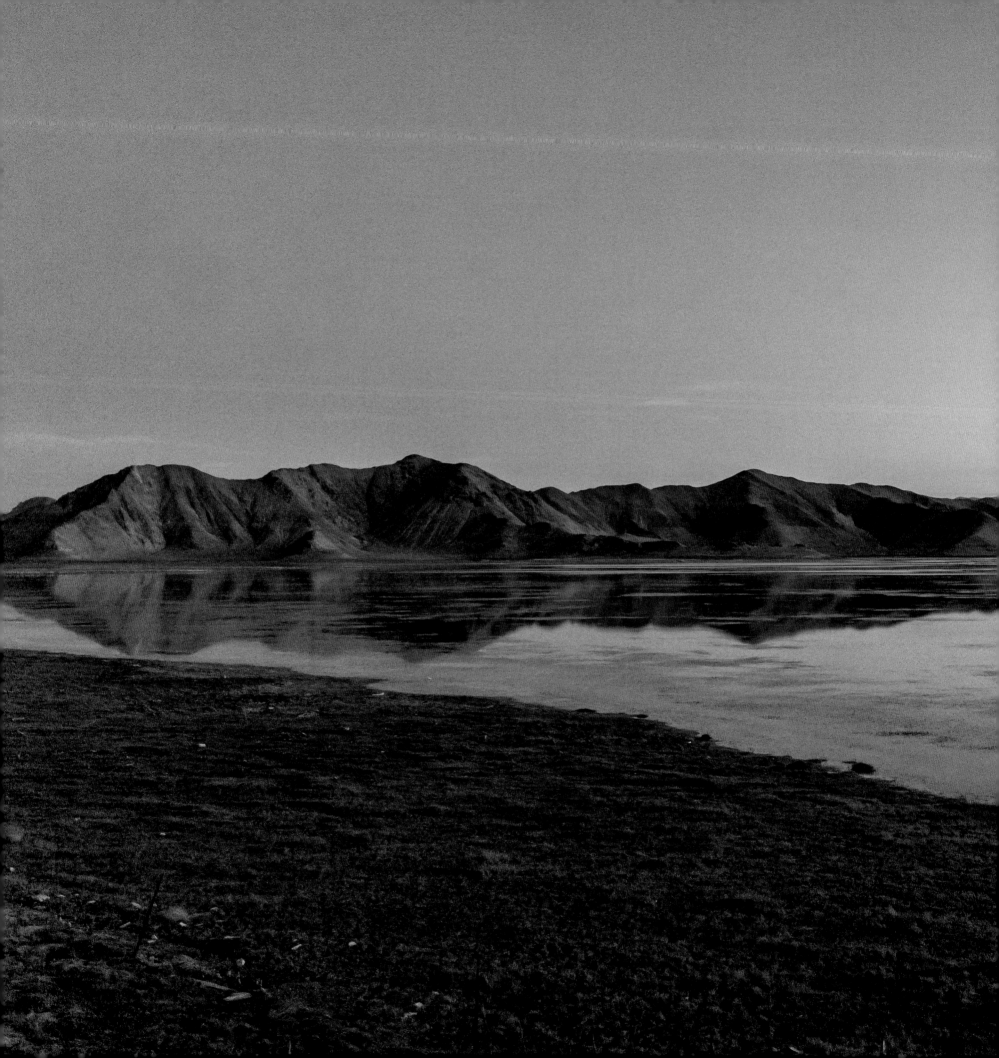

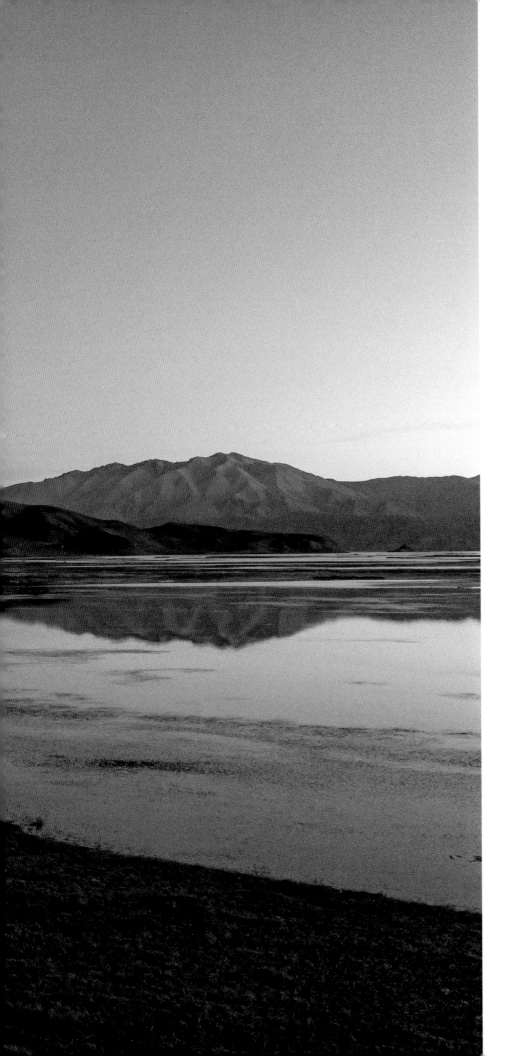

日土～革吉

　　班公湖海拔 4,242 米，大部分位于日土境内，一小部分则在印度控制的克什米尔地区，在军事上是个比较敏感的地带。这座湖的神奇之处在于由东向西依次为淡水、半咸水、咸水，位于中国境内的是淡水，湖上鱼跃鸟飞，自然风光无限；另一边则是咸水，寸草不生。同一湖的水，却呈现两种截然不同的状态，真可谓大自然带来的惊喜。

　　班公湖的日出比较晚，让我们得以悠闲等待太阳升起。这次并未携带三脚架，我以手持的方式拍摄日出的整个过程，足足有十多分钟，效果居然不错，很是欣喜。阳光从湖边的山尖上，一点一点的投射下来，直至日照金山。班公湖也随之慢慢地苏醒，各种鸟类早已纷纷聚集到湖岸边，昭示新一天的到来。

　　朝阳升起后，我们沿岸边小路绕行过日土湿地，行走在 219 国道上。在阿里，有水的地方就是生命的绿洲。倒映着蓝天白云的一片片水洼包裹在黄色草甸里，还有远处干旱的山坡、大地辽阔，粗犷与婉约并存。

Day 14
Rutog County ~ Gegyai

Pangong Lake, situated at an elevation of 4,242 meters, portions most of its extent within Rutog County and the rest in India-controlled Kashmir, a relatively sensitive zone in military strategy. The lake boasts a miraculous composition of fresh water, brackish water, and salt water from the east to the west, and the fresh-water area with enchanting scenery lies within Tibet China, where birds fly in the air and fish jump in the water, while the other side is deserted. Two distinct ecosystems coexist in the same lake, what an incredible creation from nature!

The sun rose later from Lake Pangong, which allowed us more time to welcome its arrival. Without bringing a tripod to steady the camera this time, I held it in my hands for more than 10 minutes to capture the entire process of the sunrise and was quite satisfied with the final work. Rays of golden sunlight first kissed over the lakeside mountain top then flooded inch by inch across the whole mountain. The Pangong Lake woke up from a good sleep, twittering birds of all kinds around the lake welcoming the beginning of a brand-new day.

Against the rising sun, the lakeside path around the Rutog wetland sent us to National Highway 219. In Ngari Prefecture, where there is water, there is life. The yellow marshland with distant arid mountains at the background was patched with water puddles mirroring the azure sky and white clouds. The mixed beauty, both rough and graceful, featured this extensive ground.

初露旭日从后山冉冉升起，把漆黑大地燃亮起来，金光万道，日照金山。
The morning sun rose from the back of the mountain and lit up the darkness, with its scattering splendor flooding the whole mountain.

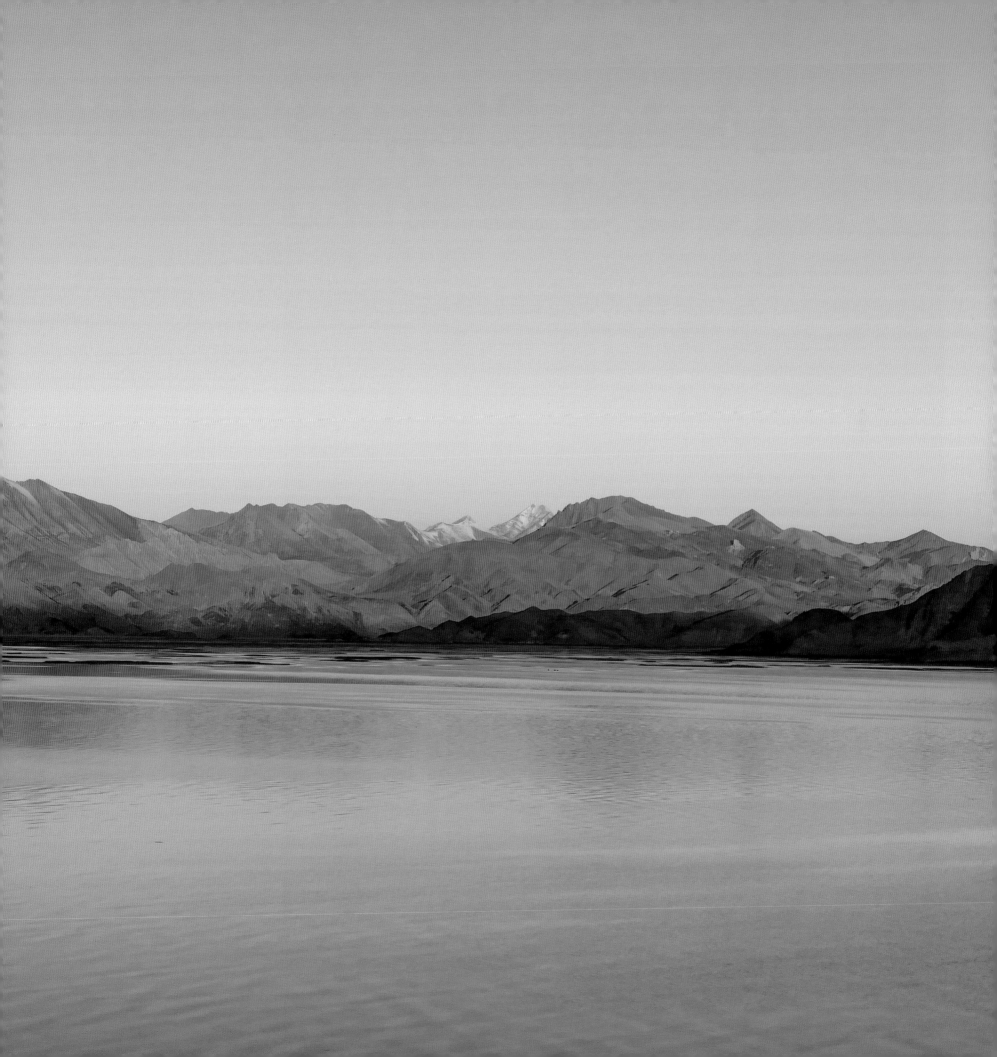

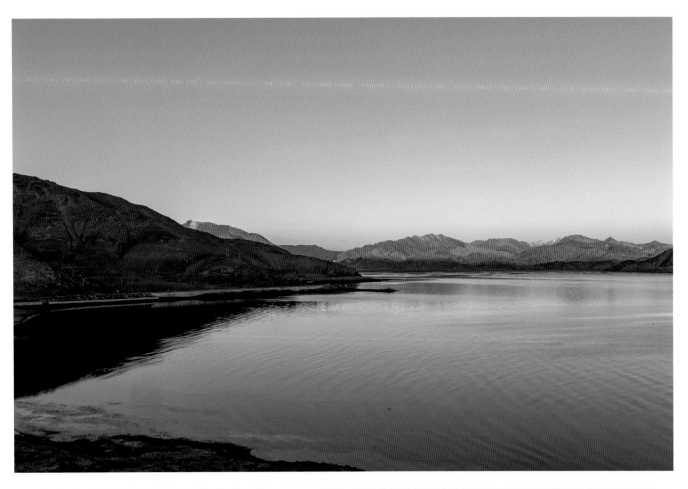

班公湖的日出比较晚，
让我们得以悠闲等待太阳升起。
The sun rose later from Lake Pangong,
which allowed us more time
to welcome its arrival.

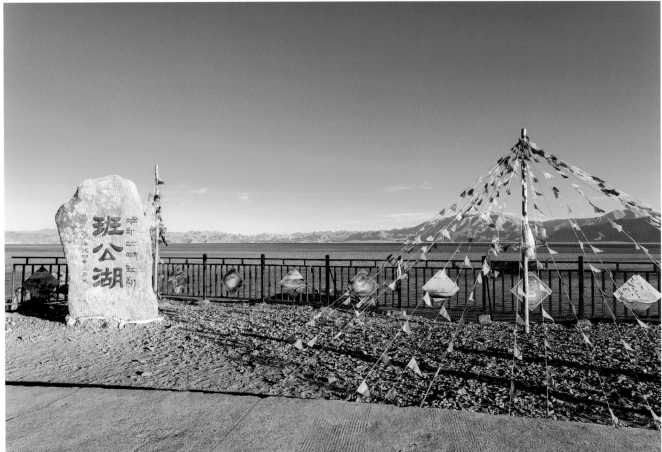

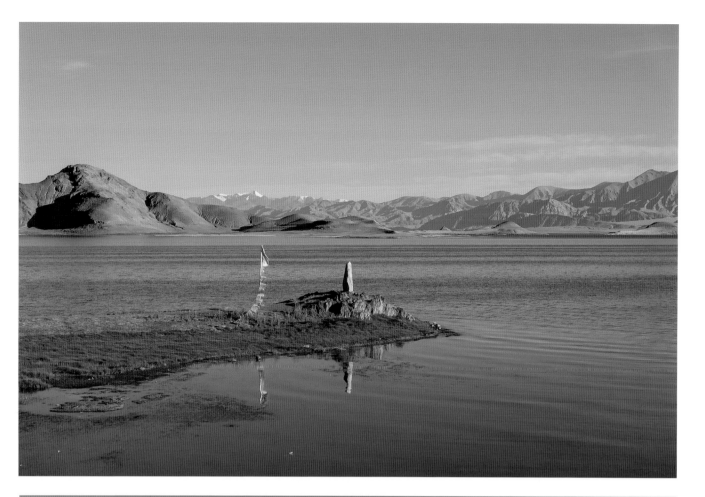

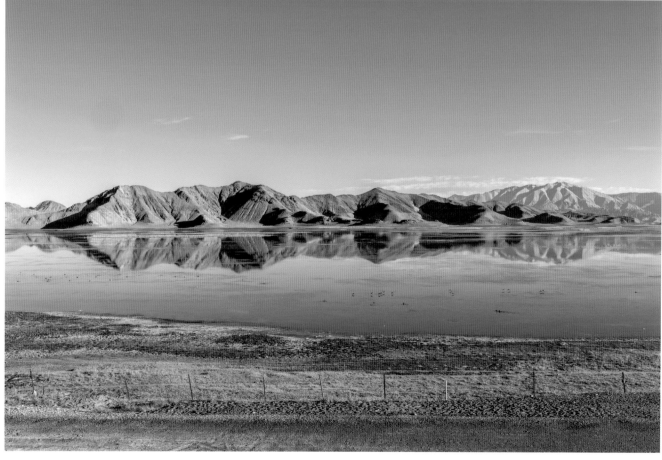

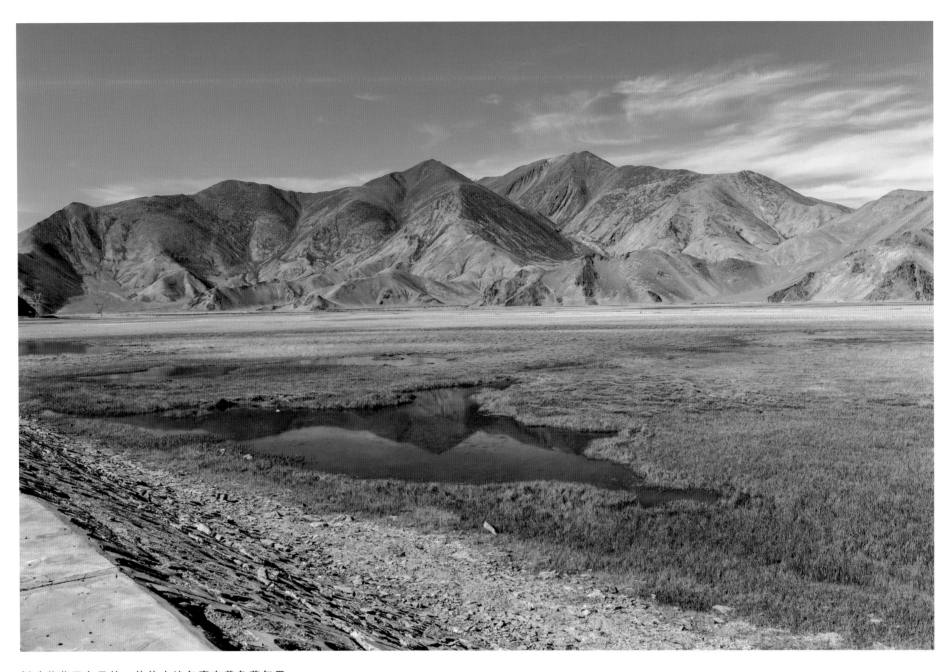

倒映着蓝天白云的一片片水洼包裹在黄色草甸里，
在阿里，有水的地方就是生命的绿洲。
In Ngari Prefecture, where there is water, there is life.

日土～革吉　　Rutog County ~ Gegyai

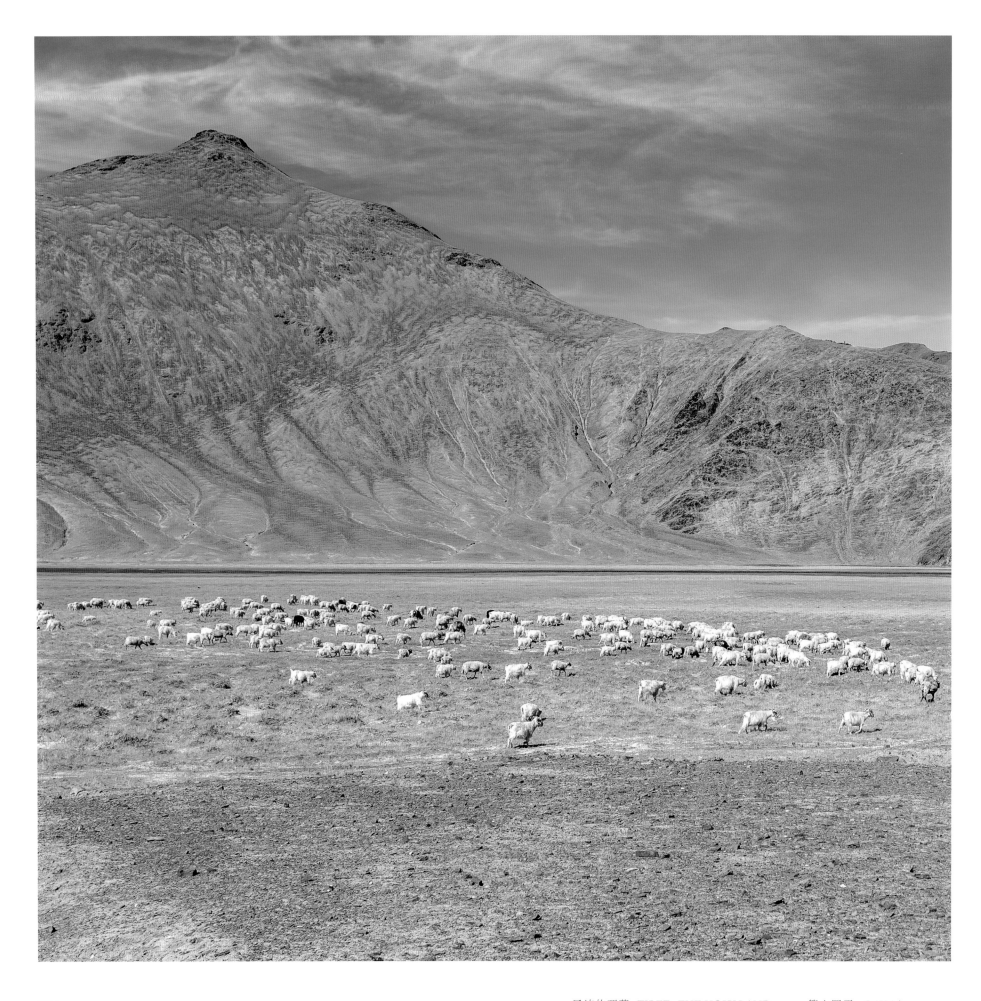

圣洁的西藏 TIBET : THE HOLY LAND 第十四天 DAY 14

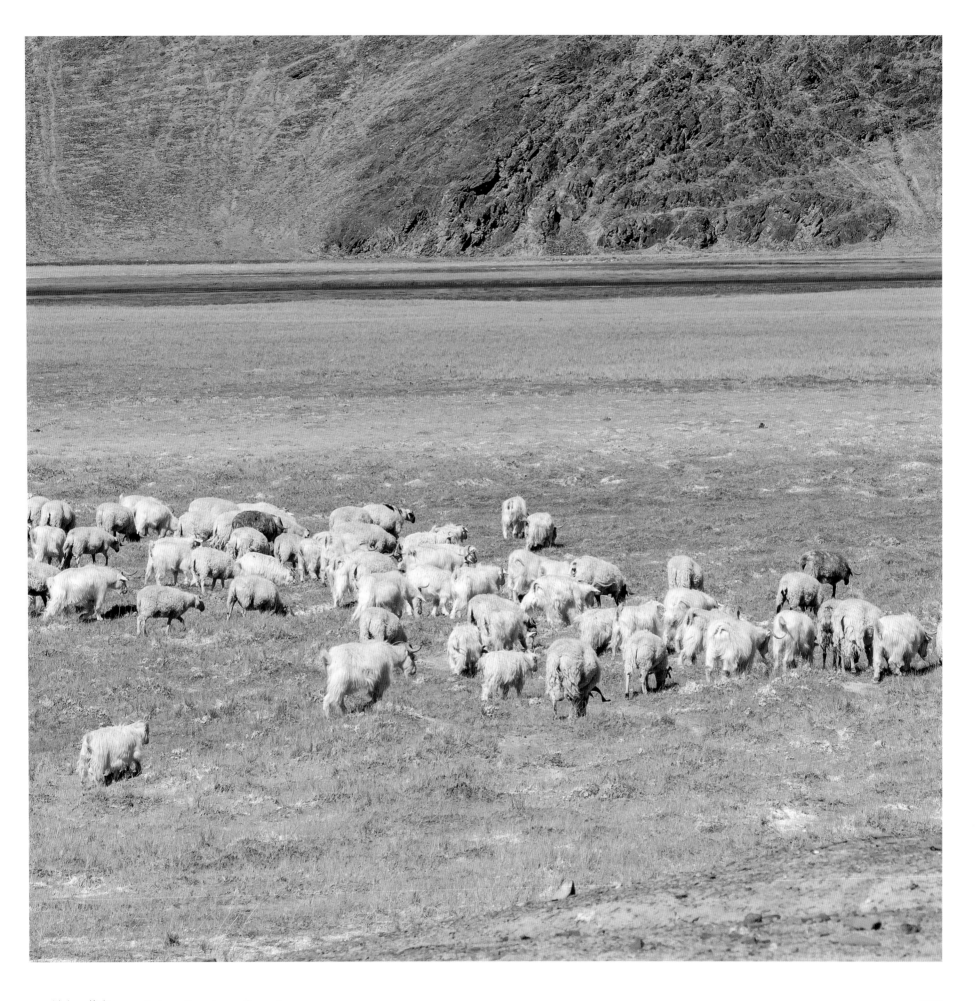

日土～革吉　　Rutog County ~ Gegyai

革吉 ～ 措勤

第十五天

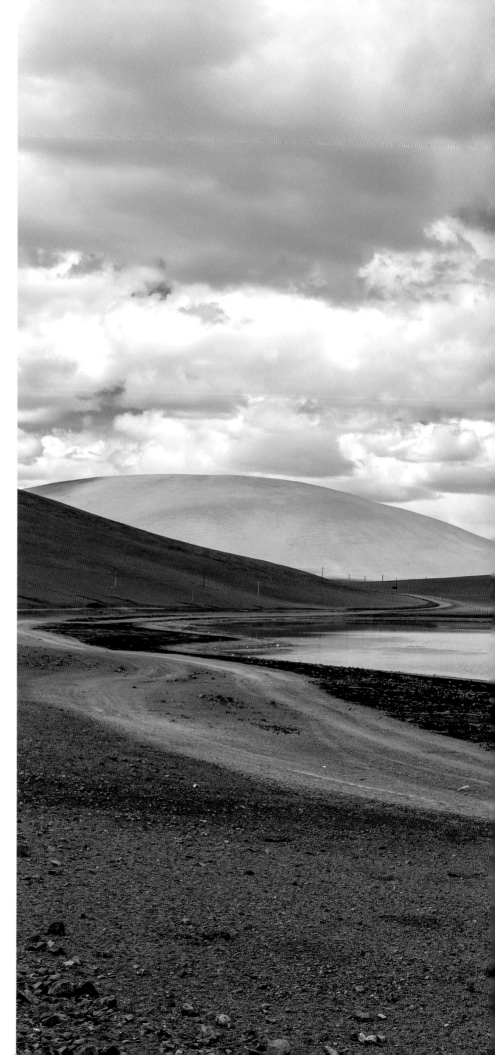

革吉在藏语中意为"美丽富饶的土地"，地处羌塘高原（藏北高原）大湖盆区，因是狮泉河的源头，潺潺河川流淌穿行其中。这片高原辽阔无际又平静荒凉，很难用语言来准确描述所看到的景致，目之所及尽是广袤无垠的旷野。

扎布耶茶卡的出现，为这样一片荒野增添一抹别致的色彩。青海的"天空之镜"茶卡盐湖几乎人尽皆知，但对于西藏这座盐湖却知之甚少。扎布耶茶卡是世界第三大锂盐湖，也是世界上唯一以"天然原生碳酸锂"形式存在的盐湖，因其所含化学成分的不同呈现出不同的色泽，像是天上的彩云之境。

离开扎布耶茶卡之后的路段又是无尽的荒野，车窗两边的山坡、土地几乎没有植被，地表展现出原本的样子，只有不定时出现的藏野驴、藏羚羊、土拨鼠等各种野生动物，牠们才是这里真正的主人。

今天是个特殊的日子——中秋节，在这合家团圆的日子里，我们一度在荒原中迷路。当满月在冈底斯山脉徐徐升起，四下一片荒芜，天上的月光却是流动的。我们停下车，在一片寂静中感受"明月出天山，苍茫云海间"中传达的意境，深深体会到了时间之无涯，空间之无尽，"今人不见古时月，今月曾经照古人"。

事实上，我们不仅在月光下迷了路，车子还陷入沙土中，在无人的旷野上等待救援。而这，又是另一段故事了。

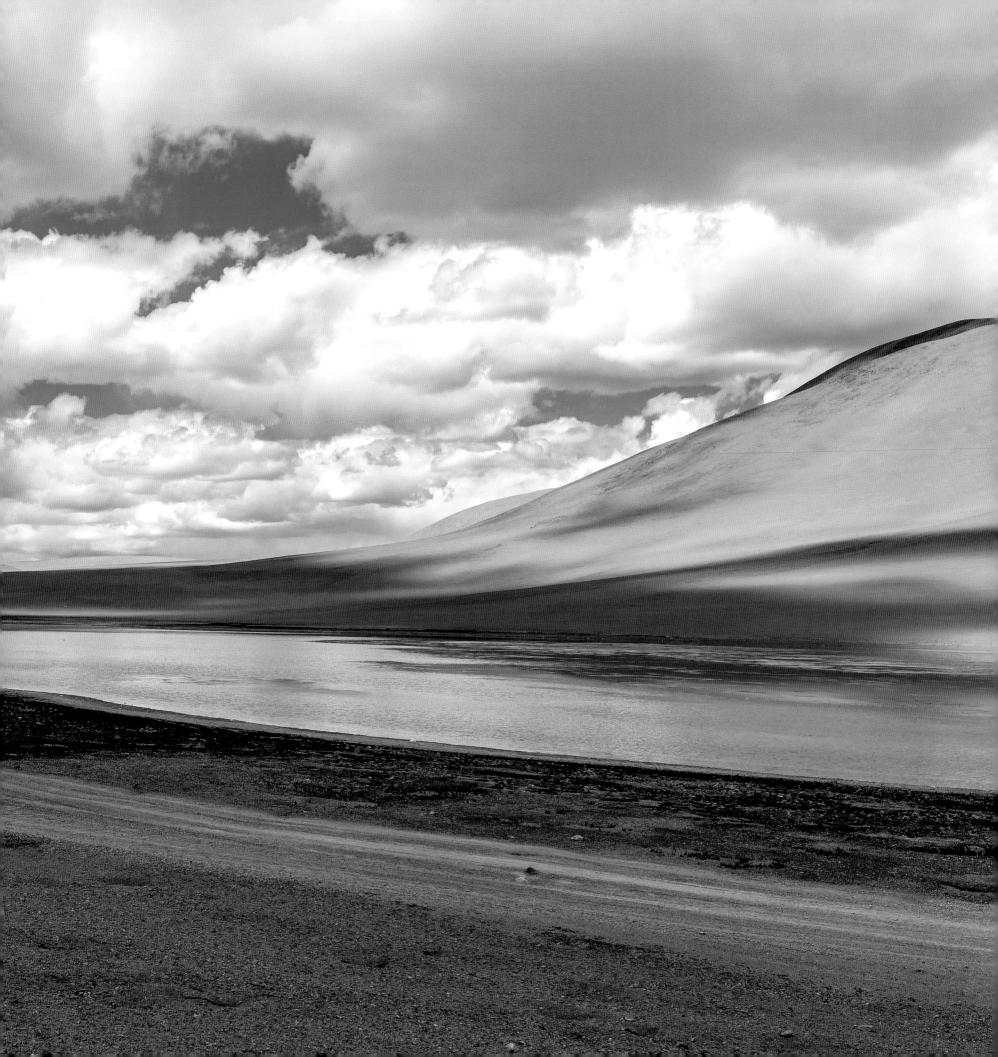

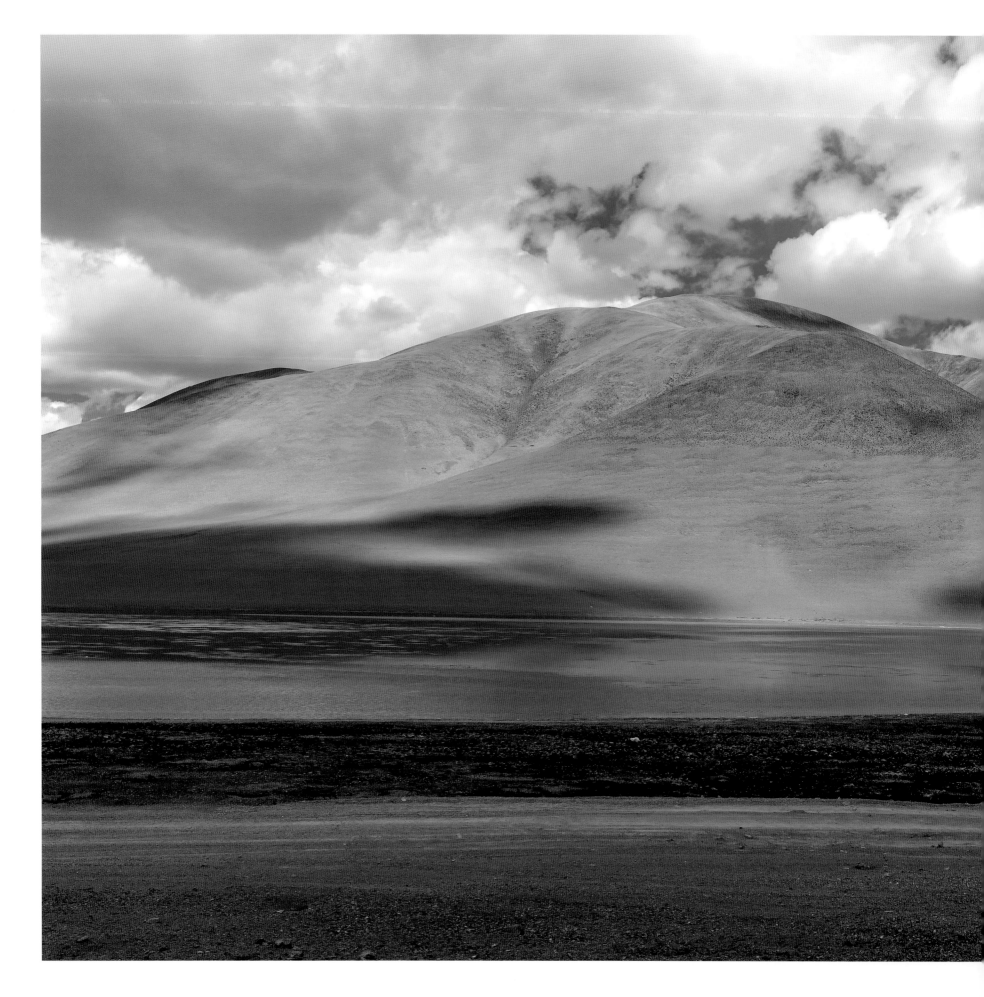

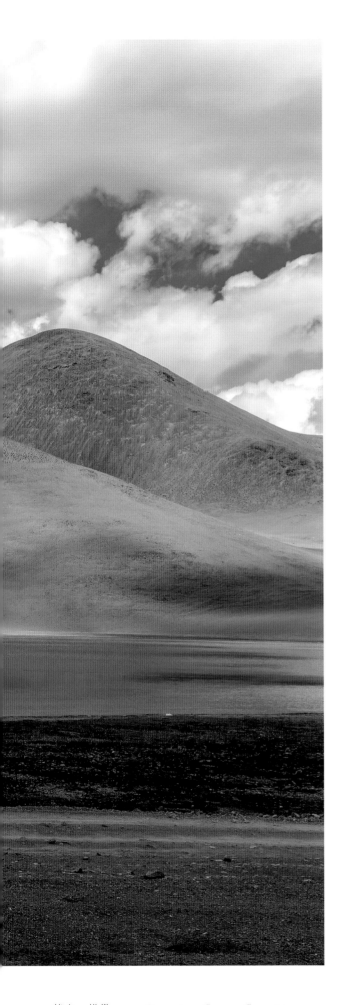

Gegyai ~ Coqen County

Gegyai means 'beautiful and fertile land' in Tibetan. The county, situated in the Great Lake Basin of the Qiangtang Plateau (Northern Tibetan Plateau), is the headwater area with Sengge Zangbo (the Shiquanhe River) bubbling down. It is difficult to think out any language descriptions for the calm plateau of immensity and desolation, all scenery within sight being of a vast wilderness.

Lake Zabuye brings a wash of bright color to such a desolated ground. Compared to the Chaka Salt Lake of Qinghai Province enjoying a considerable reputation, this Tibetan salt lake is unknown to the public. As the third largest lithium salt lake in the world, Lake Zabuye is the only salt lake in the form of 'natural lithium carbonate', and its containing chemical compositions present hues in variety, coloring the lake like an iridescent wonderland from heaven.

Another bare wilderness spreads out behind Lake Zabuye, hillsides and grounds on both sides without any vegetative cover showing their original colors. The occasional appearances of wild animals, such as Tibetan wild donkeys, Tibetan antelopes and groundhogs, manifest their ruling identity in this place.

On this special day today, the Chinese Mid-Autumn Festival, we lost our way in the wild. When the full moon came out behind the Kailash Range, the deserted plateau was bathed in the glinting moonlight. We stopped the car, and in the still of the night, let the thoughts drift into the profound. The moment like that was once chanted by Li Bai (the greatest romantic poet of the Tang Dynasty) from the distant past, 'from Heaven's peak the moon rises bright, over a sea of clouds' (*The Moon over the Mountain Pass*). All things, before and after, would eventually melt into endless time and boundless space. Another work of his called *Reflection on the Moon While Drinking* as well poetically responded to our feelings at that time, 'we see the ancient moon no more, but it has shone on men of yore.'

In fact, not only did we get lost in the moonlight, but the car also got stuck in the sand, waiting for rescue in the deserted wilderness. And that, of course, was another story.

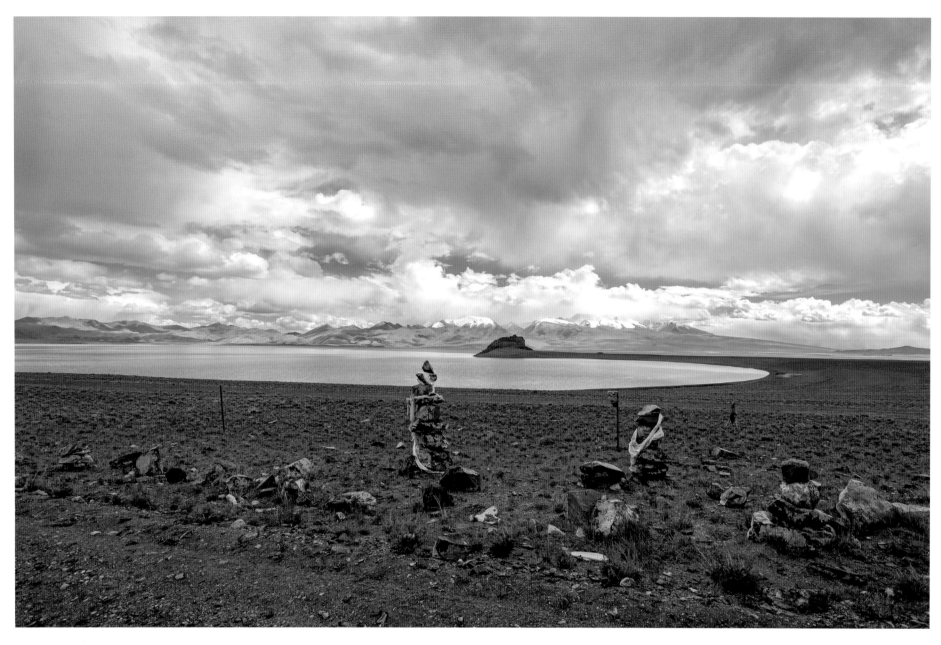

扎布耶茶卡是世界第三大锂盐湖，
也是世界上唯一以"天然原生碳酸锂"形式存在的盐湖。
As the third largest lithium salt lake in the world,
Lake Zabuye is the only salt lake in the form of 'natural lithium carbonate'.

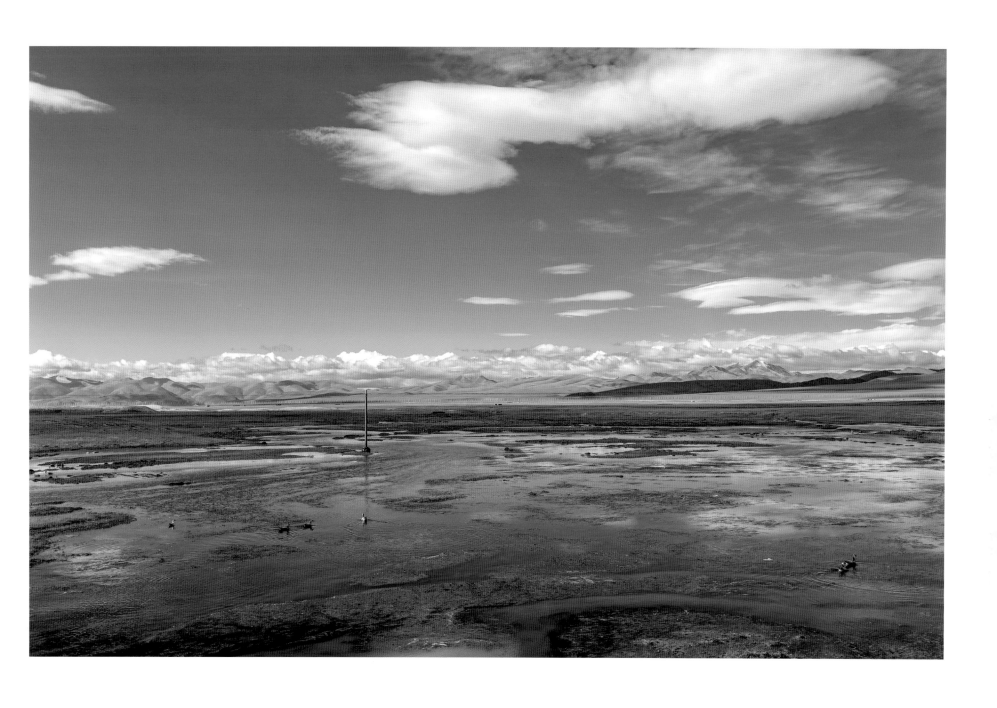

革吉~措勤　　Gegyai ~ Coqen County

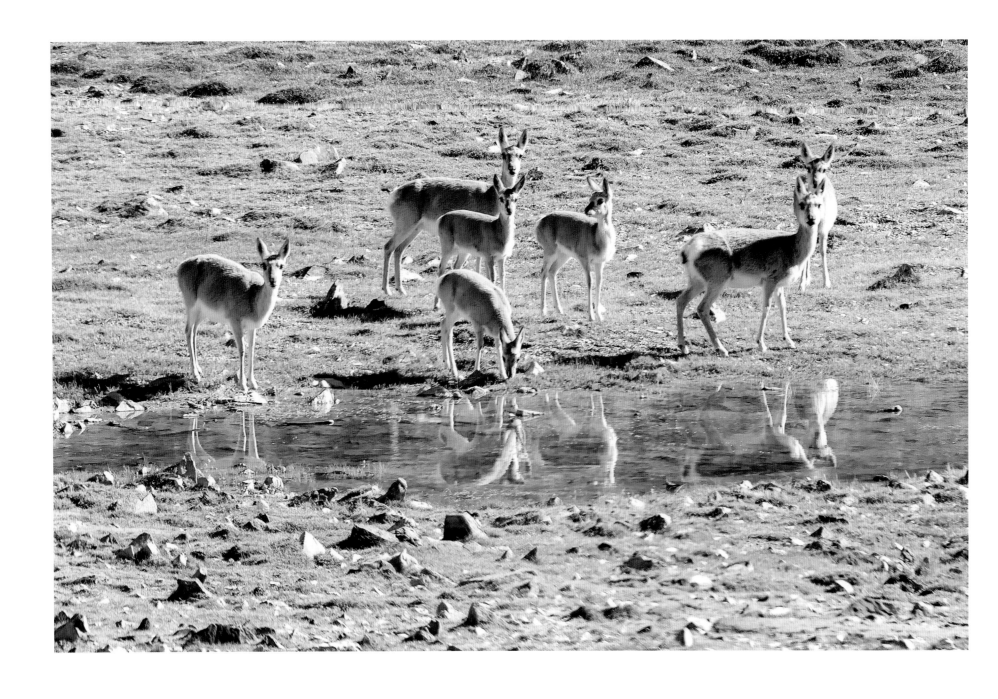

离开扎布耶茶卡之后的路段又是无尽的荒野，
只有不定时出现的藏野驴、藏羚羊、土拨鼠等各种野生动物。
Another bare wilderness spreads out behind Lake Zabuye.
The occasional appearances of wild animals manifest their ruling identity of this place.

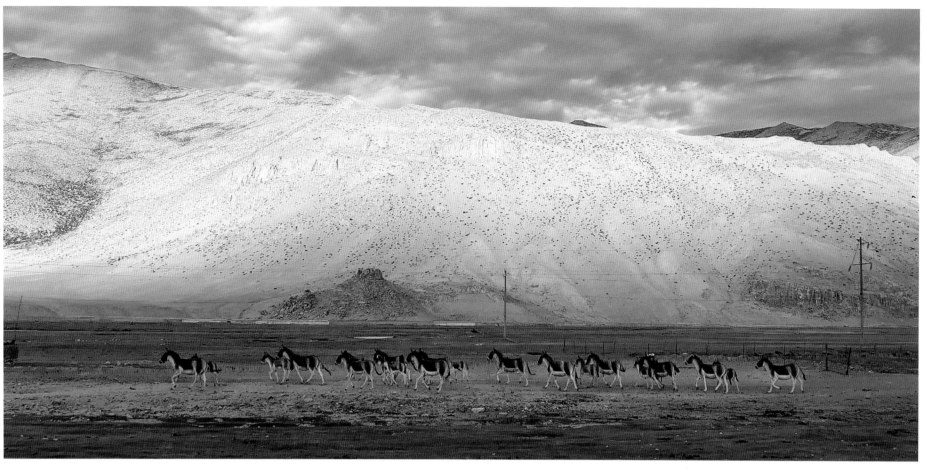

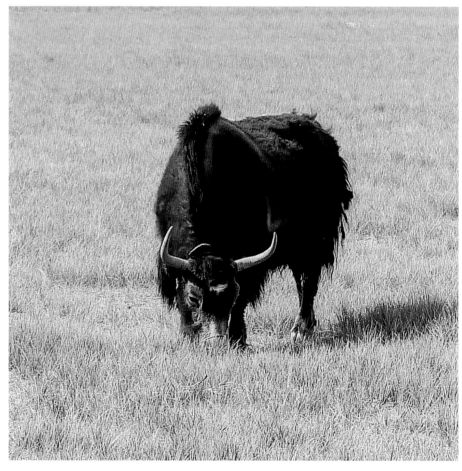

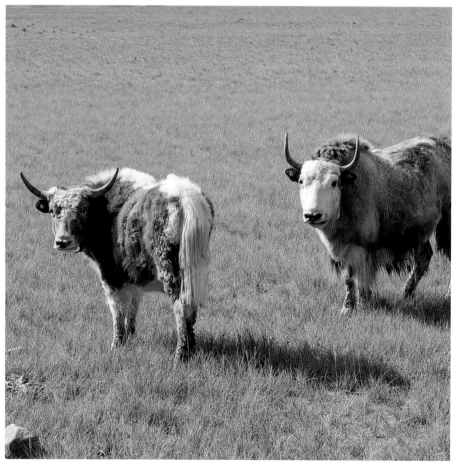

革吉～措勤　　Gegyai ~ Coqen County

措勤～尼玛

一路颠簸，车子的避震器坏了一个，迫使我们后面的行路越发小心。还好大家都抱持平常心，享受旅途中的喜悦和艰辛，而且到尼玛的这段省道跟前一日相比，路况已是好上太多。

羌塘高原上的大措小措无数，今天遇到的是达瓦措，很安静的一个小湖，坐落在措勤县辽阔的大草原上，海拔 4,636 米，是藏族人心中的月亮湖。这个湖名气不是很大，很少有人专程到此，但美是不分名气的，平静的湖水与广袤的大地连在一起，模糊了界线，湖水颜色深浅不一，但却是通透的，看了心情也变得舒畅起来。

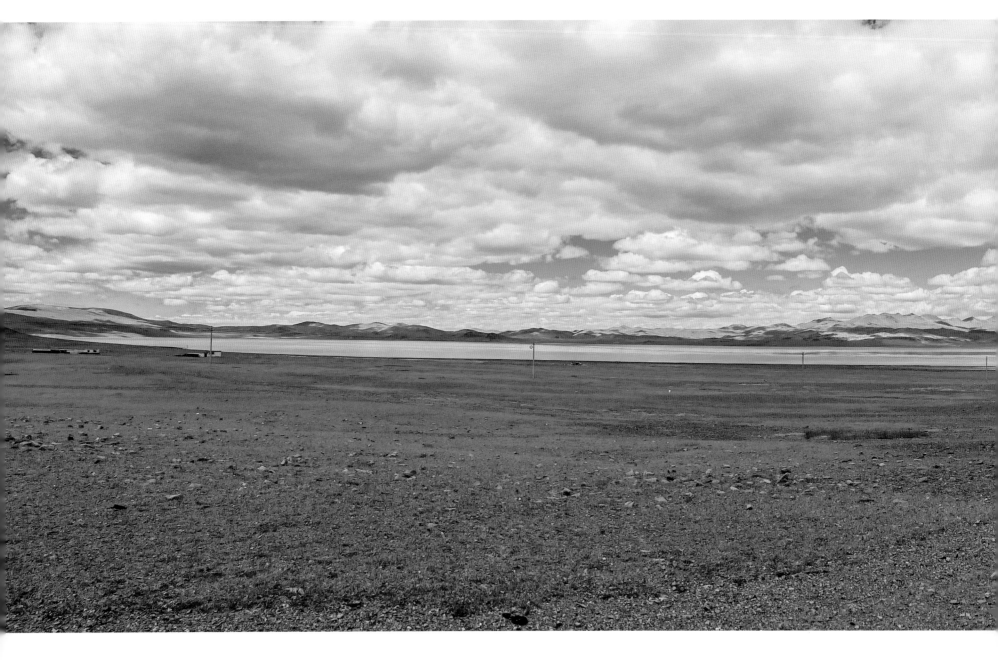

离开达瓦措没多久就看到夏岗江雪山，雪峰终年积雪不化，主峰周围有十来座海拔 6,000 米以上的山峰陪伴，雪山绵延千里起伏，很是壮观。再之后就是一直赶路，偶尔见着一些藏野驴、牦牛出没。想到一路上只有我们一台车，几个人，也不知道是我们在欣赏风景，还是在点缀风景。

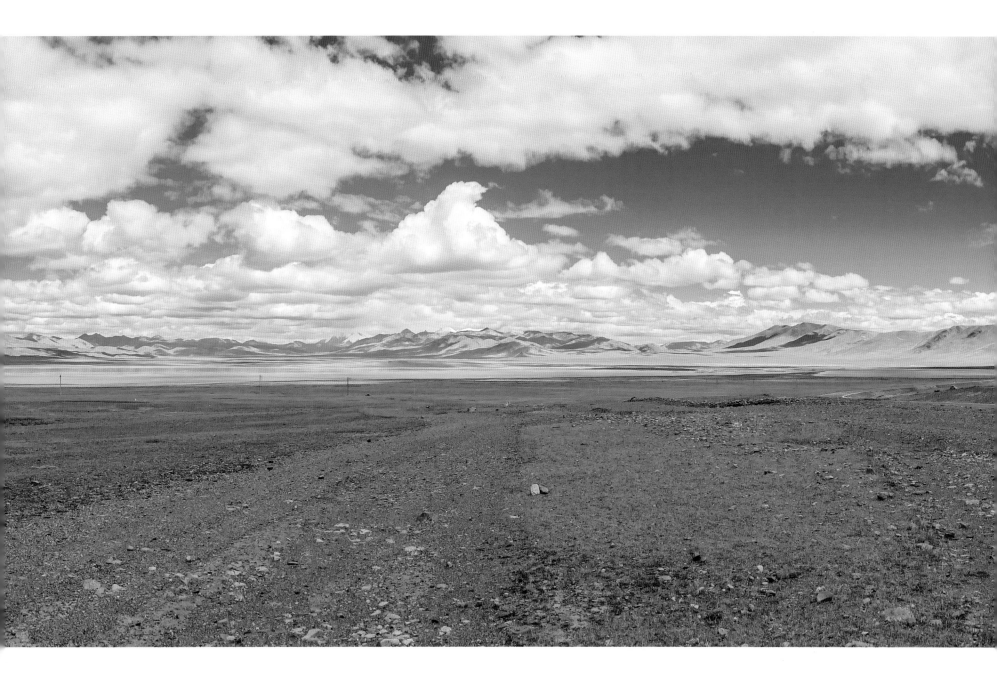

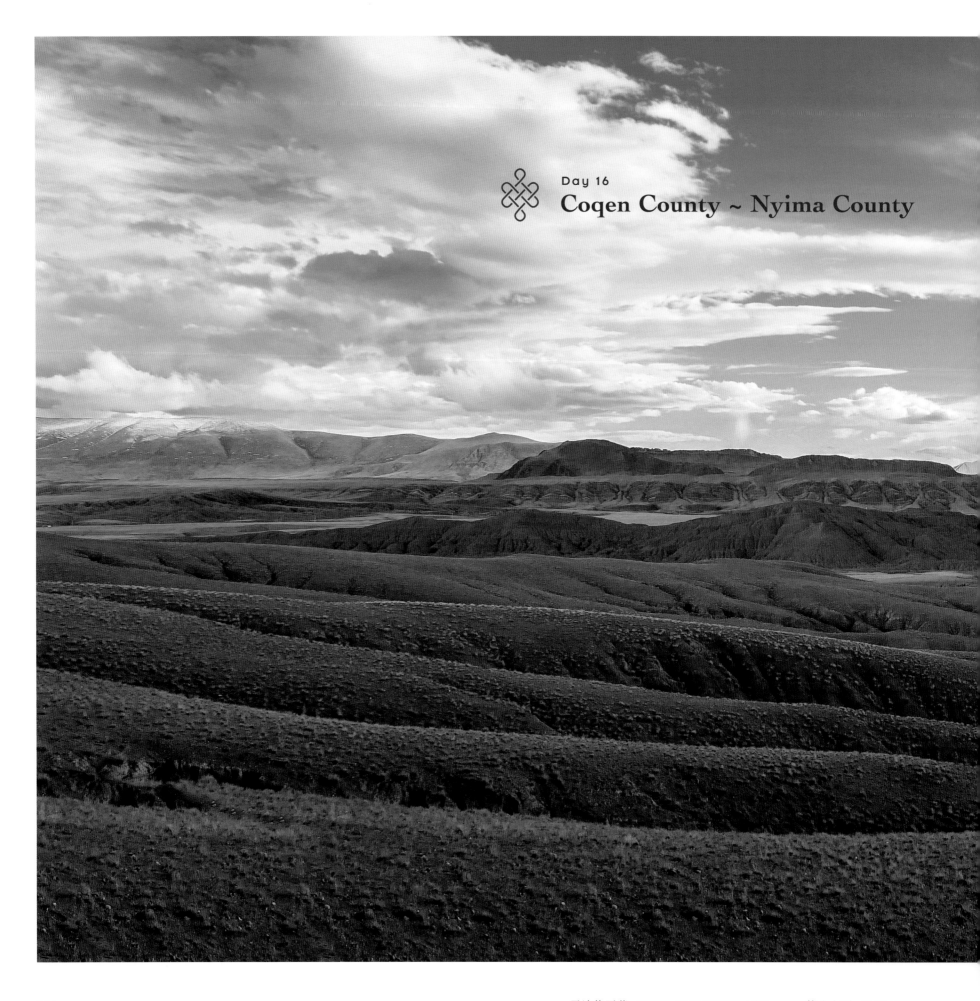

Day 16
Coqen County ~ Nyima County

The bumpy road condition, coupled with one broken shock absorber of the car, made us more cautious about the following journey. Happily, everyone still stayed calm, grateful for all the joys and bitters on the way. The road of this provincial-highway section to Nyima County was much better than that of the previous day.

Qiangtang Plateau boasts a myriad of lakes in all sizes. Today, we were greeted by Lake Dawatso, a small lake quietly lying in the wild prairie of Coqen County at an elevation of 4,636 meters, the Moon Lake to Tibetans. The noteless lake attracts few admirers to pay a special visit here, but beauty is not discriminated by popularity. The tranquil waters blurred the boundary with the vast land. Though varying in shades, the lake was so limpid that it mellowed our mood.

Not far from Lake Dawatso, the Xiagangjiang Snow Mountain soon came in sight. The mountain is capped with snow throughout the year, the main peak of which is surrounded by a dozen peaks about 6,000 meters high. The snowy mountains stretching out to a long distance are spectacular. After that, we resumed the journey. Except for some Tibetan wild donkeys and yaks putting in occasional appearances, a group of us was the only moving object on the road, admirers or perhaps embellishments of the scenery as well.

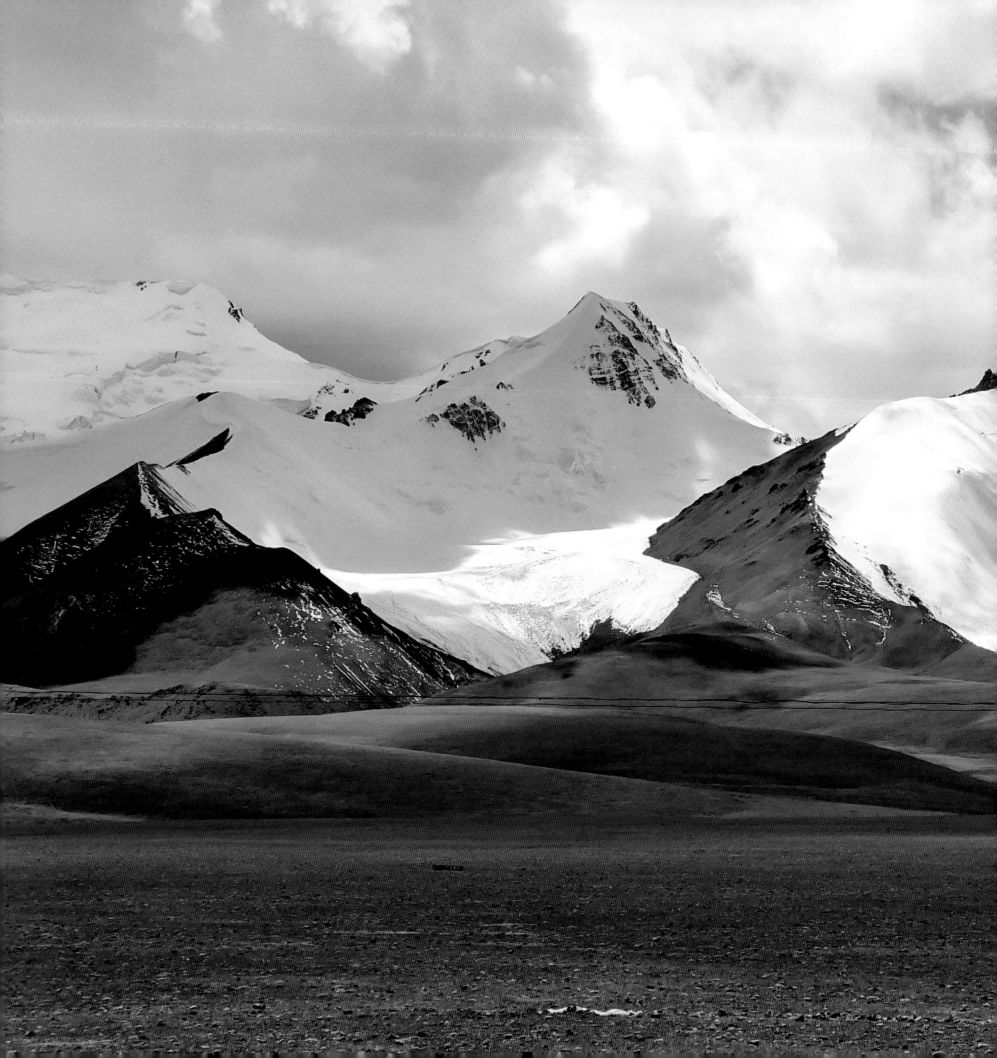

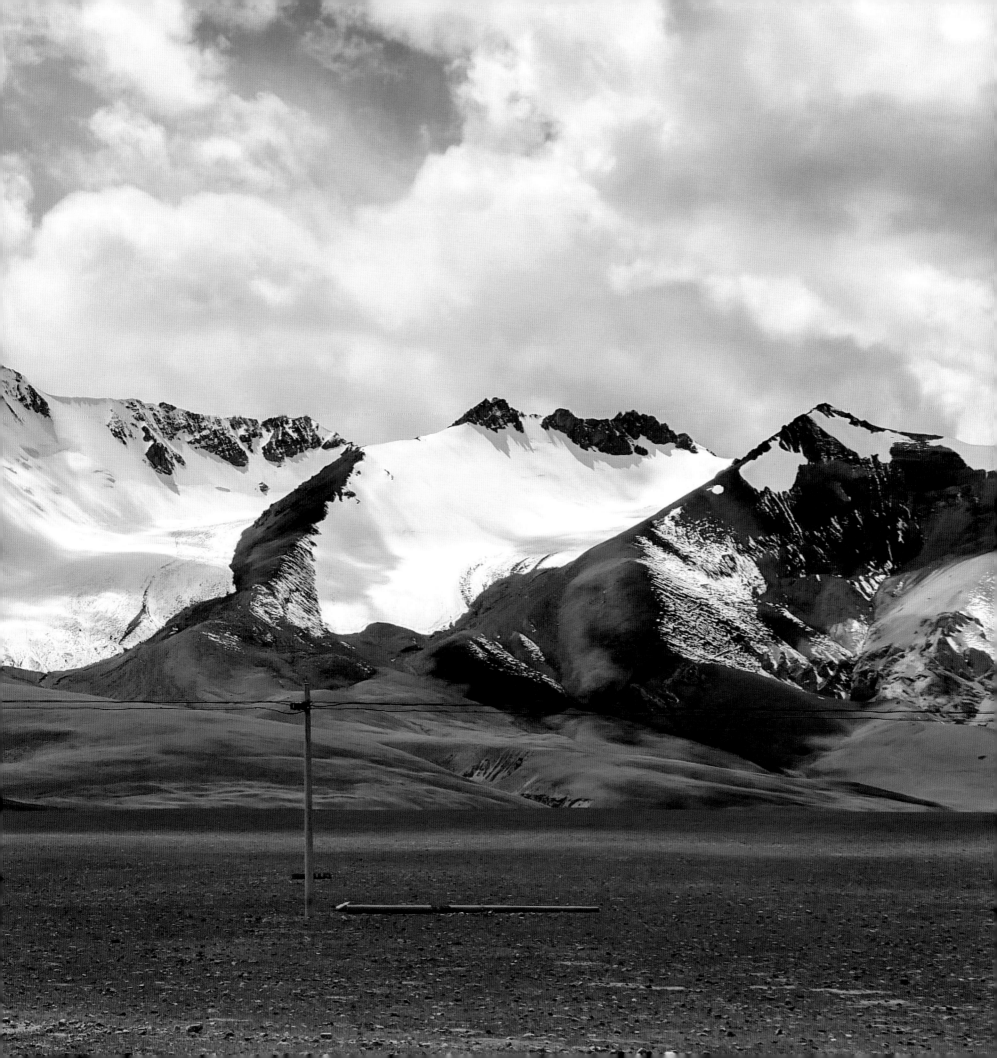

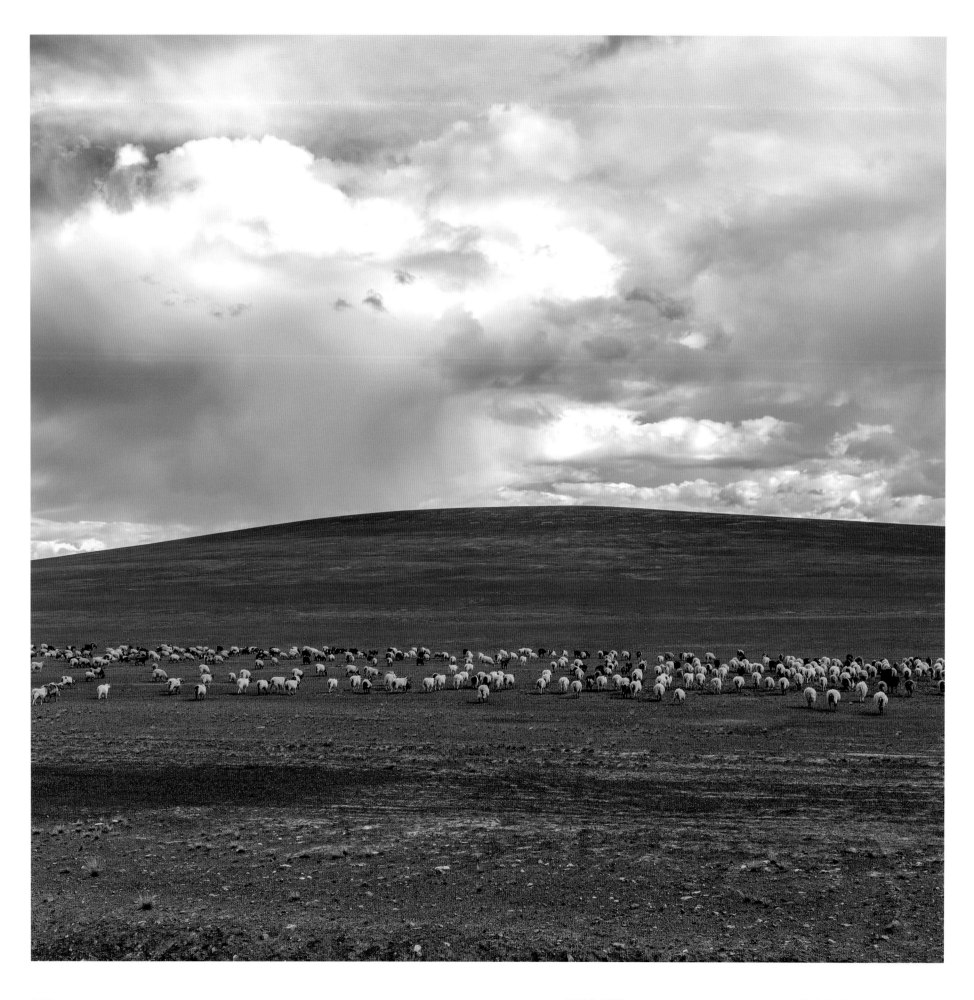

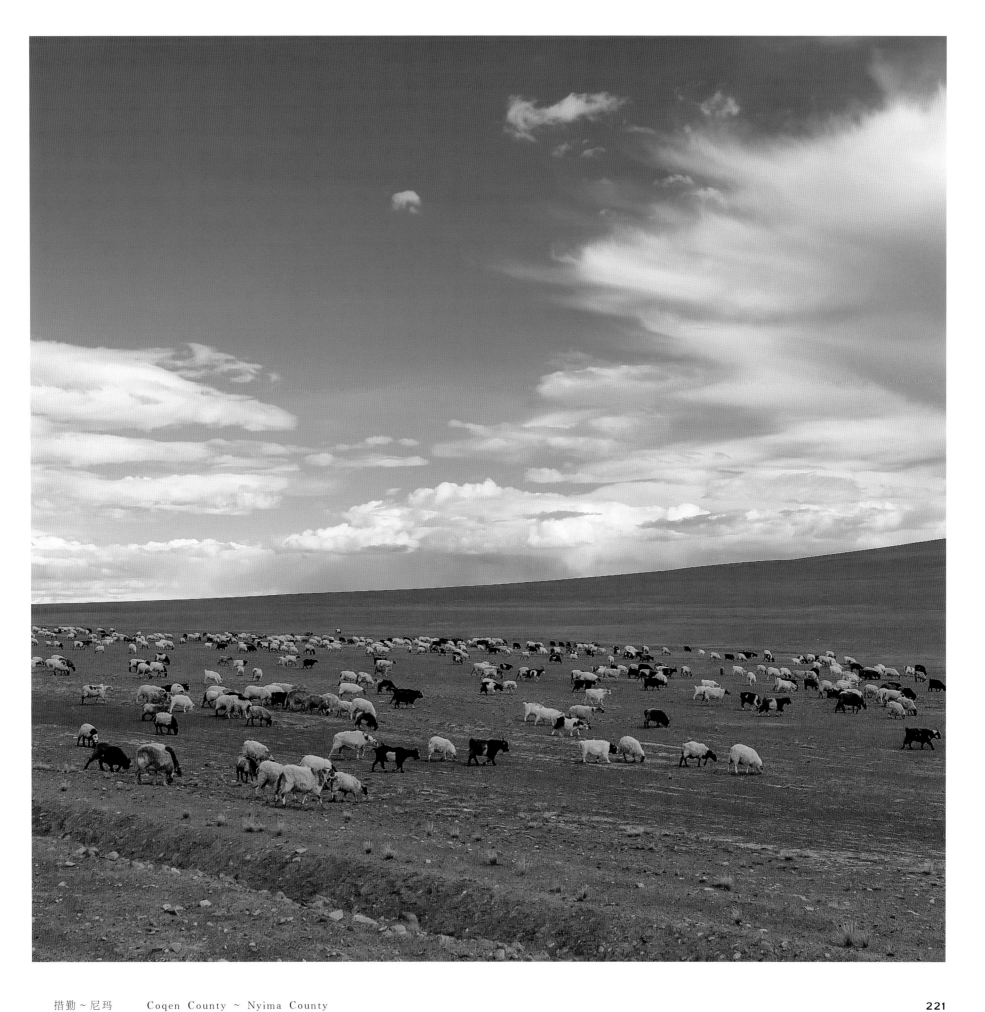

措勤 ~ 尼玛 Coqen County ~ Nyima County

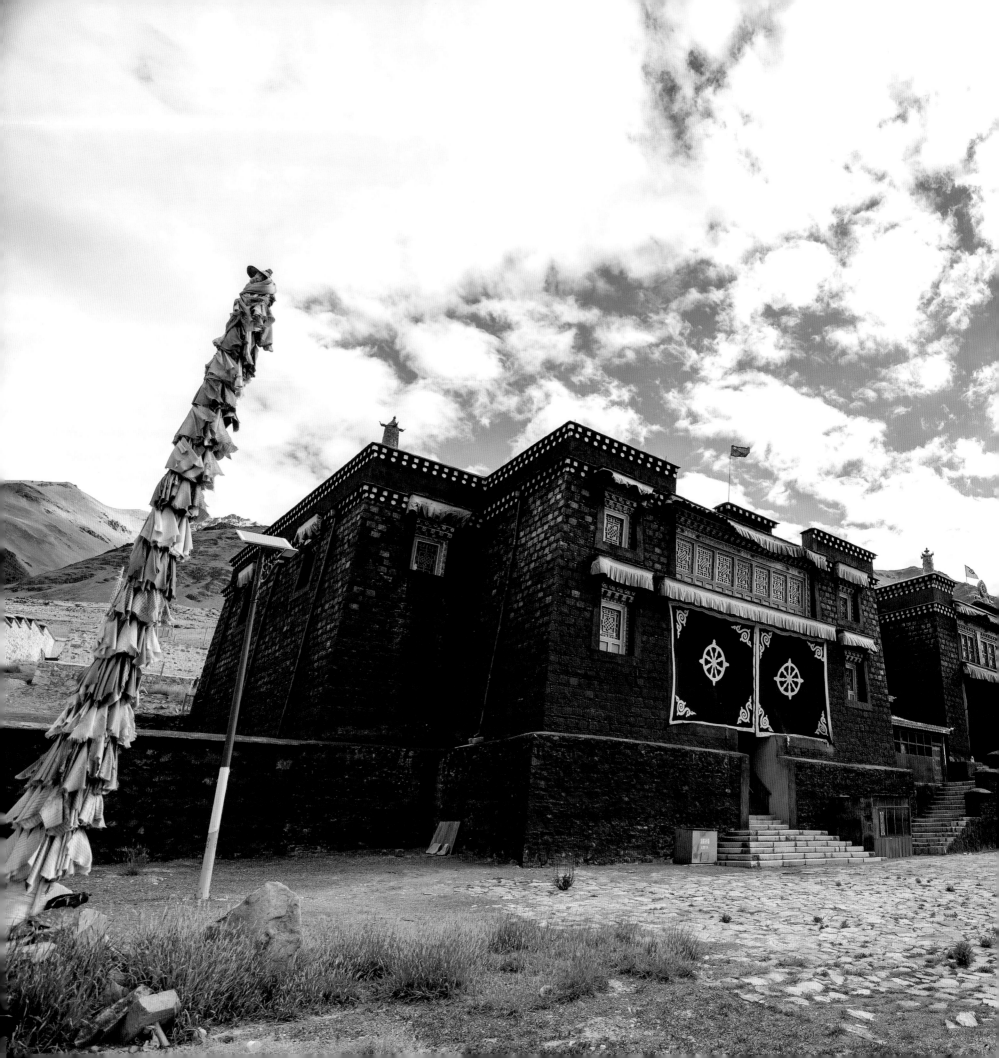

尼玛

驶离尼玛县城后，有一段相当长的无人区，高山草甸戈壁荒漠，但幸好沿途还有野生动物的陪伴。这些散发着蓬勃生命力的高原生物，偏僻广袤的荒野是牠们尽情娱乐的大舞台，人在这里反成了最稀缺的风景。一路艰辛，却也一路美好。

文布北村依山而建，面朝圣湖当穹措，湖水碧蓝清亮，随阳光照射不断变换颜色。村里有座当穹寺，坐落在村子最高处，赤红的外墙格外醒目吸睛。登上寺庙的屋顶眺望远方，天高云淡，远处群山积雪，大美无言！

从寺庙出来一路向前开到了文布南村，临近中午，村民们在成片的青稞地里开镰收割，一派农忙景象。他们顶着晒得黝黑的面庞、熟练的收割动作，有着《拾穗者》的画面感，却展现出健康的劳作之美，忙碌中不断有歌声传出，原生态的唱法粗犷、明亮而充满生命力。

文布南村最出名的是它所依附的当惹雍措和达果雪山。"雍措"在藏语中的意思是碧玉般的湖，当惹雍措也当得起这个名，湖水湛蓝到失真。达果雪山是历史悠久的古象雄佛法雍仲本教圣地，传说这里是古象雄诸神的聚集处，也是藏区四大雪山之一，连同当惹雍措被人们奉为神山圣湖。在这无边的壮丽秀美中，我换上了当地的服饰，在圣湖边上，也来载歌载舞一番。

村里有座当穹寺，坐落在村子最高处，赤红的外墙格外醒目吸睛。
There is the Dangqiong Temple commanding the highest point of the village, walled in an eye-catching crimson color.

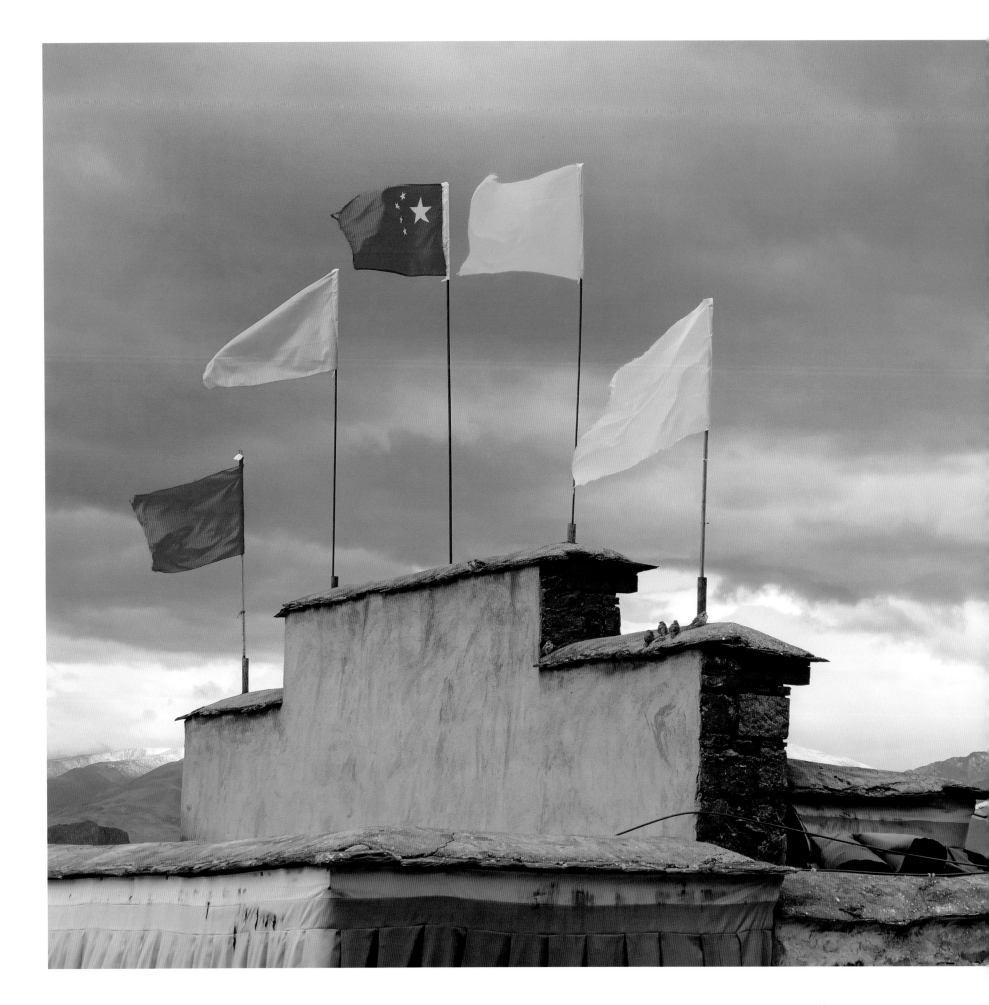

圣洁的西藏 TIBET : THE HOLY LAND 第十七天 DAY 17

Nyima County

In a large-sized depopulated area behind Nyima County there are ubiquitous high mountains, meadows, and deserts, but happily our drive was accompanied by wild animals along the way. To the remote wilderness, highland animals indulging themselves to the full on a great plateau-stage are a common sight, while humans are a rare view. The journey was demanding but worthwhile.

Wenbu North Village, sitting with a mountain at the back, fronts the sacred Lake Dangqiongtso. The limpid, greenish lake waters vary its colors with the sun. There is the Dangqiong Temple commanding the highest point of the village, walled in an eye-catching crimson color. The roof of the temple offers a panoramic view of the high sky floating with light clouds and distant mountains carpeted by snow. Grandeur pervades in heaven and earth, with beauty beyond words!

From the temple all the way forward, we arrived at the Wenbu South Village at noon when farmers were busy harvesting in the highland barley fields. Their suntanned faces and skilled harvesting movements chimed in with the tableau of Jean-Francois Millet's representative work, *the Gleaners*, and at the same time, it conveyed energetic beauty from the hard work. Songs from the busy fields were continuously wafted to our ears, the natural-styled singing of which was rough, bright, and bouncing with life.

Wenbu South Village is best known for its Lake Dangjak Yumtso and Daguo Snow Mountain. Yumtso, 'yong cuo' in Chinese pronunciation, means jade-colored lake in Tibetan, and Dangjak Yumtso well deserves its name as its water is of unbelievably azure blue. Daguo Snow Mountain is worshiped as the holy land for the ancient Zhangzhung Buddha dharma and is said to be the gathering place for gods of the ancient Zhangzhung kingdom. As one of the four largest snow mountains in Tibet, it is treated as a sacred symbol together with Lake Dangjak Yumtso. The sight of grandeur was so enchanting that I changed into local costumes, singing and dancing joyously by the holy lake.

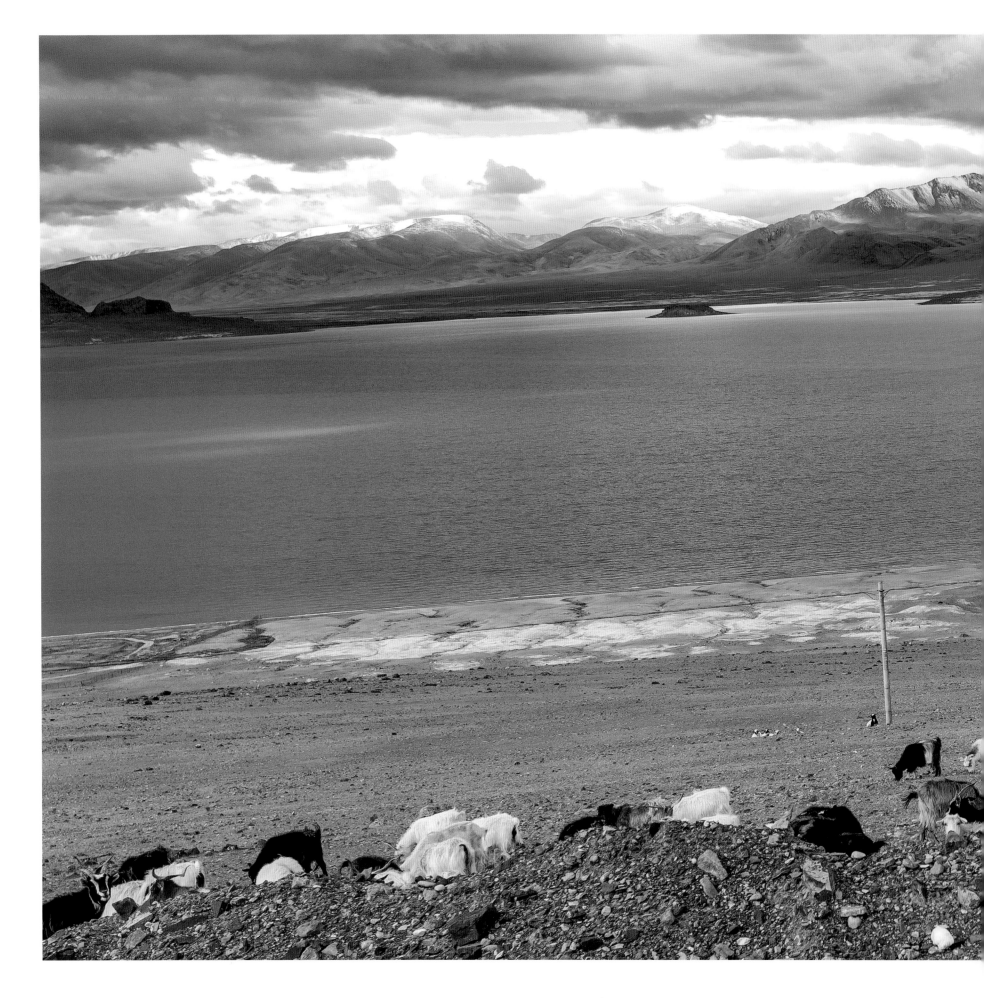

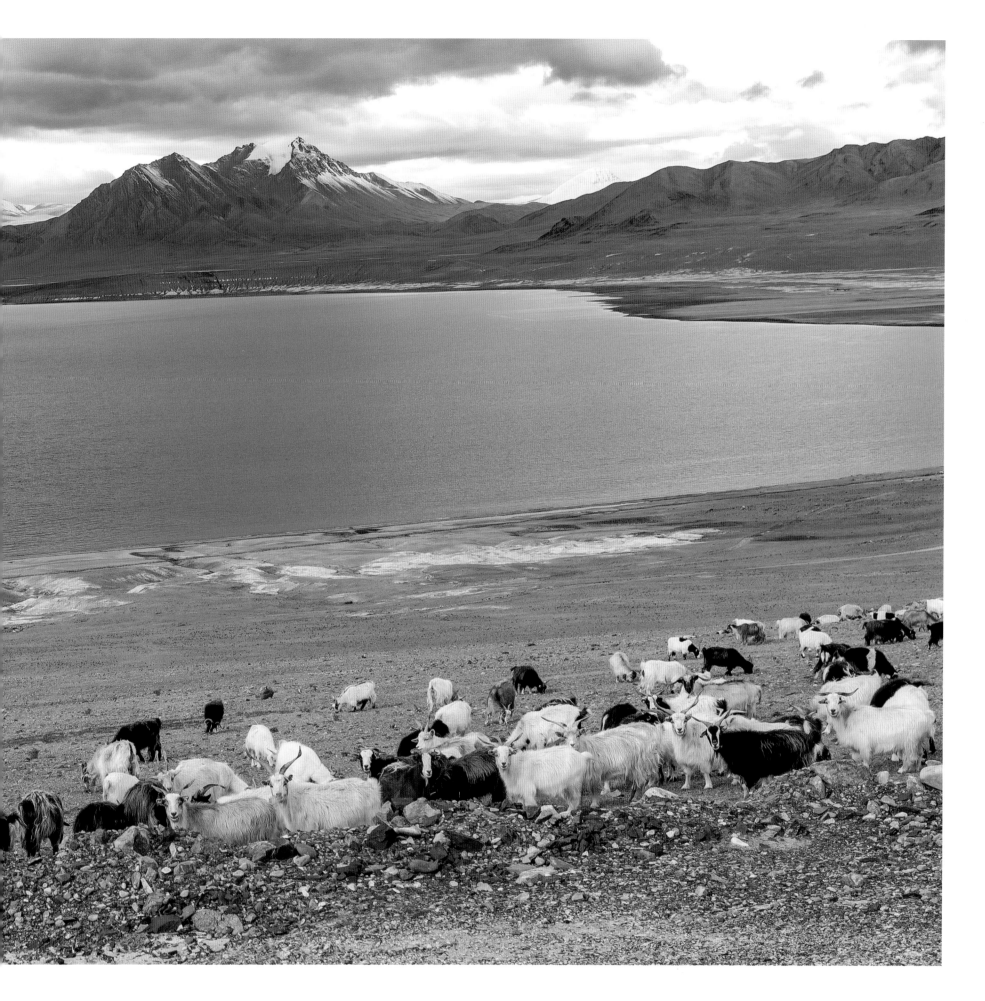

尼玛　Nyima County

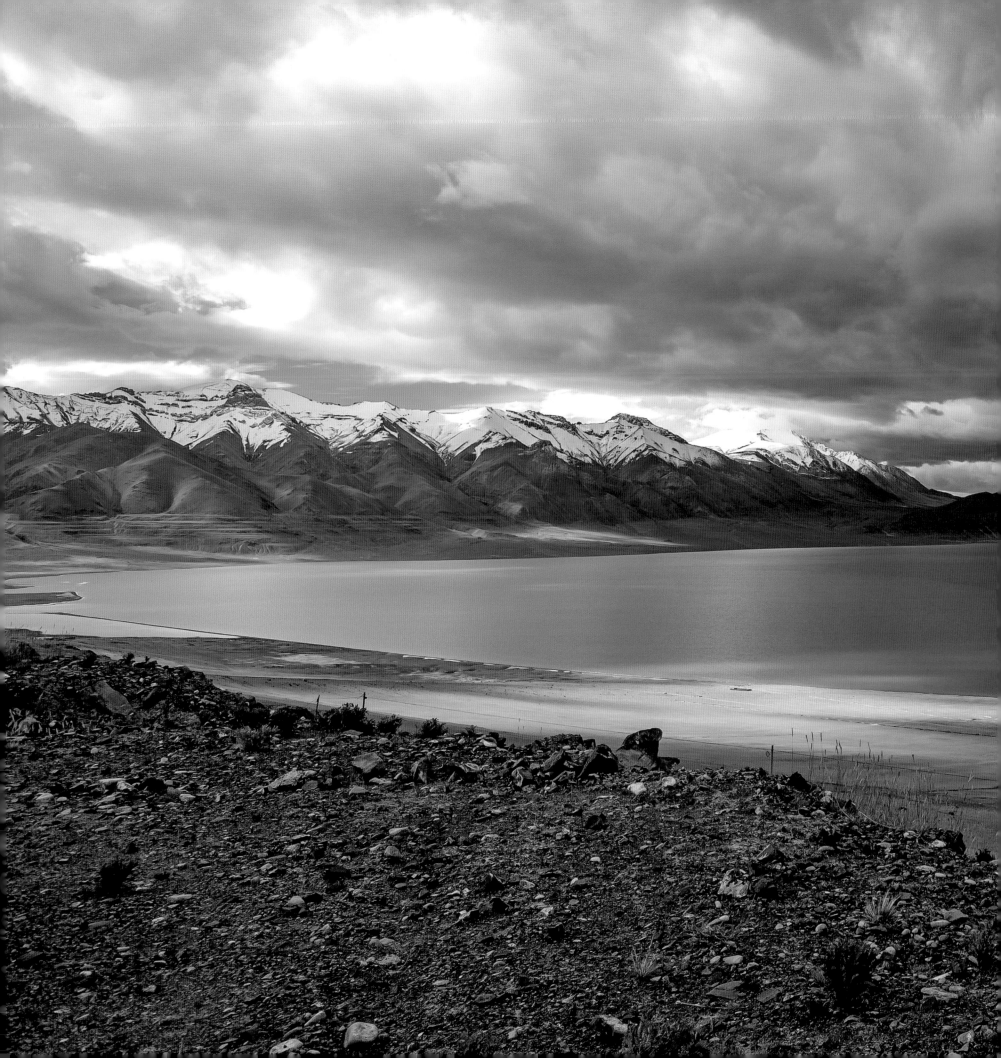

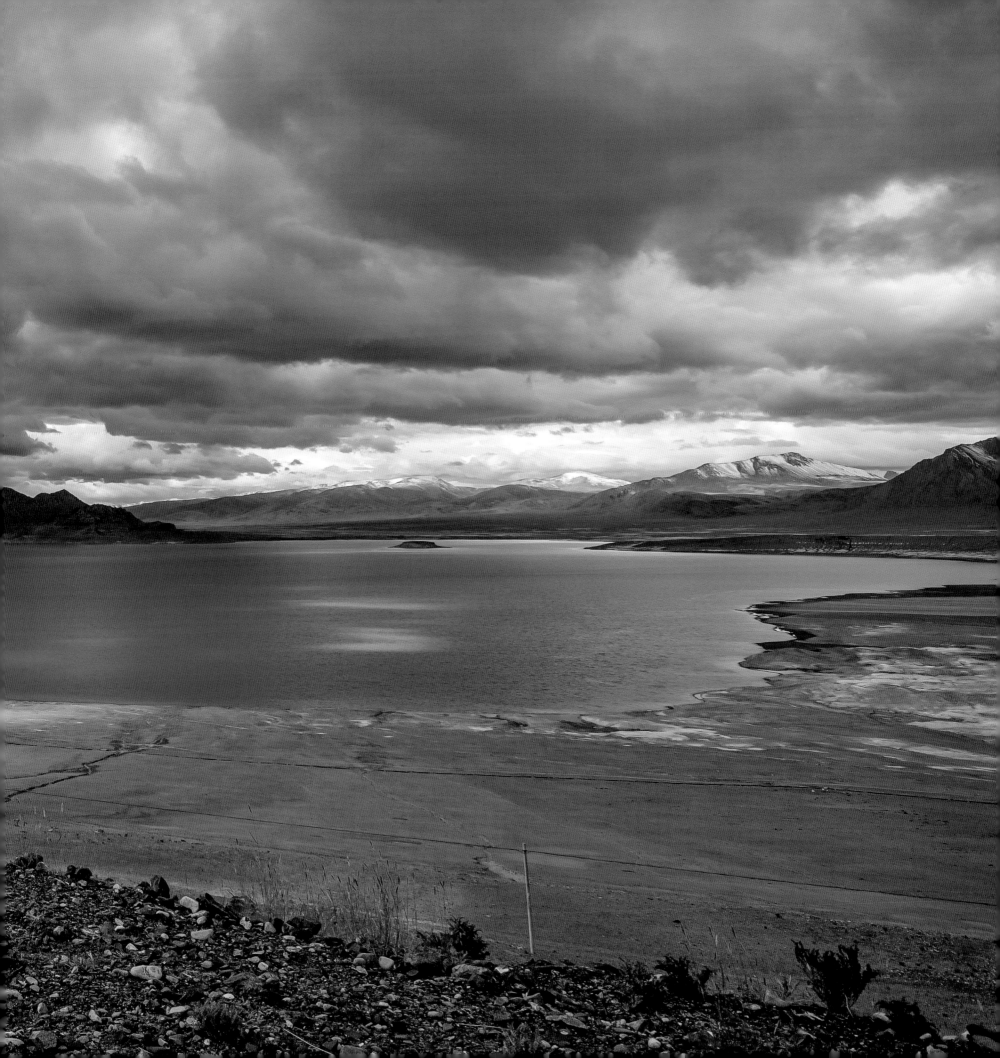

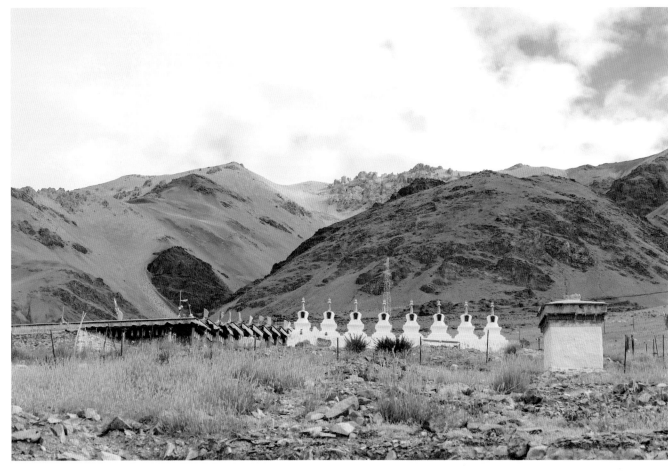

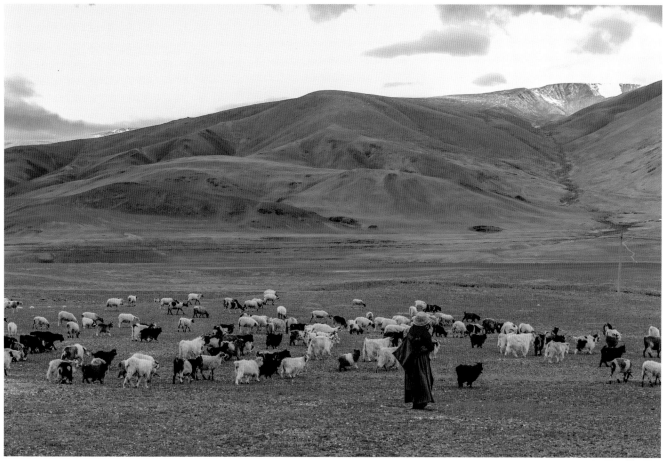

尼玛　Nyima County

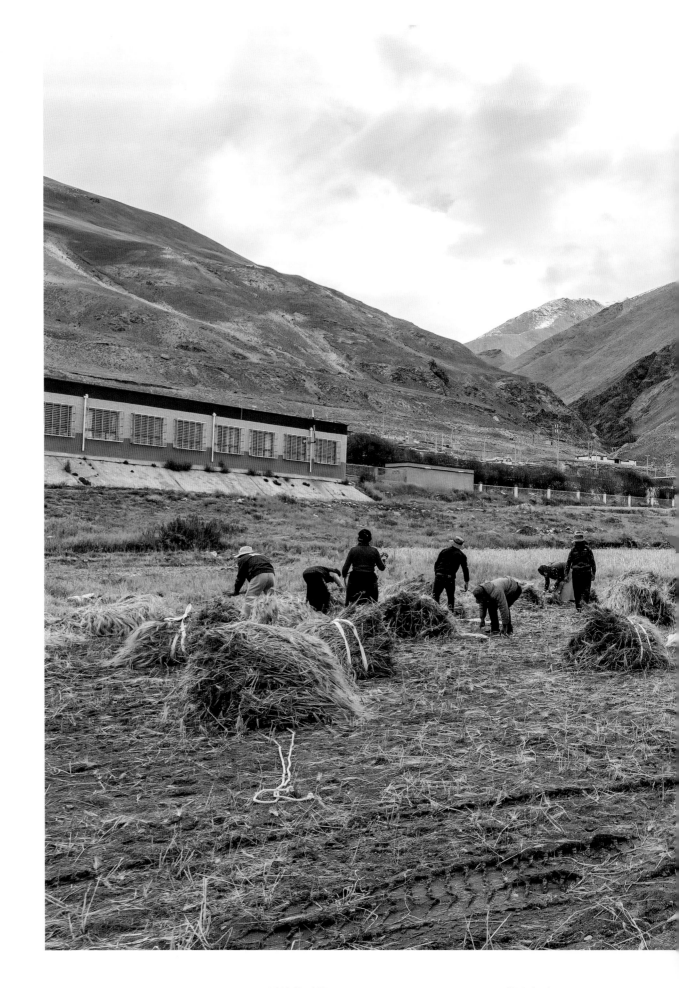

一路向前开到了文布南村，临近中午，
村民们在成片的青稞地里开镰收割，
一派农忙景象。
We arrived at the Wenbu South Village
at noon when farmers were busy harvesting
in the highland barley fields.

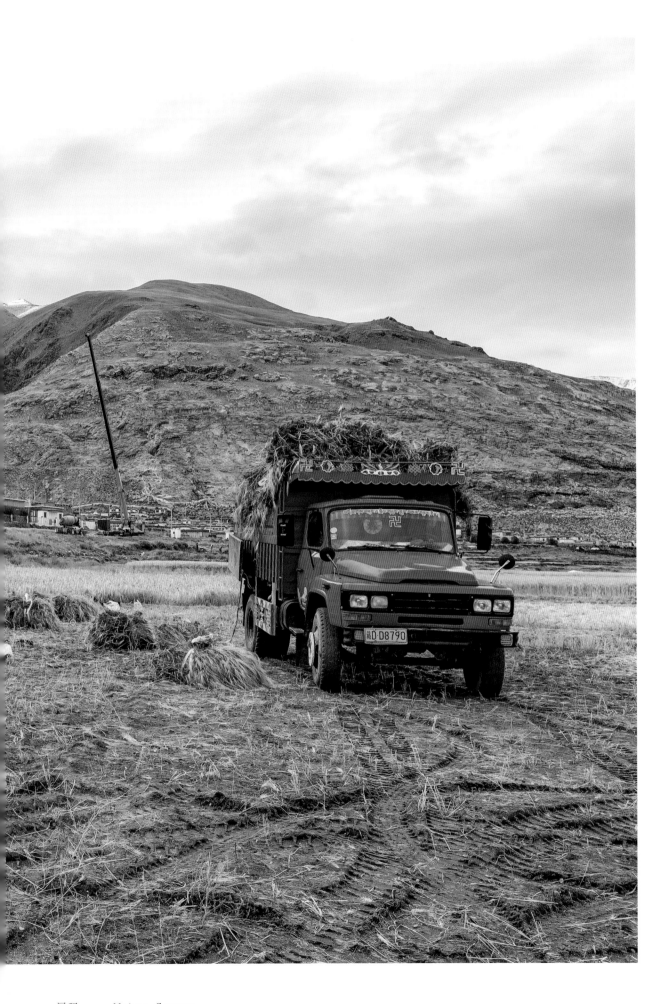

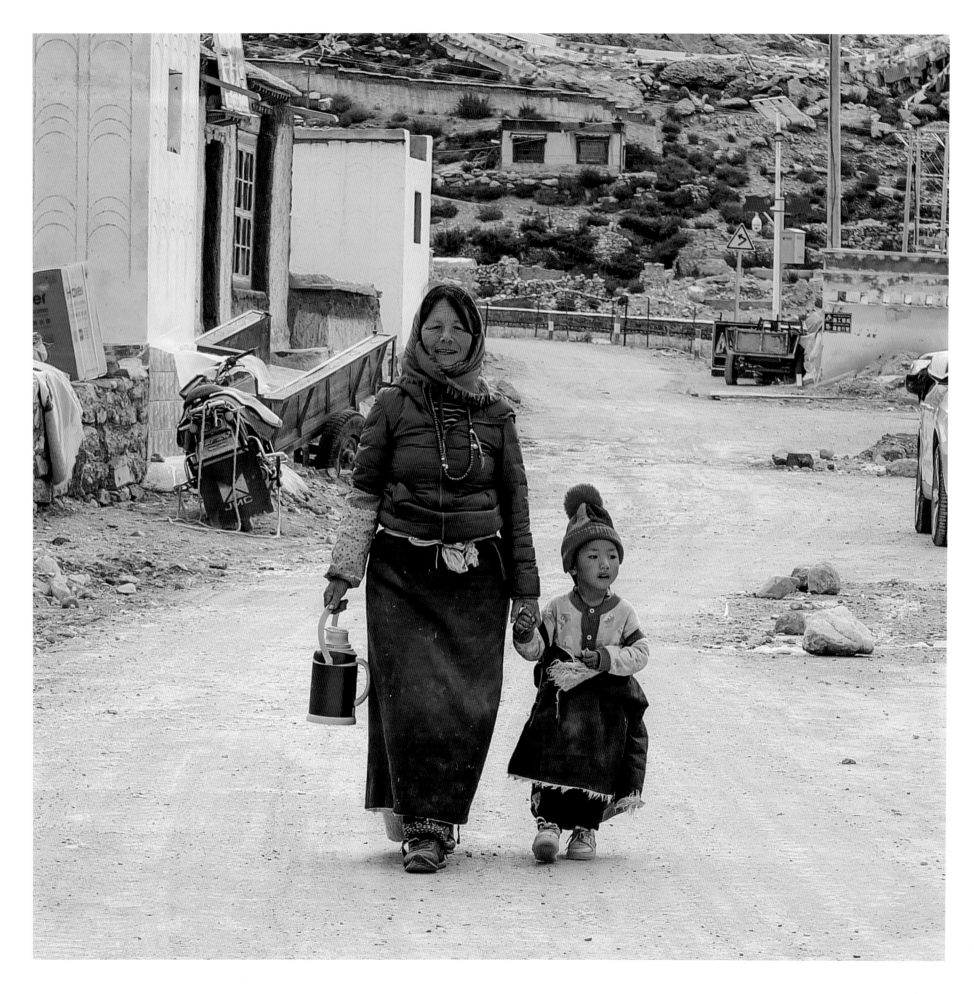

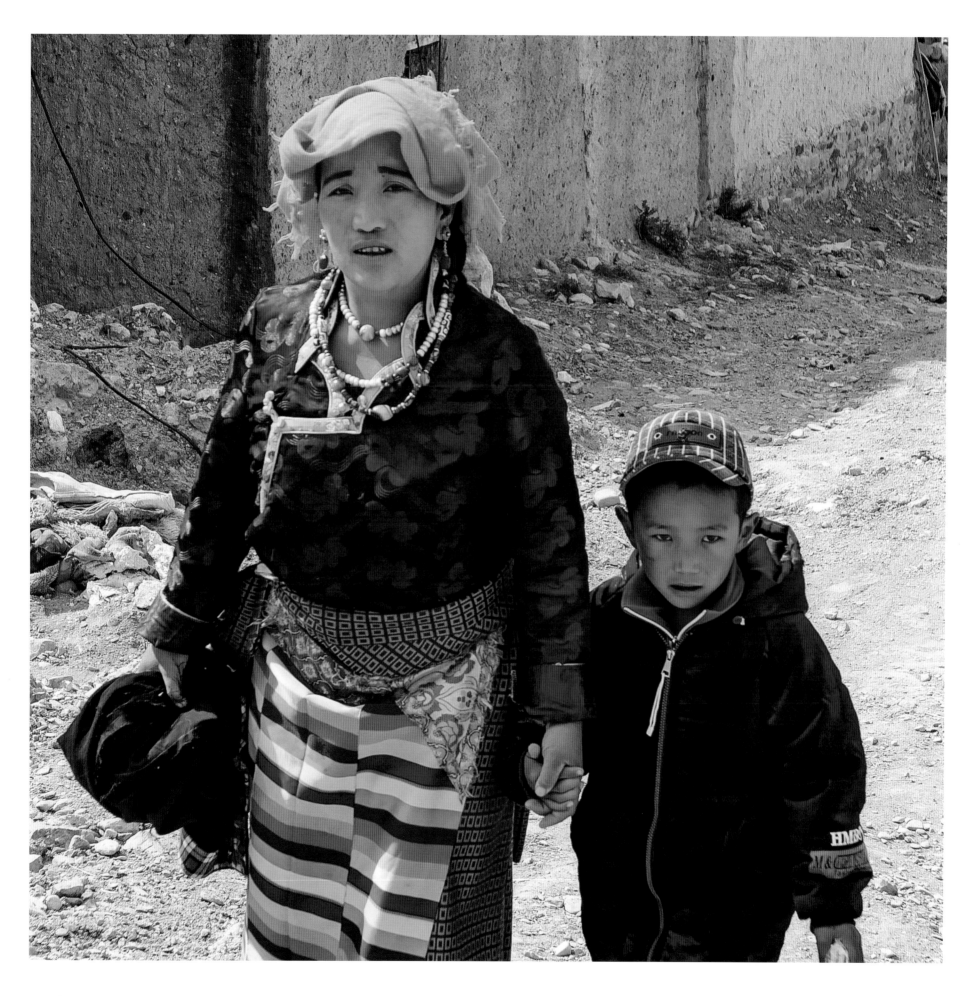

尼玛　Nyima County

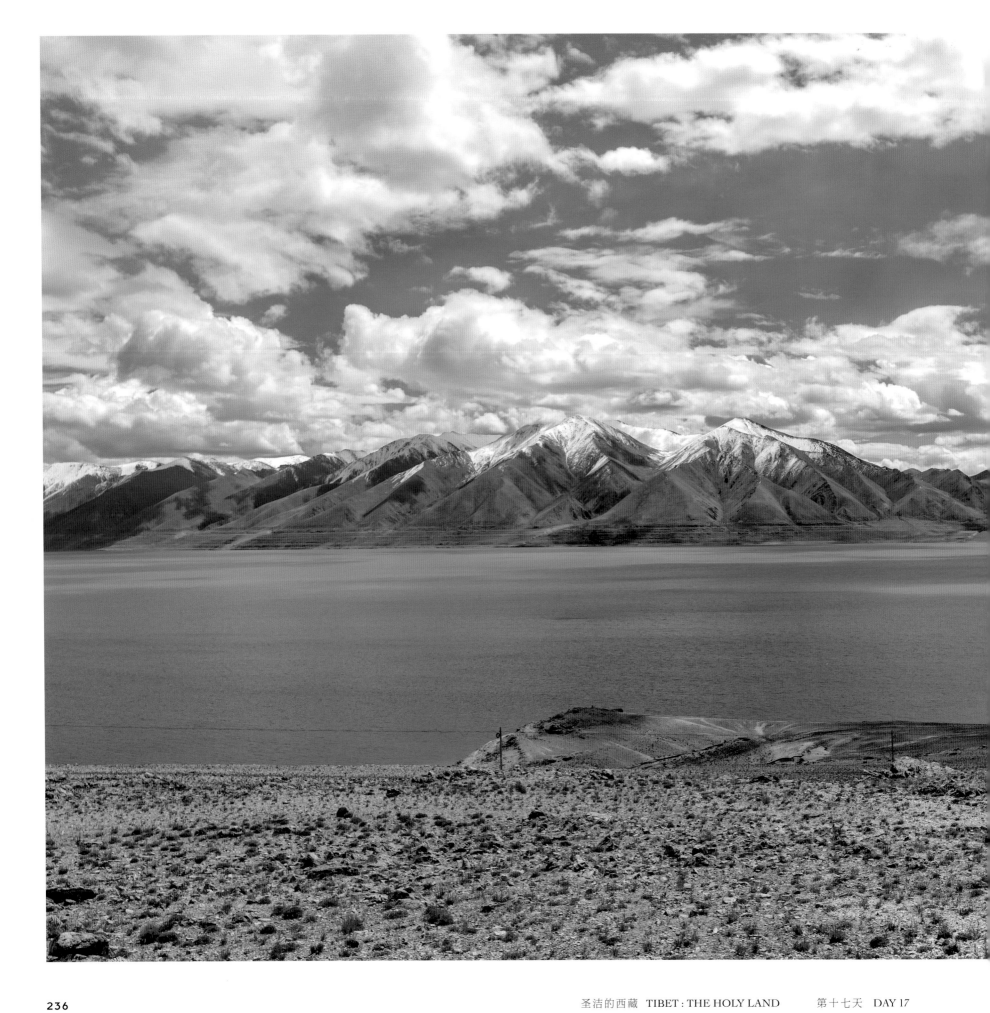

圣洁的西藏　TIBET : THE HOLY LAND　　第十七天　DAY 17

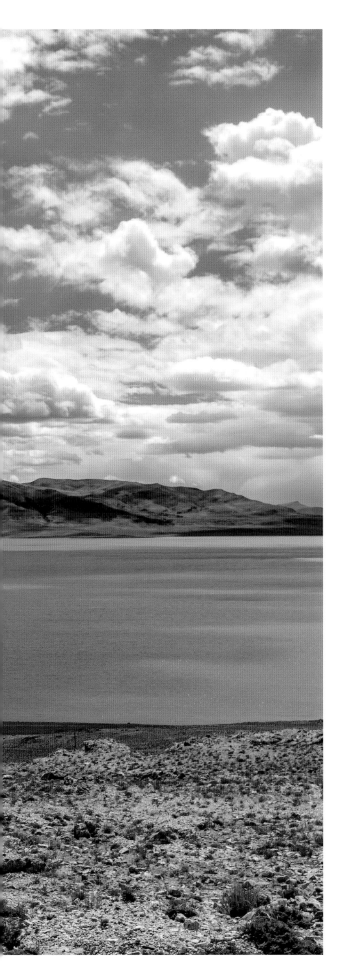

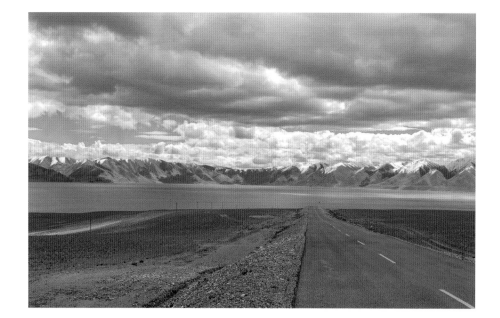

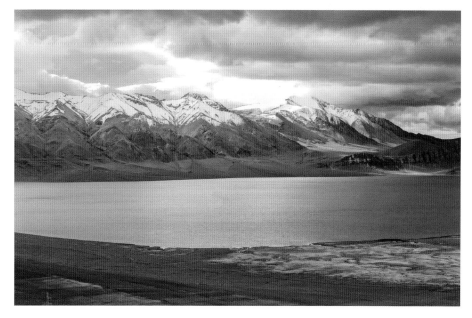

"雍措"在藏语中的意思是碧玉般的湖，
当惹雍措也当得起这个名，湖水湛蓝到失真。
Yumtso, 'yong cuo' in Chinese pronunciation, means jade-colored lake in Tibetan,
and Dangjak Yumtso well deserves its name as its water is of unbelievably azure blue.

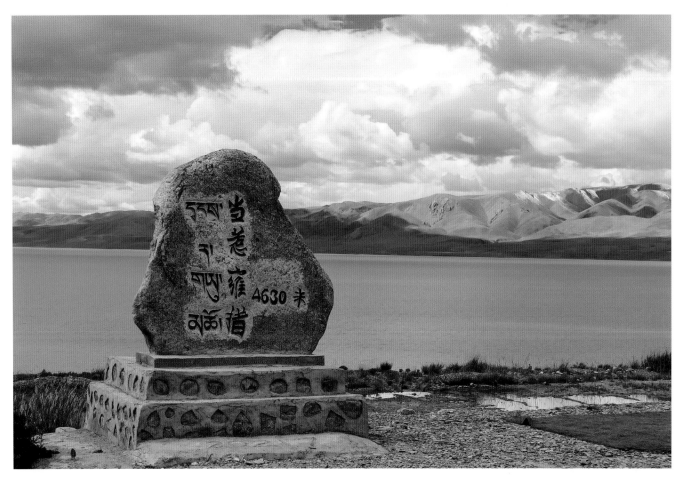

文布南村最出名的
是它所依附的当惹雍措和达果雪山。
Wenbu South Village is best known
for its Lake Dangjak Yumtso and
Daguo Snow Mountain.

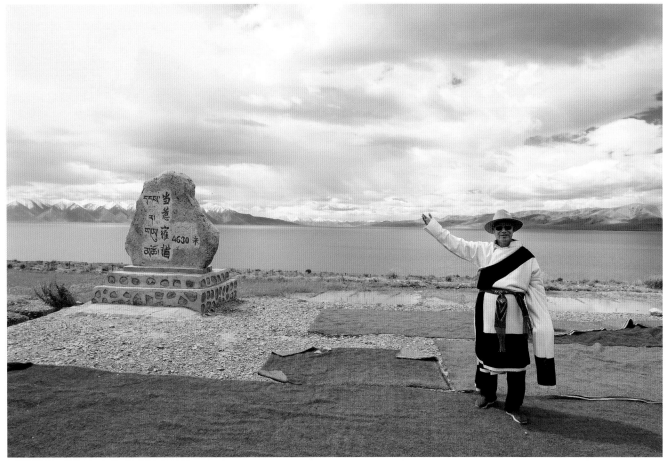

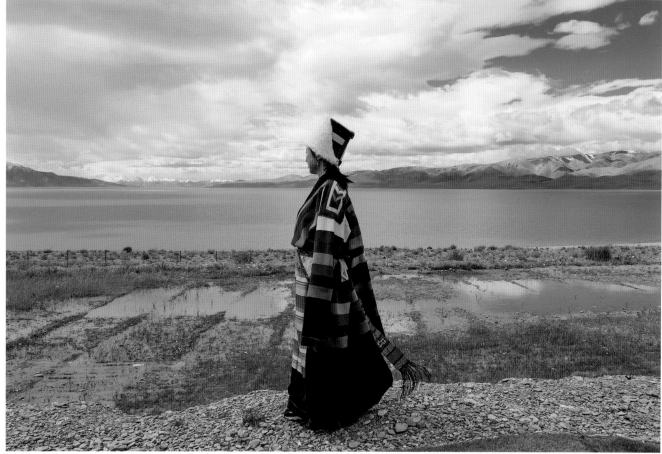

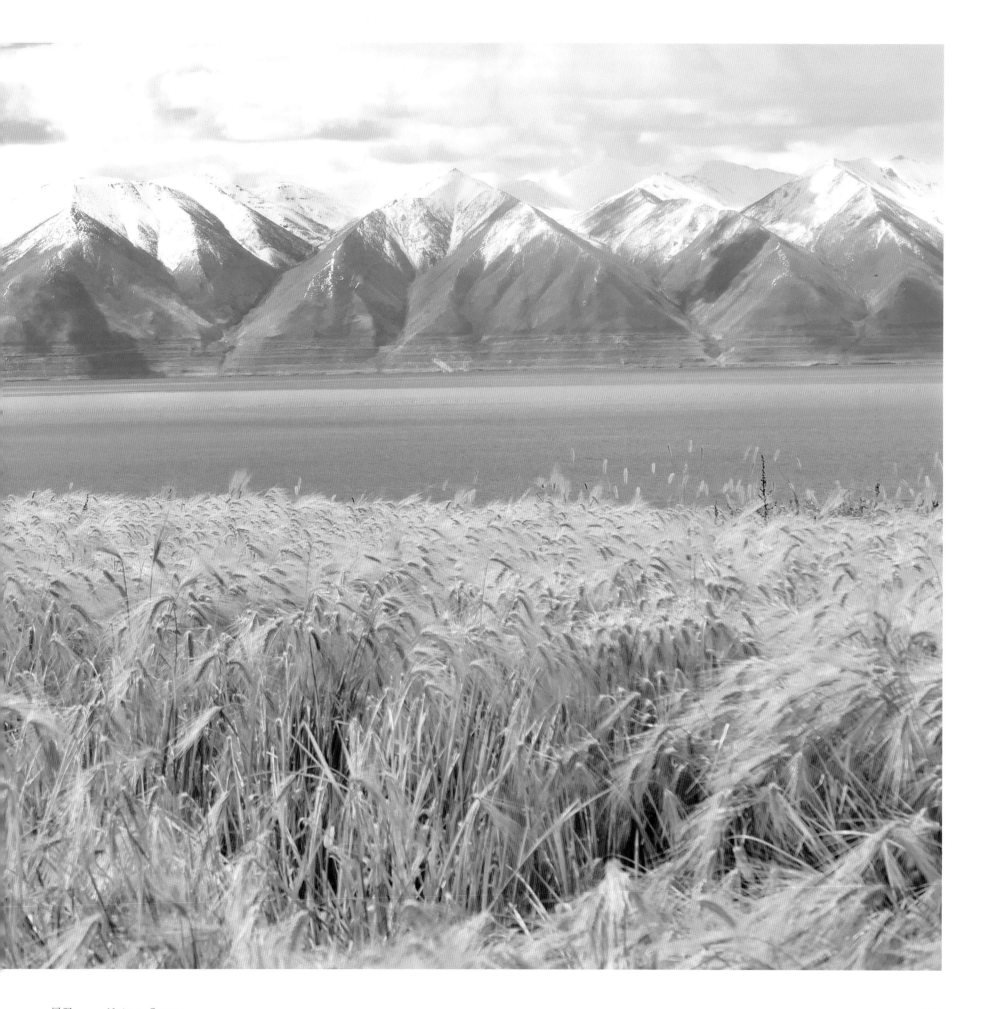

尼玛　Nyima County

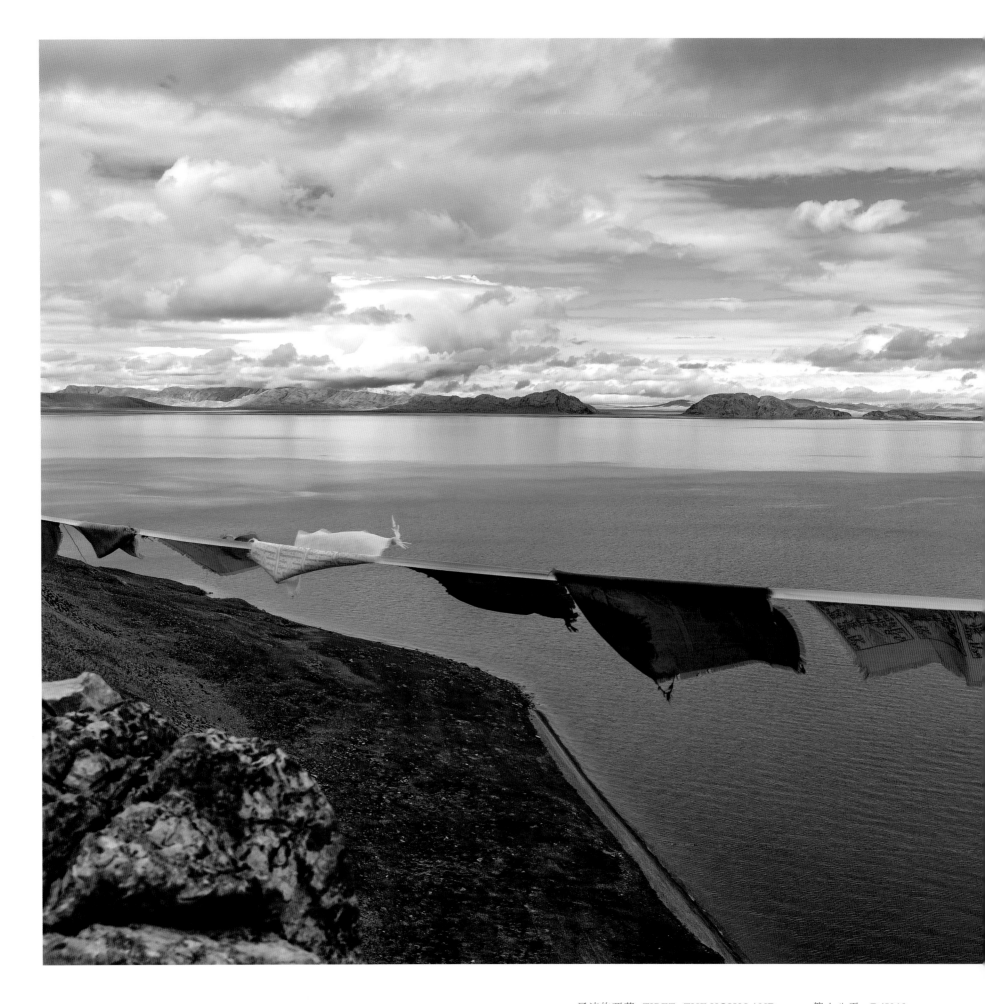

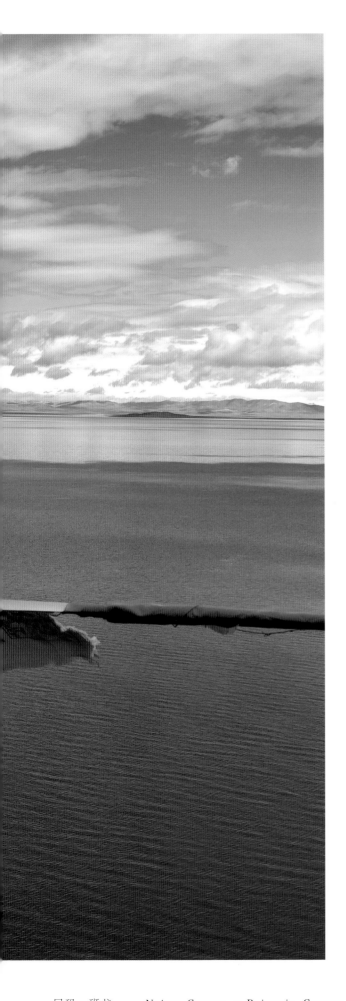

阿里北沿线的一"措"再"措"太多了，有名气的也好，不知名的也罢，分散在荒原旷野中，变成一颗颗高原明珠。沿着 317 国道前往班戈的方向，遇到的第一个名措是色林措，是青藏高原形成过程中产生的构造湖，更是西藏第一大湖，它如大海般辽阔深远，经常无风起浪，有"魔鬼湖"之称。但不同于"鬼湖"拉昂措的谢绝生物，色林措是藏北野生动物的天堂。我们一行人爬上色林措边上的悬崖，山壁陡峭，近 5,000 米的海拔确实有点惊心动魄，也因此将高原湖的原始之美展现得淋漓尽致。视野中色林措的边际与天相连，湖水如变色龙一般随着阳光不断变幻。我一路上看了大大小小无数措，私以为色林措被大大低估了，言语在它面前都显得贫瘠。

色林措的右边是错鄂措，南北相望，左边湖水厚重，辽阔无垠；右边水色澄碧、波光粼粼。"措"上加"措"，不由感叹大自然才是美的创造者。关于色林措还有一点要说明，从上世纪 70 年代以来，这个湖就不断扩张，已经吞并了周边很多小措。湖水外延使得更多的高原野生动物在这里繁衍生息，但同时也意味着岸边土地的消失。

没有大多数高原湖泊的广阔，恰规措显得格外的小巧玲珑，湖边的经幡是它的装饰品，伴着水波流动在旷野中随风飘荡。在藏北高原，在辽阔无际的荒原，恶劣的生存环境使得大部分地方人迹罕至，但万物有灵且美，没有了铁笼围栏，这里成为众多野生动物的美好家园，是美丽湖泊的最佳落脚处。

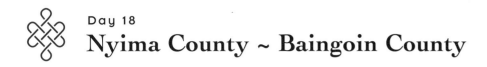

Nyima County ~ Baingoin County

Lakes along the northern line of the Ngari Prefecture, either popular or obscure, are beyond count. They scatter all over the wild expanse, shining like pearls on the plateau. National Highway 317 heading to Baingoin County led us to Lake Siling, the first lake with a great cachet along the way. As the largest in size across Tibet, it is a tectonic lake, a derivative of the formation of Qinghai-Tibet Plateau. Occupying a vast extent rippling even without any breeze, it derives the name 'the demon lake shined by divine light' from its habitable accommodation for wild animals of North Tibet, unlike the 'Ghost Lake' Lhanagtso (Lake Raksha) that denies any survival. A cliff by the lake with its precipitousness and the scary altitude of nearly 5,000 meters is quite a challenge for a group of us to climb up, but the height dominates a breathtaking panorama of the plateau lake with primitive beauty. The blue sky and the Lake Siling merge into the horizon, the waters shifting colors with the sun like a chameleon. Considering so many lakes of various sizes I have explored on the way, I really recommend Lake Siling, in my opinion, is substantially underestimated by the world, as no language seems powerful enough to extol its glamour.

On the right side of Lake Siling is Lake Cuoertso, accompanying each other all the time. The left lake is vast in size and thick in water quality, while the right one has green and clear water dancing and sparkling in the sun. One lake after another has proved that the great nature force is the genuine origin of all the splendors. Here are some additional remarks about Lake Siling: the lake has been expanding its domain by annexing many small lakes around since the 1970s, which provides larger habitable areas for more and more highland wild animals, but it also means shrinking land areas by the lake.

Not as vast as most of the highland lakes, Lake Chagchutso characterizes itself in a small and exquisite style. Prayer flags are ornaments by the lake, waving together with the lake waters in the wind. Born by nature are all things of beauty and spirituality. Although the Northern Tibetan Plateau of boundless wilderness is an untraversed region due to its harsh living environment, it is also an unfenced homeland for many wild animals as well as numerous scenic lakes.

视野中色林措的边际与天相连，湖水如变色龙一般随着阳光不断变幻。
The blue sky and the Lake Siling merge into the horizon,
the waters shifting colors with the sun like a chameleon.

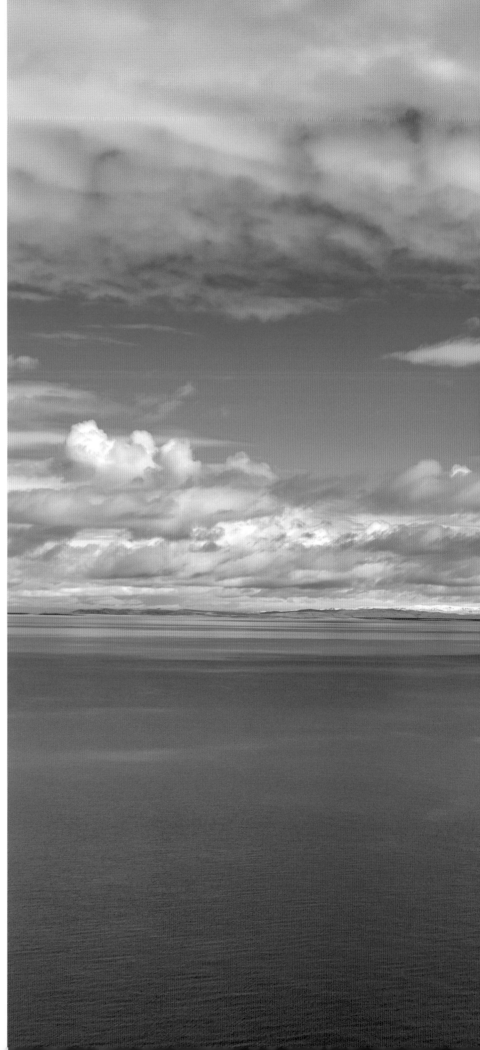

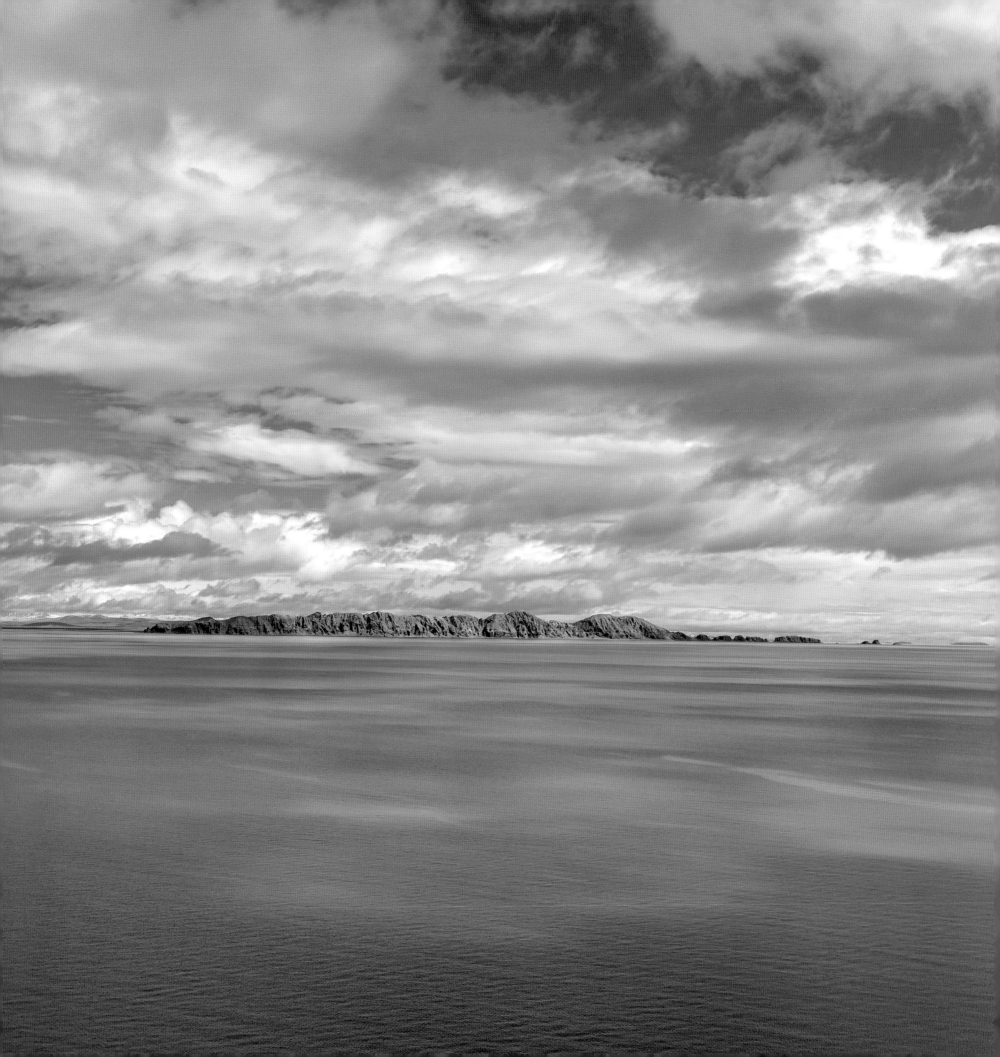

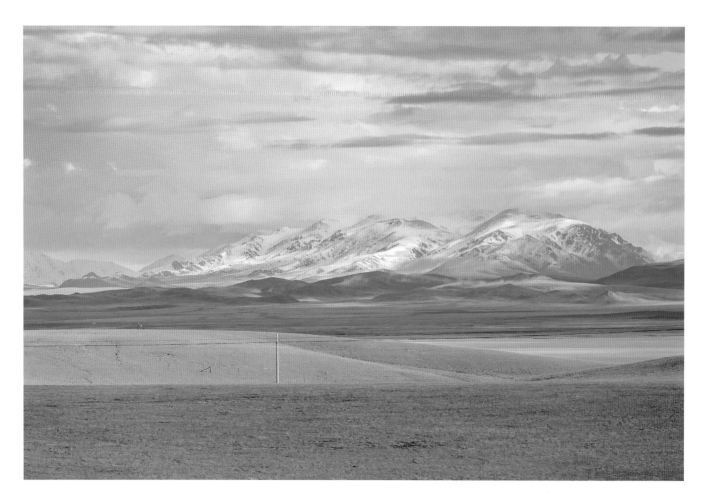

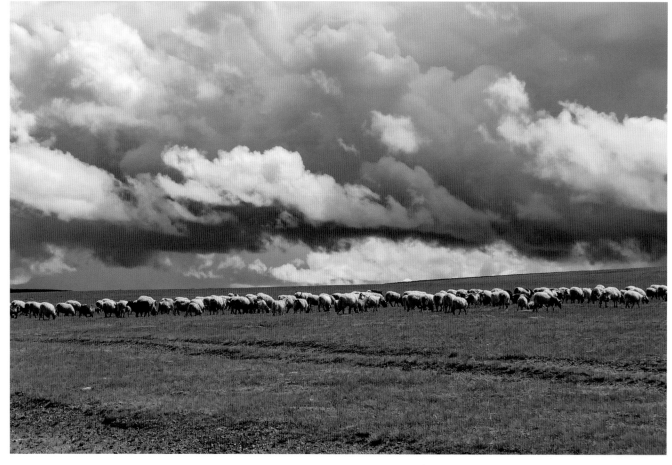

色林措不断扩张，已经吞并了周边很多小措。
湖水外延使得更多的高原野生动物在这里繁衍生息。
Lake Siling has been expanding its domain by annexing many small lakes around,
which provides larger habitable areas for more and more highland wild animals.

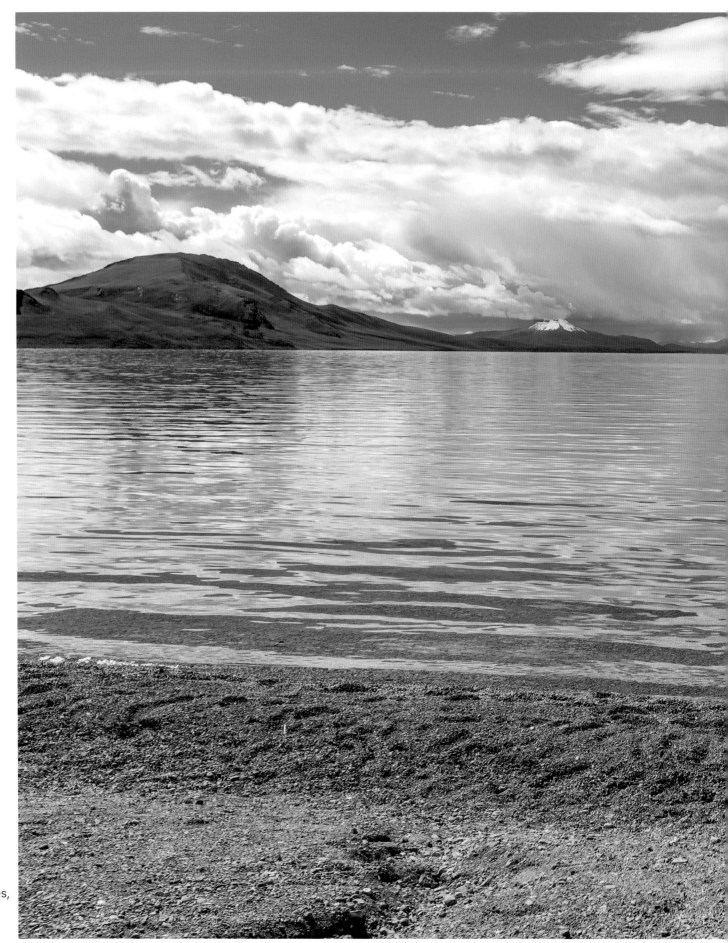

没有大多数高原湖泊的广阔，
恰规措显得格外的小巧玲珑。
Not as vast as most of the highland lakes,
Lake Chagchutso characterizes itself
by the small and exquisite style.

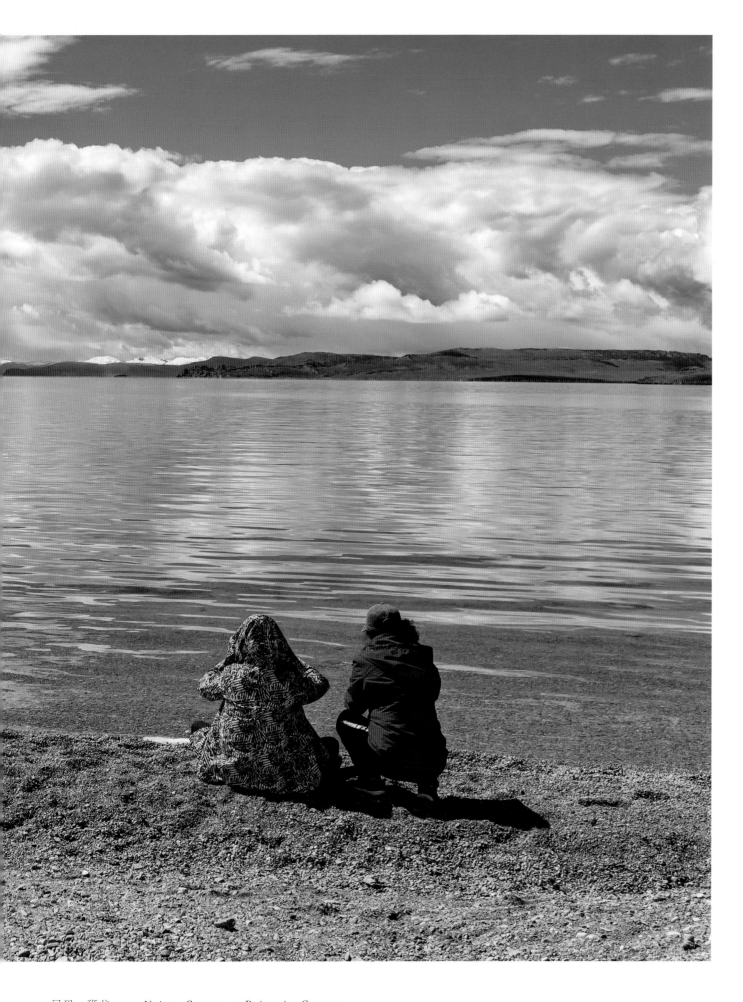

尼玛~班戈　Nyima County ~ Baingoin County

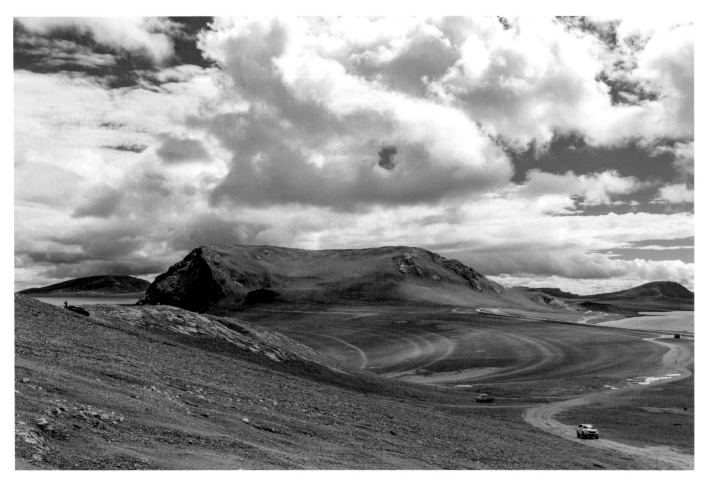

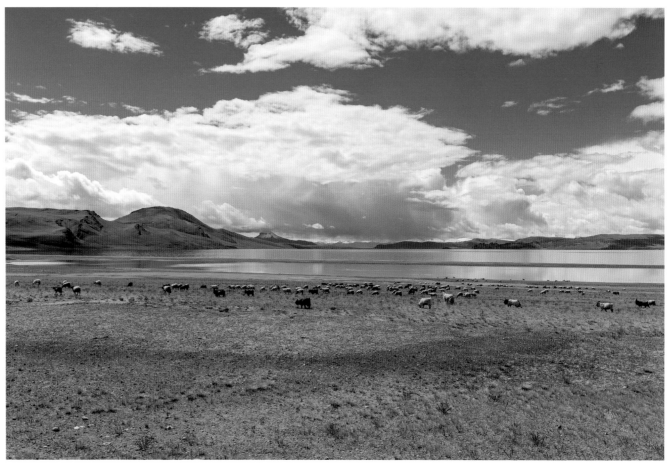

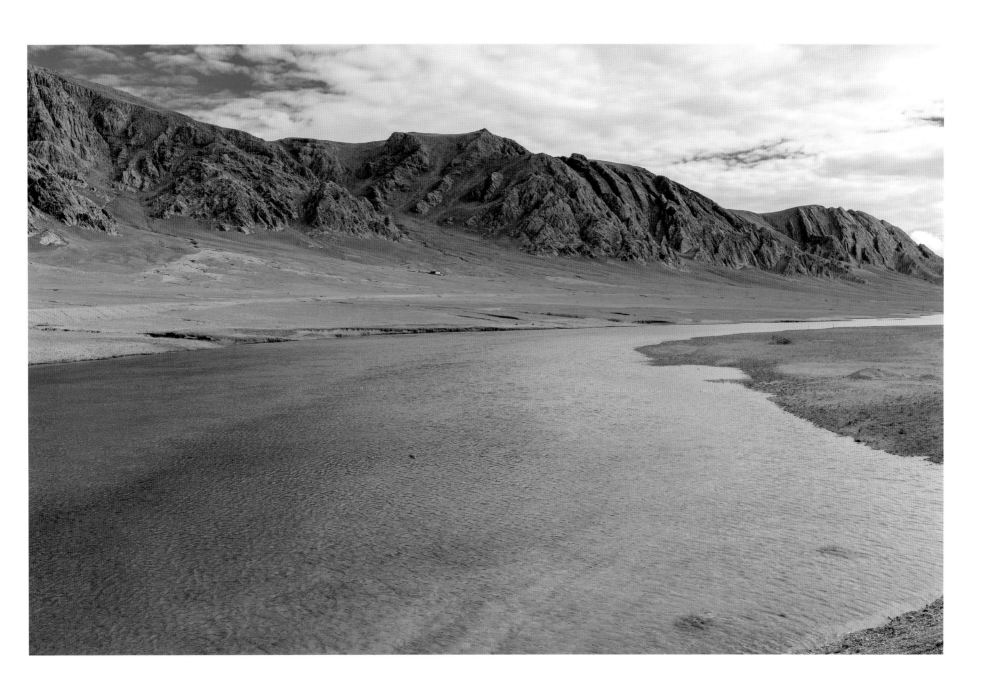

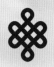

阿里之行即将走到尽头，一大早班戈就开始下雪，大片大片的雪花从天上急急飘下来，看来今天要雪中行了。

都说"五岳归来不看山"，经过这几天高密度观赏一个又一个的措，大概回去后可以不看湖了。巴木措是纳木措的姐妹湖，海拔 4,555 米，一片蔚蓝色的大湖，尽管有纳木措的盛名在侧，巴木措依然把我惊艳到了。我们在这里下车走向湖边，四周静谧无人，湖边成片的玛尼堆代表着人们美好的祝福，优美的湖岸曲线一览无遗，我们稍微花了一些时间在此逗留。

雪时停时续，在念青唐古拉山脉沿途欣赏高山雪景，"四顾尽荒原"，满眼白茫茫。纳木措，是西藏三大圣湖之首，在藏语中是"天湖"的意思，单从名字也能看出它的地位有多高。雪天的缘故我们没有近距离看湖，只是在行进的车上远观，尽管云层遮挡，"几分朦胧几分清"中亦可窥得其美。纳木措是此行的最后一座湖，之后经过海拔 5,190 米的那根拉垭口，算是最后的告别。

　　这片高原，有着奔腾的江河、辽阔的草原、高耸的雪山、自由的生灵、古老的文明。在恶劣的生存环境中，从古到今世居于此的人们有着独特的生活方式，并将继续传承下去，生生不息。

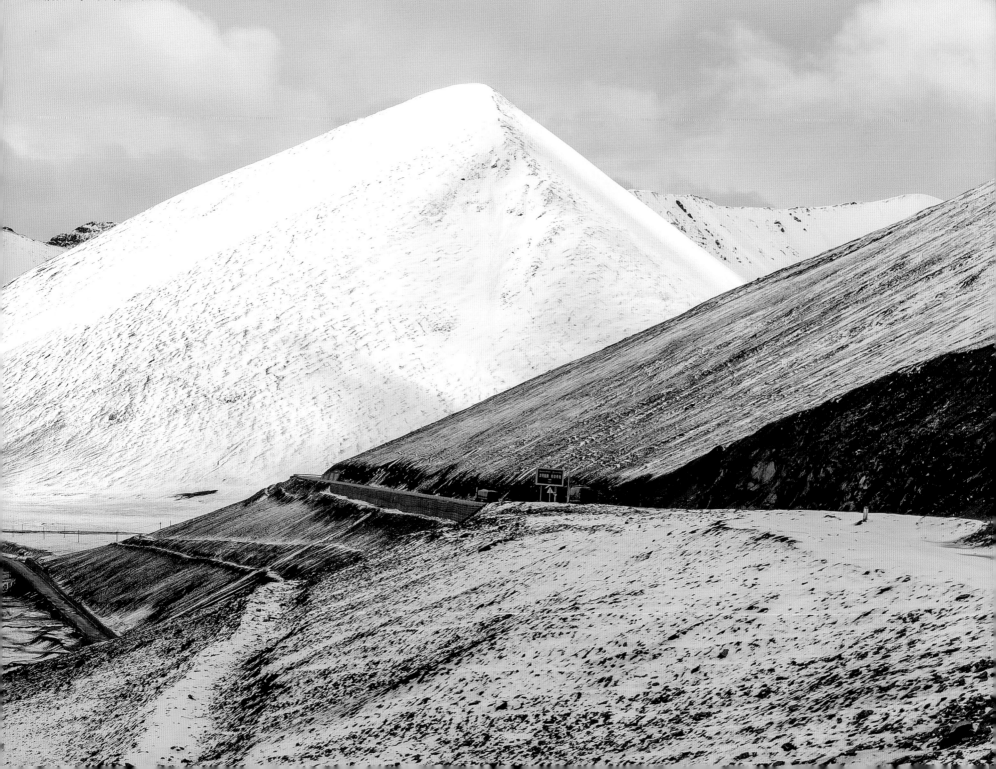

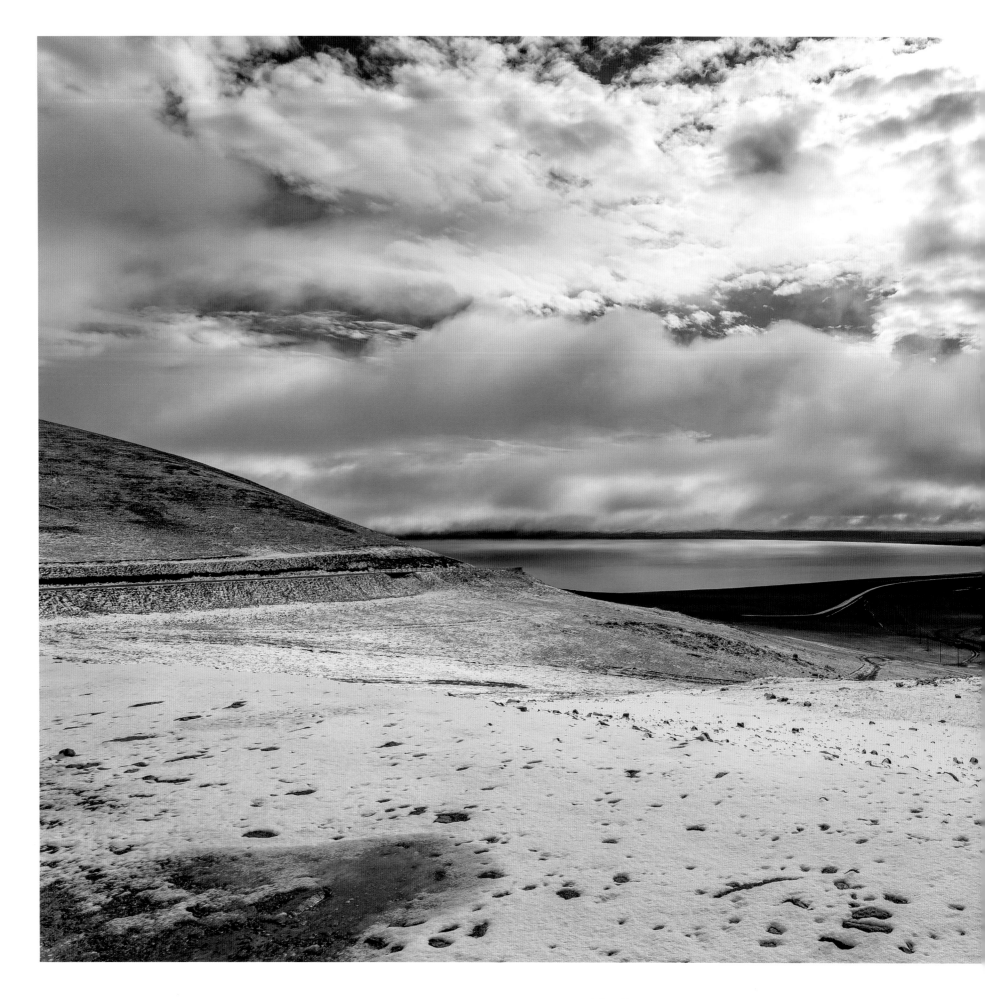

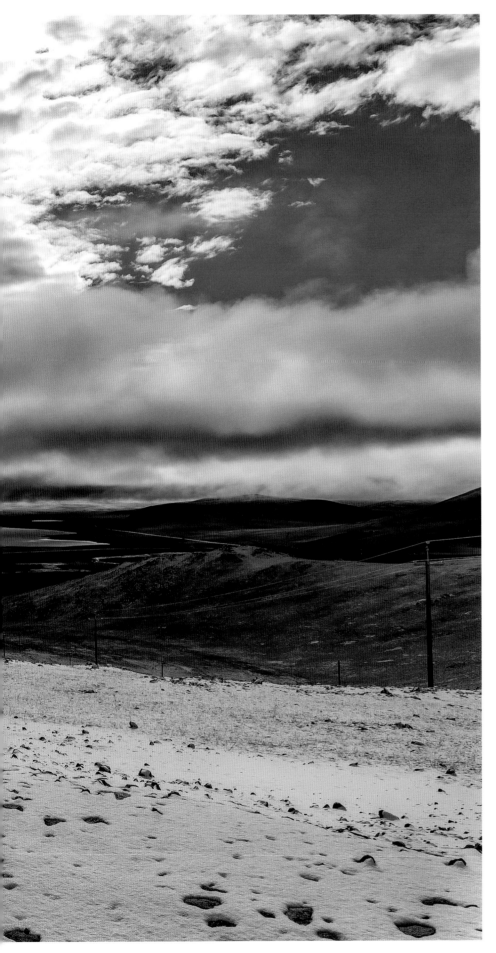

Baingoin County ~ Lhasa

Our Ngari Prefecture tour was near to completion. In the early morning, Baingoin County met a heavy snow falling down from the sky, which seemingly forecast a snowy trip of the day.

As a Chinese saying goes, trips to China's Five Mountains (Taishan Mountain in Shandong, Hengshan Mountain in Hunan, Huashan Mountain in Shanxi, Hengshan Mountain in Shanxi and Songshan Mountain in Henan) render trips to other mountains unnecessary. I think, nowhere would lakes be able to fascinate me any more after such intensive visits to Tibetan lakes one after another during these days. Lake Bamtso, with an elevation of 4,555 meters, stunned me so much by its blue expanse of vastness, despite its twin lake Namtso in high repute. We stopped the car and walked to the quiet and empty lakeside. Piles of Marnyi Stone by the lake represented good wishes from people. The elegant curve of the lake shore was in full view, so we lingered around for some time.

It snowed on and off all day, but the snowy scenery of Nyenchen Tanglha Mountains along the way glutted our eyes. All around was the huge expanse in white. Lake Namtso is the head of the three sacred lakes of Tibet, and its superb status is self-evident by the meaning implied in the name, the 'lake of heaven' in Tibetan. Instead of getting out of the car, we only had a browsing view of the lake from a distance due to the snowy weather but still sensed its misty beauty behind the screen of clouds. Lake Namtso was the terminal lake of the trip, and the Lakanla Pass with an elevation of 5,910 meters announced the closure of the entire journey.

The plateau nourishes mighty rivers, vast grasslands, towering mountains, unconstrained souls and ancient civilizations. No matter how harsh the living environment is, the local inhabitants have survived and developed in their own way since ancient times, passing down the tradition as well as wisdom through successive generations.

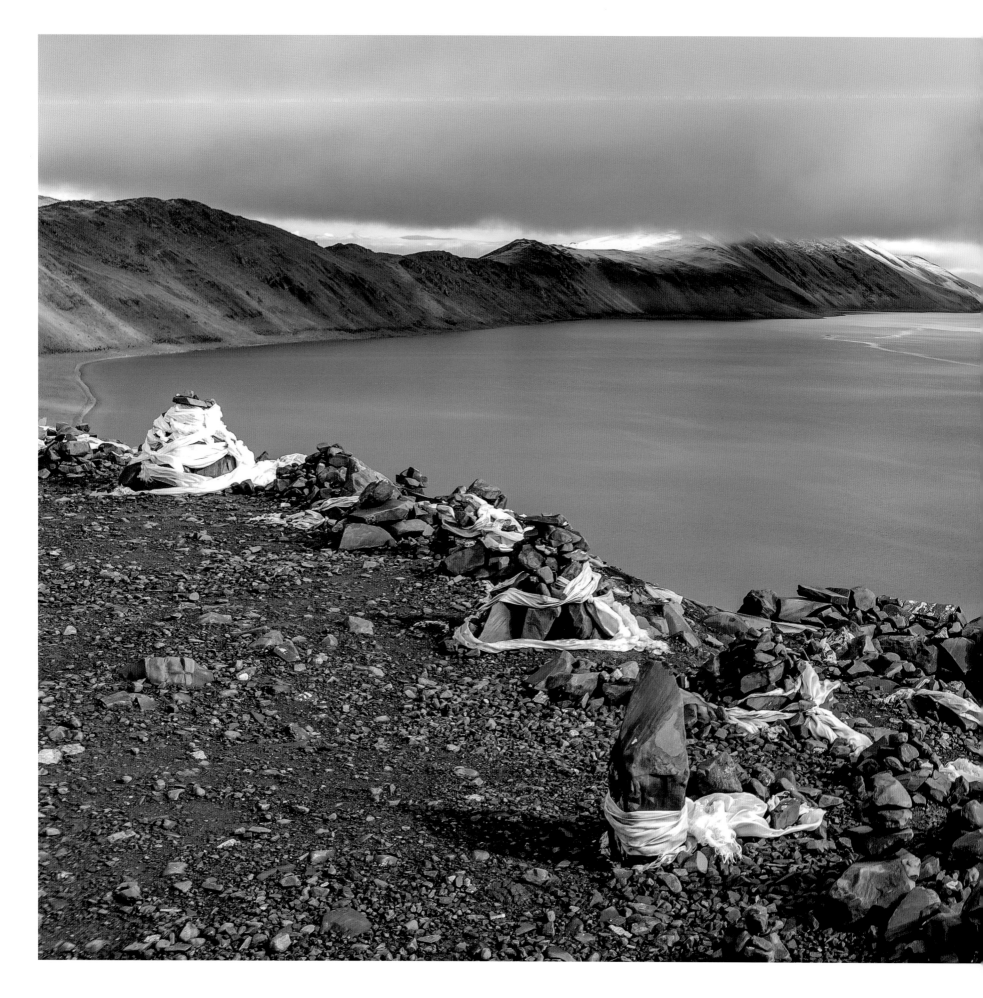

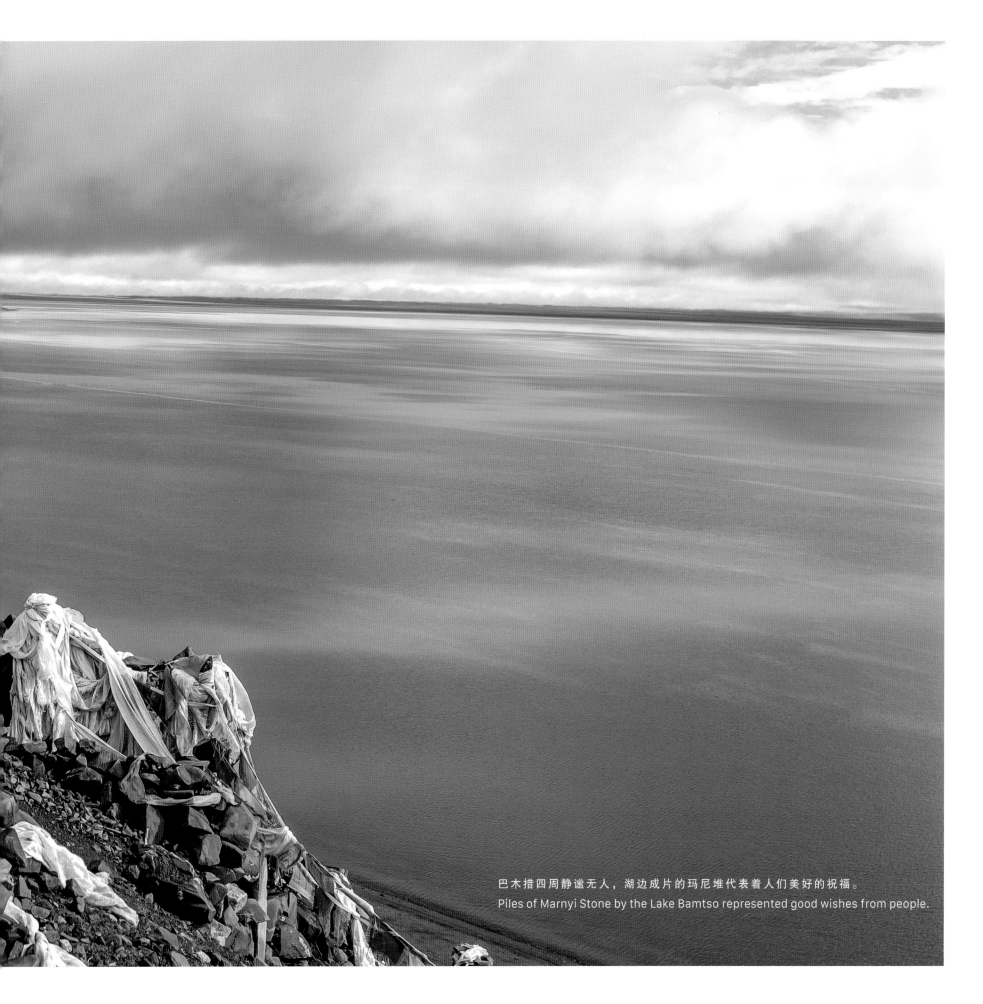

巴木措四周静谧无人，湖边成片的玛尼堆代表着人们美好的祝福。
Piles of Marnyi Stone by the Lake Bamtso represented good wishes from people.

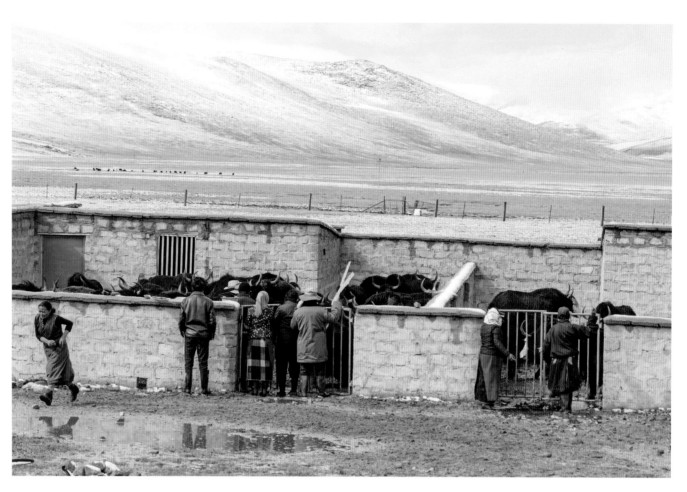

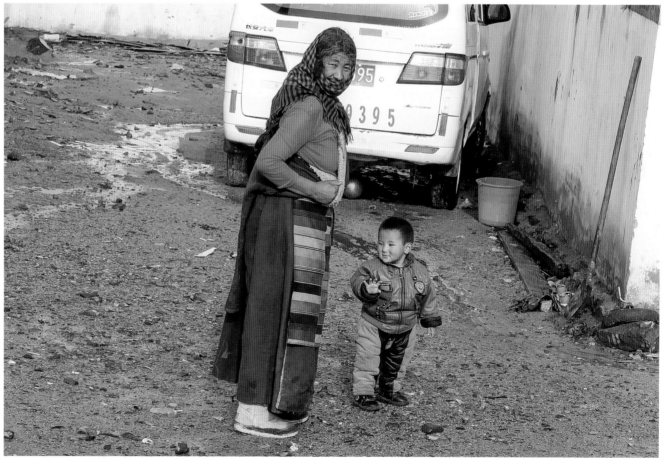

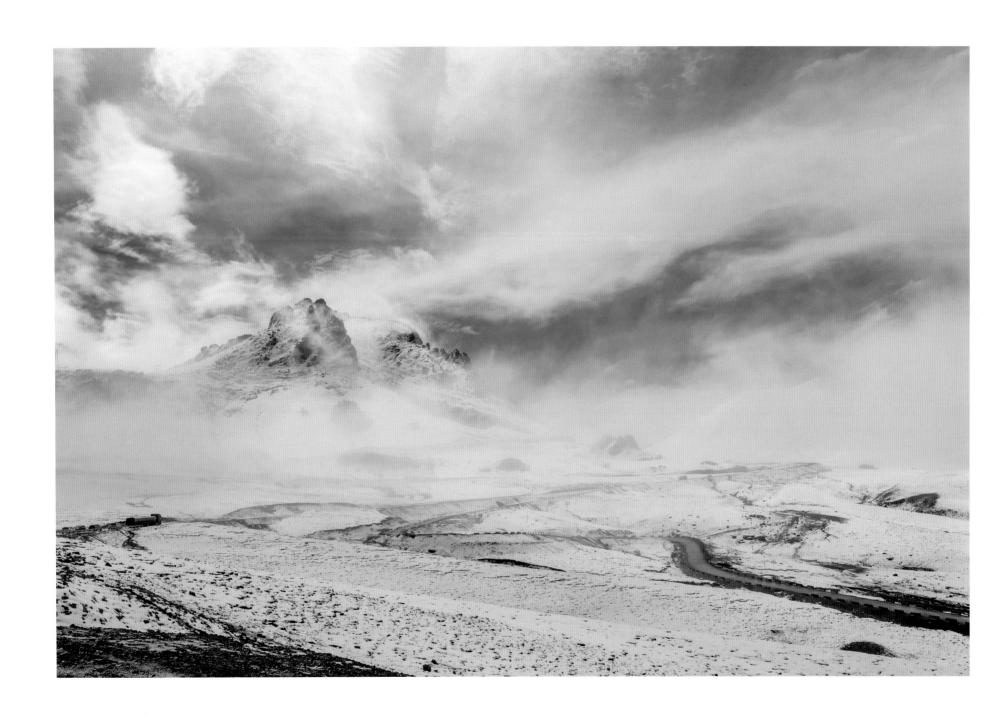

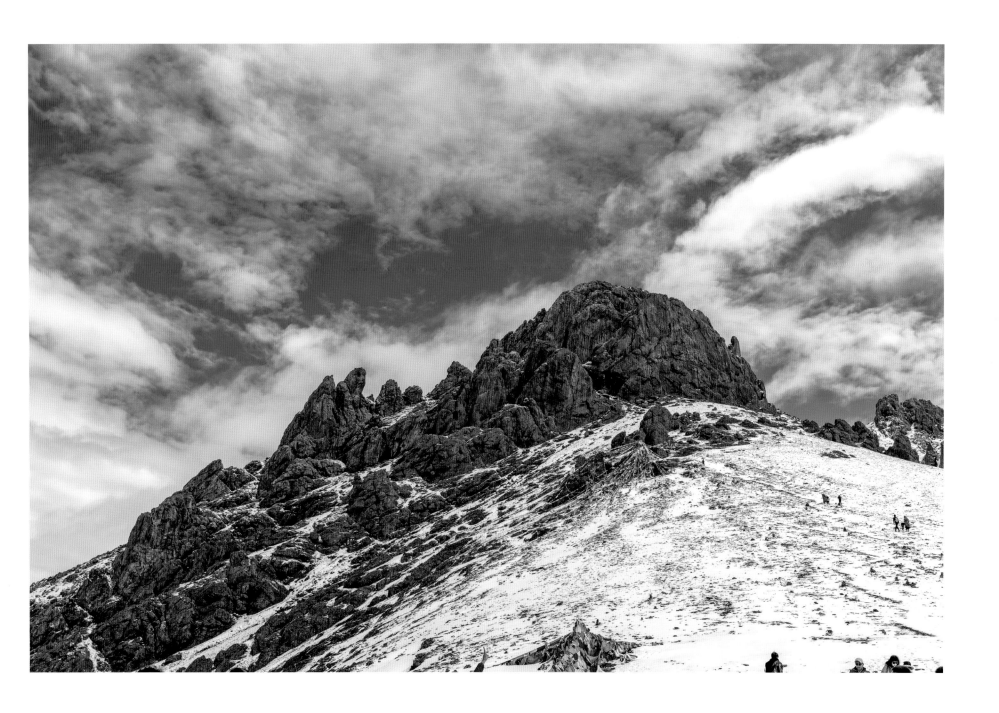

班戈～拉萨　Baingoin County ~ Lhasa

一行人经过海拔 5,190 米的那根拉垭口，算是最后的告别。
Lakanla Pass with an elevation of 5,910 meters announced the closure of the entire journey.

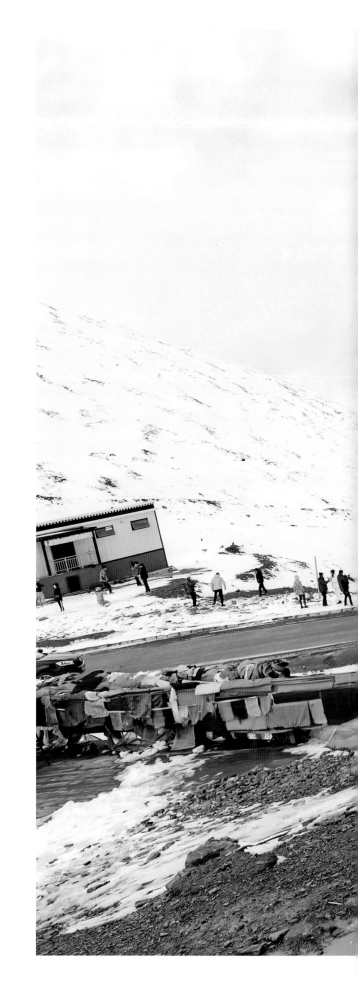

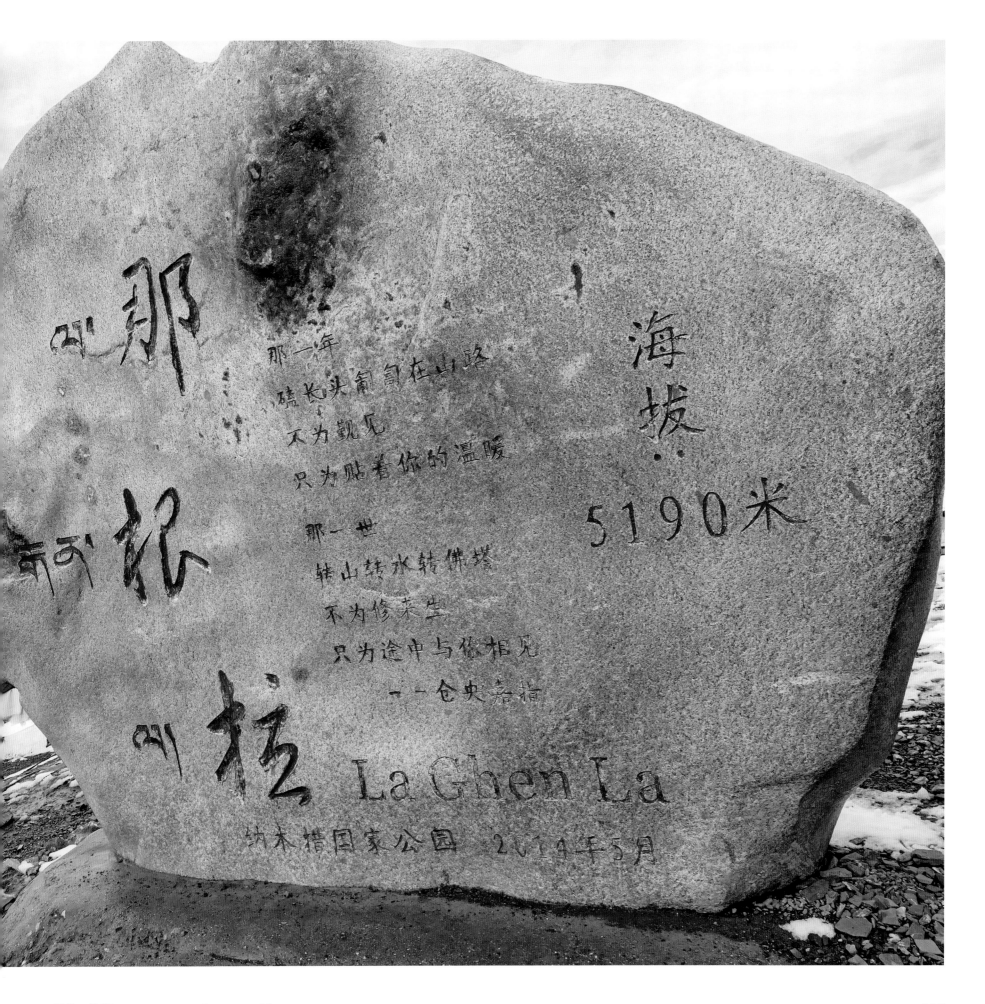

那一年
磕长头匍匐在山路
不为觐见
只为贴着你的温暖

那一世
转山转水转佛塔
不为修来生
只为途中与你相见
——仓央嘉措

海拔 5190米

La Ghen La

纳木措国家公园 2014年5月

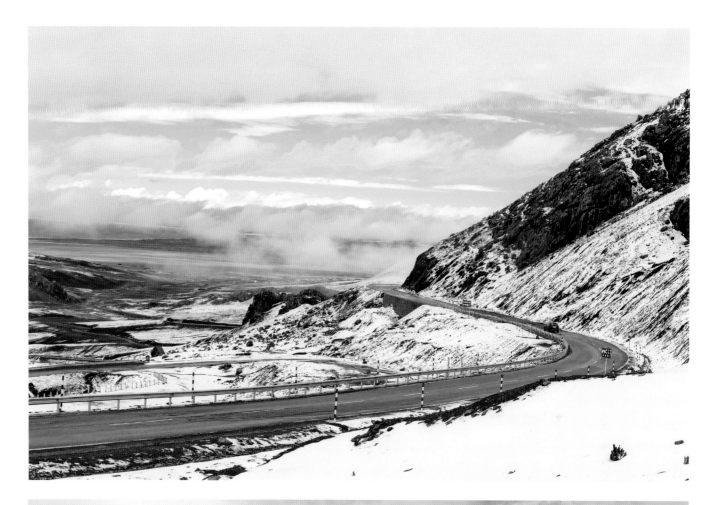

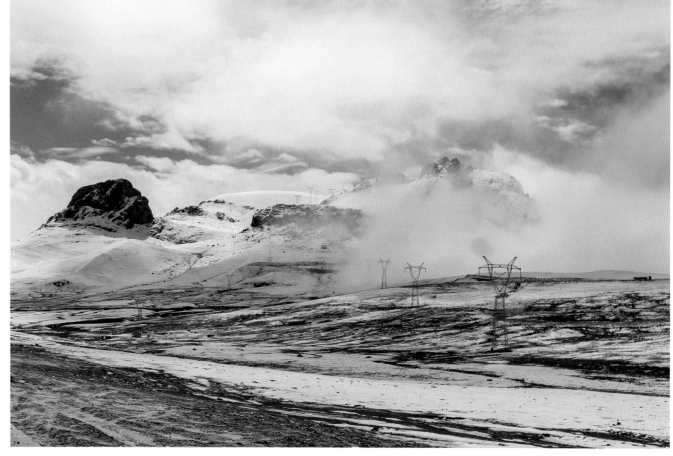

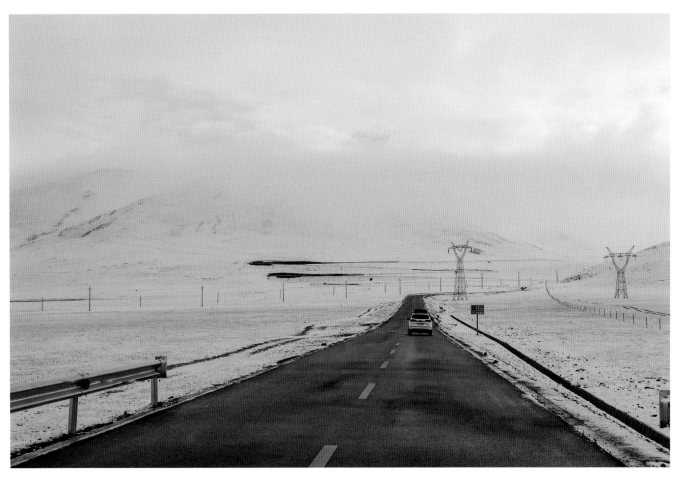

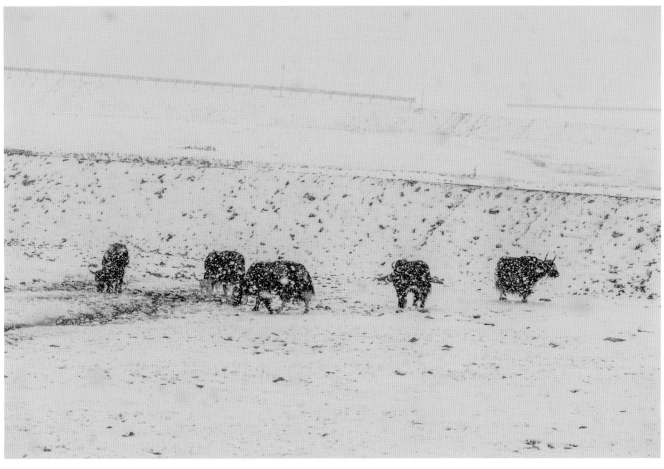

班戈~拉萨　　Baingoin County ~ Lhasa

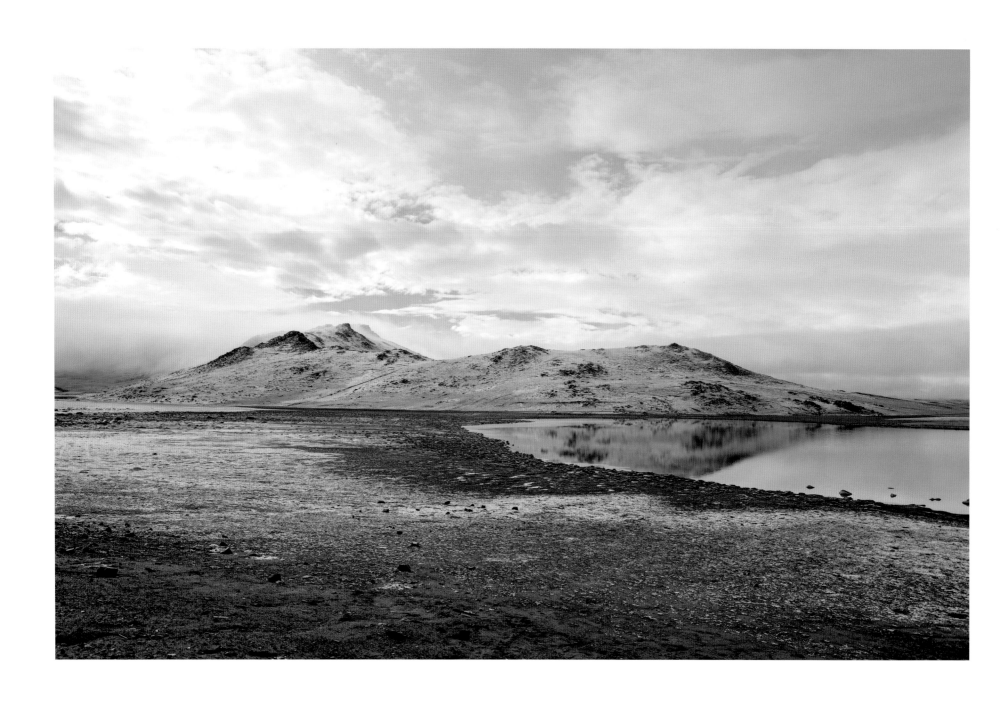

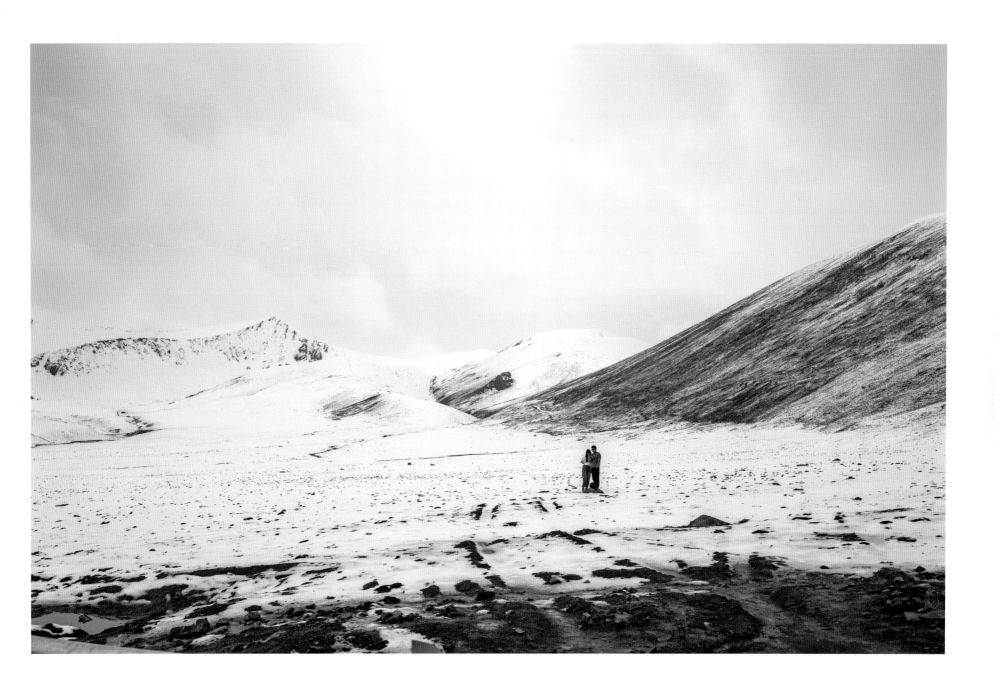

班戈～拉萨　Baingoin County ~ Lhasa

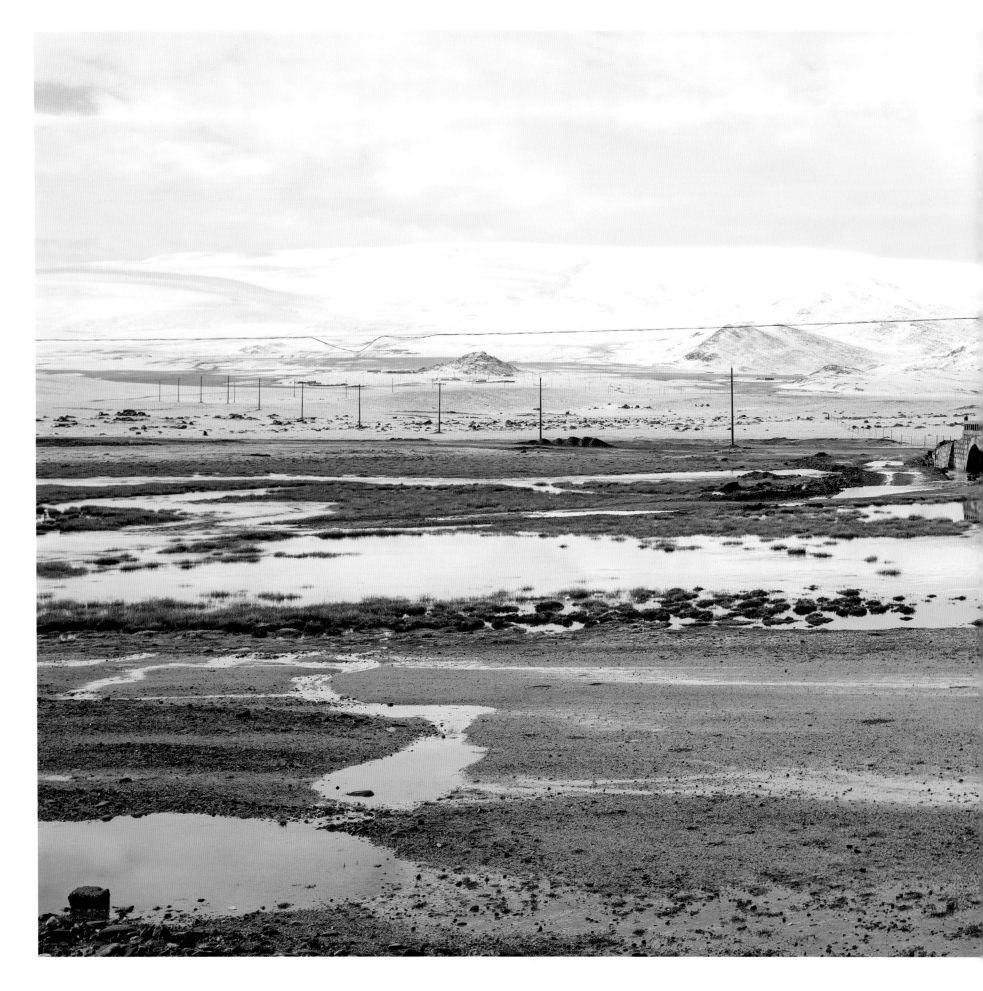

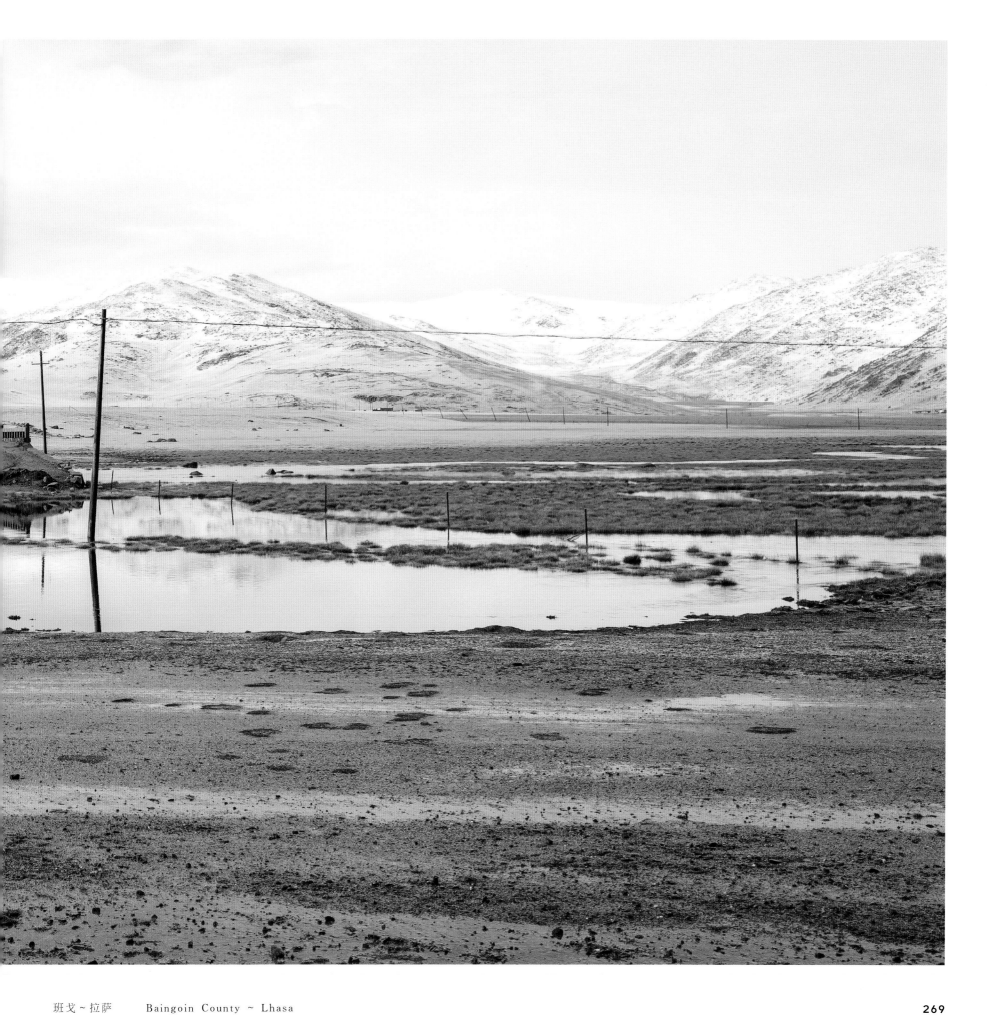

班戈~拉萨　　Baingoin County ~ Lhasa

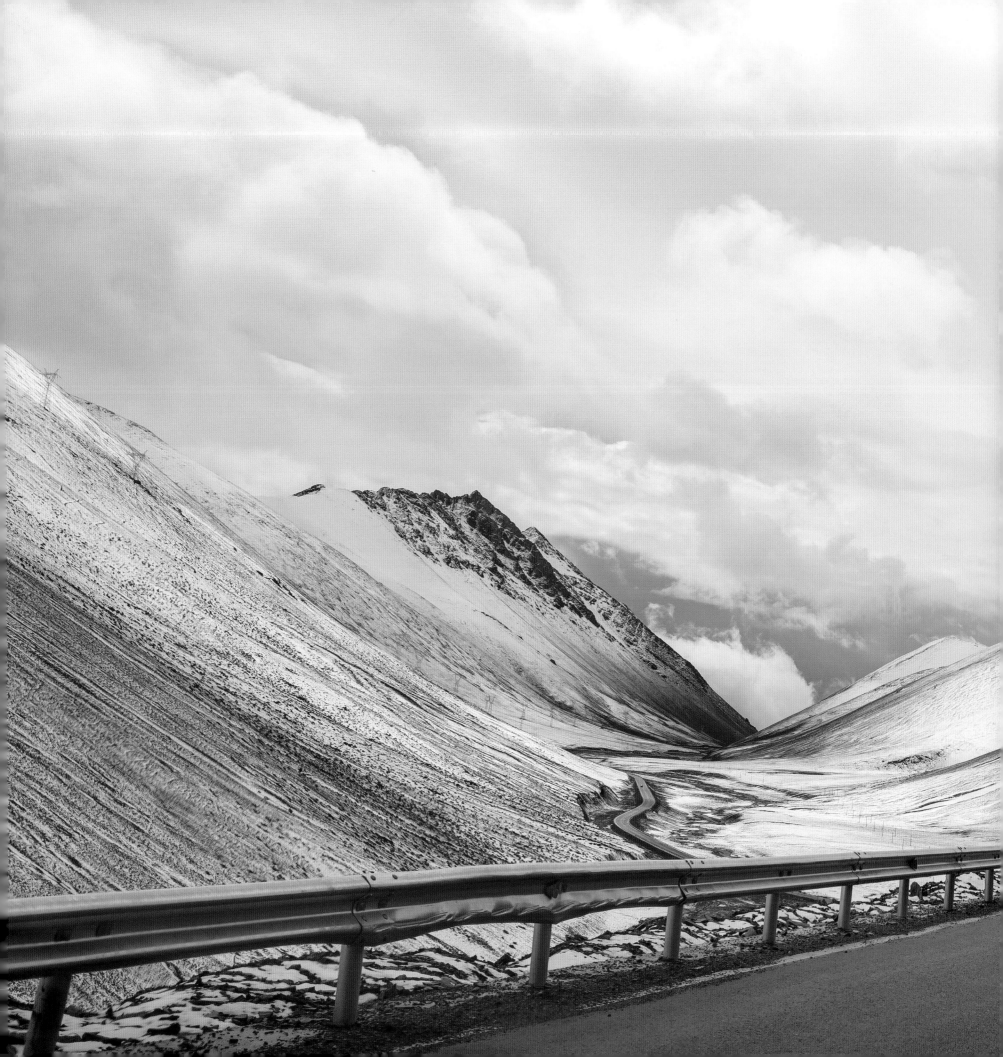

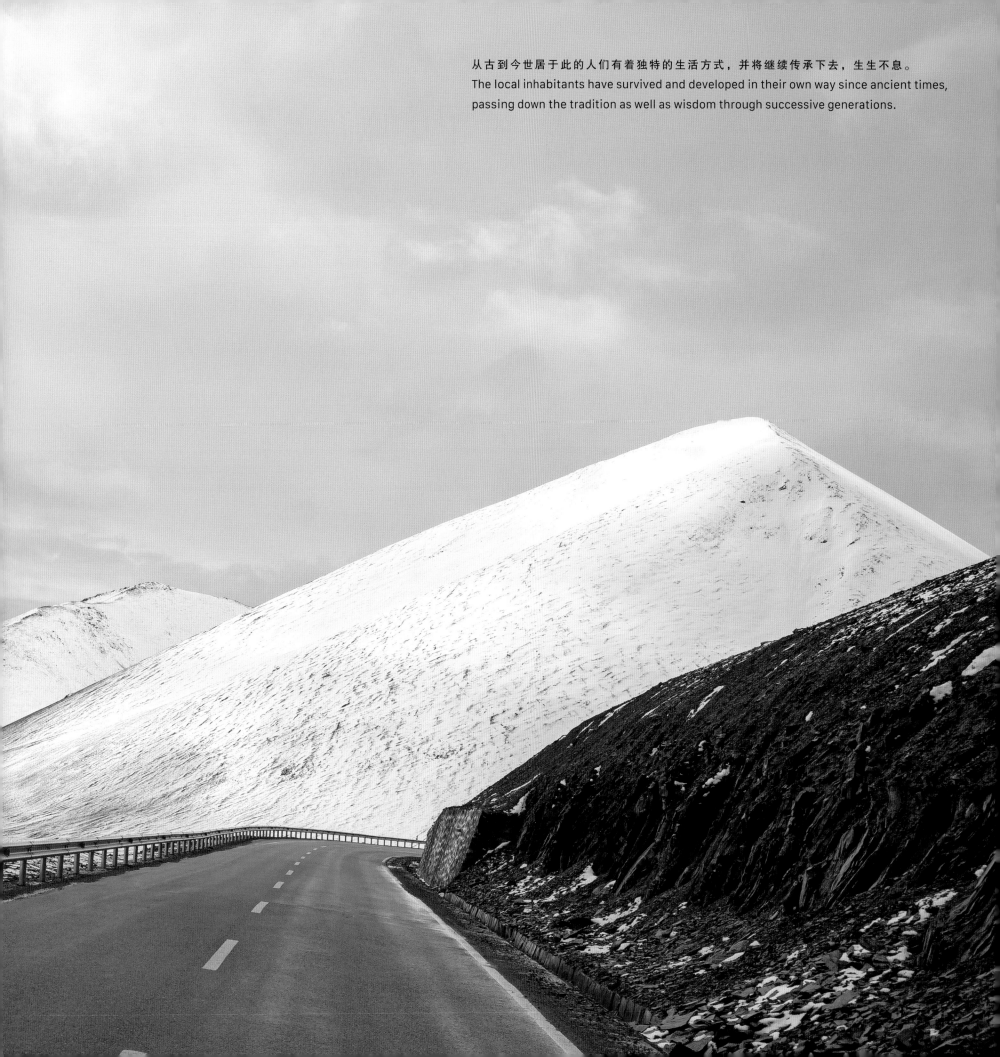

从古到今世居于此的人们有着独特的生活方式，并将继续传承下去，生生不息。
The local inhabitants have survived and developed in their own way since ancient times, passing down the tradition as well as wisdom through successive generations.

TIBET - THE HOLY LAND
圣洁 的 西藏

邓予立　Tang Yu Lap

翻　译	李伟华	TRANSLATOR	Grace Li
资料搜集	赵　露	INFORMATION GATHERING	Zhao Lu
责任编辑	郭子晴	EDITOR	Elise Kwok
装帧设计	Sands Design Workshop	DESIGNER	Sands Design Workshop
排　版	Sands Design Workshop	TYPESETTER	Sands Design Workshop
印　务	刘汉举	PRODUCER	Eric Lau

出版

中华书局（香港）有限公司
香港北角英皇道四九九号北角工业大厦一楼 B
电话：（852）2137 2338　传真：（852）2713 8202
电子邮件：info@chunghwabook.com.hk
网址：http://www.chunghwabook.com.hk

PUBLISHER

Chung Hwa Book Co., (H.K.) Ltd.,
Flat B, 1/F, North Point Industrial Building,
499 King's Road, North Point, H.K.
Email: info@chunghwabook.com.hk
Website: www.chunghwabook.com.hk

发行

香港联合书刊物流有限公司
香港新界荃湾德士古道 220-248 号荃湾工业中心 16 楼
电话：（852）2150 2100　传真：（852）2407 3062
电子邮件：info@suplogistics.com.hk

DISTRIBUTER

SUP Publishing Logistics (H.K.) Ltd.
16/F, Tsuen Wan Industrial Centre,
220-248 Texaco Road, Tsuen Wan, NT, H.K.
Tel: +852-2150-2100/ Fax: +852-2407-3062
Email: info@suplogistics.com.hk

版次

2022 年 1 月初版
© 2022 中华书局（香港）有限公司

First Edition, Jan 2022.
© Chung Hwa Book Co., (H.K.) Ltd.

规格

12 开（280mm × 280mm）

ISBN 978-988-8760-50-3

ISBN

978-988-8760-50-3

TIBET - THE HOLY LAND
Text Copyright © 2022 Tang Yu Lap
All Rights Reserved

༁ྃ།།ཀ།། ཕྲིན་ཕྱིར་བདུབསནསཀོི་ནུ་པུ་དུ་ཆེ
ནནཔ་དཀྱིཿ ཙུ་མ་ག་ཧུ་ང་ཀྲུབ་བདུད་ཙོ་ར་
ཀྲུལ་བདུ་ང་ཆེ་ས་བེ་ས་ག་ས་ཕ་ཡཿ ཐུ་ག་བ
ེ་ན་ཆེན་ཟ་མ་དུ་གཿ ར་དུ་བདུ་ཙེ་ས་བཔ
ཡུང་མ་ན་ཕ་ན་ཙེ་ནས་དོས་ཀྲུབ་བཙུམ